CAMERA
CLUES

CAMERA CLUES

A Handbook for Photographic Investigation

JOE NICKELL

THE UNIVERSITY PRESS OF KENTUCKY

Copyright © 1994 by The University Press of Kentucky

Scholarly publisher for the Commonwealth,
serving Bellarmine College, Berea College, Centre
College of Kentucky, Eastern Kentucky University,
The Filson Club, Georgetown College, Kentucky
Historical Society, Kentucky State University,
Morehead State University, Murray State University,
Northern Kentucky University, Transylvania University,
University of Kentucky, University of Louisville,
and Western Kentucky University.

Editorial and Sales Offices: Lexington, Kentucky 40508-4008

Library of Congress Cataloging-in-Publication Data

Nickell, Joe.
 Camera clues : a handbook for photographic investigation / Joe
Nickell.
 p. cm.
 Includes bibliographical references and index.
 ISBN 0-8131-1894-8 (acid-free paper)
 1. Legal photography. 2. Photographs—Dating. 3. Photography in
historiography. I. Title.
TR822.N53 1994
770—dc20 94-15623

CONTENTS

ACKNOWLEDGMENTS

I have been assisted by many people with expertise in a wide variety of specialties. In addition to the authors of the various source materials cited throughout the book, I am grateful for the assistance of Tom House, photo-archivist in the Department of Special Collections, King Library, University of Kentucky; my longtime colleague, John F. Fischer, a forensic analyst in a Florida crime laboratory and an experienced crime-scene investigator; and Robert H. van Outer, a professional photographer of Lexington, Kentucky, who has many years' experience in most aspects of photographic work and who produced the wonderful illustrations for my *Pen, Ink and Evidence*.

I am, of course, responsible, ultimately, for any deficiencies. I hope they are few, and that the reader finds this material as interesting and useful as I have in researching it.

1

INTRODUCTION

Photography, evolving from tentative experiments beginning about the turn of the nineteenth century, became commonplace by mid-century, and—with the introduction of the Brownie camera in 1900—it became widely popular: Practically anyone could "capture" anything at any time on film. Now, with millions of photographic images being made annually, photography has invaded virtually every area of human activity.[1]

With this proliferation of photos have come attendant mysteries—questions raised about the date when or conditions under which a given photo was made, about its subject matter or other concerns. Many are historical questions: Could this be a rare portrait of Abraham Lincoln? Who are the people in these old family photographs? When was this "view" of a certain town made? Does this represent an honest historical document, or was the depicted scene staged? What about this old picture: is it an original or a copy, one made perhaps many years later? Are there clues as to when and where this daguerreotype was taken? And so on and on.

Other questions may be more scientific in nature: Has this picture been retouched? Does that crime-scene photograph distort distances and thus create a false impression? Can particular features in a photo be enhanced? Is it possible to photograph a certain document in such a way as to reveal obliterated writing? Is this photo of a "UFO" really proof of alien visitation? Could that photo of a "ghost" actually result from a double exposure? And what about this strange picture: is the odd image some defect of camera or film?

This book attempts to provide answers to such questions, representing a wide-ranging study of photography from an investigative standpoint. On the one hand, I discuss the use of photography in investigative work; on the other, I show how investigative methods are applied to photographs themselves. Appropriate discussions of early photographic processes and other

developments and techniques are given. To avoid unnecessarily complicating the text, however, I occasionally refer the readers to a specialized article or textbook for a more in-depth study. Extensive notes, an annotated bibliography at the end of each chapter, and an appendix on the chronology and identification of photos are also intended to help accomplish this goal and to make the text more useful.

Throughout, I also cite numerous case studies not only for their entertainment value but also for the light they shed on how photographic mysteries arise and how investigative strategies may be devised to solve them. Such strategies apply to photographs that may have been deliberately intended to deceive as well as to ordinary snapshots or professional photographs that—through the vagaries of time or circumstance—have inadvertently raised questions or become the subject of controversy. Because of the controversy surrounding many sensational photographs—for instance, those alleged to depict American prisoners of war still being held in Vietnam or Cambodia or pictures of the Loch Ness Monster—it is appropriate to discuss briefly some rules of evidence and procedure.

First of all, one should keep in mind the maxim that the burden of proof is always upon the advocate of an idea—that is, in a court of law the plaintiff, or, elsewhere, whoever is the asserter of a fact or the one who advances some hypothesis. A skeptic does not have to prove something is *not* so, the difficulty of proving a negative being well known. Consider, for example, trying to prove there are no leprechauns in Ireland: whatever contrary evidence you amass, someone can always insist your approach has been inadequate.[2]

One should keep in mind, too, the maxim that "extraordinary claims require extraordinary proof"—that is, that proof should be commensurate with the degree of remarkableness of the claim being made. For instance, someone entering your home or office with a dripping umbrella and announcing that it is raining outside is naturally accorded more credibility than someone producing an instant-camera snapshot of a flying saucer that is alleged to have just flown by.[3]

Another useful principle is known as "Occam's razor" or "the maxim of parsimony." It is often invoked in cases in which more than one hypothesis can account for the known facts. Occam's razor holds that the simplest tenable explanation—that is, the hypothesis with the fewest assumptions—is most likely to be correct and is, consequently, to be preferred.[4]

These are only a few general guidelines. More specific rules of evidence and standards of proof may need to be applied depending on the circumstances in a given case. A family historian taking a photo of an ancestor's gravestone, for example, is not expected to follow all the guidelines of providing documentation and establishing the chain of evidence that would be

required of a forensic expert taking a photograph of a bloodstain at the scene of a homicide.

I point this out because I am hopeful that the book's broad scope will make it useful to a wide variety of potential readers: genealogists and family researchers; historians, biographers, and other scholars; reporters; police and private detectives, as well as insurance adjusters and attorneys; scientists; photographers, photo archivists, and collectors of photographs; and, indeed, all who encounter photos in their private or professional lives—in a word, everyone!

Given my background—a patchwork of experience in a number of professional fields—I have long seen the need for such a book as this, one that pulls together information from rather scattered sources and places it in a useful context. At last, however, resigned to producing the book myself, I find I am able to draw on my diverse background for illustrative cases and insights. As a former professional stage magician, for example, I have learned much about the art of illusion and the uncovering of deception. Other relevant work has included stints as a private investigator (as an operative for an internationally known detective agency), a historic-document specialist (and author of *Pen, Ink, and Evidence: A Study of Writing and Writing Materials for the Penman, Collector, and Document Detective*[5]), a museologist, and—not to exhaust the list—as a newspaper "stringer" and historical columnist.

In short, I have faced many of the kinds of photo mysteries that readers are themselves likely to have encountered. Though it has not been possible to anticipate every kind of mystery and offer a ready solution, there are certainly many procedures and techniques that point the way.

Recommended Works

Baker, Robert A., and Joe Nickell. *Missing Pieces: How To Investigate Ghosts, UFOs, Psychics and Other Mysteries*. Buffalo: Prometheus Books, 1992. Comprehensive investigators' manual, with extended discussions of investigatory tactics and techniques, rules of evidence, and related subjects.

Coe, Brian. *The Birth of Photography: The Story of the Formative Years, 1800-1900*. London: Spring Books, 1989. Highly readable, well-illustrated text on photography's most formative period.

Winks, Robin W., ed. *The Historian as Detective*. New York: Harper and Row, 1969. A textbook for the historical investigator, featuring essays on evidence and case studies of many historical mysteries, including the Kennedy assassination.

2

THE HISTORY OF PHOTOGRAPHY

The Development of the Photographic Process

Ever since prehistoric times—when cave dwellers painted likenesses of animals they hunted on the walls of caves such as the Altamira caverns in Spain[1]—people have sought to make images of the world around them. Later developments such as the landscape paintings beautifully rendered on silk by ancient Chinese artists[2] or portrait art (developed by the Egyptians and Romans and introduced, in the West, at the beginning of the Renaissance[3]) continued the tradition.

The growth of the middle class in the eighteenth century created a demand for artistic likenesses of people that were less expensive than the oil portraits commissioned by wealthy patrons. Miniature paintings satisfied the demand to an extent, but it was largely the silhouette—traced and filled in in black ink from a shadow cast by a lamp, or cut freehand from black paper by an artist using small, long-handled scissors—that first captured the mass market.[4] Named for Etienne de Silhouette, a French minister of finance who was an amateur profile artist, these shadow portraits were at first one-of-a-kind originals (see Figure 2.1) until another Frenchman, Gilles Louis Chretien, invented in 1786 a multiple-image-making device called the Physionotrace.[5] This apparatus was similar to a draftsman's pantograph, and to the device Thomas Jefferson used to make instantaneous copies of letters he was writing.[6] When a pointer was traced over the lamp-cast profile, a system of levers caused an engraving tool to reproduce the outline on a copper plate. Details of features and costumes could be added, and the plate could then be inked and printed to make many duplicate images. Soon artists and inventors began to speculate about optical devices that might produce images directly.[7]

Such an optical device—the camera obscura—was known in ancient times, but there was then no means of permanently recording the transient

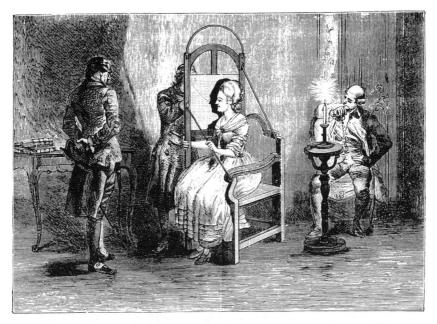

Figure 2.1. Traced silhouettes were forerunners of later photographic techniques that also used light to record an image. (From an 1898 text, *Magic: Stage Illusions and Scientific Diversions, Including Trick Photography.*)

image. As Leonardo da Vinci described the camera obscura in his note-books: "When the images of illuminated objects pass through a small round hole into a very dark room . . . you will see on the paper all those objects in their natural shapes and colours. They will be reduced in size, and upside down, owing to the intersection of the rays at the aperture."[8]

Various portable models of the camera obscura were developed, and in 1589 Giovanni Battista della Porta published a note on the advantage of using a lens instead of a small hole. About 1665 Robert Boyle constructed a box-type model that could be extended or shortened, like a telescope, so that the image could be focused onto a paper placed across the back of the box directly opposite the lens. While scientists used the camera obscura for solar observations, artists adapted the device (using a mirror to correct the left-right reversal of the image) as an aid in drawing, since they could easily trace the projected image.[9]

About 1800, the first experiments in attempting to "fix" camera ob-scura images were made in England by Thomas Wedgwood. He sought to copy paintings made on glass onto sheets of paper treated with silver nitrate. As demonstrated by C.W. Scheele in 1777, such silver compounds darken by the action of light. The great chemist Sir Humphry Davy wrote of his friend

Wedgwood's experiments: "When the shadow of any figure is thrown upon the prepared surface, the part concealed by it remains white, and the other parts speedily become dark." With the painting on glass, "the rays transmitted through the differently painted surfaces produce distinct tints of brown or black, sensibly differing in intensity according to the shades of the picture." Unfortunately, the resulting images were impermanent, and—due to their light sensitivity—could only be viewed by candlelight. Moreover, as Davy wrote, "the images formed by means of a camera obscura, have been found to be too faint to produce, in any moderate time, an effect upon the nitrate of silver." [10]

It remained for the Frenchman Joseph Nicephore Niepce to produce the first permanent images made by the direct action of light. An amateur scientist and artist who was interested in the new printmaking technique of lithography but who was not very skilled at drawing, Niepce sought ways of transferring images directly onto the printing plate. He tried Wedgwood's methodology and was even able to record faint images using the camera obscura, but the impermanence of the images remained a problem.

At length Niepce discovered that a bitumen varnish was sensitive to light, remaining soft where protected from light and hardening wherever exposed. A plate coated with the varnish and exposed by passing light through a line drawing or print made on translucent paper could then be washed with a solvent that dissolved the soft, unexposed areas and left a permanent image on the plate. The first such "heliographs" date from 1822, and by 1827 Niepce had succeeded in using a camera obscura to record an image on a bitumen-coated pewter plate. This was a view made from a window of his home, requiring an eight-hour exposure, and regarded as "the oldest surviving image produced by a camera." [11]

In 1835 William Henry Fox Talbot discovered the fundamental principle upon which modern photography is based: the photographic negative from which many positives could be made.[12] Talbot also identified silver chloride as the silver compound most suitable for photographic prints. In 1840 he gave the name *calotype* to his improved process in which a latent image was developed on paper.[13] In the meantime, however, his work was overshadowed by a French process that produced a very different photographic image known as the daguerreotype.

Daguerreotype: The First Practical Process

At a January 7, 1839, meeting of the French Academy of Sciences, the physicist François Arago announced the discovery of the world's first practical photographic process. The discoverer was Louis Daguerre (1789-1851), an

artist known for his skillful paintings of dioramas. Through that work he was acquainted with the camera obscura and soon became obsessed with the possibility of fixing the image that the device projected. Although his early experiments were unsuccessful, when he learned of Niepce's promising work he began a correspondence which culminated in the two becoming partners.[14]

Niepce died in 1833, and two years later his son Isidore signed an agreement recognizing certain technical developments that Daguerre had himself made. In 1837, Isidore signed a further agreement acknowledging that Daguerre had developed a method that successfully produced permanent images and was sufficiently different from Niepce's heliography to constitute a new process that should bear Daguerre's name.

Backed by the influential Arago, Daguerre sold his process to the government of France for a lifetime pension of 6,000 francs per year for himself and 4,000 annually for Isidore Niepce.[15] Daguerre, however, promoted his invention, organizing public demonstrations of his process, circulating a handbook, commissioning his brother-in-law to market cameras with his trademark, presenting daguerreotypes to notables, and entering into negotiations with potential commercial agents including Samuel Morse,[16] the inventor of the telegraph, who introduced Daguerre's process into the United States.[17]

Daguerre's successful process had both significant advantages and drawbacks. One of the latter was its complicated methodology. As Brian Coe describes it, in *The Birth of Photography*:

To prepare, expose and process the Daguerreotype plate a considerable amount of apparatus and manipulation was required. First the plate, usually of silvered copper, was held in a hand vise and polished on a leather buff, using powdered pumice stone and olive oil. It was finished to a high polish with jeweller's rouge. The plate was then placed face down in a sensitizing box, usually with two compartments for iodine crystals and bromine water. Close observation of a succession of colour changes on the plate's surface during this operation told the operator when the desired degree of sensitivity had been reached. The prepared plate, loaded in a plateholder, was then placed in the camera. (Usually the Daguerreotype camera consisted of two wooden boxes, one sliding closely within the other. One carried the lens and the other the focusing screen and plateholder. . . .)

Then,

When the plate had been exposed, usually for about 30 seconds in the studio, it was removed from the camera and taken to the darkroom, where it was placed face down in the top of a developing box. In the bottom was a dish of mercury, heated by a spirit lamp. As the mercury vapour 'developed' the image, progress could be followed by candlelight through a yellow glass window in the box. When fully developed the image was fixed by chemical treatment, removing the remaining unused silver salts. The plate was placed on a levelling stand to keep it perfectly horizontal, covered with

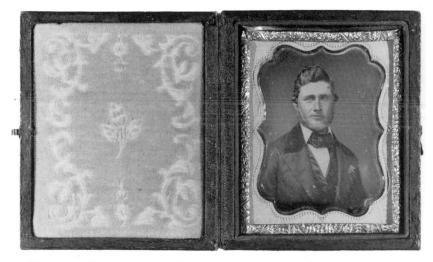

Figure 2.2. Daguerreotypes—like this portrait of a gentleman in its original hinged, velvet-lined case—represented the first practical photographic process (1839-ca. 1860). This is a "ninth plate" size image (i.e., 2 x 2^1/$_2$ inches).*

gold-bearing solution and heated. Finally, after washing and drying, the finished plate was covered with a gilt or brass matt—a decorative mask with an appropriately shaped aperture—covered with a protective glass and bound in a pinchbeck or brass foil frame. An airtight seal was necessary, as the silver plate would tarnish rapidly if exposed to the atmosphere. The mounted Daguerreotype was usually sold in a leather-covered, plush-lined case.[18] [See Figure 2.2]

In addition to its complexity, the process was expensive and cumbersome, requiring the photographer to travel with a small laboratory, and it was limited to producing fragile, one-of-a-kind pictures that—being "direct positives"—were mirror-imaged. With portraiture, the plates yielded figures "seemingly in agony,"[19] not surprisingly since one daguerreotypist advised: "Paint in dead white the face of the patient, powder his hair and fix the back of his head between two or three planks solidly attached to the back of an armchair and wound up with screws."[20]

But many improvements were to come. Exposure times—originally extending to as much as thirty minutes for a portrait—were reduced. Cameras were improved in a variety of ways. Among other technical improvements was a method of gold toning introduced in 1840 by Hippolyte Fizeau that increased both the picture's contrast and its permanence.[21]

*(Unless otherwise indicated, photographs are from the author's collection.)

One problem was inherent in the daguerreotype's polished silver surface: it was so highly reflective (described as "the mirror with a memory"[22]) that the viewing angle was quite critical. Technically, "The light tonalities of the image were formed by the deposit of mercury which scattered the light while the darker tonalities were formed by the specular reflection of the mirror surface of the plate."[23] The image therefore had the quality of appearing as either a positive or a negative depending on the angle from which it was viewed and the direction from which light fell on it.

Despite all the disadvantages, daguerreotypes caught the popular imagination. It is said that news of the process caused the artist Paul Deloroche to exclaim, "From today painting is dead."[24] Samuel Morse, who happened to be in Paris to patent his telegraph when discovery of the daguerreotype was announced, stated that, although the images were not in color, "the exquisite minuteness of the delineation cannot be conceived. No painting or engraving ever approached it."[25] Similarly, Sir John Robinson, who had been invited to Paris to inspect the daguerreotypes, reported to the Society of Arts in Edinburgh that "the perfection and fidelity of the pictures are such that on examining them by microscopic power, details are discovered which are not perceivable to the naked eye in the original objects: a crack in plaster, a withered leaf lying on a projecting cornice, or an accumulation of dust in a hollow moulding of a distant building."[26]

And so, although the daguerreotyping processes were hazardous to the health (especially because of mercury poisoning), would-be photographers were attracted in droves. Who were these intrepid artisans? Many had been artists of one sort or another, but there were also former watchmakers and dentists—even one man who had plied his trade as a lampshade maker.[27]

The daguerreotype quickly flourished. In March 1840 Alexander Wolcott and John Johnson (associates of Samuel Morse) opened the first United States studio in New York. A month earlier, Johnson's father took the system to London where he entered into an arrangement with a speculator named Richard Beard. It was Beard who opened the first public studio in Europe, in London at the Royal Polytechnic Institute, in March 1841. An early review in the *Spectator* observed: "If the charge be moderate . . . thousands will flock to the Polytechnic portrait room and the patentee, Mr. Beard, will make a fortune." The forecast proved correct, and other studios soon followed. Indeed, "Attendance at a daguerreotype portrait studio soon became an essential social exercise for the fashion-conscious."[28]

Nevertheless, although the process had been virtually perfected by 1844, it was not fated to last. By the mid-1850s a new photographic process—the collodion or "wet-plate" method—began to eclipse the daguerreotype, although it lasted somewhat longer in America, "until 1860 or so."[29]

Ambrotypes: The Early Wet-plate Process

Although Fox Talbot's paper negatives offered the advantages of easy dupli-
cation, prints made from them lacked the clarity and detail of daguer-
reotypes. Experimenters tried using glass as a base for the light-sensitive
compounds, but there was a problem in preventing the chemical solutions
from running off the plate while it was being exposed. In 1847, Abel Niepce
de Saint-Victor, a cousin of the great pioneer Niepce, used potassium iodide
mixed with albumen (egg white) to coat the glass. When dry, the plates were
then sensitized with silver nitrate solution and, after exposure, developed
with gallic acid.[30]

In 1851, Frederick Scott Archer tried a different approach: He used a
clear liquid called collodion to coat the plate. From the Greek word meaning
"gluelike," collodion is a syrupy solution made by dissolving nitrocellulose
(which is also used in making celluloid) in alcohol and ether.[31] After the
plate was coated with the collodion, it was given a bath in a solution of silver
nitrate. This rendered the plate light sensitive, but only so long as it re-
mained wet. Thus was born the collodion, sometimes called the "wet collo-
dion," or "wet-plate" process.[32] (Although Archer lived to see his process
revolutionize photography, having published his work freely he never prof-
ited from it, and he died penniless in 1857.[33])

Subsequently, in 1852, Archer described a variant process in which a
solution of mercuric bromide was used to whiten the collodion negative.
Backing the image with black paper or a coating of black varnish (or placing
the emulsion on darkly tinted glass) caused the negative image to appear as
a positive. This collodion positive soon began to displace the daguerreotype
for portraiture.[34] Unlike daguerreotypes, ambrotypes required little skill and
small investment. Consequently, "the difference in cost was considerable,
and even the poor could be tempted into a photographic studio for a sixpen-
ny portrait."[35]

A major advantage of the process was that it eliminated the distracting
reflections of the daguerreotype and could be viewed from any angle. Adver-
tised one photographer, who called them *verreotypes*, "they can be seen in
every shade of light."[36] (See Figure 2.3.)

Of couse, like daguerreotypes, each ambrotype was one of a kind. If
the subject desired an additional picture, he had to sit for another exposure
or (much less satisfactory in terms of quality) have his original copied. Also
like the daguerreotype, the ambrotype image was a "direct positive" with
left and right backward as in a mirror. Being usually on clear glass, however,
it could consequently be reversed without the use of a special device (a prism
or mirror) in front of the lens.[37]

Because the image was somewhat fragile, the collodion positive had to

Figure 2.3. Ambrotypes, popular from 1855 to ca. 1865, were collodion images on
glass. Note in this gentleman's portrait the damage in the area of
the chin, caused by the emulsion flaking off the glass.

be carefully packaged: first with a thin brass mat over the image followed by
a cover glass, the resulting sandwich secured by a thin brass rim called a
"preserver." This package was then placed in a folding case like that already
being used for daguerreotypes—usually into the right-hand side, with a vel-
vet pad filling the left, although some cases held photographs on both
sides.[38]

There were several American developments concerning the process.

The Philadelphia daguerreotypist Marcus Root named it the "Ambrotype" (from the Greek word *ambrotos*, "immortal"). In 1854, James Cutting of Boston patented a technique in which the cover glass was sealed to the glass plate with Canada Balsam, a resin. In the same year the "Union" case was patented by a daguerreotypist named Samuel Peck. Sometimes incorrectly referred to as gutta-percha,[39] these thermoplastic cases were actually molded from a compound of shellac and sawdust.[40]

The ambrotype's popularity was sudden and extensive, and according to one authority, "Its reign lasted from the mid-1850s through the early 1860s. Many Civil War soldiers chose this process to immortalize themselves for loved ones back home."[41] Its replacement, however, was another type of collodion positive photograph.

Tintypes: Later Wet-plate Photos

Whereas ambrotypes were collodion wet-plate products on a glass support, another collodion wet-plate process utilized a thin sheet of blackened iron. Named the "melainotype" (from the Greek *melas*, meaning "black") or—more appropriately, perhaps, given its base—"ferrotype" (from the Latin *ferrum*, "iron"), nevertheless this type of photograph became popular under the misnomer "tintype."[42]

Although the process was patented in 1856 by Hamilton Smith, an Ohio chemistry professor (who then sold the rights to Peter Neff), actually it was first described three years earlier by the French photographer Adolphe Martin. In any event tintypes became popular about 1860.[43] Neff sold his process throughout the United States, and some tintypes are consequently stamped along their edges "Melainotype Plate/For Neffs Pat/19 Feb 56." Others may be impressed "Griswold's Pat. Melainotype," after Victor Griswold, who manufactured his own brand of plates.[44] A tintype in the author's collection is stamped "GRISWOLD PATENTED OCT 21 1856."

While tintypes lasted well into the twentieth century, when they were produced by the gelatin-silver bromide process, early tintypes were made by the collodion wet-plate method. The thin iron plate that some sources describe as "enamelled"[45] or "lacquered"[46] was actually coated with "a black [or brown] japan varnish" (japan color being pigment ground in varnish). Sometimes no varnish at all was applied so as to yield an image that more closely resembled the daguerreotype.[47]

To produce a tintype photograph, the plate was cut to size, "sensitized," inserted in the camera, exposed, and developed much as the related ambrotype was.[48] Special cameras were even designed that permitted all the chemical operations to be conducted within the camera itself.[49] To prevent

Figure 2.4. Tintypes—actually images on sheet-iron plates—were often sold in hinged cases like the earlier daguerreotypes and ambrotypes or (as with this 1885 woman's portrait) came in a decorative paper mat. Many of the popular, inexpensive images, common 1856-ca. 1945, were sold without encasement of any type.

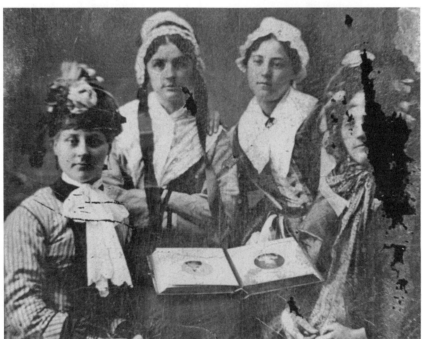

Figure 2.5. A photograph album is the focus of this old tintype group picture. (Note how the emulsion is missing from the face on the right, revealing the undersurface of blackened iron.)

abrasion, the resulting image was usually given a protective coat of clear varnish.[50]

Unlike its cousin the ambrotype, the tintype was developed as a positive image, and therefore it did not have to be backed or even mounted in the elaborate manner of that other type of wet-plate photo. The metal base was also less fragile than the glass support of the ambrotype, and—although tintypes were often mounted in the familiar double cases—their relative thinness permitted them to be sold in a paper sleeve like that shown in Figure 2.4 or kept in albums as in Figure 2.5.

Even though tintypes were essentially one-of-a-kind photographs like daguerreotypes and ambrotypes, multiple identical images could be produced with multilens cameras. These were capable of exposing four, six, or more photographs simultaneously on a single plate. After processing, the duplicate pictures were then snipped apart with metal-cutting shears.[51]

The following approximate plate sizes (not case sizes) were available (as given in Blodgett's *Photographs: A Collector's Guide*):

Whole plate	$6^1/_2$ by $8^1/_2$	inches
Half plate	$4^1/_2$ by $5^1/_2$	inches
Quarter plate	$3^1/_2$ by $4^1/_2$	inches
Sixth plate	$2^3/_4$ by $3^1/_4$	inches
Ninth plate	2 by $2^1/_2$	inches
Sixteenth plate	$1^5/_8$ by $2^1/_8$	inches

(These approximate sizes apply also to ambrotypes and daguerreotypes.)[52] The sixth-plate format—which another source gives as $2^1/_2$ x $3^1/_2$ inches— was the most common size.[53] During the latter years of the Civil War, miniature tintypes, measuring only about an inch on a side or smaller, were sold for as little as twenty-five cents (Figure 2.6). Albums made especially for these "gem pictures"—like the one shown in Figures 2.7 and 2.8—were common.[54]

Although the tintype photograph lacked the tonal range of the ambrotype, its relative inexpensiveness rendered it exceedingly popular, particularly in America (it never really caught on in Europe) and during the Civil War, especially among the lower paid Union enlisted soldiers. Confederate tintypes, however, became progressively less common because of the increasing wartime shortages of sheet metal.[55] Wrote one military observer:

Decidedly, one of the institutions of our army is the travelling portrait gallery. A camp is hardly pitched before one of the omnipresent artists in collodion and amber-bead varnish drives up his two-horse wagon, pitches his canvas gallery, and unpacks his chemicals. Our army here is now so large that quite a company of these gentlemen have gathered about us. The amount of business they find is remarkable. Their tents are thronged from morning to night, and while the day lasteth, their golden harvest runs on. . . . They have followed the army for more than a year, and taken

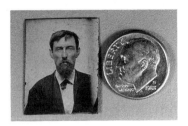

Figure 2.6. Tiny tintype images like this one—known as "gem pictures"—became popular during the latter years of the Civil War. (Actual size above.)

the Lord only knows how many thousand portraits. In one day since they came here, they took in one of the galleries so I am told, 160-odd pictures at $1 (on which the net profit was probably ninety-five cents). If anyone knows an easier and better way of making money than that, the public should know it.[56]

This practical, profitable method of photography continued to be in use, despite the trend toward paper prints, for decades. Indeed, the process remained in use, generally at beaches and fairgrounds, until after World War II.[57]

Glass Negatives, Paper Prints

Despite the use of multilens cameras that were capable of producing several identical pictures on a single tintype plate, photography still needed an effective means of making multiple duplicates and doing so on such a practical, inexpensive base as paper. Fox Talbot's calotypes represented early fundamental answers to these needs.

Based on experiments he conducted beginning in 1834, Talbot discovered several basic principles on which modern photography is based, including the use of silver chloride in making prints on paper and the concept of the photographic negative. In February 1835 he wrote in his notebook: "In the Photogenic or Sciagraphic process, if the paper is transparent, the first drawing may serve as an object, to produce a second drawing, in which the lights and shadows would be reversed."[58]

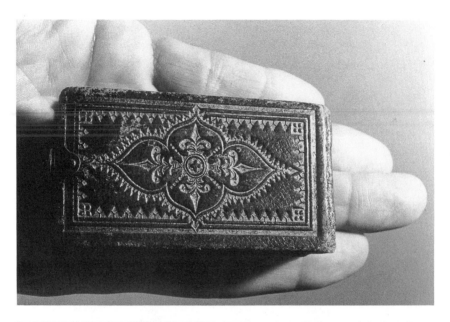

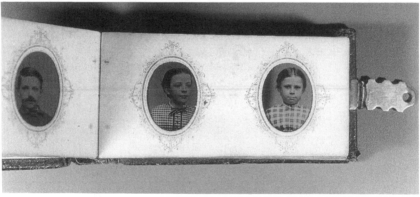

Figures 2.7-2.8. With the popularity of the tiny "gem pictures" came miniature albums made especially to hold them.

By summer of that year Talbot was making somewhat successful camera pictures, but there were problems: lengthy exposure times were required, and a successful means of "fixing" the prints was still elusive. Becoming involved with other projects, Talbot neglected his new process for a few years, and not until he received the (to him) shocking news of Daguerre's discovery in January 1839 did he seek to make up for lost time. He arranged to display some of his "photogenic drawings"—including camera prints—at

the Royal Institution in London later in January, and by month's end had presented the first of two papers on his method, "Some account of the art of Photogenic Drawing," with his second paper on February 20 providing details of his process.

Talbot also returned to work with renewed energy. He published the discovery of Sir John Herschel (1792-1871) that sodium thiosulphate (then known as hyposulphite of soda and still called "hypo" by photographers) was ideally suited to fixing a photographic image. But although Daguerre immediately adopted this method, it was expensive and it reduced the density of Talbot's already rather faint "photogenic drawings."

In September 1840, however, Talbot discovered that, as was the case with the daguerreotype, a briefly exposed image—although latent—could be revealed by chemical development. Talbot treated fine quality writing paper first with a solution of silver nitrate and then, when dry, with potassium iodidic solution, thus forming the light-sensitive compound silver iodide in the paper fibers. The paper was then washed and again dried.

When it was required for use, the paper was treated, in minimal light, with a fresh solution of "gallo-nitrate of silver" (a mixture of gallic acid, silver nitrate, and acetic acid). This light-sensitive sheet was now placed in a camera and exposed, after which the latent negative image was enhanced by further treatment with the gallic acid/silver nitrate solution and then fixed with hot "hypo" solution.[59]

After washing and drying, this paper negative—usually waxed to render it more translucent—could be used to make as many positive prints as desired. Paper intended for prints was soaked in a solution of ordinary salt, dried, then sensitized with silver nitrate solution. This dried paper was placed in contact with a negative and exposed to sunlight, subsequently being fixed and washed.[60]

Talbot called his new process Calotype (from the Greek *Kalos*, "beautiful"), but many referred to it as "Talbotype" in honor of its inventor. Because of the use of common salt in developing the positive prints, calotypes are often called "salt prints." Talbot applied for a patent in 1841, forcing those who wished to use his process to apply for a license. This added to the disadvantages of calotypes, which already required longer exposures than daguerreotypes. Although between 1844 and 1846 Talbot published his six-part *The Pencil of Nature*, which promoted his process and became the first book illustrated with photographs, the calotype was largely eclipsed by the daguerreotype—especially for portraiture.[61]

Nevertheless, the process was used to an extent by travelers and others who found it well suited to both landscape and architectural photography, and in 1852 it won new-found popularity, not only in Talbot's native-

England but also in France, when Talbot relinquished his patent rights for any use except making commercial portraits. The process was little used after 1855.[62] It was displaced by a photographic process that, while it evolved from the negative-positive calotype principle, lacked its limitations.

It was glass negatives that replaced the paper calotype ones. They were produced by the collodion process, like ambrotypes, except that the final step of backing the negative to convert it to a positive was eliminated. As we have seen, Frederick Scott Archer developed the method (adapted from Abel Niepce de Saint-Victor's 1847 albumen process) in 1851.

Although it was "the fastest negative system yet devised," as Blodgett notes, there were nevertheless seven basic steps, during most of which the glass plate had to be kept continuously moist and free from light. The final step was warming the plate over a frame until it was dry and—while still warm—coating it with protective varnish.[63]

The glass negative could be employed to make prints on the salted paper used for calotypes, but on May 27, 1850, a French photographer, Louis-Desire Blanquart-Evrard, published a description of an improved method: the albumen printing process. Paper was first coated with albumen into which ammonium chloride had been mixed, then sensitized with silver nitrate. A smooth surface resulted, improving the paper's ability to record fine detail. Albumen printing paper was also less given to fading than the calotype, and it remained in use until about 1895.[64]

There were also various non-silver papers in use from about 1860 to 1890 that produced such photos as the *carbon print*, which became practical in the late 1860s and utilized pigments—initially carbon black, hence the name—that had exceptional stability; the *gum bichromate print*, resulting from a process similar to the preceding one except for a different binder; the *platinum print* or "platinotype," obtained by using a platinum salt, which is quite stable, dating from the last two decades of the nineteenth century; and the *cyanotype* or "blueprint" process, so named because of the distinctive blue color of the prints, dating from 1840 but used infrequently until the 1890s.[65]

Nevertheless, albumen paper—which was soon produced commercially—was dominant until about 1890. According to Blodgett, in his *Photographs: A Collector's Guide*:

The photographic boom of the 1860s created great demand for albumen paper. According to one estimate, 6 million eggs a year were being used in 1866 to provide albumen for photographic prints. (What happened to all the egg yolks? Apparently they were thrown away.) Most albumen paper was made at the time of year when eggs were cheap. At the paper-making companies, there were rows of women who did nothing but break eggs and separate the whites from the yolks. The frothy albumen was then treated with bromide or chloride and poured into shallow trays. Finally, the paper was floated on the surface of the liquid and hung to dry. High-quality albumen prints often were

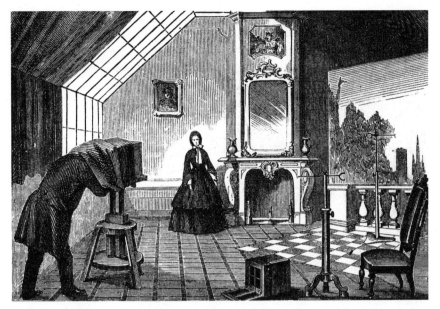

Figure 2.9. Some nineteenth-century photographic studios—such as this one in Paris—were dignified places with elaborate backgrounds and equipment. Note the stands (at right) with neck clamps to hold the subject steady and (on the floor) a carte-de-visite camera, its open back showing the characteristic four picture apertures. (From an old engraving.)

toned with gold chloride; this process imparted a distinctive warm brown color that is an almost certain sign that the work is a nineteenth-century albumen print.

He adds:

> From a collector's viewpoint, one problem with the combined wet-plate/ albumen-print process is that an unlimited number of prints could be made from a single negative. Although few exact records exist, some pictures—particularly portraits of notables and photographs of Egypt, Jerusalem, and other Near East lands, which were so popular with the British—may have been run off by the thousands. Commercial publishers, like the British art firms of Agnew's and Colnaghi's, got into the photography business and distributed albumen prints of images by leading photographers. Thus, many of the best-known works are not at all scarce—all to the good if you are looking to acquire one for a reasonable price, but a definite drawback if you are concerned with rarity.[66]

In any case the glass collodion negative-albumenized paper process was ideally suited to meet the increasing demand that resulted from the popularity of three particular fashions in photographs: the carte de visite, the cabinet photo, and the stereograph.

The carte de visite. "The year 1861 is memorable for a revolution in pictures . . . the card photograph has swept everything before it, and is the style to endure." Thus wrote the editor of the *American Journal of Photography* in 1862.[67] Called "cartomania" or "photomania," the phenomenon resulted in the sale of 300 to 400 million cards annually between 1861 and 1867—and that in England alone![68]

At the center of the fad was a small paper photograph, usually a portrait, mounted on a card about the size of a calling card—about $2^1/_2$ by 4 inches (the photo itself being slightly smaller). Although there are conflicting claims that one or another person originated the practice of placing photographs on visiting cards; the authority on the subject, William C. Darrah, in his *Cartes de Visite in Nineteenth Century Photography*, states: "Whatever their respective merits, there is little question that the Frenchman A.A. Disderi introduced the name, the format, and method for producing multiple images, as many as ten, on a single glass plate, in November 1854." At that time Disderi patented his "carte de visite" ("visiting card") process. Despite the name, however, the photographs were little used as actual visiting cards.[69] (See Figure 2.9.)

The rather standardized size of the image—slightly smaller than the card, about $2^1/_8$ x $3^1/_2$ inches—resulted from the way in which the glass negative was made, as popularized by Disderi. Eight images were produced on a single plate measuring $6^1/_2$ x $8^1/_2$ inches; therefore, each image was an eighth plate. (Once pre-cut mounts were produced commercially, photographers were obliged to produce—or trim—their images to fit.) The multiple negative images could be duplicates made simultaneously with a multilens camera, or the customer could be offered several poses, the plate being moved between exposures.[70]

It was about 1860 that the carte de visite craze developed and with it the desire for collecting carte photographs of notables as well as those of family members and friends. Portraits of Napoleon III taken by Disderi and distributed throughout France in 1859, as well as an album of carte de visite portraits of Queen Victoria and her family published by the noted daguerreotypist the following year, caused hundreds of thousands of French and English citizens to flock to photographic studios to obtain carte de visite portraits.[71]

In addition to portraits, cartes de visite photographs were made of world landmarks, city street scenes, historic events, even flower still lifes and other subjects. In the United States carte photos of Lincoln, especially, and other historical figures such as Kit Carson and Mark Twain, can be valuable, as can be various cartes relating to the Civil War. (Civil War photographer Mathew Brady was also a prominent carte photographer.) In England, carte portraits of Queen Victoria, Prince Albert, and other British royalty

are actively collected, although the great quantity in which most specimens were produced limits their monetary value.[72]

Unlike tintypes, cartes de visite were easy to write on, and soldiers frequently signed their names below the picture or on the back. Notables also autographed their carte portraits, but alas (the temptation of forgery being what it is), many did so posthumously, as we shall see in a later chapter.

The cabinet photograph. While the carte de visite remained in use until well into the twentieth century and was very common in America until the early 1880s,[73] in the later 1860s its popularity began to diminish in favor of the similar but larger "cabinet" photograph. Introduced in 1866, the paper-print photograph measured approximately 4 inches wide by $5^1/2$ inches high, being mounted on a card about $4^1/2$ by $6^1/2$ inches.[74]

Because of its larger size, the cabinet photo was more suitable for serious, quality portraiture, and soon albums were being sold having pages with windows to accommodate photos of the newly popular size. Interestingly, it was an Englishman appropriately named F.R. Window who had suggested the format.[75]

In the next decade, a series of other sizes of photograph followed the cabinet: Victoria, promenade, boudoir, imperial, and panel. But the cabinet portrait remained the most important of the formats that followed the carte de visite.[76]

The stereograph. Another type of glass negative-paper print photograph that enjoyed immense popularity during the nineteenth century was the stereograph. Also called "stereo views," these were double-picture photographs made from slightly different angles that—when viewed through an optical device called a stereoscope—yielded an illusion of depth. The effect was discovered by Sir Charles Wheatstone in 1838, and stereographs may therefore be found in virtually every type of photographic process, including the daguerreotype, ambrotype, and others, including the albumen print.[77]

The paper prints eliminated the reflective problems caused by daguerreotypes and were an effective and inexpensive means of producing the double-picture cards. Viewing the three-dimensional pictures was exceedingly popular from the early 1850s through the 1870s, then largely fell from favor before experiencing a great resurgence of popularity from about 1887 until the 1930s.[78] "A stereoscope in every home" was the slogan of the London Stereoscopic Company, which was established in 1854. The company sold half a million viewers in just two years, during which time it also increased the number of subjects offered in its catalog of "Groups and Scenes" from 10,000 to 100,000.[79] According to Blodgett:

Because millions of different stereoscopic views were published to satisfy public demand, stereographs offer one of the most comprehensive documentations available of nineteenth-century life and events. Subject matter—so widely varied—includes royalty, presidents, famous actors and actresses, circus performers, world landmarks, expeditions, well-known buildings, city street scenes, cemeteries, historic events, Biblical allegories, expositions and fairs, warships, pictures (primarily blacks, Indians, Mormons, and Shakers), still lifes, humorous pictures, and nudes.[80]

Indeed, stereoscopic views are a rich source of historical illustrations for books and magazines, whose publishers merely copy one of the double pictures for the purpose.[81]

Dry Plates and "Snapshots"

As successful as the wet-plate process was, there remained a need for a process by which prepared plates could be kept for some time before being exposed in the camera. Early attempts involved substances that were used to keep the wet plates moist for extended periods. Glycerine, licorice, raspberry syrup, and similar materials were tried, but the first successful method was a "dry"-plate process devised by J.N. Taupenot in 1855. It employed sensitized layers of collodion and albumen: the plates could be stored for weeks before exposure.

Subsequently, in 1864, W.B. Bolton and B.J. Sayce discovered that an "emulsion" of silver bromide in collodion, applied to a glass plate and allowed to dry, produced a plate with a lengthy shelf life, although the plates were less sensitive than the wet plates and required longer exposure times. Such precoated plates began to be sold in 1867 by the Liverpool Dry Plate and Photographic Printing Company.[82]

In 1871 came a further major development when Dr. Richard Leach Maddox published details of a new process in the September 8 issue of the *British Journal of Photography*. Dr. Maddox had returned to a substance used previously in photography (as a sizing agent for paper in the Calotype process)—gelatin. He found that a mixture of silver nitrate and cadmium bromide in a solution of warm gelatin yielded a silver bromide emulsion that produced rather effective dry plates, although there were imperfections in the process.[83]

Two years later, a Londoner named John Burgess began to sell a ready-mixed gelatin emulsion for coating glass plates, and the following year (1874) Richard Kennett marketed the emulsion in a dried form that was to be reconstituted with water for use. Called "Kennett's Patented Sensitized Pellicle," it inadvertently gained sensitivity from the heat-drying process by which the gelatin "pellicle" was prepared. Promised one of Kennett's adver-

tisements, in 1875: "The Pellicle gives the most sensitive plate ever brought before the public. It possesses all the fineness of an albumen film. It requires neither substratum, washing, nor preservative. Will keep good and retain its sensitiveness any length of time."[84]

It remained for Charles Bennett of London to investigate the increased sensitivity and use prolonged heating to "ripen" the emulsion and so produce highly sensitive, easily manufactured plates. The new process was eminently successful, and by 1880 photographers could travel without the dark tent and box of chemicals previously required. Instead, the photographer could make an excursion with just his camera and tripod and a few plate-holders loaded with prepared dry plates. These would be processed on the photographer's return. Remaining popular until about 1920, the gelatin dry-plate glass negatives wrought several important changes in photography, notably the devising of means to measure sensitivity of the plate. This was important since, unlike the wet plates—which were developed in the field and permitted the photographer to make successively corrected exposures—the results of dry-photo photography were not immediately apparent.[85]

Along with the manufacture of plates with constant specified sensitivity came methods of calculating the necessary lens aperture (the size of the opening in the iris diaphragm) and exposure time. By 1886 this was being accomplished by pocket-watch-size actinometers—devices which, in various forms, continued in use until the 1920s.[86] And with the great reduction in exposure times came a truly radical advancement in photography. States Coe: "For the first time 'instantaneous' photographs of fractions of a second in duration could be achieved without difficulty. The photography of moving subjects, a dream for so long, became practicable at last."[87]

With the lengthy exposure times required by the earlier, insensitive photographic plates, any movement produced a blur. Therefore, not only were photographs of moving objects out of the question, but even those who sat for portraits typically had their heads held in place by clamps affixed to the backs of chairs or fastened to upright stands.[88] An exception was the tiny plate (about 1 1/2 inches in diameter) used in Thomas Skaife's "Pistolgraph" camera. The small plate permitted use of an exceptionally large aperture which enabled it to pass over 200 times more light than the ordinary landscape lens. In addition, whereas the conventional camera's exposures were made by leisurely removing and replacing the lens cap, Skaife's Pistolgraph had a rubber-band-powered shutter that permitted exposures brief enough to freeze the action of slow-moving objects.[89]

Such cameras were uncommon, but shuttered cameras did come into regular use with stereographs, made possible by their small, typically three-inch-square images. When stereo views were made of scenes involving movement, both pictures had to be exposed at precisely the same instant. There-

fore simple shutters, consisting of flaps or sliding plates, could yield exposures as brief as one-fourth second.

Credit for characterizing an instantaneous photo as a "snapshot" (a term first applied by fowlers to a hurriedly aimed shot[90] is usually given to Sir John Herschel. In the May 11, 1860, issue of the *Photographic News*, in discussing moving pictures, Herschel wrote about "the possibility of taking a photograph, as it were, by a snap-shot—of securing a picture in a tenth of a second of time."[91]

Such brief exposures permitted cameras to be freed from the tripod, which had served to prevent the camera from being jiggled by the photographer and thus blurring the picture. Now, with the addition of a viewfinder to aid in framing the picture, cameras could be hand held. In 1881 Thomas Bola called his smallish box-type camera (unlike the usual folding-bellows models) a "Detective" camera, and soon diminutive models were hidden in parcels, hats, bags, even the handles of walking sticks. The glass plates remained a problem, however, even though there were rather awkward mechanisms that allowed several dry plates at once to be pre-loaded, then changed, in turn, after exposure. Such cameras were termed "magazine" cameras (after the French word meaning "storehouse").[92] Soon a revolutionary development in America permitted successive snapshots to be made quite quickly.

The Kodak and Roll Film

George Eastman (1854-1932), a Rochester, New York, bank clerk turned amateur photographer, had been impressed by Bennett's dry-photo process that involved "ripening" gelatin emulsions, and he began immediately to manufacture gelatin dry plates. Selling them as early as 1880 through a photographic supply house, he was one of the first to do so in the United States.

Eastman soon sought additional ways to simplify photography, realizing that the complexity and outright messiness of the requisite processes were keeping photography from being enjoyed by everyday folk. Working with camera manufacturer William H. Walker, Eastman developed a holder for a lengthy roll of paper negative "film." Although there had been earlier experiments along similar lines (such as sheets of calotype paper gummed together and wound onto rollers, patented in 1854 by J.B. Spencer and A.J. Melhuish), the Eastman-Walker invention combined the roll-holding feature with an effectively sensitive, lightweight material. It was an immediate success.[93]

Next, Eastman designed a small, hand-held camera that utilized the roll-holder. Patented in 1886 with an employee, F.M. Cossitt, the detective

model was produced in a run of only fifty cameras. Too complicated and expensive to be successful, however, they were sold off as a single lot to a dealer the following year.

Eastman immediately developed a new model which he launched in June 1888. As described by Brian Coe:

It was a small box, containing a roll of paper-based stripping film sufficient for 100 circular exposures 2^1/$_2$ in. (6 cm) in diameter. Its operation was simple: set the cylindrical shutter by pulling a string; aim the camera using the V lines impressed in the camera top; press the release button; and turn a key to wind on the film. Since a hundred exposures had to be made, it was important to keep a note of each picture in the memorandum book provided, since there was no exposure counter. Eastman gave his camera the invented name "Kodak"—which was easily pronounceable in most languages, and had two Ks, which Eastman felt was a firm, uncompromising kind of letter.[94]

Although there had been earlier roll-film cameras (notably the Berlin-manufactured Stirn "America" model of 1888), the Kodak was the first to be backed up by a service that processed the exposed pictures. Realizing that not everyone had the time, facilities, or inclination to do their own developing and printing, Eastman adopted the slogan, "You Press the Button, We Do the Rest." After completing a 100-exposure roll, the customer sent the camera to Eastman's factory (first in Rochester, later in Harrow, England), where the film was unloaded, developed, and printed and the reloaded camera was returned to the owner. After a year's success, in 1889 Eastman marketed a model with an improved shutter which he called the No. 2 Kodak.[95]

At the end of 1889, Eastman introduced a new product that replaced the paper-based film, which was complicated to handle, requiring the processed negative image to be stripped from the paper base for printing. The new product was a roll film on a celluloid base. With this clear, flexible material, the roll-film camera became fully practical.

Popular Photography

The Kodak camera and the development of celluloid roll film launched the era of popular snapshot photography, although there remained problems to be solved. In due course, however, the need to expose a hundred images was obviated by shorter films and simpler methods of loading—including cameras that could be loaded in daylight (introduced in 1891 and greatly improved in 1895). Numbered markings (patented by Samuel N. Turner, and sold in 1892) were placed on the black backing paper that helped protect the celluloid film from light when it was wound on a spool. These numbers could be read through a window on the camera's back, and they permitted the film to be wound a precise distance each time until a new number was

centered in the window.[96] Eastman incorporated the idea in his tiny pocket Kodak of 1895 and the first of his folding Kodak cameras in 1897.

Since photography still remained too expensive in his opinion, Eastman assigned his camera designer, Frank Brownell, to develop a simple camera that could be mass produced inexpensively. The result was the Brownie Kodak, introduced in February 1900. Despite the similarity to Brownell's name, the camera's designation was supposedly intended to partake of the popularity of the Brownies, the wee folk featured in Palmer Cox's children's stories. This was tied to Eastman's advertising claim for the Brownie camera that "the simple Kodak method enables even a child to make successful and charming photographs."[97]

As Brian Coe concludes: "The evolution of photography from the first shadowy, impermanent images made by Wedgwood to the introduction of the simple camera within the reach of all took almost exactly 100 years. During that time photographers, often coping with inadequate materials and imperfect apparatus, produced some of the finest photographs ever made. Their surviving images illustrate the evolution of creative photography that accompanied the technical development of the photographic process."[98]

Not everyone was pleased with the popular revolution in photography. As the *Weekly Times and Echo* reported in 1893: "Several decent young men, I hear, are forming a Vigilance Association for the purpose of thrashing the cads with cameras who go about at seaside places taking snapshots of ladies emerging from the deep. . . . I wish the new society stout cudgels and much success, and wonder how long it will be before seaside authorities generally take steps to render bathing for both sexes decent, safe and pleasant as it is on the Continent."[99]

Nevertheless, photographic enthusiasm continued to spread, and further advancements were steadily made. In 1893 came the first practical motion pictures made on Eastman's transparent celluloid film and shown in Edison's Kinetoscope viewing machine. These were based on earlier experiments by the Englishman Eadweard Muybridge who, working in the United States in 1878, succeeded in arranging a series of cameras whose shutters were triggered by trip wires across the path of a galloping horse, thus producing a picture sequence that recorded the horse in motion. Muybridge was followed by a French physiologist, Professor Etienne-Jules Marey, who produced cameras that recorded series of images on a single plate and who in 1887 developed the "chronophotographic" camera, which recorded action photos on rolls of film.[100] (See Figure 2.10.)

Among significant technical steps in photography was the development of flash-light. Although flash powder had been used for illumination virtually from the beginning of snapshot photography, it was, needless to say, quite dangerous. In the 1920s the flashbulb was invented; automatically

Figure 2.10. An early form of motion-picture camera, the "cinematograph" (invented by Lumiere & Sons), in operation. (From the 1898 text *Magic: Stage Illusions and Scientific Diversions, Including Trick Photography.*)

triggered flashes came with professional cameras in the mid-1930s and with simple cameras in 1939—the first having been the Falcon Press Flash.

Another development came in 1938 when the first fully automatic camera was developed, utilizing a photoelectric cell to move a meter needle, this being locked in place by initial pressure on the shutter release. Then a spring-loaded sensor linked to the aperture setting moved until stopped by the locked needle, thus automatically setting the exposure.[101]

Among the most important developments was color photography. Although its possibilities were considered early in the history of photography, the earliest colored pictures were simply black and white daguerreotypes that were hand colored. The first colored photograph was produced in 1861 by James Clerk Maxwell, but the first color plates were not produced until 1896. The first really successful color plates were marketed by the Lumiere Brothers in 1907 and were called Autochrome plates. Their manufacture ceased in 1932. A three-color "carbro" process was employed by some commercial photographers in the 1930s for fashion and other advertising clients,

but it was not until 1935 that the great breakthrough in color photography came with the introduction of Kodachrome film.[102]

Kodachrome was produced at the suggestion of two musicians, Leopold Godowsky, Jr., and Leopold Mannes. They proposed coating film with three different black-and-white emulsions, each sensitive to a different one of the primary colors of light. A single exposure, upon processing, produced three exactly superimposed black-and-white images, each of which could be selectively dyed to yield a full-color picture. Kodachrome was originally introduced as motion-picture film, but a version for still cameras was soon marketed.

About the same time, Agfa, in Germany, produced a film that used the same three layers (sensitive to red, blue, and green light), but the color-forming compounds (called "couplers") were placed directly into the film's emulsion. The Agfa and Kodachrome systems are the basis for almost all color photography in use today.[103]

Some still later improvements in photography concerned cameras that had various "instant" features. The Polaroid Land camera (model 95) was marketed in 1948. Within a minute of removal from the camera, the deckle-edged print yielded a sepia-colored image. It was a great success, and improved cameras and films soon followed, including color Polaroid film in 1963. The Kodak Pocket Instamatic camera simplified a common problem for the photographer: loading the film. Introduced in 1963, the Instamatic was similar in principle to the Brownie, but it introduced foolproof loading with drop-in cartridges that would only fit one way. Kodak's 1982 Disc cameras had cartridges in the form of a circular disc circumscribed with negatives. But the small size of the negatives resulted in grainy pictures, and the camera failed to capture the public's interest as the Instamatic had.[104]

More recently have come technologically innovative cameras that replace film with an electronic component. In Kodak's 1991 model, the images are stored electronically at a potential speed of 2.5 images per second and a capacity of 600. The system includes a ten-pound shoulder pack holding a small television monitor and a key pad. The photographer can view the images or transmit them directly by telephone lines to a computer. Such systems, intended primarily for photojournalists and police surveillance, are not expected to replace traditional film-based photography, which is not only cheaper but also produces images of high quality. Even more radical concepts are surely in the future.[105]

Both technically and socially, photography has developed from a time when its principal subject consisted of "the straightlaced bourgeois posing in a studio"[106] to today, when it is practiced by virtually everyone for virtually every conceivable purpose. Nevertheless, its history—which, as Peter Turner noted, "could almost be a story of the world since 1839"[107]—is still being written.

Recommended Works

Blodgett, Richard. *Photographs: A Collector's Guide*. New York: Ballantine, 1979. A history of photography integrated with other aspects of the subject relating to collecting: determining value, buying at auction, conservation, authentication, etc.

Coe, Brian. *The Birth of Photography: The Story of the Formative Years, 1800-1900*. London: Spring Books, 1976. Authoritative text on photography's antecedents, origins, and later developments by the curator of the Royal Photographic Society (formerly curator of the Kodak Museum).

Ford, Colin, ed. *The Story of Popular Photography*. North Pomfret, Vt.: Trafalgar Square Publishing, 1989. Authoritative essays on "The Beginnings of Photography," "Photography and the Mass Market," "The Rollfilm Revolution," "The Inter-War Years," "Colour Comes to All," and "From Home Movie to Home Video."

Gilbert, George. *The Photographic Collector's Price Guide*. New York: Hawthorn Books, 1977. Popular book covering major developments in photographic images and camera equipment; explains, illustrates, and gives relative prices of standard items such as box and detective cameras and tintypes, as well as more obscure items such as cameras obscura and stanhopes (tiny photographic images placed under glass-bead magnifying lenses, such "peep" windows incorporated in jewelry items, letter openers, and various souvenirs).

Kelbaugh, Ross J. *Introduction to Civil War Photography*. Gettysburg, Pa.: Thomas Publications, 1991. Concise discussion of the photographers of the Civil War era and the photographs (notably the ambrotypes, tintypes, and cartes de visite) they produced.

Lemagny, Jean-Claude, and André Rouille, eds. *A History of Photography: Social and Cultural Perspectives*. Cambridge: Cambridge Univ. Press, 1987. A broad study of photographs analyzed in their social, cultural, and historical context.

Turner, Peter. *History of Photography*. Greenwich, Conn.: Brompton Books, 1987. Expansive text tracing the development of the camera and photographic processes from the early experiments to the computer-analyzed image.

3

HISTORICAL PHOTO MYSTERIES

Historical mysteries abound—many of them *concerning* photographs, others *involving* photographs as a source of evidence. In this chapter we will look at the former with a view toward dating old photos and distinguishing original prints from later copies and outright fakes. (Questions of identity in old portrait photos will be discussed in the following chapter.) Also we will look at photos treated as evidence in a series of case studies that illustrate how clues may remain latent in an old photograph—rather like an undeveloped image—until subjected to scrutiny many decades later.

Identifying and Dating Old Photographs

The first step in dating an old photograph is to identify the photographic process that produced it. As we saw in chapter 2 there were three major types of photographs—each one of a kind—that were produced on non-paper supports; two of these, the daguerreotype and the ambrotype, were typically sold in protective frames or cases, as was the third, the tintype, in its early incarnation.

Daguerreotype (1839-ca. 1860). The daguerreotype (a photographic image formed on a silver-coated copper plate) is easily identified either in or out of its protective case. Its highly polished, silver mirror surface is an immediately distinguishing feature, together with its distinctive quality of appearing as either a positive or a negative, depending on the viewing angle (as shown in Figure 3.1).

Daguerreotypes were first announced on August 19, 1839. They were especially popular—being made in the millions—between 1843 and about 1855, but were rarely made after 1860. European daguerreotypes were often

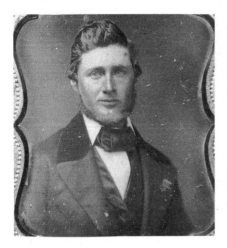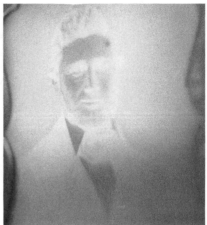

Figure 3.1. Identifying daguerreotypes is easy: they have mirrorlike surfaces and they shift from a positive image (*left*) to a negative (*right*) when tilted.

framed for wall display or set into lockets or other jewelry mounts. Hinged cases constructed of wood with either paper or leather covers were also common, particularly in America. Many cases carry the photographer's name and address, which may provide a clue to the date. "Union" cases—distinctively molded from a compound of shellac and sawdust (not, as is often said, of gutta percha)—were patented in 1854.[1] Therefore, a daguerreotype in its original Union case would presumably date from 1854-ca. 1860.

Plate marks—where they exist, and where research concerning them is available—can be helpful. For example, a daguerreotype of Edgar Allan Poe, the so-called "Painter" daguerreotype, bears in its upper-right corner (originally covered by a mat) the die-stamped hallmark, "SCOVILL MFG. CO./EXTRA." That is a trade device indicating the plate was manufactured between 1850 and 1854.[2] Poe died in 1849, proof that the picture is a copy, despite a penciled inscription in the leather case, written by the son of its owner (William Painter, a Baltimore inventor and businessman), that reads: "Edgar A. Poe. Taken from Life. Presented to W. Painter by Mrs. Maria Clemm (His Mother-in-law) 1868. She believed this to be the last picture he ever had taken." In fact, it is a copy of what is known as the "Annie" daguerreotype.[3]

Ambrotype (1855-ca. 1865). The ambrotype (a collodion negative image on glass that appears as a positive when backed with black varnish or paper or made on dark-colored glass) enjoyed its greatest popularity in the late 1850s.

Ambrotypes can be identified by carefully using a knife blade to pry the "sandwich" of plate and glass cover from its case, disassembling it (if the

Figure 3.2. Like daguerreotypes and ambrotypes, tintypes are "direct positive" images with left and right reversed as in a mirror. Therefore, women's and men's garments (which are buttoned oppositely) will appear to be fastened backward, just as wedding rings will appear on the wrong hand, as in this portrait.

backing material is opaque), and examining the plate by transmitted light (light shone *through* the plate from behind) whereupon the image will appear as a negative. However ambrotypes can be provisionally identified by negative evidence: by not being a daguerreotype or tintype.[4]

Case designs were like those used for daguerreotypes, and the Union cases were common. Ross J. Kelbaugh, in his *Introduction to Civil War Photography*, provides these additional tips:

In some ambrotypes, the identities of the soldiers and/or galleries were included. Photographers sometimes stamped their names on the mat, embossed it on the pad inside the miniature case, or placed a tradecard behind the image. A few, like Richmond photographer Charles Rees, scratched their names on the plate in the collodion. Some mats may be stamped "Cutting's Pat. July 4 & 11, 1854." James Cutting, who held patents for collodion solutions and a method for sealing together the image plate and covering glass, sold licenses to photographers to use his processes. Soldiers may be identified by paper attached to the case pad or placed behind the image. Unfortunately, most ambrotypes are unsigned and the identities of subjects and photographers are unknown.[5]

Tintype (1856-ca. 1945). Known less popularly but more correctly as the ferrotype, this type of photograph consists of a collodion image on a var-

nished iron plate. The tintype became popular about 1860, and remained in use—mostly at fairgrounds, boardwalks, and the like—until after the Second World War. (See Figure 3.2.)

Tintypes are easily identified by their metal support and are distinguished from daguerreotypes by the lack of a polished surface. When cased, they may appear indistinguishable from an ambrotype, but one can tell the difference by using a small magnet, as it will be attracted to the "tintype" iron plate, even through the glass cover. Certain other processes were in use between 1850 and 1870 that were based on the same principle of a positive collodion image on dark supports, including black leather and oilcloth, but such images are not common.[6]

Because of their long history, tintypes may be difficult to date. However, plates of the Civil War period may have patent designations—like "Melainotype Plate/For Neffs Pat/19 Feb 56" (as mentioned in the previous chapter)—stamped into their edges. States Kelbaugh: "Like the ambrotype, soldiers sometimes wrote their names in the miniature cases and photographers occasionally included tradecards behind the image, but many are unidentified. Names of soldiers are often found written on the paper sleeves holding their tintype, and the photographer's imprint is stamped on the back. Research of the subject's military records and photographer directories may help in narrowing the time period of the image."[7]

Some tintypes as well as cartes de visite (see Figure 3.3), bear a revenue stamp on their back. Like a number of other articles that were taxed to raise funds for the war, photographs were subject to a tax from September 1, 1864, to August 1, 1866. The revenue stamp (the amount depending upon the cost of the photograph, but usually being about three cents) was supposed to be dated as well as canceled, but some photographers only did the latter, using a penned slash or "X" or their initials for the purpose. Nevertheless the mere presence of the stamp is helpful since it dates the photo to within a 23-month period.[8]

Styles of dress (about which more will be given later) can help assign tintypes to a particular period, as can "internal evidence" provided by the inclusion of an automobile or other datable clue within the image.

Carte de Visite (1854-ca. 1925). The carte de visite (a paper print made from a glass-plate negative, measuring about $2^1/8$ by $3^1/2$ inches and mounted on a card about $2^1/4$ by 4 inches tall) was patented by Adolph Disderi in 1854 but was not popular until almost the end of that decade. Cartes flourished from then until about 1900. They survived into the 1920s though they were rare after 1905 and very rare from then to 1925. (See Figure 3.4.)

Cartes de visite may be dated in a variety of ways as indicated by William C. Darrah in his authoritative *Cartes de Visite in Nineteenth Century*

Figure 3.3. Revenue stamps affixed
to the back of old tintypes and (in
this example) cartes de visite allow
such pictures to be dated from
September 1, 1864, to August 1,
1866, when photographs and certain
other articles were taxed to raise
funds for the Civil War.

Figure 3.4. Cartes de visite
photographs (popular from
1854 to ca. 1900 but surviv-
ing until the 1920s) were
made from glass-plate
negatives and mounted on a
card measuring about 2¹/₄ x
4 inches tall. Their paper
surface permitted them to
be signed, as in this in-
stance.

Photography. The thickness of the card stock is one good indicator. Thin cards (.010-.020 as measured by a micrometer caliper) with square corners date from about 1858 to 1869. Medium-thick cards (.020-.030 inches) were common from about 1869 to 1887, those with round corners and cardstock in colors other than yellow dating ca. 1873-1880 and those with beveled edges, often gilt or red, spanning ca. 1875-1881. Thick cards (greater than .030 inches) usually date from about 1880 to 1910.

Portrait styles are another good indicator, with the following dates being approximate: vignetted (shaded-off) head (1860-1870), bust covering half of print area (1870-1875), large head covering three-fourths of print (1874-1890), seated figure (1860-1870), and standing full-length figure (1860-1870).[9]

Various other timeframe indicators include the use of delicate tinting of skin, cheeks, lips, eyes, and hair (early 1860s) or only the cheeks (late 1860s); props such as artificial fences and fireplaces made of papier-mâché (1870s and after); cameo portraits, lending an oval-shaped convexity effect (1868-mid 1870s); montages of celebrities (1860-1890); and borders of single or double lines on the face of cards, usually red or gilt (1861-1870). On the back of the card, look for a revenue stamp, or box for same (1864-1866); rubber-stamped photographer's imprint (1861-1890); printed designation "Mezzotint Photograph," or similar wording, indicating a patented process that produced a soft portrait image (after 1867); and overall ornamentation with tiny floral or geometric designs (1880-1888). For additional indicators and illustrations, see Darrah.[10]

Cabinet and other cards (1866-ca. 1930s). The "cabinet" photograph (a paper print photo about 4 by 5^1/$_2$ inches high mounted on a card about 4^1/$_2$ by 6^1/$_2$ inches) was introduced for scenic views in 1862 and for portraits in 1866. However, cabinet cards before 1873, states Darrah, "are surprisingly scarce." By 1876 the ratio of cabinet cards to cartes de visite was about one to three; by 1880, about one to one; and by 1890 about nine to one. (See Figure 3.5.)

Another type of card—the Victoria card—was intermediate in size between the carte de visite and the cabinet card, measuring 3^1/$_2$ by 5 inches (the image being 3 by 4^1/$_2$ inches). These date from about 1872 to 1876. Other card sizes were known by such names as promenade, boudoir, imperial, and panel, but they did not gain the popularity of the carte de visite or cabinet photographs.[11]

The stereograph, or "stereo view" (a double photograph—each image taken from a slightly different angle—that yields a three-dimensional view when seen through a stereoscope), was popular from the daguerreotype period. It was exceedingly common from the early 1850s through the 1870s but

Figure 3.5 (*left*). "Cabinet" photographs—introduced for scenic views in 1862 and for portraits in 1866—were paper prints mounted on cards measuring about 4¹/₂ x 6¹/₂ inches. (Family photo courtesy of Mrs. Jane Dillon.) Figure 3.6. (*right*) Double-image "stereo views"—which yielded a three-dimensional image when viewed through a stereoscope—were common from the 1850s to the 1930s.

then generally fell from favor before undergoing a revival from about 1887 until the 1930s.[12] (See Figure 3.6.)

Cabinet and other portrait cards may be approximately dated in four different ways. The first is by a date that may be handwritten or imprinted on the card. In the latter case, the year may be printed on the front of the card or the card may contain a notice on the reverse, such as "copyrighted 1889" (see Figure 3.7), indicating that the often-elaborate artwork, including the photographer's imprint, is copyright protected. Similarly, a statement printed on a cabinet card's back such as, "We were awarded the First Prize Medal at the Ohio Centennial, 1888"—can indicate that the photograph was made after a given date.

With any handwritten date, the style of handwriting—together with the type of pen used, which is determinable with a magnifying loupe—can indicate whether the writing was done approximately contemporaneously with the time the photograph was taken. For instance, ballpoint writing in Victorian albums would obviously be of a comparatively recent vintage since the ballpoint was not successfully marketed until 1945.[13]

A second means of dating cabinet and similar cards is by the style of

Figure 3.7. Cabinet and other portrait cards often have elaborately decorative backs. Some bear copyright dates (like the 1889 specimen pictured here) or offer other clues (such as photographers' addresses) that may help date them.

the card and printing. Generally speaking, stylistic elements tend to follow those of the cartes de visite, and there is a general trend toward elaborateness from decade to decade. For example (like cartes de visite) very dark borders, and sometimes also backs—with gold imprinting—tend not to be seen until the 1880s when they appear quite often. The serious collector or photo detective can easily assemble a reference collection by visiting antique stores and collectible shows and purchasing dated specimens. Kept chronologically in an album (a ring binder with clear, pocketed, archivally safe pages available from a photo supply store), the known standards can serve as a means for dating other pictures on stylistic grounds.

A third means of dating old photographs, whatever their type, is by using "internal evidence" (mentioned earlier in regard to tintypes). Consider the changing fashions in men's and women's clothing. The bustle, for instance, is known from the 1830s, but about 1880 the rearwardly projecting bustle was in full popularity. Or take a gentleman's collar: the tall, upstanding variety with two points jutting on the cheeks earned its name of *Vatermorder* or "parricide," a term arising from the legend of a university student who wore such an extreme collar that, on returning home and embracing his father, it cut the elderly gentleman's throat. This type of collar was common from the beginning of the nineteenth century. However, "From about 1848 onward excessively high collars and wide cravats gradually went out of fashion, but well on into the 'fifties old men were still wearing their 'parricides.'"[14] Here, one can only suggest the possibilities represented by top hats and bowlers, ties, lapels, and the like, including fashions in beards, as well as clues from ladies' hats, bodices, sleeves, hairstyles, and such accouterments as parasols. Among the useful reference books (see the Recommended Works at the end of this chapter) are Peacock's *Costume 1066-1966*, Dalrymple's *American Victorian Costume in Early Photographs*, Gernsheim's *Victorian and Edwardian Fashion: A Photographic Survey*, and Dolan's *Vintage Clothing 1880-1960*. For military dress, there is Langellier's *Parade Ground Soldiers: Military Uniforms and Headdress, 1837-1910*.

Finally, a fourth means of dating card photographs is by researching the photographer whose advertising imprint invariably appears on the front and/or back. Addresses change (either because the studio moves or because the streets are renumbered), partners come and go, and for other reasons business names are modified or changed outright. Determining when such changes took place can help in dating photographs. Take for example the products of Pennsylvania photographer Charles L. Lochman. Thanks to the diligent work of Linda A. Ries of the Pennsylvania State Archives, researchers can date the cartes de visite of Lochman, of Lochman and his partner, and of Lochman's successors to within about two years or so, as shown in Table 1. How to find such information for a particular photogra-

Table 1. Dating Lochman Photographs

Most dates are approximations of Lochman's studio locations in Carlisle and Newville obtained by examining his and related photographers' cartes de visite and by following his advertisements in the *Carlisle Herald*, *Carlisle American*, and the *Newville Star of the Valley*.

DATE	IMPRINT ON PHOTO
June 1859-Nov. 1862	"C.L. Lochman, Artist, Carlisle, PA"
Nov. 1862-Jan. 1865	"C.L. Lochman, Artist, Main Street opposite Marion Hall, Carlisle, Penn."
Jan. 1865-Feb. 26, 1866	"Lochman and Bretz, Artists, Newville, PA"
Jan. 1865-Oct. 1865	"J. McMillen (Successor to C.L. Lochman), Artist, Main St., opp. Marion Hall, Carlisle, PA"
Oct. 1865-Mar. 1869	"From C.L. Lochman's First Premium Photograph Gallery, Main St. opposite Marion Hall, Carlisle, Penna." or: "C.L. Lochman's First Premium Photograph Gallery, No. 21 West Main St., opposite the First National Bank, Carlisle, PA"
Mar. 1869-May 1870	"C.L. Lochman's First Premium Ground Floor Gallery, No. 12 East Main St., opposite Saxton's Store, Carlisle, PA"
May 1870-ca. July 1874	"C.L. Lochman's First Premium Photograph Gallery, Market Square, East Main Street, Carlisle, PA removed from 21 W. Main Street to the Gallery formerly occupied by J.C. Lesher."
ca. July 1874-?	"R.H. Buttorff (Successor to C.L. Lochman) S.E. corner Market Square and Main St., Carlisle, PA. Buttorff and Lochman's negatives preserved."
ca. 1874-1875	"A.A. Line (Successor to C.L. Lochman) S.E. corner Market Squ. and Main St., Carlisle, PA. Buttorff and Lochman's negatives preserved."
1875-?	"J.N. Choate (Successor to C.L. Lochman) S.E. corner Market Squ. and Main St., Carlisle, PA. Buttorff and Lochman's negatives preserved."

Compiled by Linda A. Ries, Penn. State Archives 9/88. Rev. 3/93, with thanks to Richard Tritt of the Cumberland Co. Historical Society.

pher? If it has already been compiled, it may possibly have been included in one of the sources listed in Peter E. Palmquist, ed., *Photographers: A Sourcebook for Historical Research* (see Recommended Works at end of chapter) or it may have come to the attention of the photoarchivist in the department of special collections of the university library nearest you. Otherwise original research—

beginning with advertisements in the city directories and newspapers for the place indicated—may do the job.

Paper prints (1830s-present). Although paper prints are known from the 1830s, those that are not mounted on cards are comparatively scarce until the late nineteenth century. Identifying the various specific processes used for them (as well as for card-mounted prints) can help date such photographs. However, except for a few, like the cyanotype or "blueprint" process (mentioned briefly in chapter 2 and popular from about 1890-1910), most require microscopic examination to identify, and some—such as gelatin printing-out paper versus collodion printing-out paper—"are often indistinguishable" (except by more sophisticated laboratory analyses). According to Kodak's *Conservation of Photographs*:

There is a simple spot test that can be used to distinguish between albumen, collodion, and gelatin processes. It involves placing a very small drop of water or alcohol on the edge of a non-image area of the print, waiting 60 seconds, and blotting it carefully with a clean blotter. Alcohol will not affect albumen or gelatin and leaves no aftermark. It does dissolve collodion. When water is used, neither collodion nor albumen is affected but gelatin is. If the gelatin is in good condition, a slight swelling may be observed on the prints by viewing it at an oblique angle; if the gelatin is very soft, it will lift off on the blotter. Collodion dissolves in alcohol; gelatin swells in water; and albumen is unaffected by either.

Again:

For situations in which positive identification is necessary, there is a chemical test that distinguishes unmistakably between gelatin and albumen. Gelatin contains hydroxproline which is not present in albumen and which can be readily identified. The procedure involves a simplified testtube colorimetric method based on the use of Ehrlich's reagent. This test is known as the Tri-Test Paper Spot Test and it is available in kit form from W.J. Barrow Laboratory in Richmond, Va. The reference noted should be carefully read and further literature studied before these tests can be applied responsibly. The foregoing information provides only minimum details, more complete instruction on the use of these tests is required.[15]

The serious student is also referred to James M. Reilly's *Care and Identification of 19th-Century Photographic Prints*, also published by Kodak (see Recommended Works at end of chapter).

From about the turn of the century many unmounted paper prints are found and many may be dated by the means already discussed. Some prints were dated in photofinishing, such as the one shown in Figure 3.8. Another in my own reference collection is a small ($2^3/8$ inches square), black-and-white, deckle-edged print stamped "GENUINE/VELOX PRINTS/JUN 25 1940/ WARNER/ PHOTO SHOP." Velox was Kodak's name for a "Gaslight" or chloro-

Figure 3.8. In addition to dates (such as this date supplied in photofinishing) the backs of old photos may contain other clues including penciled notations and even evidence of the type of album in which they may once have been mounted.

bromide contact paper introduced in England as Alpha in 1889 and in America as Velox.[16] According to one source:

Most b&w prints made commercially until about the 1960's were made on 'single weight' papers. There were a number of papers available during this era; the most commonly used was Velox. Velox was a paper made by Kodak, and the word "Velox" appeared in light blue-grey on the back of the paper. It was single-weight (slightly heavier than typewriter paper) with a glossy surface generated by drying on a ferrotype plate or rotating drying drum. The surfaces of the ferrotype plates or drums were chrome-plated and highly polished. The wet prints were applied to the surfaces of the plates or drums with the wet emulsion facing the highly polished surface. When dry, the emulsion side of the print was very smooth and glossy. Should the prints have been dried without the use of the ferrotype surface, the emulsion side of the print would be smooth to the touch, but would appear as a semi-gloss finish.[17]

Specimens in my reference collection are marked "KODAK/VELOX/PAPER."

Kodacolor film, originally marketed by Kodak as a motion picture film in 1928, was offered as a print film in 1942.[18] Prints were marked on the back: "THIS IS A KODACOLOR PRINT/ MADE BY/ EASTMAN KODAK COMPANY/ T. M. REGIS. U. S. PAT. OFF." The prints were also dated. Faded and yellowed examples in my reference collection bear dates in 1949 and 1952. Another imprinted similarly but designated "KODACHROME" (a process introduced in 1936[19]) is dated "Week of Nov. 12, 1951," and its color is still in reasonably good condition.

A surprising number of one-of-a-kind or limited edition prints were actually postcards—not the printed-on-a-press variety but genuine photo-

Figure 3.9. Real-photographic postcards (as opposed to the printed variety) were actual photo images developed onto a piece of cardstock imprinted with a postcard back. They were especially popular during the first quarter of the twentieth century, this example being postmarked 1907.

graphs actually developed onto a piece of cardstock having a printed post-card back. According to Martin Willoughby's *A History of Postcards:*

Small photographic companies would keep stocks of such postcard backs for just such a purpose. Indeed, the development of this type of postcard production enabled many village photographers to issue their own cards. In their hands the method's full potential was reached, for it was the local photographer's knowledge that enabled him to capture the type of scenes that are so eagerly sought by today's collectors and historians, scenes of localized interest that were overlooked by the larger publishing concerns.

The local photographer would go out and about in his neighbourhood taking photographs of back alleys as well as high streets and market squares, of the post office and village stores, and of children playing in the street. In fact, the animation of the local people would often prove to be a feature of the photograph, some proudly posing, others shy yet curious of the camera, and those captured while carrying out their trade or profession.

Then the postcards would be produced—maybe two or three dozen of a particular scene. The location was usually handprinted on the negative—thus appearing white on the finished postcard (although this was not always done and many scenes therefore remain unidentified). The cards were then offered for sale in local shops.[20]

Real-photographic postcards were also mass-produced by larger companies, and they were used for individual portraits as well. Sometimes a photo has been trimmed but still shows a bit of the postcard back (perhaps the printed word "Address"). The mailed postcards are of course dated by their postmark (Figure 3.9). Others may provide clues to their age. For example, before 1907 in the United States, the back of a postcard could contain nothing but the address. Therefore the illustration on the front was usually cropped to allow a strip of blank space along one edge for the message, which was often pathetically crowded in in minuscule script. From 1907 on, divided backs—half for the message, half for the address—were standard, and real-photographic postcards remained especially popular during the first quarter of the twentieth century. One British card—undated, but stylistically probably from the thirties—portrays celebrity Elizabeth Allan and on the back states: "This is a Handcoloured Real Photograph."

Early glass plate negatives produced same-size prints by simple contact (hence the term "contact prints"), but enlarged pictures were made possible by a device invented before the Civil War called a solar camera enlarger. It permitted photographers to make enlargements from the glass negatives.[21] These usually required enhancement, and led to what were called crayon portraits or crayon enlargements—enlarged prints reworked with pastel crayons and sprayed with a thin protective varnish. They are easily recognizable by their appearance, which on first glance resembles a

photograph but on closer inspection shows distinctive crayon strokes, notably in the hair and beard areas, the outlining of the irises of the eyes, and other areas including enhancement of the margins of the lapels. Crayon enlargements (as well as simple crayon portraits, produced freehand or traced with the aid of a camera lucida) were common in the latter part of the nineteenth century. On the back of a cabinet card in the author's reference collection is printed: "Duplicates or Enlargements can be furnished from this Negative. Fine crayons a specialty. Copyrighted 1889."

These, at least, are some of the basics of dating old photographs. A magnifying glass will naturally be helpful, and, for the occasion when stronger magnification is needed, a 10x loupe is excellent (especially a Bausch and Lomb "Illuminated Coddington" magnifier, available from Edmund Scientific Co. in Barrington, New Jersey). With those items, plus this book, the resources of a good library, and the experience, say, that one can obtain from searching out specimens for one's own reference collection, the student is well on the way toward becoming a photo detective—at least concerning pictures that may be taken at face value.

Originals, Copies, and Fakes

Dating an old photograph is predicated on the assumption that one has in hand the original, and not a copy—even a multiple-generation copy! To complicate matters, the picture may even be a clever fake, utilizing old paper, tin, or other support materials and old-style processes in a deliberate attempt to deceive.

Therefore, to borrow a page from questioned-document examination, whenever a photo comes under scrutiny all possibilities should be carefully considered. Keeping in mind that a photograph actually is—in an extended sense—a kind of document, Ordway Hilton has this to say in his 1982 textbook, *Scientific Examination of Questioned Documents*: "A comprehensive approach to any document problem is essential. Many times the question of a document's authenticity, or its fraudulent nature is answered only by a careful consideration and correlation of all or a number of the various attributes that make up the document." [22] Let us look in turn at those factors which may suggest authenticity, indicate copying, or perhaps prove outright forgery.

Originals. Genuine old photographs have an intrinsic value that later copies and fakes do not possess—although for such purposes as display and publication a copy may be preferable to the original, as it can be enlarged, enhanced to counter fading, and so on. *Copy* here is used in the sense of a photograph of a photograph, often termed a copy print. A print made from

 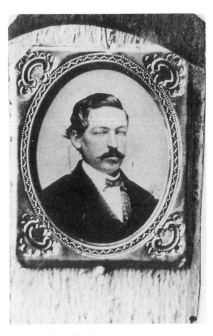

Figure 3.10 (*left*). As shown by the paper mat on this old tintype, photographs of the tintype era may actually be copies of earlier ambrotypes or daguerreotypes. Daguerreotype copies of oil paintings also exist. Figure 3.11 (*right*). A tintype *copy* of an earlier photo is easily identified as such from the presence of the original mat within the margins, as well as push pins (visible at top and bottom) that have secured it to a wood background for rephotographing. (Photo courtesy of Steve Armstrong, Lexington, Kentucky.)

the original negative is considered an original, and is considered a "vintage" print if it is made within a year or so of the negative. However, in the case of a photographic art print that is made in a second edition or any print in which considerable time has elapsed—as in the case of a modern print made from an antique glass negative—then perhaps the respective terms *reprint* and *modern reprint* should apply.[23]

It is not always possible to determine whether a photograph is an original, but it may be accepted as genuine to a degree commensurate with the weight of evidence in its favor and the absence of evidence to the contrary. Therefore, it is essential that we be able to recognize some of the warning signs of copy prints and modern fakes.

Copy prints. Prints made from a negative produced by photographing another photograph have been with us from the beginning of photography when one-of-a-kind daguerreotypes were rephotographed so as to produce

Figure 3.12 (*left*). Another obviously copied picture as shown by the appearance of the entire photo within the margins of the tintype. Figure 3.13 (*right*). Not to be mistaken for a copy print, this scroll-like image is merely the effect of an artistic convention.

additional copies. As well, just as we are having our old cabinet photos, crayon enlargements, and tintypes copied to share with family members, the same activity occurred in the past. In the author's collection is, for example, a tintype in its original paper sleeve imprinted: "BOSTON PICTURE TENT. OLD PICTURES Copied and Enlarged." (Figure 3.10.) Indeed, one not only encounters tintype copies of daguerreotypes, but even daguerreotype copies of earlier oil paintings![24]

There are several indicators that a picture may in fact be a copy. One in my reference collection is unmistakably rubber-stamped: "THIS IS COP-IED FROM ANOTHER PICTURE." However, few pictures are so identified.

Another unmistakable indicator is illustrated in Figure 3.11. It is the obvious presence of the original within the margins of the copy. In this case the metal mat in which the original is encased has been secured to a board by push pins visible at top and bottom. Only slightly less obvious is the baby picture in Figure 3.12, although much less conspicuous examples can still provide clear evidence of copying. (The cabinet photograph in Figure 3.13, however, is not another example; the effect is merely an artistic convention seen occasionally in pictures of the period.)

Figure 3.14. This cabinet portrait is actually a copy of an earlier daguerreotype, as indicated both by the woman's dress and by the washed-out appearance near the extremities resulting from glare on the daguerreotype's mirrorlike surface. (Original photograph courtesy of Mr. and Mrs. Oscar Dillon.)

Copies of daguerreotypes may sometimes be identified by a washed-out appearance near the extremities of the picture—a result of glare from the silvered mirror surface. A good example is shown in Figure 3.14. Although the picture is a cabinet photograph (ca. early 1880s), photohistorian Bill Rodgers of Frankfort, Kentucky, took one experienced look at the picture and assigned it to the era of daguerreotypes. The glare effect was one of the indicators.

Another potential indicator comes from elements in a given picture that may be anachronistic for the era of the photograph in hand. In the case just mentioned, for example, Mr. Rodgers called attention to the dress and hairstyle of the young lady as being inappropriate for the 1880s but instead quite consistent with about 1850. This—together with the glare effect—strongly indicated the picture was copied from a daguerreotype. This evidence was obviously quite significant (as we shall see in the following chapter) since it established the original picture's having been made at least thirty years previously than would otherwise have been assumed.[25]

Yet another indicator lies in the "direct positive" nature of the daguerreotype, ambrotype, and tintype, which results in the image being reversed as in a mirror. A simple case will illustrate how this can be significant in spotting a copy. Several years ago, I obtained an old tintype in the course of some genealogical work. However, the alleged subject of the photo seemed younger than she should have been after 1856 (the year tintypes were invented). Was it really her picture, as oral tradition maintained? Or was the picture that of someone from a later period? In attempting to answer that question, I contacted University of Kentucky King Library photoarchivist Tom House. He called attention to the way her dress was buttoned. (Traditionally, men buttoned left over right, women right over left.) That the woman's dress was buttoned *correctly—not reversed*—indicated that the image was a copy (that is, that the mirror imaging of the tintype had reversed a prior mirror-imaged picture) and thus supported the conclusion that the original was an earlier, daguerreotype photo.

Of course such reversal might also be owing to an optical device (prism or mirror) very rarely used for the purpose.[26] However, the cheap quality of the tintype in question suggested that was unlikely to have been the case. In any event, a certain example is found in what is known as the Marcus Root daguerreotype of Edgar Allan Poe. The buttons on Poe's vest, the part in his hair, and other features are not reversed as they should be for a daguerreotype. In fact the picture can be shown to be an exact copy of the so-called "Annie" daguerreotype of Poe. Once again, the reversed image has yielded a non-reversed portrait and allowed a copy to be identified. (Another indicator in this instance was a die-stamped photographer's hallmark in the upper right corner that dated the plate about 1855—some six years after the writer's death.)[27]

In addition to the buttoning of men's shirts, vests, and coats, and women's blouses and dresses, other features that may help indicate reversal of an image are wedding rings on the "right" hand, backward printing on book covers, and reversed insignia on a Union soldier's "Hardee" hat (which featured in a case discussed later in chapter 4).

Many copy prints may not be easily identified as such, but there is often a loss of quality in making the copy that may be apparent to an experienced eye. Among the indicators are a loss of fine detail and an unnatural contrast buildup where the loss of intermediate gray tones is noticed. Moreover, if a known original is available, direct comparison of the questioned print with the original should settle the matter.

Faked historical photographs. In his 1979 book, *Photographs: A Collector's Guide*, Richard Blodgett states:

Fakes are another area which seems to trouble many would-be buyers. But while they represent a major theoretical problem, they have so far avoided becoming a significant practical one. That may change, if photography prices climb high enough to attract swindlers.

However, even if some fakes do begin to appear on the market, the problem is not likely to become an overwhelming one. An experienced collector or dealer can discern most fakes fairly easily. . . .

It would seem that photographs, as the end product of a series of mechanical and chemical processes, are more susceptible to precise copying than any other art form. But the opposite actually tends to be true, particularly for older photographs, since it is almost impossible to duplicate the effects of aging and to recreate the exact chemical processes used in the past.[28]

Blodgett may have understated the case, and in any event the times seem to have changed. Fake tintypes are now showing up at antique shops, malls, and shows—and perhaps not surprisingly. According to Richard Busch, in a 1977 article in *Popular Photography*, modern old-process photographs have been increasingly produced as novelties—especially tintypes, which "seem to abound":

They often appear at Civil War meets and antique shows of various sorts, setting up their studio/darkrooms on location, and usually doing a brisk business making portraits of people dressed in costumes and adorned with other paraphernalia of the era. Last year, the International Museum of Photography at George Eastman House in Rochester, N.Y., had its own resident tintypist, Tony Kiburis, who demonstrated his technique and photographed tourists by the hundreds. At Greenfield Village, the Henry Ford Museum in Dearborn, Mi., a similar operation has been in existence, off and on, since 1929. To give an idea of the volume of business there, on just one weekend last summer the museum's tintypist, Jim Rantala, and an assistant made 166 plates of which 80 percent had four images to the plate—for a total of over 550 pictures.

The article continues: "Most of the old-process photographs made today are of 20th-century subjects—modern buildings, people wearing contemporary hair styles and wristwatches, and other things easily identifiable as post-19th century. (Daguerrotypes and ambrotypes were out of vogue, except for a few isolated examples, by the end of the 1860s; tintypes lasted longer, but only as a novelty after the general acceptance of dry-plate photography around 1880.) But, as a kind of self-imposed challenge, most practitioners occasionally endeavor to make pictures that look as authentic as possible." [29] One Greenfield Village tintypist took his best example, a four-image whole plate tintype, to a large photographic swap meet where he showed off his production—without identifying it as such—to dealers and collectors. For several hours he received comments and even offers to purchase the tintype from people who obviously considered it a vintage photograph. Finally one person took a closer look and discovered that the owner of the tintype was the very person depicted in it: it was a self-portrait!

Another fake was a quarter-plate tintype of Abraham Lincoln, copied from an 1863 print by Alexander Gardner. The tintype copies originally sold at Greenfield Village as novelties for only a couple of dollars, but they soon appeared at antique shops for more serious prices.[30]

Since subject matter can be a problem, some modern fakers of old photos eschew the grooming and costuming necessary to photograph people and instead concentrate on old buildings—attempting to find views that do not show telephone lines or other evidence of modernity. An easier method by far is simply to copy an existing nineteenth-century photograph, thus eliminating all the problematic steps involved in creating a credible setting, having to photograph outdoors (in unpredictable lighting), and so forth. This, says the *Popular Photography* article, makes it "far more feasible for the enterprising counterfeiter to bother mastering the process and going into 'business.'" [31]

Indeed, fakes of this type are showing up with increasing frequency, including forged Civil War tintypes. Fortunately, many of these fakes—including one in my reference collection—can easily be spotted with a magnifying loupe which reveals the mechanical pattern of halftone dots that betray the fact they were copied from printed works like books or magazines. Halftoning is a means of reproducing a continuous-tone original (one with a full range of graduations from light to dark tones) by photographing the picture through a screen that breaks the image into a graduated system of dots. (A look at a newspaper photo with a magnifier will reveal the characteristic pattern.) [32]

Since halftone illustrations did not appear until about the mid-1880s, their presence in an ostensibly old tintype (probably somewhat fuzzy from having been copied) is a fatal anachronism.

An article in a 1992 issue of *Antique Week* magazine reported other possible signs of fakery, discovered in an example sold at an antique mall.

Remember that a tintype, like an ambrotype, is a negative image viewed against a black background. Close examination of this image suggested that it wasn't a negative image at all, but was a positive image against an off-white background. A little poking and probing and, lo and behold, the top emulsion can be peeled back and underneath isn't the black of a tintype base but a creamy off-white surface. So not only is the image faked, it isn't even a tintype. It is an entirely different process deliberately made to appear as if it were a tintype. Because there would be little financial incentive to have faked a Civil War tintype before they became highly collectible, this imitation is probably of very recent vintage.

Moreover,

There are a few other clues that can be used to spot this variety of imitation. It appears that the white backing has been sprayed on to an imperfectly prepared surface—there are bumps in the surface and—at the edges—ridges. It looks as though an old tintype, with some chipping of the black lacquer coating along the edges, was recoated. When the new coating was sprayed on, the edges where the undercoating was chipped show in relief.

In this particular example, the image is full-bleed—that is it goes all the way to the edges on all four sides. Examination of true tintypes suggests that few are full-bleed. One or more edges were usually covered by the plateholder of the camera during exposure and those areas would contain no image. Since the edges would be covered by a paper or metal matt in the finished product, there would be no reason to trim off the edges.[33]

A simple chemical test (such as that mentioned earlier in the discussion of dating paper prints) can differentiate between the collodion emulsion that was used on all tintypes during the early period (from their invention in 1856) and gelatin emulsions which began to be marketed in the mid-1870s and were used in producing later tintype photographs. With a toothpick, one simply places a small drop of denatured alcohol in an out-of-the-way spot on the emulsion, lets it stand for one full minute, then blots any remaining liquid. A collodion emulsion will be dissolved, as will the clear varnish over-coating which may be placed over either type of emulsion, but a gelatin emulsion will be unaffected.[34]

Other old-process pictures are also being counterfeited, including ambrotypes. In 1976 a "rather chagrined man" visited the *Popular Photography* offices to show an ambrotype, mounted in its small leather case, that portrayed an American Indian family posing in front of their tepee. Experts had determined that the ambrotype—which had sold for $500—was of recent vintage and had probably been copied from a post-ambrotype paper print. The chagrined man told how another collector had paid $125 for an ambro-

type that depicted a U.S. naval officer posing next to a cannon on the deck of a ship. It too was branded a fake, another recent copy apparently made from an old paper photographic print.[35]

Scarcely more trouble to fake than tintypes, ambrotypes are easily made by obtaining a suitable piece of clean glass (possibly salvaged from an old ambrotype having an image that is peeling or otherwise damaged). Next this is coated with modern liquid emulsion (an off-the-shelf item at photo supply houses) or even prepared in the traditional way (one counterfeiter learning the ambrotype process from a photo-chemistry book published in 1858). After being exposed in an old camera, processed, and finally backed with black varnish or even black paper, the plate is reassembled with its cover and replaced in its original case. By using particularly collectible subject matter, the faker can hope to sell his products at an apparent bargain while still reaping rich profits for a small investment per photo in time and materials.[36]

Some clues to spotting fake ambrotypes include excessively large grain structure (vintage ambrotypes appeared grainless); thick, rough-textured emulsion; and faulty backing material (in one case a "layer of thick, black, almost tarlike paint" with "a very strong chemical odor—a dead giveaway that the ambrotype has been tampered with recently").[37]

Daguerreotypes are more challenging for the forger, but, as Stuart Bennett observes in his *How to Buy Photographs*, "they have been known to be inserted in old cases and passed off as originals on an undiscriminating public."[38]

Richard Busch, in his *Popular Photography* article, states, "Contemporary daguerreotypists . . . have succeeded in virtually duplicating the 19th century materials, appearances, and effects." He adds: "Thus, nearly all signs point to the inevitable conclusion that it can be virtually impossible for most people to tell what is new and what is old, and that anyone who really wants to make counterfeits will master the necessary technique."[39]

Fake daguerreotypes are not easy to spot, but Busch gives this advice to the prospective buyer of a sensational but bargain-priced daguerreotype:

He should question the seller about the photograph's origins, where he got it, etc. If the seller says he doesn't know anything about it, the best thing to do is ask to examine the plate out of the frame. However, if the case is sealed, as daguerreotypes usually are with glued rice paper, this can be taken as a good sign that the picture is authentic, although it is not impossible that a skilled person could make a new seal look old. But if the seal has already been broken, or if there is no seal, which is often the case with ambrotypes, and sometimes the case with daguerreotypes (tintypes rarely come in cases), then the dealer should have no objections. If he does, this should be taken as a second warning signal.

If you are allowed to remove the plate from the case, what should you look for?

Unfortunately, unless you are very knowledgeable, and familiar with the way authentic plates look, it is difficult to spot clues, especially if the modern maker or counterfeiter has done a top-notch job, and has seen to it that everything conforms closely to the way it was done in the 19th century.[40]

Stuart Bennett advises: "Get to know what *modern* daguerreotypes look like." Echoing Busch, he adds: "Beware of any signs of tampering with the original casing."[41] Beyond that, the best advice is to seek expert advice when the situation warrants it.

In theory, at least, cartes de visite photographs would be comparatively easy to counterfeit. The paper print could be soaked free from its card backing, chemically bleached to remove the old image, resensitized, and so forth, with the finished product being reglued to the original. Just such a scenario was presented in the delightful *Emily Dickinson Is Dead* by famed mystery writer Jane Langton.[42] Thus far, however, most forged cartes de visite are genuine ones of celebrities like Abraham Lincoln and John Wilkes Booth that have been (shall we say) posthumously signed.[43] One I investigated was a common carte of Robert E. Lee, enhanced by a signature that bore unmistakable signs of "forger's tremor" (the shaky writing characteristic of slowly penned copies) and other evidence of fakery.[44]

Even very early process prints are apparently easy to counterfeit, as demonstrated by a 1974 show at the National Portrait Gallery in London. The show featured the works of a hitherto unknown photographer named Francis Hetling, from whose alleged "diaries" captions were taken for each photograph in the remarkable series depicting street urchins and child prostitutes of Victorian London. All was well until one exhibition visitor recognized the ragged urchin in one putative 1840s salt print as Johanna Sheffield, the daughter of a friend of his who was a professional child model.

As it happened, an advertising photographer named Howard Grey had dressed the eleven-year-old girl in Victorian garb, photographing her—and others—for what he said were some novel pictures to include in his portfolio. He gave a set of prints to the painter Graham Ovenden, a collector of Victorian photographs. According to an article in the *Sunday Times*, Ovenden transformed seven of the prints into "original" Victorian photographs by obtaining old paper—watermarked 1835 in at least one instance—and impregnating it with the appropriate chemicals for producing a calotype print. Scientific tests on the prints were reportedly inconclusive.[45] However, Stuart Bennett observes of one of the photographs:

one look should ring alarm bells in the viewer's mind. Why does the girl have her hand over her face? Out of shame for her depraved life and to protect her identity from the camera? But the notion of the intrusive photographer is a modern one, unknown to early photography, and this apparent modernity in the 'Hetling' leads by

deduction to even more conclusive doubts of its authenticity. Part of the photograph's impact derives from the appearance of the little girl's flinging her hands up as if to protect herself, but to get this effect in an 1840s or 50s calotype the pose would have to be held for at least two or three minutes, quite an improbable feat for a young street urchin. A closer look at this photograph also reveals a too-great resolution of detail for an 1840s calotype, while I for one am now suspicious of a too-rich 'purply-pink' colour in calotypes, though on neither of these features would one be likely to brood unless suspicions had already been aroused.

Concludes Bennett: "the important thing to remember is always to heed your instincts. If something looks or even somehow 'smells' the slightest bit wrong, start asking questions. Provenance [i.e., origin or source], technique, documentation, all these are legitimate subjects of enquiry of anyone offering works of art for sale."[46] That is sound advice from an expert in the field.

Case Studies

Supplementing the foregoing approaches to dating and authenticating old photographs, the brief cases presented here will also illustrate how to examine such pictures and glean evidence that may help solve many additional types of photo mysteries. As Scottish writer George Oliver states in his excellent book, *Photographs and Local History*:

For the historian who is examining and analysing photographs, first impressions, however vivid and apparently significant, are never enough. The historian must look and look again, and draw the maximum possible amount of information from the two-dimensional evidence of the photograph, whether in colour, in black and white or in sepia (the single tint most commonly met in elderly prints). He or she must scan every single square centimetre for clues to support or amplify deductions and conclusions already made provisionally. Such stringent tasks cannot be taken to a successful finish without ample knowledge of both the subject in hand and the wider background.

Oliver adds: "This knowledge need not be of a highly specialised kind. For most of the time, indeed, the proper reading of photographs, almost regardless of age, depends largely on common sense. Specialized information can then be drawn upon when necessary. This applies as much to the identification of subject matter as it does to the dating of individual photographs. Fortunately the carrying out of the necessary operations tends to be an interesting, sometimes exciting and usually enjoyable affair. There are inevitably 'problem' pictures, however, which baffle, frustrate or annoy."[47] With these points in mind, we turn now to some interesting studies.

The "Bangor" postcard case. To illustrate the kind of approach Oliver describes, let us first look at one of his own studies. It concerns a real-

photographic postcard—unfortunately unused and therefore bereft of a postmark to provide answers to the when and where of its posting. Although it is captioned "Main Street, Bangor," and is a British card (thus eliminating the city in Maine), there are no fewer than three Bangors in the British Isles, two in Wales and another in Northern Ireland. It seemed there was nothing in the picture to identify which of the three was depicted. However, instructs Oliver:

With the aid of the researcher's most immediately useful tool, a good magnifying-glass, let us look, firstly, for distinctive shop or street names to tell us whether we are in Wales or Ulster. There are no Williams or McGuggies here, however. Common sense and general knowledge having failed, let the author, as a road transport specialist, take over. Looking closely at the visible cars, and then at their registration plates—all of which, apart from that of the Morris 'Eight' saloon [a sedan-like car] on the extreme left, carry the letter 'Z'—the country can be identified as Ireland. Since the introduction of compulsory motor vehicle licensing at the beginning of 1904 use of the letter 'Z' has been restricted to Northern Ireland (and 'I', as a matter of interest, to Eire).

He continues:

Furthermore, because the Morris 'Eight' did not come onto the market until September 1934 the photograph could not have been taken earlier. Because it is the newest vehicle on the scene the chances are that the picture was made during the following summer. Summer? For one thing, the shop blinds are down, to protect perishable or fadeable goods on show. Further, the younger pedestrians are wearing warm weather clothing, the men sporting white, open-neck shirts: the women comfortable summer frocks. The fact that most of the older people wear hats and coats is of no seasonal significance, it was the custom then, as it is still to some extent, for mature citizens of both sexes to dress so, in warm weather as well as cold, to conform with the social formalities of being outdoors.

Finally, "More period details include the aproned butcher's boy, the standardised front of the F.W. Woolworth store (where nothing cost more than 6d-2¹/₂p today) and the general air of order and tidiness. This is a good representative example of a completely unretouched record; here is how Main Street, Bangor looked more than 50 years ago." Oliver concludes, "About the only thing not revealed is the fact that Bangor is a seaside resort."[48]

The postcard with a view. Another interesting real-photographic postcard was discovered by W. Lynn Nickell (a distant cousin of mine) who was doing research for a book on his home town in the hills of eastern Kentucky, *The Changing Faces of West Liberty: A Pictorial History*.[49] Although the photograph was readily identified as to place, the lack of a postmark necessitated efforts

Figure 3.15. A real-photograph postcard of West Liberty, Kentucky. Although un-
dated, its time frame was approximated as 1915 due to the presence or absence
of buildings of known date. (Photo courtesy of W. Lynn Nickell.)

to date the rare "view"—one of the town at a time of dirt streets, rail fences,
and at least one log house. A few earlier panoramas of the Licking River
valley town exist, but this one was made from a less accessible hilltop and
thus showed buildings not seen in other photos. (See Figure 3.15.)

The picture's time frame could be closely approximated by the pres-
ence or absence of buildings of known date. For example, the courthouse
(the town's fourth) was built in 1907, so the photo obviously dated after
that, and the absence of the old Methodist Church—which was located op-
posite the courthouse and whose spire should have been visible had the
church still been standing—proved the picture was made even later, some-
time after the 1911 Main Street fire. Eventually, as the minimum and maxi-
mum possible dates moved closer together, the year 1915 was determined.

So remarkably in focus was the postcard overview that even very large
blowups (made by then University of Kentucky photographer Robert H. van
Outer using large negatives to reduce graininess in the enlargements) al-
lowed tiny, detailed clues to be picked out and interpreted.

The fact that most of the deciduous trees were leafless demonstrated
the photograph was not made in summer, and the relative absence of chim-
ney smoke eliminated winter. Fall was indicated rather than spring because
of fodder shocks clearly recognizable in distant fields. The temperature on
the day the photo was made was moderate, since homes were not being
heated, yet windows and doors were generally closed. Taken together, these

factors indicate the picture was taken about the last week in October (or possibly the first few days in November).

That the C.W. Womack general store appeared to be open (the front door seeming to be ajar and a man standing outside) suggested the scene was captured on a weekday. Since the sunlight was from the east it was obviously morning, and the long shadows demonstrated it was early morning. At the time of year indicated, sunrise would have been 7:00 A.M., and the photo was taken well after that.

In short, it is a tribute to the work of the unknown photographer who made the picture that we can date it to the end of October, 1915, on a weekday—about 8:23 in the morning. How can we be so precise as to the latter? That is the time just visible on the clock on the distant courthouse's cupola![50]

Dating two old photos. Two additional cases of local-history interest demonstrate how good fortune and careful examination can combine to provide accurate dates for historical photographs.

In the first instance, when the old Morgan County National Bank building was being relocated near its original site at Cannel City, Kentucky, a large old cloth-backed photograph was discovered rolled up in an inside drawer. It obviously depicted the interior of the previous bank structure— and was the only known such picture—prior to that building's destruction by fire on November 9, 1931. Just how much prior, given the building's then twenty-six-year history, was the question.

Careful examination of the photo with a 10x loupe revealed a calendar just visible on the wall behind the teller's cage. Unfortunately, the bars obscured much of the calendar, but it was possible to decipher "RUARY" and the last digit of the year, a "1." It was also possible to see, for example, that the first Monday fell on the second day of the month.

With this information it was possible to consult a perpetual calendar and thus learn that Monday was the second day of February—in years ending in 1—only in 1891, 1931, and 1981. Therefore, since the bank did not open until 1905, the photograph was taken sometime in February 1931—a few months before the fire.

The second case was an attempt to date one of several photographs reproduced from an old (but unidentified) book, the caption indicating the picture was a relatively recent one at the time of publication. The picture was a photocopy of a halftone print and, although there was a calendar on the wall, it was scarcely legible. Nevertheless, all twelve months were showing and it was possible to see, for example, that the last two spaces for dates in March (those for Friday and Saturday) were blank, thus indicating that

the last day of that month (the 31st) fell on Thursday. A perpetual calendar showed potential dates of 1927, 1938, and 1949. The first was too early based on the accompanying photos, one of which showed Mrs. Roosevelt on her visit in 1937; 1949 was too late, since the book in which the photo was printed had a reference to World War I as "The World War" and no mention of World War II. Therefore, the calendar dated the picture to 1938.

The Commander Peary controversy. Of far greater significance than the foregoing examples—and one involving the question of exact *place* rather than time—is the claim of Commander Robert E. Peary that he had reached the North Pole on April 6, 1909. Because of the competing claim of Dr. Frederick Cook, who maintained he had reached the pole a year earlier, and also because of the accusations of debunker Dennis Rawlins, who called Peary a fraud based on his analysis of a Peary document at the National Archives, the great arctic explorer's victory has been clouded by controversy. In 1990, however, scientific analysis of Peary's expedition photographs finally seemed to settle the matter.

Subsequent to Peary's expedition, first a committee of the National Geographic Society (in 1909) and then a committee of the U.S. House of Representatives (1911) investigated Peary's claim and found no reason to doubt that he was indeed the first man to set foot on the North Pole. In fact, Dr. Cook's conflicting claim was soon discredited, and he was accused of making fraudulent claims in other matters.[51] As to Rawlins's analysis and conclusions of fraud, it turns out that what he assumed to be calculations for compass variation were actually the serial numbers on Admiral Peary's chronometer watches![52] Nevertheless, *National Geographic* commissioned the Maryland-based Navigation Foundation to investigate fully the question of Peary's accomplishment.

The Foundation used a variety of techniques to examine Peary's claim, including copying his expedition's ocean-depth soundings with modern profiles of the ocean floor under the Arctic ice (which soundings, concluded the Foundation's president, retired Rear Admiral Thomas D. Davies, "support Peary's account of his entire trek to the pole").[53] The Foundation also used a sophisticated technique called photogrammetric rectification to analyze Peary's expedition photographs.

Pioneered during World War II and perfected during the Cold War through satellite observations, photogrammetric rectification is used to determine the sun's elevation at the time photographs were taken. The elevation can be determined from the shadows in pictures, provided that they both begin and end within the frame of the negative, that there is a horizon showing so that the orientation of the camera can be determined, and that the focal length of the camera is known. As Rear Admiral Davies explains:

The technique is one based on simple perspective. Imaginary lines drawn through each object and the end of its shadow would be, in the real world, parallel to the sun's rays. Such lines drawn on a two-dimensional picture converge at a vanishing point (often outside the picture). This vanishing point is also the point at which a ray of sunlight through the camera would cast a shadow of the camera. Thus the vanishing point defines the angle of the sun's rays relative to the optical axis of the cameras— which may be pointing up or down, as shown by the locations of the horizon. The mathematical method used to fix these relationships is spherical trigonometry, much like that used in the reduction of a navigation sight. The *Nautical Almanac* gives the declination of the sun at the Pole for the date, and the time (taken from Peary's account or other sources) tells which meridian the sun is on. The altitude of the sun measured from the photograph was used to establish a rough "line of position."[54]

Peary's photographs met the basic criteria, and the focal length of the type of camera he used was determined with the assistance of the International Museum of Photography in Rochester, New York. Averaging the information from five pictures made by Peary's expedition in the vicinity of Camp Jessup (his North Pole camp) placed him clearly at the Pole "within the limits of his instruments."[55]

(Similar analyses, in which photographic or video images are analyzed to determine time, are often important in legal matters. Called *chronophotogrammetry*, the technique is discussed in the chapter on forensic photography, chapter 5.)

The "MIA" photos. Quite a different historic issue was at stake regarding photographs that made news in 1991. The most widely publicized one supposedly showed three Americans—Colonel John Robertson, Major Albro Lundy, and Navy Lieutenant Larry James—who were being held captive in Southeast Asia. On the one hand, relatives of those men were convinced it was indeed they who were depicted.[56] On the other hand, there were warning signs that the grainy picture represented only another in a series of cruel hoaxes involving America's missing Vietnam-era soldiers, sailors, airmen, and marines.

First of all, the Defense department reported that the photograph had been linked to "a ring of Cambodian opportunists led by a well-known and admitted fabricator of POW-MIA information." In addition, it was among a set of five pictures, four of which came from the Soviet Magazine *Sovietskiy Soyuz* ("Soviet Union") and did not depict missing Americans.[57] Moreover, biographical details on the three servicemen in the photograph—including Social Security numbers, home addresses, and birth dates—were erroneous.[58]

Although the exact source of the photo seemed to remain elusive (a news report that it was copied from a 1923 photograph of three Soviet farmers was equivocal[59]), the circumstantial evidence clearly pointed toward fakery.

Less certain was the status of another controversial picture, a color photograph allegedly showing Army Captain Donald Gene Carr, missing since 1971, alive in a Laotian prison camp. The picture, which also surfaced in 1991, was so clear and seemingly convincing that Pentagon officials began a full investigation. Carr's former wife, although initially unsure about the photo, became convinced that it was indeed her ex-husband. Matthew Carr said of his sibling, "My brother—and I don't care what anybody says—is alive. We have proof."

Alas, the photo was a hoax. ABC News investigated the matter, interviewing Colonel Jack Bailey who brought the photo to light. Bailey heads an organization named Operation Rescue that has been accused of using deceptive tactics to raise funds, supposedly to search for missing Americans. Bailey showed various photos of what he said was a POW camp where "there's 40-some Americans being held against their will." [60] The photos even showed bamboo cages in which the men were reportedly confined. However, when ABC News sought to find the location of the "prison cages," the investigative trail led to bird cages at a former exotic bird export company just outside Bangkok. The man in the photograph was not Captain Carr but a convicted bird smuggler, a German man named Guenther Dittrich. ABC's *20/20* reporters found Dittrich in East Germany where he was free on bail awaiting trial. Asked if he were Captain Donald G. Carr, Dittrich responded, laughing, "Nein." The former Mrs. Carr agreed, after traveling to Germany at her own expense to see in person the subject of the deceptive photograph.[61]

"Lying" Civil War photographs. During the Civil War, photography was available to document battle lines, battlefield carnage, and other aspects of the American tragedy. Unfortunately, analysis reveals that many of the photographs show recreated or otherwise staged scenes, scenes photographed after the war, and other examples of fakery, according to an article by Walter F. Rowe in the *Journal of Forensic Sciences*, "The Case of the Lying Photographs: The Civil War Photography of George N. Barnard." [62]

For example, a plate in Barnard's *Photographic Views of Sherman's Campaign* represented "Defenses of the Etawah [sic] Bridge," a railroad bridge across the Etowah River in northwest Georgia. Several factors suggest the postwar status of the photograph, including the remains of wooden trestles near the intact bridge. Since trestles were generally used by Union army engineers to replace bridges that had been destroyed by retreating Confederates, there is a strong possibility that the photograph was taken after the war, between April and October 1865 when the Western and Atlantic Railroad was rebuilt.[63]

Another example is a photograph of Union entrenchments in front of Kenesaw Mountain, Georgia. The trenches were occupied on June 27, 1864,

by Union soldiers assigned to attack Confederate troops on the mountain. However, Rowe observes:

Barnard's photograph of the Union lines before Kenesaw Mountain contains internal evidence that it was made after the War Between the States. The gun pits in the foreground are eroded and somewhat dilapidated. The fences bordering the Burnt Hickory Road would have been thrown down by the Union lines of battle or their skirmishers during the attack on Kenesaw Mountain. Fences were also routinely used as sources of firewood by both Union and Confederate armies. The line of woods behind the farm buildings shows a number of dead trees (those with light-colored trunks), probably killed by artillery and small arm projectiles which struck them during the fighting. It would have taken about a year for trees to die from the embedded projectiles. The condition of the farm buildings in the middle distance in Barnard's photograph is also strong evidence that this photograph was not taken immediately after the Battle of Kenesaw Mountain. The York House, which stood just out of Barnard's photograph on the right, was razed by Confederate artillery firing from Kenesaw Mountain when it was used as cover for Union sharpshooters. The cabin and its outbuildings [depicted in the photo] would almost certainly also have been destroyed at the same time for the same reason.[64]

Another Barnard photograph is an outright fake. It is a group picture showing General William T. Sherman flanked by some of his subordinates. States Rowe, "The symmetrical arrangement of Sherman's officers is spoiled by the position of General Francis P. Blair," who is shown seated at the right of the picture. A careful inspection of the photograph, states Rowe, "shows that General Blair's image has been carefully cut from another photograph and transferred to this one."[65] Rowe notes that the same scene—without General Blair—is depicted in a 1911 book, *The Photographic History of the Civil War*.[66]

Nor was Barnard the only offender. Two photographs by an unknown photographer, allegedly showing dead soldiers on the Gettysburg battlefield, have been branded outright fakes. Rowe (following William Frassanito[67]) calls attention to "the fact that although the rock formations in the two pictures are the same, the bodies are in different positions." In addition, "The presence of numerous firearms is also inconsistent with the practice of both the Union and Confederate armies of collecting all usable military equipment from battlefields." The scene is thought to have been staged in November 1863 when the soldiers' National Cemetery was dedicated at the site (at which time Lincoln gave his famous Gettysburg Address) "when a number of soldiers would have been available to pose."[68]

Still another photograph, taken either by Alexander Gardner, James Gibson, or Timothy O'Sullivan (members of a team who photographed the battlefield at Gettysburg on July 5 and 6, 1863), is a stereo view that has been staged. According to Rowe: "It shows the blanket the photographers used to

drag the dead soldier almost 36.5 m (40 yds) from the original location of the body. They apparently wished to create a more dramatic scene by positioning the body behind the improvised stone breastwork. The rifle propped against the stone behind the body was probably added also, since what appears to be the same rifle appears frequently in the Gardner-O'Sullivan-Gibson photographs of Gettysburg."[69] Such evidence should urge caution upon the scholar wishing to use photographs as authentic historical documents.

Lincoln originals or copies? Some years ago, I investigated a case involving Civil War-era photographs of Abraham Lincoln. A dealer in antiquities wished to know if two large photographs of the president were copies or originals. If the latter, he intended to invest a significant sum in purchasing the pictures, which he had on approval for a short time.

Observing a crease mark and the dark margins of a water stain in one photograph, I removed the photo from its frame and examined the back of the sheet of photographic paper. The paper was not *itself* creased or stained, which proved that the photograph was actually a copy, made from an original print which did exhibit such damage.

The other photograph had an embossment in a lower corner, which I deciphered with the aid of a magnifier and oblique lighting (to intensify the shadows of the embossment). It was the mark of a particular New York studio. Library research the following day revealed that that particular image was originally made by Mathew Brady and that therefore the picture was another copy.[70]

"The greatest" air combat photographs. Sensational photos from a later war—supposedly from air combat engagements in World War I—surfaced in 1931 at an international exhibition of aviation art in New York, presented by the publishing firm of G.P. Putnam's Sons. The photographic detail, composition, and remarkable subject matter—a portrayal of colliding aircraft and their dying pilots—made the Cockburn-Lange Collection the hit of the exhibition. Subsequently, according to an authoritative source:

The first of the photographs were published by the "Illustrated London News" in 1932. Gladys Maud Cockburn-Lange explained that her first husband had violated RFC rules by taking photographs during combat. He had found a German camera that accepted 3x4 glass plates and had strapped the camera to the wing of his Nieuport fighter. The camera shutter was controlled by the machine gun trigger. One other Flying Officer knew what her husband had been doing, but since he was still on active service, no mention of names, rank, unit, or specific service locations could be made. Several hundred photographs were available for publication by other publishing groups. The "Illustrated London News" photographs created great interest in England. The praise for the composition and close-up views of combat continued.[71]

A few critics were skeptical, however. One questioned, for example, how a fallen pilot could photograph *British* planes in combat when the shutter of his camera was controlled by the trigger of his machine gun. Another pointed out that the wheels on all the planes were clean and shiny—a puzzling fact given that both the Germans and the Allies used airfields of dirt or grass. Still another doubter observed that all the planes in the hundreds of photographs dated after mid-1917, which meant they had been made in only a fifteen-month period; this would have required the pilot-photographer to have made no fewer than three sorties a day for every day of the period—considering the pilot's claim that many times his photographs failed to turn out. (In contrast, the typical flying time for a combat pilot on the Western Front was about every third day, given the attendant military and weather conditions.)[72]

These problems went largely ignored, and during the early thirties Gladys Maud Cockburn-Lange provided photographs for the media and sold copies to England's social elite. The photographs elicited praise as the greatest air combat photos of the First World War, later of "all time." Curiously, however, the photographs' owner could never be reached in person, although she could be contacted through third parties. Finally, in the mid-1930s she disappeared entirely, leaving behind the remarkable photographs which were "repeated from book to book and ended up in museum displays, war anthologies and air combat histories."[73]

Half a century later, in 1984, an elderly gentleman donated to the Smithsonian Air Museum several trunks filled with World War I memorabilia, such as uniforms, goggles, a swagger stick, a dented .45 automatic pistol, and various maps, letters, documents, and photographs, including the originals of many pictures from the Cockburn-Lange Collection. The collection traced back to one Wesley David Archer, a former Royal Flying Corps (RFC) pilot who later tried his hand at making movies and designing dioramas before becoming a skilled airplane model maker.

Despite this information, Smithsonian researchers still became excited when they discovered, together with the original air combat photographs, copies in which support wires holding up the planes had not been retouched out! Further investigation revealed that the mystery woman who had peddled the photographs, Gladys Maud Cockburn-Lange, had in reality been Gladys Maud "Betty" Archer (nee Garrett), wife of the RFC-pilot-turned-model-maker. Document examiner David A. Crown determined that handwriting on papers signed by the mysterious Gladys Maud Cockburn-Lange matched the writing in letters and an address book that had belonged to Mrs. Archer.

Therefore, Wes Archer and Gladys Maud Archer had (as Crown stated in a professional paper) "perpetrated a glorious scam on the aviation

Figure 3.16. Old photographs—like this 1898 one of Dawson City, Yukon, during the Klondike gold rush—may offer myriad bits of invaluable information to the historical investigator. (Photo by famed gold-rush photographer E.A. Hegg, reproduced by permission of the Historical Photography Collection, University of Washington.)

world and the media using photographs of model planes and had made quite a decent living out of it in the early 1930s." [74] It was thought that exposure of the hoax in aviation publications and the Smithsonian's own magazine would put an end to the hoax. Yet a recent book on World War I fighting planes used one of the "Cockburn-Lange" photos on its dust jacket for dramatic effect! [75]

Klondike gold rush photos. A final case has nothing to do with dating or authenticating photographs or even with questioning the subject matter in a photo. Instead it shows how incidental details in old photographs—in this case some of Klondike gold rush photographer E.A. Hegg's early views [76]— can provide interesting and valuable historical information.

The author was designing exhibits for the museum in Dawson City, Yukon, "the heart of the Klondike," in 1975-76. Blowups of Hegg's Dawson city scenes, ca. 1897-99, showed signboards that—on closer inspection—

were not what they had seemed: Instead of *planks* the signs were actually made of *cloth* tucked over a skeletal frame.[77] (See Figure 3.16.)

Attempting to determine why cloth signs were used provided unique insights into business practices, logistics, and other aspects of life in Dawson's heyday. For example, research showed that the earliest available lumber in the boom town, which began as a tent city in 1897, was whipsawed: too green to paint and too rough for artistic flourishes. As the town grew, its only sawmill was swamped with orders for boards—for commercial buildings and dwellings, for bars for saloons, for pews for churches, and for other needs. So boards, and consequently board signs, were at a premium. An exception was one store's narrow signboard, made of four skimpy planks.

But there were other, more important considerations leading to the use of cloth signs. The heavy canvas required no background paint, and therefore no drying time; thus it was instantly ready to letter—an important factor in the hectic heyday of frontier Dawson. Moreover, the cloth was freely available, especially after the tents began to be replaced by wooden structures, leaving a surplus of usable tenting material. And for some large banners strung across the dirt streets or between hastily-erected storefronts—so characteristic of the carnival atmosphere that prevailed—wood was out of the question anyway.[78]

Even the wording on the signs and the implications thereof reveal much about the time and place: "GOLD DUST ACCEPTED," "NEW TENTS," "DOGS," "MEALS 5¢," "SALOON," and "FANCY DRESS MAKING." The numerous signs also provide a ready index to the wide scope of enterprises in Dawson. There were doctors and dentists (who filled teeth with nuggets!), lawyers and barbers (one of whom, his sign informed, operated a "shaving parlor"). Laundries, bakeries, cafes, hotels, trading posts, markets, hardware and dry goods stores and saloons were in abundance. There were outfitters, tobacconists, and stationers, tailors and photographers (including "Goetzman the Tin Typer"). In addition, the signs show, there were packers and forwarders, freighters and carriers, and more. A storage company sign promised, "Carry your key." There was at least one sign proclaiming "BATH HOUSE." From a single banner we learn that passage to "SEATTLE and VANCOUVER" via the steamers "BONANZA KING" and "ELDORADO" took just "10 DAYS."

From the signs in the old photographs, one could compile a substantial list of the wares available to the sourdoughs (seasoned prospectors) and Cheechakos (greenhorns). Among these were fruits and "fine candies," fresh meats, butter and eggs, pies, cakes, waffles, and doughnuts. Drinks included wines and liquors, "bass ale," root beer, sodas, and lemonade. Boots, moccasins, mitts, and other clothing items, including "winter underwear" (the temperatures ranged into the minus sixties!) were advertised by signs. So

were "clean beds" and "class meals." For the ladies (few though they were), there were fancy dresses and other amenities. The list goes on and on.

Prices, too, can be cataloged from the signs in the old photographs, although they fluctuated greatly. Typically, the signs say, 50¢ would buy a meal or a haircut, a tintype or a box of cheap cigars. For a dollar, one could purchase a spring bed or "the best $1 dinner in town."

Because every street sported a flurry of signs, it is surprising to finc one of Hegg's street-scene photographs—in utter defiance of the usual laws of commerce—completely devoid of advertising. Then we realize why: Standing in the doorways and leaning out the windows are nearly a dozen tradespersons of the "oldest profession." (This street was located on the outskirts—not out of morality, but, from experience, for fire protection.) Here, where only a single type of commerce flourished, advertising signs would have been superfluous!

As this brief study illustrates, one way to consider a whole is to focus on a part—in this case what were literally "signs of the times." Although many of Hegg's photos were once almost destroyed (when a woman who found them in her cabin contemplated using them as panes in her greenhouse),[79] they have survived to provide fresh insights into the history of the Klondike gold rush.

These cases by no means exhaust the possibilities, but they do illustrate how photographs often contain subtle clues for those persevering enough—and sometimes innovative enough—to read them. Additional approaches will be given in later chapters—notably the following one (chapter 4) on photography and identification.

Recommended Works

Dalrymple, Priscilla Harris. *American Victorian Costume in Early Photographs.* New York: Dover, 1991. A guide to dating old photographs from the sitters' mode of dress.

Darrah, William C. *Cartes de Visite in Nineteenth Century Photography.* Gettysburg, Pa.: W.C. Darrah, 1981. The definitive text on the subject of cartes de visite, profusely illustrated and containing considerable specific information on dating carte photographs.

Deas, Michael J. *The Portraits and Daguerreotypes of Edgar Allan Poe.* Charlottesville: Univ. Press of Virginia, 1989. A scholarly cataloging of all the known daguerreotypes of Poe, including copies, doctored photographs, and even hoaxes.

Davies, Thomas D. "New Evidence Places Peary at the Pole," *National Geographic* 177.1 (January 1990): 44-60. Engrossing study that vindicates Peary in his claim to have reached the North Pole in 1909, utilizing analysis of photographs by photogrammetric rectification, a technique used to determine the sun's elevation at the time a photograph was taken.

Dolan, Maryanne. *Vintage Clothing 1880-1960*, second edition. Florence, Alabama: Books Americana, 1987. A nicely illustrated identification and value guide to eight decades of men's, women's, and children's apparel. (See also Gernsheim; Peacock.)

Frassanito, Wiliam A. *Gettysburg: A Journey in Time*. New York: Charles Scribner's Sons, 1975. Detailed, investigative look at the work of the photographers who documented—and occasionally staged—the post-battle scenes at Gettysburg; examines the technical factors involved, reconstructs the photographers' itineraries, and attempts to resolve many complex issues of captions, dates, and context regarding the photographs.

Frassanito, William A. *Grant and Lee: The Virginia Campaigns 1864-1865*. New York: Charles Scribner's Sons, 1983. Like Frassanito's earlier study of the Gettysburg photographs, a comprehensive examination of the photographs recorded during Grant's Virginia campaigns.

Frisch-Ripley, Karen. *Unlocking the Secrets in Old Photographs*. Salt Lake City, Utah: Ancestry, 1991. Genealogically oriented text with chapters on "Identifying the Family," "Dating Photographs," "Public Sources of Information," "How to Locate Family Photographs," and others.

Gernsheim, Alison. *Victorian and Edwardian Fashion: A Photographic Survey*. New York: Dover, 1981. A photographically illustrated look at the changing of men's—and especially women's—fashions, from 1840 to 1914. (See also Peacock; Dolan.)

Hirsch, Julia. *Family Photographs: Content, Meaning and Effect*. New York: Oxford University Press, 1981. Insightful look at the subject of family pictures, ranging from the candid snapshot to the formal portrait, emphasizing the clues they provide to the lives of the people they depict.

Langellier, J. Phillip. *Parade Ground Soldiers: Military Uniforms and Headdress, 1837-1910*. Madison: State Historical Society of Wisconsin, 1978. Illustrated survey of military uniforms and accouterments in Wisconsin from the earliest explorations to the eve of World War I.

Nickell, Joe. *Pen, Ink and Evidence: A Study of Writing and Writing Materials for the Penman, Collector, and Document Detective*. Lexington: Univ. Press of Kentucky, 1990. Historical study of handwriting and its accouterments with much information of use to the photographic detective, especially on dating and authenticating signatures and other writings.

Oliver, George. *Photographs and Local History*. London: B.T. Batsford, 1989. Practical text on the value of photographs to the local historian (although oriented to the British reader), with insights into the value of photographic evidence.

Palmquist, Peter E., ed. *Photographers: A Sourcebook for Historical Research*. Brownsville, California: Carl Mautz Publishing, 1991. Reference work on discovering information on early photographers; includes Richard Rudisill's "Directories of Photographers: An Annotated World Bibliography" which provides a means for researchers to study biographies of photographers around the world.

Peacock, John. *Costume, 1066-1966*. London: Thames and Hudson, 1986. A chronological reference spanning over ten centuries of English historical costume (with analogous American developments), lacking text but illustrated with a profusion of annotated drawings (noting such features as fabric, accessories, etc.). (See also Dolan; Gernsheim.)

Rowe, Walter F. "The Case of the Lying Photographs: The Civil War Photography of George N. Barnard," *Journal of Forensic Sciences*. JFSCA 28.3 (July 1983): 735-755. Enlightening analysis of contemporary Civil War photographs that were faked in various ways—for example, battlefield carnage simulated by having living soldiers pose as the dead.

Strauss, David Levi. "Photography and Propaganda," *Afterimage*, vol. 15, no. 19 (April 1988): 12-16. Penetrating look at the illusion of objectivity in mass media news publications, in the context of the work of photojournalists Richard Cross and John Hoagland in Central America (who were killed in 1983 and 1984 respectively).

Wise, David Burgess. *Veteran and Vintage Cars*. New York: Grosset and Dunlap, 1971. Comprehensive guide to automobiles from their origins to the end of the vintage period (the beginning of the 1930s), useful in helping to date old photographs that may depict a motorcar.

4

PHOTOGRAPHY AND IDENTIFICATION

Since their invention, photographs have naturally been associated with identification. In this chapter we will look first at the use of photographs as an aid to identification, primarily by law enforcement personnel, and then at the need to identify the subjects of old photographs, a frequent challenge to the photo detective.

Photographs for Identification Purposes

History of identification. Descriptions of wanted criminals were employed during the reign of the pharaohs in Egypt, as elsewhere throughout antiquity. In fact, before the advent of photographs and fingerprints, detectives usually had to rely on memory—theirs or that of someone else. According to a history of the London police force: "Criminals gave as many false names as possible, and travelled over the country by rail, committing offences in many places. A man might be caught in one place and treated as a first offender, even though he had 'done time' for robberies elsewhere. A useful way of identifying a suspect was to ask a policeman who might have arrested him earlier if he recognized the man. Detectives would go to a prison specially to see men being released, and would try to memorize their appearance."[1]

The first really scientific attempt at identification of criminals was made in 1860 by a Belgian prison warden named Stevens, who began taking measurements of criminals' heads, ears, feet, lengths of bodies, and so forth. His imperfect method was abandoned, but by 1882 a Frenchman, Alphonse Bertillon (1853-1914), had developed an elaborate anthropometrical system that involved tabulating height, sitting height, length of outstretched arms, length and breadth of head, length of right ear, and other measurements.

Bertillon supplemented his system with such additional data as scars and eye color, plus full-face and profile photographs.[2]

Eventually fingerprinting replaced *bertillonage*. Although fingerprints had apparently seen limited use for personal identification in ancient Babylonia and China, it was not until about 1860 that they began to be used on a consistent basis. A British colonial official in India, William Herschel, started including handprints of the natives on their contracts to deter forgeries and the refutation of signatures. Other developments came in time: in 1881, Henry Faulds, a Scottish medical missionary in Japan, wrote that finger impressions left at the scene of a crime could identify the perpetrator; in 1892, Sir Francis Galton authored the first textbook on fingerprinting; and by 1910 fingerprints were in widespread use in the United States.[3]

Although fingerprinting became the mainstay of identification and Bertillon's cumbersome system was relegated to little more than a historical footnote, his descriptive *portrait parle* (or "word picture" telling height, weight, color of hair and eyes, and so forth) and "mug" photos have remained very much in use.

Also, because (as with fingerprints) no two things in nature are exactly alike, many other methods of identification have served on occasion, including lip impressions, dental X rays, and certain features that may show in photographs, such as distinctive front teeth, unique scar patterns, and ear configurations (treated at length later in this chapter). Although some of these methods are relatively rarely employed, that does not lessen their validity in cases in which they can be used.

"Mug" shots. Some police departments recognized the value of photographs in identifying known criminals in the early 1840s (notably in Belgium as early as 1843) and files of daguerreotypes were maintained by police in France, Belgium, and the United States during the 1850s.[4] The ability to produce multiple prints from negatives greatly facilitated the use of "mug shots" (the slang term for face having possibly derived from the eighteenth-century custom of fashioning drinking mugs in the form of grotesque human faces[5]).

Although the multiple mug prints were not intended for public distribution, they were occasionally sent to police departments in other cities. Apparently they were made in carte de visite format, like one illustrated in William C. Darrah's *Cartes de Visite in Nineteenth Century Photography*, which has the prisoner's identification number "1025" imprinted at the upper left. It came from a dispersed police file in Boston, Massachusetts, in 1883. Sometimes, portraits of well-known criminals were produced commercially by enterprising photographers, but these should be distinguished from the mug prints per se.[6]

As mentioned earlier, mug photographs were included with Bertillon's anthropometrical system of identification, and London police began to build up their "rogues gallery" (a reference collection of portraits of persons arrested as rogues or criminals) in 1889.[7] Later, albums called "mug books" were common in larger police departments.[8]

It is unclear who initiated the practice of taking a profile photograph of a criminal in addition to a full-face one, but it became the standard practice in *bertillonage*,[9] no doubt because of the additional information the profile photo contains, such as the shape of the ear, the straightness or degree of convexity or concavity of the nose, and whether the chin juts or recedes. Sometimes full-length pictures are taken, which have the advantage of showing the subject's build and posture. In either case, the two shots are taken on a single sheet of film, that being permitted by the "split back" feature of mug cameras (or adapter backs for press-type cameras) whereby only half of the film is exposed at a time. The first picture is taken with the film holder in one position; then the holder is slid to one side and the second picture is made.[10]

Other qualities a good mug shot should have may be briefly listed— not just for the police photographer who will be "mugging" prisoners (as they say) but for anyone who may become involved in identification matters, whether it is in selecting the best picture to publish for some identification purpose (on a "missing" flyer, for instance) or in discussing with an expert the qualities in a given portrait that may be under study.

Six main requirements should be met: (1) sharp retention of detail (to show clearly such features as skin texture, hair, and scars) which may be accomplished by using a good lens, fine-grain film, proper lighting, and firm camera support; (2) good depth of field (all features in sharp focus), which is important to details in the subject's nose and, in the full-face view, the ears (good depth of field being accomplished by "stopping down" the camera's aperture—that is, making it smaller); (3) accurate tone separation (in black and white gradations) as an aid to correctly judging skin tone; (4) natural lighting effect (usually accomplished by using two flood lamps in reflectors placed at an appropriate height on either side of the camera, approximately five feet apart and four feet from the subject) to avoid distorting the features (for example, if the lights are placed too high, there will be unnaturally heavy shadows in the eye and mouth regions; if placed too low, shadow lines will extend up the sides of the nose and thus cause an unnatural appearance); (5) proper characterization of the subject (avoiding taking pictures while subjects are attempting to disguise themselves, such as by closing the eyes or making faces); and (6) employing some means of identifying the subject in the photograph (such as by using an identification number in the picture, usually on a number plate placed in front of the subject so that it will appear at the bottom of the front-view pose).[11]

Even with the assistance of good photographs—a great improvement over memory—mistaken identifications have sometimes been made, especially when other evidence was lacking in a case. As C.A. Mitchell states in *The Expert Witness*: "Mistakes of identification have probably been a more fruitful cause of miscarriages of justice than all the other causes put together. Every work on the laws of evidence cites notorious instances of the kind to prove how liable to error the direct evidence of eyewitnesses may be."[12] Mitchell also states:

The invention of photography placed a new weapon in the hands of the police authorities for establishing the identity of a "wanted" person. In many a case it has led to the detection of a criminal who was trying to escape from justice, but, on the other hand, it is not proof against an efficient disguise, and the registration files now kept by the police in all the big cities of the world show many instances of men who have so disguised their features as to be quite unrecognisable on casual comparison with an earlier photograph.

Moreover, since a photograph represents only one aspect, and often a false one, of a person at a particular moment, there is a chance of its being mistaken for a portrait of someone else, who in reality is not at all similar, and the possibility of wrong identification may thus be intensified. There have, as a matter of fact, been numerous cases of mistaken identification from photographs.[13]

An example of tragic misidentification is the case of Londoner Adolph Beck who, in 1896 and again in 1904, was mistaken for the swindler William Thomas. Fifteen out of seventeen women identified Beck as the man who had obtained money from them under false pretenses, although one woman was adamant that Beck was the wrong man. Poor Beck served five of his seven years before being released in 1901. Then, three years later, after complaints of similar swindles were again received, police rearrested Beck. This time he was identified by nineteen women and was again tried and convicted. Only a postponement and the interim arrest and correct identification of Thomas kept the unfortunate Beck from serving out a second prison term.[14] Photographs of the two men do show similarly stout men with walrus mustaches.[15] However, closer inspection shows that their actual facial features were not really very similar.

An even more remarkable case occurred at Leavenworth Penitentiary in 1903. On May 1 of that year a young black man named Will West was being admitted on a charge of manslaughter. At this time *bertillonage* rather than fingerprinting was in use in the United States, and West was being processed in the usual manner. However, a clerk thought he recognized him and—despite Will West's denial that he had been an inmate there before— searched the files. Bearing measurements virtually identical with those of the new prisoner, one card read "William West," and its full-face and profile photographs obviously depicted the same man. (See Figure 4.1.)

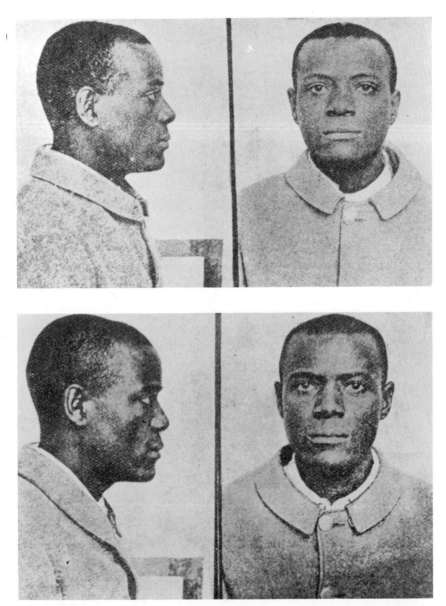

Figure 4.1. "Mug" photographs of Will West (*above*) and William West (*below*), whose uncanny resemblance led to the triumph of fingerprinting over the Bertillon system of identification in America.

But they were *not* the same man: William (Bill) West was still incarcerated at Leavenworth, a "lifer" sentenced for murder, and soon the two men were placed side by side in the same room. Contemporary accounts described them as being "as alike as twin brothers" though they "were unrelated." The case (discussed further later in this chapter) marked the beginning of the end of *bertillonage* and a triumph for the budding science of fingerprinting.[16]

Lookalikes such as Bill and Will West are not common, but as we shall see in the second part of this chapter antique portraits of "John Doe" are frequently misidentified as celebrities like Edgar Allan Poe, creating controversies that may require the services of a photo detective. As we shall see, there are established techniques for attempting to resolve such cases of questioned identity.

Composite portraits. Frequently, especially if a suspect cannot be identified from police mug books, a composite picture—sometimes called a "police sketch"—is made. As police artist Douglas P. Hinkle states in his book on the subject, *Faces of Crime*:

There are two principal ways in which a police sketch serves the investigative process. First, it helps concretize the facial type, enabling people to visualize what the offender probably looked like in a general way. Second, it saves a lot of time because it eliminates hundreds, and in some cases thousands, of mug shots the witnesses or investigators don't have to wade through. But as a positive identifier in court, the police sketch is next to worthless. No matter how close the resemblance, there will be some differences. For this reason any prosecutor who submits such a drawing in evidence is taking an awful chance that the defense attorney will concentrate on the differences: "My client has a mole on his neck. There's no mole in this picture. Ergo, you have the wrong man. This drawing proves that my client is *innocent!*" And so on, ad infinitum. The drawing is an investigative aid, not a prosecutorial tool.[17]

Such pictures are usually made in one of four ways (the terms *sketch* and *composite* not being precisely accurate to all of them). In the first, a freehand drawing is made by a police artist in cooperation with a crime victim or other eyewitness. The artist may begin by establishing the basic head shape (possibly by showing the witness a chart of fundamental head forms) followed by "negative spaces," i.e., the distances between or surrounding features (the five most critical distances being between the hairline and the eyebrows, between the eyes, across the face from ear to ear, from tip of nose to mouth, and from lower lip to bottom of chin), before concentrating on the actual features of eyes, nose, and mouth, which are considered "positive space."[18]

The second method is a true composite drawing made by using a "kit"—such as the famous Identikit—which has individual elements such

as hair and eyes produced as line drawings on sheets of clear plastic that serve as overlays. Using a trial-and-error process in which the witness selects the features, probably changing his or her mind occasionally as the work proceeds, the police artist assembles the components by placing the overlay for each selected feature over that of the chosen facial outline until a complete face is assembled.[19]

The third method replaces the overlay drawings with actual photographs of features, such as horizontal rectangles that each contain a pair of eyes, wedgelike segments with noses, U-shaped portions with jaws and chins, and so forth. The components are interchangeable, like pieces of a jigsaw puzzle, so that a large variety of composite faces can be produced. Developed by Jacques Penry, this composite-kit identification method is known as PHOTO-FIT and it is the basis of Penry's book *Looking at Faces and Remembering Them*.[20] An advantage of this method is presumed to be the photographic realism of the finished picture, although, since a given picture will to some degree be inaccurate, the finished, lifelike image may be somewhat misleading, prompting a viewer to see it as *the* rather than *a* likeness.

The fourth method of producing composite pictures is by means of computerized techniques like Comfotofit. These techniques compensate for the problem of fixed sizes of components inherent in "kit" methods like the previous two. For instance, a nose might be the correct shape but be too large in proportion to other features. The computerized versions permit the operator to adjust the size of any feature.[21]

There are also computerized techniques that perform other facial-feature tasks. For example, there is artist Nancy Burson's patented method of fusing two or more photographs into a single composite image like her *Presidents* (1992), a computer-generated portrait made from the synthesized features of former U.S. presidents Johnson, Nixon, Ford, Carter, and Reagan (a mature, solid, pleasant, and capable-looking sort of fellow).[22] This is a sophisticated development of a concept originated ca. 1877 by Sir Francis Galton (mentioned earlier as a pioneer in the use of fingerprints) which he intended as a tool in studying racial, "criminal," and other "types." Galton's method was to make multiple photographic exposures wherein each picture was superimposed on the others to create a single composite portrait, such as his *Composite of the Members of a Family* (ca. 1878).[23]

Another computerized technique for manipulating faces is that of computer aging, often used in cases of missing children to project their theorized appearance after an elapse of several years. This was the first computer technique that Burson explored, and it is based on the fact that people's faces age in the same general way. In 1986, for example, two missing children were found after photographs that had been "updated" by the technique were broadcast on a television special. Again, in 1989 a scientifically

"aged" picture of murderer John E. List, who had executed his mother, wife, and three children almost eighteen years before, was broadcast on the television series *America's Most Wanted*, and an alert neighbor called the FBI.[24]

Still other computerized techniques are used to enhance poor quality photographs (such as those taken of bank robbers by video surveillance cameras), to retouch or alter pictures for any of a variety of reasons (discussed in a later chapter), and to analyze two portrait photographs to determine if they are of the same person (a process discussed later in this chapter).[25]

Identifying People in Old Photographs

Historical investigators—such as genealogists, historians, and biographers—are frequently confronted with questions of identity posed by old photographs: Is this carte de visite picture of a bearded man on his death bed actually a rare photograph of Abraham Lincoln? Could an old daguerreotype handed down in the Norcross family depict Emily Norcross Dickinson, mother of the celebrated American poet? And what of photos of the man who assassinated John F. Kennedy in Dallas: do they indeed picture Lee Harvey Oswald, or, as a popular book maintained, are they instead photographs of a look-alike Soviet agent?

Even when the putative subject is not some famous or infamous figure but instead someone's humble ancestor, the import may be just as great to that inquirer, who is desirous of possessing at once a likeness of a forebear and a tangible link with the past. Perhaps there is some reason to suspect the attribution: Can the issue be resolved so that the photo can be confidently included in a published family history, or just as confidently consigned to that special limbo reserved for old photographs whose subject cannot be identified?

To answer such questions the photo detective has at his or her disposal a number of investigative techniques that *may* prove illuminating, even decisive. These techniques are explained in the following discussions, moving from the general to the more specific: provenance, historical clues, etc.; facial features comparison; and ear identification.

Provenance, historical clues, etc. Oftentimes, some of the elements we discussed in the previous chapter—handwritten annotations, internal evidence, provenance, and so forth—can help substantiate, or discredit, an attribution as to the identity of a person in an old photograph.

For example, one family consulted the author about the identity of persons represented in a Victorian photograph album that was on loan from some distant relations. With white cotton gloves of the type preferred by

Figure 4.2. Carefully removing old photographs from their Victorian albums can often reveal penned identifications or other clues on their backs. (Photograph by Robert H. van Outer.)

archivists, and stamp tongs (employed by philatelists because their jaws lack the knurled surfaces of ordinary tweezers and thus will not mar valuable items), the photos were carefully removed one at a time, so as not to tear (or in this case not to further tear) the paper mats. (See Figure 4.2.) This proved beneficial since several of the photos bore names that were not otherwise apparent, written either on the back or on the front underneath the mats. Unfortunately, only slightly over a third of these were contemporary identifications as judged from the handwriting. The remainder of the names were penciled on the backs of the photos in a modern hand; worse, they were followed by question marks.[26]

False attributions of identity are frequently penned on photographs, especially those alleged to depict persons of notoriety. For example, an old ambrotype is alleged to depict a legendary additional sister to the outlaws Frank and Jesse James (born in 1843 and 1847, respectively). Their parents, Rev. Robert S. and Zarelda (Cole) James had another son, Robert (who was born in 1844 but lived only five days) and a daughter Susan Lavinia (born in 1849). An alleged fifth child, a daughter reputedly born in 1848 and named Mary, has occasionally been attributed to the family, and the ambrotype in question is inscribed "(Prudy)/Mary Eliz James."[27]

However, the inscription is in a modern hand, and the name "M.E. [COBORN?]" has been partially erased. Given the apparent age of the girl (about seventeen) and the reputed birth of Mary James in 1848, the picture would seem a rather late example of an ambrotype. In any event, James family researchers relegate her to the realm of myth by noting her absence on Missouri census records. More significantly her name was never recorded in the James family Bible.[28]

Edgar Allan Poe attibutions are rife. States Michael J. Deas in his scholarly book, *The Portraits and Daguerreotypes of Edgar Allan Poe*: "Spurious portraits of historical figures are not uncommon, yet the number of such portraits said to represent Edgar Allan Poe is staggering. Scores of fictitious Poe portraits are scattered in public and private collections throughout the United States; Washington's National Portrait Galley alone has in its files references to at least twenty-five such likenesses, and the number increases almost yearly. Approximately half of these works are posthumously produced, heavily altered derivatives based on established life portraits . . . while others are merely paintings or photographs of anonymous subjects erroneously identified as Poe."[29]

One photograph was originally published as a "full length daguerreotype of Poe," but actually the portrait extends only to the man's knees, and it is a carte de visite, an albumen print made from a glass negative. This process was not invented until 1851—two years after Poe's death—and was not widely used in the United States until 1854. Even if this were not so,

the attribution could be dismissed on stylistic grounds, since "the small bow tie, Prussian shirt collar, and swallow-tailed coat were accouterments not introduced until the 1850s."[30]

Another example is a "Poe" photograph of three theatrically attired young men which first appeared in the April 1916 issue of *Century Magazine*. Supposedly, it had recently been found among the personal belongings of Poe's foster father, John Allan, and it showed the poet and two of his University of Virginia classmates. In fact, a respondent to the magazine observed that Allan could scarcely have owned the picture since he died five years before photography was invented. Stated Deas: "Indeed, the picture's resemblance to Poe is minimal, and the composition and overall style of the photograph date the image to about 1860—well after Poe's death in 1849."[31]

Still another spurious Poe was an oval photograph that purported to depict him at age five. Originally appearing in *Southern Literary Messenger* (December 1940), the picture was discovered by a Mr. L.B. Hatke of Staunton, Virginia, in the possession of a woman who lived "just out of Harrisburg, Va." Supposedly, an inscription was attached to the picture reading "Edgar/on his fifth birthday/Born on the 19th day of January 1809" (Poe's birthdate). An article in the *Messenger* that accompanied the photograph contained several testimonials regarding its authenticity, but perhaps the reader has already determined why the picture could not depict Edgar Allan Poe. (Pause here to consider the evidence.)

All one has to do to expose this silly hoax is to consider the state of photography in 1814. It was nonexistent; putting aside purely experimental images, photography was not available until 1839, at which time Poe was thirty years old![32]

Deas concludes that genuine portraits of Poe "can be distinguished not only by the countenance they depict but by their provenance." With two exceptions, Deas states, "all of the established likenesses of Poe have histories that can be retraced to within a decade of the poet's lifetime." He adds:

Spurious portraits, by contrast, are invariably tinged with a shadowy background; more often than not their point of origin proves to be a secondhand store or . . . the library of a collector given more to zeal than to serious scholarship. While it is possible, perhaps even probable, that one or more genuine likenesses of Poe may yet survive undiscovered in a public or private collection, it must be emphasized that spurious portraits of the author have been surfacing with tiresome regularity for nearly a century. Any alleged Poe portrait discovered in years to come will have to be viewed with extreme skepticism.[33]

A similar caution proved appropriate regarding the alleged photograph of another celebrated American poet. It is a carte de visite portrait, on the verso of which is penciled: "Emily Dickenson [sic] 1860," when she was

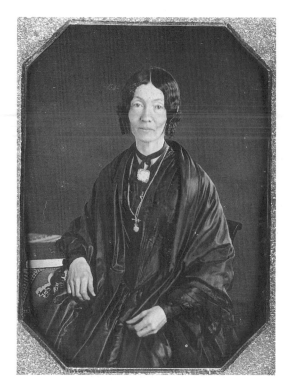

Figure 4.3. A daguerreotype portrait recently identified as that of Emily Norcross Dickinson, mother of the famous American poet. Among the clues were the brooch shown here, which was found in the poet's possession at her death, and studio props—such as the distinctive tablecloth— also seen in the daughter's daguerreotype. (Photo reproduced by permission, the Norcross Collection, the Monson Free Library and Reading Room Association, Monson, Massachusetts.)

thirty years old. The only known photograph of Dickinson is a daguerreotype portrait of her as a schoolgirl of about seventeen. A carte de visite, a type of photograph invariably produced in multiple copies, would seem an unlikely possession for a poet who became increasingly reclusive and who told one correspondent who requested a photograph in 1862 that she had none to give.

Moreover, the photo is entirely lacking in provenance before 1961 when it was offered for sale in a catalog by a bookseller and sometime purveyor of fakes named Samuel Loveman. Loveman's catalog entry implies that the photograph was discovered with the "Emily Dickenson" inscription affixed, but in fact it is in the handwriting of Loveman himself! (The photograph is discussed further in the following section of this chapter.) [34]

In contrast to such spurious identifications is a daguerreotype credibly identified as that of Emily Dickinson's mother, Emily Norcross Dickinson (Figure 4.3). The portrait was among a group of daguerreotypes that had belonged to the Norcross family, a detail of provenance that suggested the identification. In addition, props in the picture, including a distinctive tablecloth, show it was made in the same studio, probably at the very same time, as a portrait of the poet at about age seventeen. The daguerreotype image

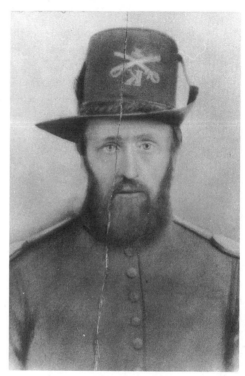

Figure 4.4. This Civil War photograph raised questions about its traditional identification, yet provided clues that ultimately confirmed it as a portrait of Milo Welton. (Photo courtesy of Prof. Oscar W. Dillon, Jr.)

compares favorably with an oil portrait of Mrs. Dickinson, and, finally, a distinctive brooch appearing in the photo matches one that was in *Miss* Dickinson's possession at her death.[35]

As the photograph of Emily Norcross Dickinson demonstrates, a rare photograph of a person of note may occasionally surface. More likely to be found, of course, are those carte de visite portraits that were often produced in considerable quantity. The author was once rummaging through a small basket of cartes de visite in a village antique store when he discovered one with a familiar face: John Wilkes Booth. Although worth many times its three-dollar price, such a picture is not fabulously valuable since numerous prints were made: *Harper's Weekly* offered carte photographs of the by then notorious actor immediately after the assassination of President Lincoln.[36] Confirmation that the discovered carte was indeed of Booth came from comparing it with published specimens.[37]

Of course questioned attributions also come from the ranks of the non-famous, as in the interesting case of a Pennsylvania Union Army soldier named Milo Welton, who died in a military hospital in Washington, D.C., in 1862. A photograph identified as depicting Welton (Figure 4.4) was handed down in his family, but doubts were eventually raised by the man's uniform:

he appeared to be an officer, whereas Welton was supposedly never more than a private. Perhaps, his descendants thought, the picture was of his son, John Alexander Welton, who was promoted to lieutenant. The man in the picture is bearded, and family tradition states that John Welton grew a beard to cover the scar from a wound received in battle. "The picture is most likely John," concluded a note accompanying the picture when it was entrusted to the author for study.

The picture is obviously a copy of a paper portrait that had a crack or tear in it, and that image (a magnifier reveals) was a "crayon enlargement" (as discussed under "Paper Prints" in the previous chapter). It appears to have been copied from a direct-positive type of photograph—an ambrotype or more likely a tintype—since the image is obviously reversed. (Note that the jacket is buttoned backwards and that the "K" on the hat is reversed.)

An expert in military dress, Tom Fugate, curator of the Kentucky Military History Museum in Frankfort, Kentucky, was consulted. He immediately identified the uniform as being not that of an officer but instead a regulation issue dress or parade uniform for an enlisted man, complete with shoulder scales and a Hardee-pattern dress hat (turned up on the soldier's right if the picture were not mirror-imaged). Fugate said the hat's crossed-swords insignia indicated a cavalry unit, and, of course, the soldier was in Company K.

It was now possible to compare this information with the military records of Milo and John Welton. (Such records are obtained by completing "NATF Form 80," available from the General Reference Branch, NNRG, National Archives and Records Administration, 8th and Pennsylvania Avenue NW, Washington, DC 20408.) They showed that both Milo Welton and his son John A. served in Company K, 4th Pennsylvania Cavalry. Therefore there was no need to question the traditional identification of the photograph as indeed representing Milo Welton. Moreover the man in the picture appears to be closer to Milo's age of 43 (in 1862) than John's of 19-22 (his service from 1862 to his death of a gunshot wound in 1865). Also, the eyes of the soldier in the photograph are very light, consistent with the description of Milo's eyes in his military record as "gray" but not with John's recorded as "brown" and "Dark."[38] Based on this preponderance of corroborative evidence, the identity of the soldier as Milo Welton was confirmed.

Another case from the same family concerned the identity of the woman in a ca. early 1880s cabinet photograph that was actually a copy of a much earlier daguerreotype (discussed in the previous chapter and illustrated in Figure 3.14). A second picture, a carte de visite, that obviously depicted the same woman at a later period was discovered in a family album (Figure 4.5). The latter photograph could be dated ca. 1865 by the presence of a revenue stamp on the back and, together with the other photograph,

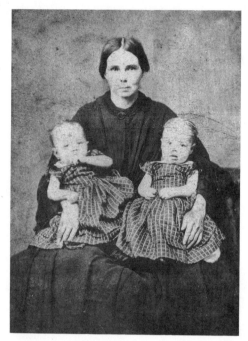

Figure 4.5. Several clues—including the photographer's imprint, and the presence of twins—led to the identification of this woman as Margaret Sarver McCrea. (Photo courtesy of Jane Dillon.)

provided a basis for estimating the woman's year of birth. Since the locale of her residence was indicated (by the imprint on the more recent photo), and since the carte de visite shows her holding twins—a valuable piece of data—family researcher Jane Dillon was able to determine the woman's identity from federal census records of Pennsylvania.[39]

Dillon is pursuing an interesting, if somewhat tenuous, clue in another cabinet photo in hopes of identifying the subject of the portrait. A pin on the collar of the man's vest was progressively enlarged (Figure 4.6) and tentatively identified by photohistorian Bill Rodgers as an Independent Order of Odd Fellows (I.O.O.F.) emblem. The author sent the photos to the order's grand lodge in Winston-Salem, North Carolina, where the insignia was positively identified by the Sovereign Grand Secretary as "the three links emblem of our order."[40] Given the Pennsylvania address on the photo, Dillon was able to narrow the possibilities as to the man's identity as "either a Sarver or McCrea," and is hopeful that the I.O.O.F. data might provide a final clue that would complete the identification. Whether or not this approach pays dividends in this instance, it underscores the importance of pursuing the most minute clue in a questioned identity case.

One other brief case—a problem encountered by University of Kentucky professor of English Joseph Gardner—illustrates how even a genetic trait can provide a decisive clue to the astute family historian. A photograph

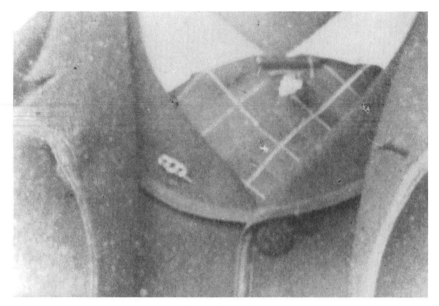

Figure 4.6. A detail of a cabinet photograph (shown earlier in Figure 3.5) reveals what was identified as an Odd Fellows pin, a possible clue to the identity of this man.

had been handed down in his family, labeled to indicate that it represented the wife of a certain ancestor. However, that man had remarried after his first wife's death, so there were two possibilities for the identification. Professor Gardner naturally wished to know whether the wife who was pictured was the one he descended from. The question was answered to his satisfaction when he detected a slight droop in one of the woman's eyelids—an inheritable trait known in his own ancestry.[41]

As these cases illustrate, a variety of types of evidence—provenance, handwriting, dress styles, jewelry, photographers' props, and many other factors, including occupational clues (see Figures 4.7-4.10)—can provide indicators that may help establish, or discredit, an identification. A sharp eye, aided by a magnifying glass, together with a creative imagination and a willingness to persevere—these are the tools with which to attempt to solve questions of identity regarding old photographs. Two further approaches, both relying on analysis of particular facial features, are discussed in the sections that follow.

Facial features comparison. The methodology applied to questions of identification in certain sensational cases—like those involving alleged Nazi war criminals, for example—is to make an expert comparison of the facial

Figure 4.7. Occupational clues are often contained even in studio shots like this tintype. The men have brought along a telegraph key and other items that help reveal their occupation.

features in the questioned image with the features in a known portrait.[42] There are a variety of approaches, as we shall see, but most rely at least in part on the underlying bony structure of the skull, which does not appreciably change after a person reaches adulthood.

Take, for instance, the case of Lee Harvey Oswald and his alleged "double." In a 1977 book, *The Oswald File*, retired British solicitor Michael Eddowes wrote that he would "endeavor to prove beyond reasonable doubt" that Soviet premier Khrushchev ordered the Soviet Secret Police to assassinate President John F. Kennedy; that "the real ex-Marine Lee Harvey Oswald" did not return from the USSR (to which he had defected in 1959) but, instead, a KGB assassin "in 1962 had entered the United States in the guise of Oswald" and committed the act; and finally, that "to avoid the possibility of World War III," a massive cover-up was undertaken, with the "Warren Report" (actually the *Report of the President's Commission* on the Assassination of President John F. Kennedy) being "a declaration of peace and incidentally an admission of defeat."[43]

Eddowes's case for two Oswalds was exceedingly weak, largely based on some discrepancies in height and scars between Oswald's Marine Corps records and post-1962 official records. He conceded that the fingerprints of

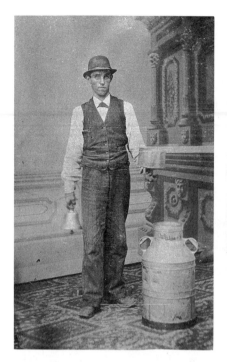

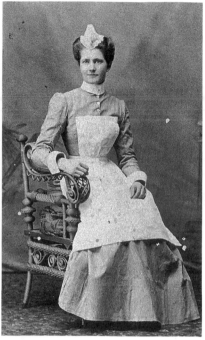

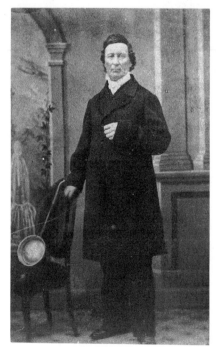

Figure 4.8-4.10. This tintype of a milkman, mounted print of a nurse, and carte de visite of a clergyman (posing with collection basket) illustrate other occupational clues—from the obvious to the more subtle—that may be discovered in old photographs and help serve as an aid to identification.

the "two" men matched, but he offered the "theory" that the "KGB had substituted a forged print card in the FBI fingerprint files, the forgery substituting the impostor's prints in place of the ex-Marine's prints." [44]

Despite the nonsensical nature of Eddowes's claims, they were given serious study by the U.S. House of Representatives Select Committee on Assassinations. For instance, the committee assembled a group of distinguished, independent document examiners to review handwriting samples from the "Marine Oswald" and those of the "Dallas Oswald" (the supposed double). After a lengthy and detailed study, each expert concluded that documents from the various periods were "all in the handwriting of the same person": Lee Harvey Oswald.[45]

In order to investigate further the theory of an alleged "second Oswald," the committee convened a panel of photographic experts and forensic anthropologists who were posed the question: "Is there any photographic evidence of an Oswald impostor?" The experts examined photographs of Oswald "ranging in time from his Marine Corps enlistment to his arrest in Dallas after the assassination." One analysis was "based on 15 indices derived from 16 measurements of the head and face." For comparison, photos were included of Oswald's fellow employee, Billy Lovelady, who bore a "strong physical resemblance to Oswald" and who had been "a source of controversy and confusion regarding the 'man in the doorway' photograph." The Lovelady photos were to provide "a convenient control or yardstick to measure the variation observed in the facial indices derived from the Oswald photographs."

The results were decisive. The indices for Lovelady (the closest Oswald "double" yet connected with the case) were notably different from those of the other photographs. In addition to the analysis of facial indices, the experts compared other facial features of the "two" Oswalds. For example, in various profile views, "the angle of the nasal bridge in relation to the face" was 37 degrees in all cases, and "the angle between the nasal septum and the facial plane" varied by less than one degree. The experts concluded: "There are no biological inconsistencies in the Oswald photographs examined that would support the theory that a second person, or double was involved." [46]

Facial feature analyses have been used in other sensational cases, for example that of Dr. Joseph Mengele, the notorious Nazi whose bizarre medical "experiments" led to his being labeled "The Angel of Death." Although Mengele eluded justice by fleeing to South America and disguising himself as one "Wolfgang Gerhard," after his death international experts were called on to establish the identity of the skeletal remains.

Among the sophisticated techniques employed was that of "electronic supraposition" used to compare the questioned skull with an authenticated photograph of Mengele. Two video cameras were used, together with a video mixer. In this way an image of the skull was superimposed on to an actual-

size copy of the photo, and points of correspondence were noted. Everything matched, including details of the facial structure and a distinctive gap between the upper front teeth.[47] As one scientist said of the superimposition technique, "It's like looking through the skin to the bone."[48] Although the questioned image in the Mengele case was a skull, similar analyses are conducting utilizing two photographs.

An analogous approach was applied to the "Emily Dickenson" (sic) carte de visite (mentioned earlier) by nationally recognized forensic anthropologist Emily A. Craig. A faculty member of the Department of Anthropology at the University of Tennessee at Knoxville, who was featured in a special presentation on forensic sciences by the CBS television program *48 Hours*, she examined the evidence at the request of the author (who in turn had been asked by the editor of the *Emily Dickinson International Society Bulletin* to investigate the matter).

Craig requested that the images on the questioned carte de visite and on the known daguerreotype of Emily Dickinson be transferred to photographic slides. Then, utilizing separate projectors, she adjusted the projected images for size and superimposed one over the other, looking for points of correspondence that would indicate a common identity. However, although there were some similarities, there were more significant differences, and Craig concluded, with what she characterized as a high level of confidence, that the carte photograph did not, in fact, depict the celebrated poet.[49]

An attempt to objectify the identification process has led to development of a computer photo analysis technique that captured national attention amid controversy over the Billy the Kid legend. The technique was used to compare a photograph of Ollie L. "Brushy Bill" Roberts with a tintype of Henry McCarty, a.k.a. William Bonney. Historians say that Bonney was Billy the Kid, who at age 21 was shot to death by Lincoln, New Mexico, Sheriff Pat Garrett in 1881. However, there are those who insist that the Kid escaped, possibly with "official" help, and lived to a ripe old age somewhere in New Mexico or Texas. Among those claiming to have been the survived outlaw was Brushy Bill Roberts, an elderly resident of Hico, Texas, who maintained on other occasions that he was Frank James of the notorious James Gang. Roberts died in December 1950.

Historians from the Lincoln County Heritage Trust commissioned the computer comparison, supplying authenticated photographs of both Bonney and Roberts to an identification team led by Oklahoma forensic anthropologist Clyde Snow. The photos were copied and fed into a scanner linked to a VAX mainframe computer that reduced the images into pixels and enhanced portions of the images where necessary. To determine identity, the technique utilizes a "similarity index," mathematically derived from 25 facial "landmarks." The computer also matched the photographs to a database

of 150 people from both sexes and various facial groups. This would show how many persons in the sample—if any—were more similar in appearance to Bonney than was Brushy Bill Roberts.[50]

If Roberts were indeed Billy the Kid, his picture should have ranked second, after Bonney's picture, which was ranked first for purposes of the analysis. Actually he came in a distant 42. Explained Heritage Trust director Robert L. Hart: "That means there were 40 other individuals [in the database] who look more like Billy the Kid than Brushy does. In short, Brushy doesn't look very much like Billy the Kid at all."[51]

Unfortunately, some of those for whom the results were intended were not convinced. Nothing apparently would convince one Brushy Bill buff, who told the Associated Press: "I don't accept the tintype as being Billy the Kid at all. On the other hand, I don't accept the study. You let me program my computer and I guarantee Brushy Bill'd be number one."[52] He seemed to echo the sentiments of others who entertain similar escape-from-death scenarios regarding John Wilkes Booth, Butch Cassidy, Jesse James, and others. (No fewer than seventeen impostors claimed to be the "real" Jesse, although one, a member of a traveling tent show performing in Columbia, Kentucky, abruptly recanted when U.S. Marshal Evan Akin presented him with an age-yellowed arrest warrant.[53]) Such mythologizing, akin to Elvis Presley sightings of today, are in what folklorist Richard M. Dorson calls "the tradition of the Returning Hero, who appears after his alleged death to defend his people in time of crisis."[54]

Of course, facial feature comparisons are dependent on approximately similar positions of the face—a problem the author encountered in investigating a reputed deathbed portrait of Abraham Lincoln. The photographer who produced the image for the carte de visite had stood at the foot of the bed and so looked, literally, up the bearded man's nose. Not surprisingly, this view was unlike that of any known photograph of Lincoln.

What was needed was a creative approach: a means of effecting a comparison of the features in the questioned carte photograph with those of the assassinated president. While a statue could have been photographed from the unusual view, the objection could be raised that such a representation was only an artist's conception. Finally, the existence of two actual life masks of Lincoln was recalled, along with the fact that a copy of one was in a local museum. Permission was readily granted for it to be removed from its display case for study, and photographer Robert H. van Outer was able to shoot it from the requisite angle. He then made a print of the mask beside an enlargement from the questioned photo. It thus became easy to see that the features—the angle of the ear, the shape of the nose, and so on—were entirely incompatible.[55]

A different approach was taken by experts who wished to compare the

Figure 4.11. This Nazi SS training camp identification card bears incriminating photograph and name of Ivan (now John) Demjanjuk.

features of accused Nazi war criminal Ivan "John" Demjanjuk with those of a photograph on a Nazi SS training camp identification card (Figures 4.11-4.13). The card was, in fact, filled in with the name "Demjanjuk/Ivan," and it bore the former Ukrainian's date of birth, physical description, and so forth. Nevertheless, Demjanjuk insisted, "I'm innocent man!" and his defenders suggested the card was a postwar, Soviet KGB forgery, made so that "at a later date" the Soviets could "seriously embarrass Israel"[56] (as if they would not seriously embarrass themselves in the process).

Identification experts employed a variety of techniques, one being a fascinating videotape produced for the Israeli prosecution. The videotape recorded Demjanjuk in his prison cell. From this motion picture, anthropologist and anatomy professor Patricia Smith had selected a still frame that captured Demjanjuk's face in the same position as the face in the questioned 1942 photograph. This enabled her to perform various superimpositions between the two images. The video is described in a book on the trial:

It was played on three monitors: one to the court, one to the defense, and one to the spectators. The entire room sat silent, entranced, during the seven-minute film.
Demjanjuk is first seen in his orange prison garb, standing in the Ayalon Prison yard. He is smiling, and squinting at the light in his eyes. The camera freezes and the superimposition begins: half his face now, half the Trawniki photo.

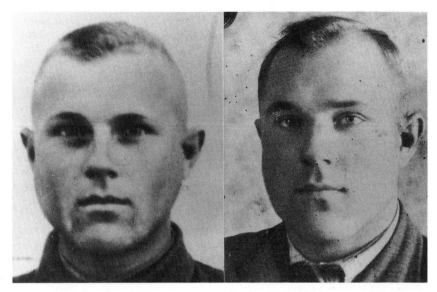

Figure 4.12. The photograph from the SS identity card (*left*) matches that from a 1947 driver's license (*right*) issued to Demjanjuk, although the face has become less muscular and the hairline has receded over the years.

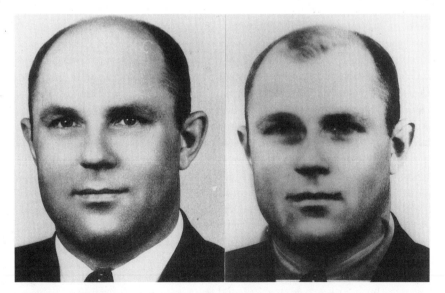

Figure 4.13. Photograph of John Demjanjuk from his 1958 naturalization certificate (*left*) is compared with his photo from the SS identification card by overlaying transparencies (*right*). Note the strong resemblance to the interim (1947) photograph from the driver's license (figure 4.12). (Overlay photo by forensic analyst John F. Fischer.)

Like a magic wand waving away the years, one face slowly faded into the other as each detail—from the tip of the ear through the crease of the nose, the indent in the chin—matched up.

The screen then performed selective impositions: just the eyes . . . just the mouth. The 1942 photo had more hair; Demjanjuk's face was now fatter, and the skin sagged, he had little neck—but still one saw the complete similarity between the two.

The expert narrated:

"Continuing down the face, you can see the exact superimposition," Smith said, "the exact continuation of the position and line of the earlobes. And on the face itself the position, shape, direction, inclination, every detail on the nose and upper lip, are identical. . . . In other words," Smith said, "the identity of morphological features, the identity of the distance between the morphological features, is identical. . . . I was asked what was the statistical probability of two individuals having identical morphological features . . . [It is] one in several hundred billion. . . . [Based on] all the examinations that I have carried out, my conclusion is that the 1942 photograph was, in fact, taken of the individual John Demjanjuk seen in the other photographs and seen in the video today." [57]

Earlier, Smith had explained the results of another analysis she had conducted concerning the identification card photo. She identified eleven individual features on the human face that could easily be identified as landmarks on a photograph. These landmarks were measured on several sets of photographs of identical twins to establish the degree of variation between two individuals who are, genetically, the most alike that two different persons can be. She then applied the same procedure to two pictures that Demjanjuk acknowledged as genuinely depicting him, as well as to the questioned photograph. A table was used to illustrate the results: the mean difference between a known Demjanjuk photo and the identification card photograph was significantly less than that of even the closest pair of twins. Smith concluded that not only were Demjanjuk and the man in the 1942 photo more alike than even identical twins, but indeed, she testified, "There can be no shadow of a doubt that we are dealing with the same individual." [58]

I was asked by the family of Demjanjuk—who received a sentence of death—to review the evidence against him and did so in collaboration with forensic analyst John F. Fischer. Enlargements of two acknowledged photographs of the convicted man, together with a blowup of the ID card picture, were sent to five specialists. The first three—a police commander and a detective (both with experience in facial feature comparisons) plus a professional portrait artist—concluded that the various details of the features, as well as their relationship to each other demonstrated that the pictures all represented the same man. [59]

The fourth expert, Dr. Virginia Smith, is an anthropologist with expertise in reconstructing faces from human skulls. She stated:

The soft tissue configuration of the face and ears, and the progressive pattern baldness lead me to conclude that the three photographs represent the same individual. This opinion, however, is made without the more conclusive comparison of the hard tissue.

The faces represented in these photographs could conform to a single skull structure. This structure is characterized by heavy brow development that is aligned in the same manner with the nasal bones in all of the photographs. All photographs show broad zygomatic arches, and a slightly higher right orbital arch. The right orbit is also slightly larger in all photographs.[60]

This evidence of distinctively similar bone structure exhibited in the questioned and known photographs is particularly significant. Taken as a whole, the photographic evidence alone demonstrates that whether John Demjanjuk is "Ivan the Terrible" of one death camp, or "Ivan the Less Terrible" of another,[61] it is unquestionably his photograph on the incriminating SS identification card—a card that ties him to a training facility for extermination camp guards.

The fifth expert—in contrast to the variety of approaches taken by the other four, as well as by the approaches in some of the other cases we have considered—studied only a single feature. As we shall see, the shape of the external ear is so distinctive that it often serves as the sole means of making a conclusive identification. It is therefore deserving of a full, separate discussion, which we take up next.

Ear identification. In the question of a "second Oswald" discussed earlier, the House Select Committee's panel of photographic experts and forensic anthropologists wrote: "In addition to the analysis of facial indices described above, other facial features were compared. For example, in the three profile views, the angle of the nasal bridge in relation to the face was 37å. *The ears are relatively distinctive in shape and are strikingly similar in all photographs where they can be examined.*"[62] (Emphasis added.)

Although brief, the reference to the "strikingly similar" ears is significant and serves to introduce a means of identifying individuals from their photographs that has proved decisive in many important cases. Long ago, Bertillon—the identification pioneer—recognized the potential of the ear in identifying criminals. As one textbook on criminal investigation states: "The ears constitute the most characteristic part of the body next to the patterns of the friction ridges [fingerprints]. . . . In cases where an arrested person has to be identified by photograph they play a deciding role." For example:

An interesting case in which the ears were used for identification purposes was that of the false Grand Duchess Anastasia of Russia. Some years after World War I a woman, after an attempt at suicide in Berlin, Germany, declared herself to be a daughter of the murdered Czar Nicholas. She said she had escaped the execution of the Czar's family in Ekaterinburg, Siberia, had lost her memory as the result of a blow on the head, and after many adventures had finally come to Berlin. She had a superficial similarity to the real Anastasia, but Professor Bischoff, the head of the Scientific Police Institute at Lausanne, Switzerland, established her non-identity by means of the ears—by comparing profile photographs of the impostor and of the real Anastasia.[63]

Though this source states that ears "remain unaltered from birth until death," it is true that ears do grow with age, but the growth does not affect the comparison of the ears for purposes of identification.[64]

Jacques Penry, mentioned earlier in this chapter as the developer of the PHOTO-FIT method of producing composite pictures of suspects, is another who recognizes the importance of the ears to identification. He states: "Although as unique to every face as a fingerprint is unique to each person, the ears have been almost entirely ignored as a means of identification." He adds: "The ears of mankind in their infinite permutations and combinations of angle, thickness of rim, length, width, position on head, size and shape of lobe, if any, and many other smaller pattern factors . . . are such that *no two people* are likely to have ears which tally exactly in their detail any more than they are likely to have exactly matching fingerprints."

Penry continues: "Since the ear-pattern is unique to every person, *its importance in facial identification from photographs cannot be too greatly stressed*, especially in cases where a missing person with a doubtful fingerprint record (or none at all) has deliberately tried to alter his facial appearance" (emphasis added). He adds that "the ironic situation at present, as it has been for centuries, is that the ear shape, the only feature which can (apart from fingerprints) provide fundamental proof, remains virtually ignored while every other scrap of photographic evidence is microscopically scanned and debated." Finally, Penry concludes:

A selection of photographs may well reveal clear views of the ear which, when examined and compared, may decide whether any photographs of faces A, B, C, and D, et cetera—taken at various stages from infancy—are pictures positively of the same person. Such a decision could be conclusive even when time, hardship, illness or artifice have made changes in the face. . . . It may be hoped that at some time not far hence, methods of unraveling problems of identity—both of malefactors and innocent people—will take far more into account the enormous assistance the conclusive ear evidence can provide.[65]

In *The Crime Laboratory*, J.W. Osterburg likewise endorses the value of ear identification. Osterburg details an intriguing case in which, during the

routine dusting of a burgled safe for fingerprints, crime scene technicians discovered a latent ear print! Subsequently, the ears of five suspects were printed and one of them was positively identified as the safecracker when his ear configurations matched those of the imprint on the safe. Osterburg lists among his references the authoritative textbook by A.V. Iannarelli.[66]

Alfred Victor Iannarelli is a distinguished identification expert with decades of experience in law enforcement, including experience as a criminal investigator with the U.S. Army Reserves. Majoring in criminology at the University of California (Berkeley), he received a B.S. in police science and a subsequent law degree. Iannarelli has studied ear identification since 1949 and is the pioneer developer of a system of classification that is especially useful in allowing ear photographs to be filed systematically, and that is described in his authoritative and comprehensive textbook, *Ear Identification*.[67] The July 1964 issue of *Fingerprint and Identification Magazine* declared that Iannarelli's book is "the first one to put [the ear identification] technique on a scientific plane."

Over the years, Iannarelli has been involved in numerous important cases of identification such as those of Martin Borman, Lindbergh, and many others (including some which he is understandably "not at liberty to state"). In three major cases he has generously assisted me by utilizing his expertise in ear identification to provide decisive answers. A brief look at each will be instructive.

In the case of Oswald's alleged double, Iannarelli studied a variety of photographs that were acknowledged as Oswald's, notably his Marine Corps pictures, in comparison with those of the so-called "Dallas assassin." Iannarelli concluded "that the flesh lines of the Helix Rim, Lobule, Antihelix, Antitragus and Concha" (specific structures of the external ear) were "identical" for the Marine Oswald and the alleged double. He added: "My total interest in this case is to set the record straight and that there is no doubt that the individual arrested, photographed, and identified as Lee Harvey Oswald by the Dallas Police Dept. . . . for the investigation of President Kennedy's murder is indeed the deceased, Mr. Lee Harvey Oswald."[68]

In the Demjanjuk case, Iannarelli stated, "I have thoroughly examined all the photographs and transparencies utilizing my system of identification and have come to the conclusion that the ears on these photographs [the authenticated and the questioned one] are all of the same individual. In addition, it is my opinion that the photograph on the identification card is *not* a Soviet forgery, but indeed, that of Mr. Demjanjuk." He added: "My congratulations to the photographer who made the photographic enlargements of Demjanjuk; the contrast and details were excellent. Each photo clearly illustrates the anatomical structure of the subject's left ear permitting me to make the comparison and identification without any hesitation or

doubt. The protrusion of Demjanjuk's left ear in all the photographs was sufficiently pronounced and producing details of each ear image with sufficient contrast that it was not necessary to use the method I used in the Lindbergh identity case such as the Compute Image Enhancement process or the Sobel Edge Detection technique."[69]

The third case posed a different question, not of identity but of family relationship. This was the matter of the criminal look-alikes, Bill and Will West, discussed earlier in this chapter. Their uncanny resemblance at Leavenworth Penitentiary in 1903 prompted references to their being "as alike as twin brothers" although they were supposedly "unrelated." In fact, my investigation uncovered impressive evidence that they were in fact (as a fellow prisoner had insisted at the time) twin brothers. The evidence consisted of documents, genetic traits in their fingerprint patterns, and, of course, similar ear patterns.

I sent Iannarelli enlarged photographs of the two Wests, and he in turn further enlarged the right ear of each from their mug-photo profiles. Superimposing certain horizontal, vertical, and diagonal axes employed in his system of classification, Iannarelli concluded: "Your theory that [the Wests] were identical twins . . . is certainly correct. . . . I will say without a doubt, that the so-called 'West Brothers' in my opinion were related and identical twins." He enclosed "Standard Ear ID Cards with the ear photographs of both Wests" to "illustrate the anatomical classification of their ears in relation to each other."

Iannarelli also sent several reproductions of the ears of identical and fraternal twins and triplets for comparison. It was easy to see that, although "identical" siblings did not have precisely identical ears (the classifications were different in each case), they were markedly more alike than those termed "fraternal." The West ears possess, as Iannarelli has noted, the same exceedingly great degree of similarity as those of identical twins or any two identical triplets.

Iannarelli called attention to "the minute differences in the upper helix rim and anti-helix of Will compared to William. This of course may have taken place soon after the ears began to form during the embryological development stage. If through the classification of the external ear or fingerprints, the classifications were identical," Iannarelli explained, "then neither system would be infallible."[70]

From the "simple" quest to identify unattributed or questioned photographs of one's ancestors, to sensational international controversies like the "Oswald's double" matter or "Ivan the Terrible" case, challenging questions of identity are constantly being raised. The foregoing discussion should provide at least a basis for attempting to answer them.

Recommended Works

Byrne, Gregory. "Did Billy Really Die a Kid?" in "Random Samples" feature, *Science* 243 (February 3, 1989): 610. A brief treatment of the computer analysis of two photographs in a sensational questioned-identity case bearing on the legend of Billy the Kid.

Iannarelli, Alfred V. *Ear Identification*. Fremont, California: Paramont, 1989. A revised edition of Iannarelli's classic text, *The Iannarelli System of Ear Identification*, the definitive textbook on the science of identifying individuals by the patterns of their external ears.

Nickell, Joe. "Double Trouble: Synchronicity and the Two Will Wests," chapter 6 of Joe Nickell with John F. Fischer, *Secrets of the Supernatural*. Buffalo, N.Y.: Prometheus Books, 1988. An investigation of the 1903 case of the famous criminal look-alikes—termed "one of the strangest coincidences in all history"—which helped promote the use of fingerprinting in America; includes analysis of the facial features from the "mug" photos, notably the patterns of the men's ears.

Penry, Jacques. *Looking at Faces and Remembering Them: A Guide to Facial Identification*. London: Elek Books, 1971. A profusely illustrated book on facial topography, based on Penry's "PHOTO-FIT" system of producing composite pictures of suspects.

Soderman, Henry, and John J. O'Connell. *Modern Criminal Investigation*. New York: Funk and Wagnalls, 1952. Discussion of various aspects of criminal investigation including (pp. 68-98) a concise history of identification.

5

INVESTIGATIVE PHOTOGRAPHY

Of the various sciences and skills applied in modern investigative work, that of photography is one of the most important, not only in forensic cases but also in historical, archaeological, art, and other investigations. For example, just as photography is used in police work to record evidence at a crime scene or help detect erasures on an altered check, the historian may use it to document and illustrate historical personages and places or to study the writing on an old manuscript. Similarly, the archaeologist might employ photography at a "dig" to record an artifact in its exact position before removing it, or as an aid in reconstructing missing portions of an Egyptian fresco painting, or even in conducting aerial surveys of ancient fortifications. The art specialist might examine a "medieval" triptych with X-ray photography to detect the presence of modern nails, or use infrared photographs to discover a painter's under-sketching technique, or simply use ordinary photos to provide an accurate visual description of artworks so they can be sought after a theft. Similar investigatory work may be carried out in other fields as well. Although this chapter focuses primarily on forensic matters (with occasional discussions of concerns in the other sciences and in the humanities), by extension the various procedures and techniques may be suitably adapted to many other investigative purposes. As we shall see, photography's capacity for documenting evidence and its potential in actually uncovering some types of evidence make it an indispensable tool for any detective.

Photographing Evidence

Because various factors—film, exposure time, filters, developers, and so forth—can affect the accuracy with which a photograph depicts its subject, a police-science text states:

All of these considerations point to the need for police photographers who are highly skilled in their field and who have a thorough understanding of cameras, lenses, light-sensitive materials, processing chemicals and the like. In the final analysis, however, "police photography" is not a branch of photography which requires extensive training; any skilled professional photographer or advanced amateur can do police photography work once he has been instructed in its special requirements. In fact, amateur photographers often know as much about it as the "pros" and are distinguished from them only in that their equipment is probably less costly and photography is not their occupation.[1]

The following discussion of photographing evidence is divided into crime-scene photographs, photography of physical evidence, and photo-macrography and photomicrography.

Crime-scene photographs. In police work, second in importance only to identification photos (treated in the previous chapter) is that class of pictures known as crime-scene photographs. According to a police-science text: "Photographs of this type include any picture taken at or about the scene of a criminal offense, such as murder, burglary, robbery, etc. Very similar in nature, although they cannot be called true crime scene photographs, are those taken at traffic accidents or of bodies in the morgue."[2]

All such photographs may simply be termed "investigative photographs."[3] According to the textbook *Scientific Police Investigation*:

The extensive use of photographs of crime scenes permits one to present, in pictorial form, all of the facts and physical circumstances of a case; it aids in preserving available evidence; it permits the consideration of certain types of evidence that because of their size or form cannot be brought into court easily; it permits reconstruction of past events at some later date; and generally it assists in accurately revealing the conditions prevailing at a past event. In addition, a good photographic record also reveals physical evidence that might otherwise be easily overlooked and constitutes an excellent refresher for the investigator when he must testify in court about some event that happened months earlier.[4]

As an illustration of many of these points, a "suicide" I was commissioned to reinvestigate for a bereaved family was most likely an accident based in part on a study of the crime-scene photographs. The deceased was found dead in his apartment, lying at the foot of the stairs. He had been shot through the head, the bullet traversing the skull at a steeply *downward* angle but entering the wall, about mid-point of the stairway, at a sharply *upward* angle. Blood spatters recorded in the several color photographs enabled a forensic blood-pattern analyst to reconstruct the victim's position when he was shot, a position consistent with his having fallen headfirst down the stairs.

In addition, the photographs yielded clues that had previously been overlooked, such as one of the victim's shoes being untied, thus providing a

means by which he could have been caused to fall, and the fact that he was wearing a cap when shot, confirming, as he had just said on the phone to his mother, that he was immediately leaving for work. (His job required that he handle large sums of money, hence the loaded automatic pistol he took to work each day.)

One deficiency of the crime-scene photos should be noted: their failure to illustrate the angle of trajectory into the wall. Fortunately, the family's astute attorney arrived at the scene just before the landlord was to have the bullet hole repaired. He placed a pencil in the hole to illustrate the angle the bullet had traveled, then extended the trajectory with a yardstick (which also established scale). A professional photographer made suitable pictures, and police detectives subsequently confirmed the relative accuracy of the demonstration. These photographs, together with the crime-scene photos, served as a basis for a reconstruction of the probable accident, which supplemented a "psychological autopsy" and other evidence. This resulted in the state medical examiner recommending that suicide be withdrawn as the probable cause of death.[5]

To be effective, crime-scene photographs should meet several basic criteria. First, since time is of the essence, photographs should be made immediately—before other stages of the investigation proceed. Prior to anything being touched or moved, therefore, photographs should be taken of the entire area, viewed from all possible angles, together with close-ups of anything that could potentially have a bearing on solving the crime. "As there are situations in which the object of interest undergoes significant change with the passage of time," cautions one criminal investigation text, "photographic equipment must be in a constant state of readiness."[6]

Second, proper views should be considered. The camera position used for each exposure should be recorded on the crime-scene sketch or in the report made from on-site notes. To be as comprehensive and effective as possible, photographs should be taken so that they constitute *overlapping* segments that flow in one direction around the room or other area. People should not appear in the photographs, and, most important, "proper photographic perspective" must be maintained, that is, care must be taken that distortions do not reduce or destroy a photograph's evidentiary value.[7]

Third, some courts object to any extraneous items—such as a paper arrow or even a ruler for scale—being present in crime-scene photographs, as they are thought to constitute "modification" of the scene. Thus, most authorities recommend taking pictures both with and without such aids.[8] States one authority, "It is always better, therefore, to make more photographs than are though to be needed; the cost involved is relatively slight and once the scene is disturbed it may be impossible to go back and take additional pictures."[9]

Taking as an example a homicide committed in a house, the following would represent the necessary photographs that should be taken (according to the textbook *Criminal Investigation*):

1. The line of approach to, and flight from, the scene.

2. Significant adjacent areas, such as the yard of the house in which the homicide occurred.

3. Close-up photographs of the entrance and exit to the house used by the suspect or those most likely to have been used if these are not obvious.

4. A general scenario photograph showing the location of the body and its position in relation to the room in which it was found.

5. At least two photographs of the body, at 90-degree angles to each other, with the camera positioned as high as possible, pointing downward toward the body.

6. As many close-ups of the body as needed to show wounds or injuries, weapons lying near the body, and the immediate surroundings.

7. The area underneath the body and under each item of evidence immediately after its removal, if there is any mark, stain, or other apparent alteration produced by the presence of the body or evidence.

8. All blood stains, preferably in color film.

9. All latent fingerprints before they are lifted and the weapon on which the prints were found, showing its relationship to the general surroundings. Latent fingerprints likely to be destroyed by lifting always must be photographed, even when it is not standard practice to shoot all fingerprints before handling.[10]

In the case of buried bodies, any evidentiary item discovered en route to the site—such as tire tracks or articles of clothing—should be photographed *in situ* (in their original place). After photographing the site, investigators should also make drawings or maps to show both plane (top) and elevation (side) views so that any items found can be located as to horizontal placement and depth. (A compass, plumb bob, string and string level, protractor, ruler, and drawing board will be needed, or, if their use is not immediately apparent, the services of a surveyor should be obtained.) With the use of stakes and string, a grid is superimposed on the site (usually oriented to north). Next, a scale drawing is made so that the location of any object encountered in digging, such as a weapon, button, cigarette pack, or other item, can be located in the corresponding square of the drawing. Smaller grids can be used to subdivide a given square when small objects are discovered so that the position can be located more exactly. One of the two dimensions of the plan (plane) view is used as the horizontal dimension in the elevation view, and depth is naturally indicated (in the same grid increments) for the vertical dimension.

Careful removal of the soil should be made in even layers of about four to

six inches, using a hand-trowel or flat-bladed spade. As dirt is removed it should be sifted, first through a quarter-inch-mesh screen followed by sifting through ordinary window screening. Any item that is discovered *in situ* should be documented with photographs—both with ruler and north indicator, and without. Items found on the screens should be photographed there (with scale of course but not north indicator); they should never be returned to the excavation for photographing, as that would constitute false documentation.

When the body is recovered with tissue remaining on it, the forensic pathologist may make a preliminary examination as soon as photographs are made. The remains are then placed on a clean sheet, the edges of which are then folded over, and the remains are placed in a body bag or container for removal from the site. All evidence is separately marked for proper identification and then carefully packaged, being handled in awareness of the fact that items may still bear latent fingerprints.[11]

Archaeological excavation is comparable to the location and removal of a buried body. The same basic procedure—involving grid and scale drawing, slow removal of soil with sifting of same, photographic documentation, and so forth—is followed at an archaeological "dig." (For more information see Maurice Robbins with Mary B. Irving, *The Amateur Archaeologist's Handbook.*)[12]

Photography of physical evidence. Before they are removed from the crime scene, items of evidence, such as a murder weapon or a blood stain, should be photographed first at close range (to show the object clearly) and then at a distance sufficient to place the object in proper context. Some items of evidence require special photographic procedures. For example, fingerprints are usually photographed with a special fingerprint camera, and trace evidence (a hair or fiber, for example) is photographed through a microscope.

For photographing evidence removed from a scene, a photographic copying stand will facilitate taking pictures of other photographs, documents, and small objects of various types. While special copying units are available, simple copying stands (or copying tables) are more economical, and they can even be improvised. One needs only obtain a tripod for stabilizing the camera, a drawing board on which to mount the picture to be copied or a table on which to stand or rest an object, and two photoflood lamps in reflectors. If available, a close-up lens should be used. The tripod should be set up so that the camera is aimed at right angles to the object, the photofloods being set on either side of the camera at approximately a 45-degree angle to the center of the object, and each equally distant from it. The subject should be studied from the camera's point of view, and the object should be fully and evenly lighted, the lights being shifted until any unwanted reflections are eliminated. A professional gives these technical tips: "In copying line drawings and prints, develop your film for maximum contrast. Use a

slow pan film and give it full development. Photographs or black-and-white pictures are best copied with fine-grain panchromatic film. Underdevelop slightly to keep contrast down. Use fine-grain pan film for color pictures, and correct for redness of photofloods with yellow-green filter on cameras."[13] (The use of special lighting techniques—such as oblique lighting, and ultraviolet, infrared, and laser illumination—will be treated later in this chapter under "Spectral Techniques.")

As an example of how photographs of evidence are used, consider the case of a burglar who inadvertently left an imprint of his Florsheim-brand shoe heel on a sheet of carbon paper in a burglarized building. When a suspect was apprehended in the case and it was discovered he was wearing similar Florsheim shoes, an inked imprint was made of his rubber heels. A forensic analyst was immediately able to match one of these to the burglar's imprint by means of various distinctive features, such as numerous nicks and pock marks, that were common to both—some thirty individualized characteristics in all. Photographic enlargements of the two imprints were then made on which numbered lines were drawn to the various matching features on each photo, thus demonstrating the similarity and consequently the suspect's guilt in a graphic manner that any jury could comprehend.[14]

As to fingerprints, they are first developed—by trained technicians—from their usual "latent" (invisible) state and are then photographed. Powders are still commonly used for developing fingerprints on nonporous surfaces, white or gray being used for prints on a dark surface, and black powder being employed for fingerprints on light-colored backgrounds. Fingerprints on paper are usually developed by spraying with a solution of ninhydrin with ethyl alcohol (0.2 to 0.4 percent). Commercial aerosol sprays of ninhydrin are available from forensic supply houses.[15]

Fingerprints developed at the crime scene should always be photographed in place, both close up and at a sufficient distance to show their placement—relative to a door casing, for example—before they are "lifted" (removed with transparent tape and transferred to special cards or the like for preservation). Photographs of fingerprints are usually made with a 1:1 camera, one that records the fingerprint's image on the negative the same size as the actual print. Because such a camera has a fixed focus, it can only be used to photograph such flat features as fingerprints, signatures, stamps, coins, or the like, but it is also extremely easy to use. After the shutter speed and lens aperture have been set, the open end of the camera is placed directly over the fingerprint (so that the camera is flush with the surface bearing the print) and the exposure button is depressed, thus activating internal flash lamps and then tripping the shutter.[16] In lieu of such a fingerprint camera, fingerprints can be photographed with an ordinary camera having a close-up lens and being steadied by a tripod or copying stand.

Fingerprints have played a crucial role in many sensational criminal cases, not the least of which was the 1968 assassination of Dr. Martin Luther King. The fatal shot—which struck King as he stood on the balcony outside his room at the Lorraine Hotel in Memphis—was fired from the window of a rooming house bathroom. The killer left a palmprint on the bathroom wall and his fingerprints on the rifle abandoned on a nearby sidewalk. The prints—suitably developed and photographed—were found to match those of an escaped convict named James Earl Ray.[17]

Photomacrography and photomicrography. Two photographic processes are used to make enlargements of minute details of evidence: fine striations in a crowbar mark on a "jimmied" door, for example, or careful retouching of pen strokes in a forged document. Simply enlarging a photograph, the negative of which may lack the resolution to have captured fine detail, may not be successful. Instead forensic analysts either use an appropriate lens to produce an enlarged image on the negative, a process called photomacrography, or, where greater magnification is required, make a photograph through a microscope, a process called photomicrography.[18]

Photomacrography is commonly used for such purposes as recording a serial number or other detail of a firearm; comparing a tool's broken-off portion found at the scene of a burglary with the remainder of the tool; photographing a forged endorsement on a bank check, or a seal or other embossment on a questioned document; or making enlargements of other small evidential items or features.[19]

Photomicrography is used where magnification greater than 10X (ten diameters) is required (and may extend up to 1200 diameters). Examples include photographing hair or fiber samples, blood, dust, particles of glass or similar substances, or other types of "trace" evidence requiring microscopic examination. For such photography a standard light microscope is fitted with a camera (often by means of an adapter that permits a 35 mm or Polaroid camera to be used). To prevent movement, a cable release (available at any camera store) is used to trip the shutter. (Photomicrography should not be confused with microphotography, which produces photos with images much smaller than actual size, a process that results in microfilm and microfiche, familiar to any library researcher, and in the "microdot." Perfected by the Nazis, a microdot is a page of text reduced to the size of a period—indeed concealed in letters *as* periods, or hidden under pencil erasers, and in other places.)[20]

Photomicrography may also be used in a process called "comparative microscopy" to attempt to match fine striations on an evidence bullet with those on a test bullet (fired from a suspect's firearm), or to compare striations in a tool mark from the scene of a crime with one made on a soft lead

"test plate" in the laboratory, or for similar purposes. To check for matching, a special comparison microscope is used. This is actually two microscopes connected to a single eyepiece so that a split image is produced, yielding half of the item of evidence and half of the test item (for example, with bullets, the front end of one and the rear end of the other). If alignment of the various tiny striations is effected between the two images, thus indicating a match, the instrument's camera is used to make a photomicrograph of the twofold image.[21]

Such a procedure is termed *firearms identification*, not *ballistics* as is used in so many crime dramas, a term that refers to the study of the motion and impact of projectiles. Without a comparison microscope the process would be more troublesome, but many firearms identifications have been accepted by the courts when only a camera was used. Photomacrographs are made of portions of the evidence and test bullets. The comparison is made by attempting to align the striations in the same-size photographs.[22]

Spectral Techniques

By taking advantage of the different properties of the visible spectrum—as well as those of the invisible—the investigator-photographer greatly augments his or her ability to enhance certain features or develop those that might otherwise lie unnoticed.

Visible light is simply one portion of what is known as the electromagnetic spectrum (that is, the range of all known radiation). It is the portion that normally stimulates the sense of sight, which perceives the continuous range of frequencies and wavelengths as a gradation in color: from red, through orange, yellow, yellow-green, green, blue-green, and blue to violet. Beyond this range—that is, beyond the visible red at one end and violet at the other—are invisible portions of the spectrum known respectively as infrared and ultraviolet radiation.

The special properties of these various bands of the spectrum are utilized by scientific investigators in interesting and often dramatic ways. These are described in the following discussions of visible light, ultraviolet illumination, infrared radiation, and laser technology—all treated as adjuncts to investigative photography.

Visible light. States one instruction manual in forensic photography, "Illumination in all photography must be arranged with the utmost care, for it is the key to successful photography."[23]

One special technique is oblique lighting. It is conducted with light striking a surface from one side at a low angle. This technique takes advantage

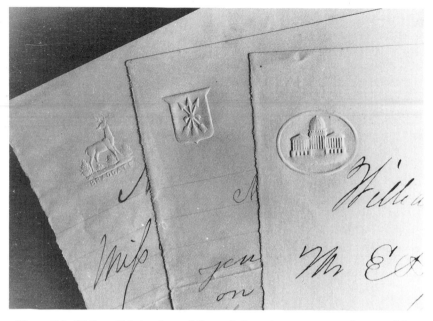

Figure 5.1. Oblique lighting is used for such forensic purposes as photographing embossments on documents, such as the stationers' crests on these nineteenth-century letters.

of the shadows that are thus produced by any surface irregularities.[24] Oblique lighting is commonly used in questioned-document examinations to reveal erasures due to the roughening of the surface that has resulted. "Indented writing" is also discovered and deciphered in this way. The indenting occurs when writing is done on a sheet placed over another, leaving traces of the latter that may be enhanced by oblique-light photography. Such writings— discovered in one instance, for example, on the lower sheet of a bookmaker's pad—represent an especially common document problem in police work.[25]

Oblique lighting may also be used for such forensic purposes as photographing fingerprints in plastic media (such as candle wax or putty), serial numbers on firearms, seals or other embossments on documents, striations on the surface of a bullet, or, indeed, any striations, scratches, impressions, indentations, embossments, or areas of roughness—anywhere there are surface irregularities or features in relief and/or recess.[26] (See Figure 5.1.)

Photographing such features may be accomplished by using a copy stand and illuminating one of the stand's two flanking lamps. However, in many cases (such as an entire sheet of typewriting indentations), a series of oblique-light photographs may be necessary, with the light being directed

from various angles and directions. Sometimes results are improved if the light is admitted from a very narrow slit.[27]

Transmitted light. In contrast to reflected lighting (normal lighting, from the front), transmitted lighting is illumination from behind the object, such as a document, so that light passes through the sheet of paper. Photography by transmitted light is used to record watermarks, as well as certain other features that may be present in antique handmade paper or early machine-made paper.[28] Forgers often pay little attention to the correct paper, as in the case of DeGibler, alias "Major Byron," who produced a forgery of a Lord Byron manuscript on paper that bore a date watermark reading "1834"— ten years after the celebrated poet's death![29]

Transmitted light will also reveal thin spots in paper caused by erasures as well as the opposite effect, opacity rather than translucency, caused by application of various types of "correction" materials, such as the white liquid used to correct typewriter errors. Photography by transmitted light may also be used to superimpose one signature over another to demonstrate that one has been traced from the other.[30] Photography by transmitted light can easily be accomplished by placing whatever is to be so photographed over a simple light box.

Other photographic techniques. Additional options involve increasing or diminishing contrast (the tonal difference between a photograph's light and dark portions). The former may be accomplished by using special high-contrast film and/or printing paper and by using special filters. Conversely, contrast may be lessened at any stage of the photographic process. A means of selectively doing so is called "dodging" and is usually accomplished during the printing process. As the light of the enlarger projects the image from the negative onto the photographic paper to make a print, the photo technician typically passes a hand, paddle, or other object over the area to be lightened, thus briefly interrupting the flow of light and resulting in that area of the paper being slightly less exposed and therefore lighter.[31]

Filters may be used in a variety of ways to affect contrast. One use is to enhance handwriting, as for a courtroom exhibit. For instance, if the writing in question was on a green registration form, then a green filter would be used to subtract the background color and thus enhance the writing. Similarly, if a medieval parchment had yellowed with age, a yellow filter might prove effective in lightening it for a photograph.[32]

Ultraviolet illumination. The ultraviolet light is a simple and effective tool for the investigator. As one police-science text explains: "When ultraviolet

radiation strikes a surface it is absorbed by some substances and its energy transformed and radiated back in light of different colors. Thus, although the original ultraviolet is invisible, its effects on an object as observed in a dark room are distinctly visible. The object is then said to *fluoresce.* This interesting phenomenon is useful to the investigator who may in this manner detect stains on a garment, alterations on a check, or secret writing in a letter." [33]

In the art world, ultraviolet light is used in some cases of questioned sculptures and other artifacts to detect a false patina, as in the case of a bronze Chinese vessel. It was genuinely of the eleventh century B.C. but had been severely damaged and crudely repaired, with the repairs disguised by the false patina. [34] Ultraviolet light is also used to detect retouching and other alterations in paintings. [35]

Other uses of ultraviolet light are to develop invisible inks, such as used for secret writing or for some laundry marks; to locate certain stains, such as semen stains on a garment in a rape case; to differentiate between gems as well as between types of glass, as in a hit-and-run case; and to process fingerprints on a distracting, multicolored surface, by employing a fluorescent powder, a technique that, when photographed, yields bright prints on a dark background. [36]

Photographing with ultraviolet light consists basically of placing the object under suitable ultraviolet illumination (such as a Hanovia quartz lamp) in a dark room, then photographing the fluorescence (using a fast panchromatic film and preferably a Wratten 2A filter to remove an excess of blue light). Exposures may range from twenty seconds to thirty minutes, a series of prior test exposures being recommended. [37]

Infrared radiation. Infrared rays lie at the opposite end of the visible spectrum from ultraviolet radiation. Whereas ultraviolet rays have wavelengths shorter than those of light, infrared wavelengths are longer than light rays and so are not detected by the eye. Infrared radiation does not offer the simplicity of use, convenience, and low economy of ultraviolet light. To be used for investigative purposes, infrared rays must not only be emitted by a particular source but the effects must either be viewed by special optical means (a special infrared viewing device) or be photographed by means of a special filter and film (discussed presently).

Despite these practical limitations, infrared illumination offers a panoply of remarkable investigative possibilities. One important area is investigative work with paintings. For instance, one painting was believed to have an inscription that was overpainted by the artist. Indeed, "infrared photography provided conclusive information that proved the existence of the legend, indicated the ground upon which it was painted, and thus justified uncovering the text." [38]

In addition, infrared photography has been used to reveal under-sketching in paintings and to detect forgeries. It has also been used to detect restoration on tapestries and to reveal designs on pottery and other artifacts that have become invisible over time.[39] *Aerial* infrared photography has also been used by archaeologists to detect certain land scars that are indicative of ancient village sites but that cannot be seen by the naked eye or revealed by ordinary photography.[40] "Museum artifacts are often examined with infra-red radiation with extremely rewarding results. In one case, infrared rays penetrated the patina and salt encrustations on a stone fragment to reveal a carbon-ink inscription. In another, illegible stenciled markings on a Civil War canteen's fabric cover were revealed by a pair of photographic tech-niques: infrared-reflection (in which the object is photographed in reflected infrared illumination) and infrared-emission (in which the object is caused to *emit* infrared radiation and to expose the film)." In addition, "badly dis-colored, faded, or dirt-covered photographs, daguerreotypes, engravings, drawings, maps, and other such items, have been successfully photographed by infrared."[41]

According to O'Hara's *Fundamentals of Criminal Investigation*, "The most fruitful field to which infrared can be applied is that of documentary evi-dence."[42] Specific applications include differentiating types of ink that ap-pear the same to the eye; recovering erased writing; and detecting secret writing; in certain cases (when the paper is transparent to infrared and the ink opaque to it) reading unopened letters; deciphering writing on charred documents; determining the presence of gunpowder marks surrounding a bullet hole; and detecting and differentiating stains. One interesting chal-lenge was provided by Charles Dickens's letters, some of which had passages that had been inked out by family members. However, infrared photography penetrated the obliterations and enabled Dickens scholars to read the pas-sages. These contained references to "Nelly" and thus confirmed what had long been rumored: that Dickens had kept a young mistress named Ellen Ternan.[43]

For infrared photography, an ordinary, good-quality camera is loaded *in the dark* with a high-speed infrared film (which, since it must be kept refrigerated, is allowed about two hours to reach room temperature, or if kept in a freezer, about four to six hours). To block unwanted light rays a special filter is used (commonly a Kodak Wratten Filter No. 87), and, for lighting, tungsten photoflood lamps are used (in the copy-stand holders). Focus is critical: After the camera is focused without the filter, the filter is affixed over the lens and the camera is refocused. (Most lenses have a red dot on the focusing scale to indicate the average recommended correction for infrared photography. Consult Kodak's Applied Infrared Photography for additional information.)[44] (See Figure 5.2.)

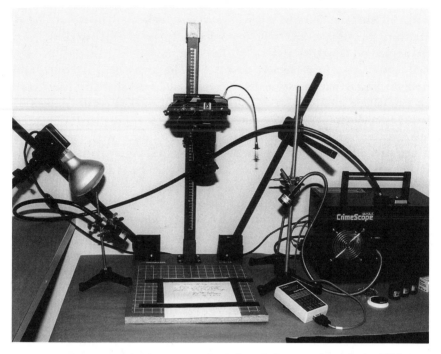

Figure 5.2. A crime laboratory setup for infrared photography, using a "Crime-Scope" infrared output (*right*) and a Nikon camera equipped with an infrared lens and filter. (Photo, courtesy of forensic analyst John F. Fischer, by Bill Schulz.)

Laser technology. Beginning at the turn of the century as a science-fiction notion—a powerful light beam, capable of piercing iron—laser technology was further envisioned by Albert Einstein. However, the first working model of the device was not built until 1960 when it was assembled from a flash lamp and synthetic-ruby rod. Termed the *laser*—an acronym for *l*ight *a*mplification by *s*timulated *e*mission of *r*adiation—it produces what is termed "coherent" light: Unlike ordinary light, which radiates in all directions, that from a laser is beamed so that all its waves are parallel, as well as in phase with one another.[45]

Because such electronic light-amplification may extend from the invisible ultraviolet range through the visible spectrum to the again invisible infrared band, the laser is an extremely utilitarian instrument. Existing in a variety of types that range from large laboratory models to portable instruments, they nevertheless have some practical shortcomings: comparatively high cost and safety concerns (requiring the user to wear protective goggles in certain applications). Still they are employed in an impressive variety of

uses that range from mundane chores, such as drilling metal and scanning product codes at supermarkets, to more exotic functions, such as cleaning art masterpieces and performing delicate eye surgery.[46]

Forensic applications include the matching or reconstruction of broken glass fragments, the detection and enhancement of stains from body fluids (including blood traces), identification of various dyes and drugs, and other uses, including the detection of latent fingerprints. For example, at the scene of a triple slaying in Aurora, Colorado, in 1984, a portable laser picked up latent prints that had been missed with conventional fingerprint-development methods. Employed in various spectroscope techniques, laser technology is also increasingly helping to identify the elemental composition of tiny specimens, such as a speck of paint.[47]

The laser has also proved effective in many document cases, including one involving an altered lottery ticket. A person had submitted the ticket and claimed a prize for matching the final three digits in the winning number. However, the ticket's apparent last three digits had been very heavily circled with a ballpoint pen, so heavily as to raise suspicions that the actual last digit had been deliberately obscured. When visual examination and even an ordinary laser inspection using special filter goggles proved unsuccessful, the argon laser was employed in conjunction with a camera fitted with a special filter, and an infrared luminescence recording was made on high-speed infrared film. The photograph revealed that there was indeed a final digit (a "4") under the heavy ink circle.[48]

Laser images can be viewed on video monitors and Polaroid photographs taken of the images as they appear on the screen. For additional information, the technical and scientific literature should be consulted.[49]

Surreptitious Photography

The development of the so-called "detective" camera by Thomas Bola in 1881 (the box-type camera mentioned in chapter two, capable of being hidden in parcels and hats) foreshadowed certain modern forms of surreptitious photography.

The early 1880s saw diminutive models that were disguised as opera glasses or concealed in walking-stick handles. The Stirn "secret" camera of ca. 1886 (which rather resembles a Boy Scout canteen) was worn suspended from the neck by a cord and hidden under the waistcoat, the lens protruding through a buttonhole.[50] According to Brian Coe, "To modern eyes few were convincingly disguised but they were sufficiently unlike the traditional stand camera to fool the Victorian non-photographer."[51] Most such cameras did

Figure 5.3. A nineteenth-century "photo detective" surveillance camera caught thieves on photographic plates.

Figure 5.4. Details of the photo detective camera apparatus.

(Illustrations from the 1898 text *Magic: Stage Illusions and Scientific Diversions, Including Trick Photography*.)

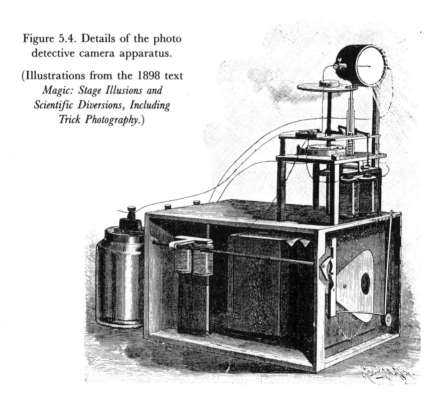

not work very well, the glass-plate negative representing one cumbersome feature.

As discussed in chapter two, George Eastman's roll-film camera made photography practical for the average person, and it also paved the way for development of today's "spy" cameras—not only the genuinely miniaturized, sophisticated devices intended for espionage, such as a camera disguised as a match box used by American Office of Strategic Services (OSS) forces in World War II, but also popular novelty models, including a 110-style camera disguised as a pocket dictionary and featuring both close-up and wide-angle lenses.[52]

Miniaturization is not always necessary for surveillance cameras, since those equipped with long-range-lenses—some with pistol grip and trigger action—can take advantage of distance. During my employment as a private investigator, I used such a camera—and the concealment of a row of shrubbery at the edge of a parking lot—to shoot surveillance film of a man making fraudulent injury claims. Film of the man bent over, working on his car, effectively disposed of his "back injury" claim, and further footage of him running up a flight of exterior stairs, two steps at a time, dispelled the allegation of an "injured leg."

Such cameras can be used for surveillance of places—for example, one where an illegal activity such as gambling is suspected of occurring—to record the comings and goings of individuals. A "4 x 5 still camera with telephoto lens" is also recommended.[53] For night viewing, a "Snooperscope" (infrared viewer) is commonly used, and for photographing the scene, infrared photography is employed. A miniature night-vision "Pocketscope," small enough to be held in the palm of the hand, even "mounts directly to 35 mm SLR cameras and C-Mount CCTV [closed-circuit television] units."[54] Another available item is a "Mirrorscope Spy Lens" which allows the photographer "to point in one direction but photograph at a 90 degree right angle to the side.[55]

Fixed-position cameras, some with scanning action, are used for security in stores, plants, and other premises. They can be rigged to be activated—rather like a burglar alarm—upon entry of a thief. An early type of such camera, "an electro-photo detective thief catcher" (see Figures 5.3-5.4) was used in the nineteenth century. A modern version of this approach is the camera rigged with a tripwire placed across animal trails, used to make photos of wildlife, especially at nighttime. One common type of fixed-position camera is part of a closed-circuit television system that requires a security guard or store personnel to observe the surveilled scene on a monitor. Some surveillance cameras are extremely sophisticated, being small enough to be hidden in a light switch or disguised as an electric pencil sharpener.[56] Remote systems—with cameras mounted atop buildings and linked by laser

beams to monitors in a police station a mile away—have been used to detect criminal activity in a two-mile-square area around a university campus.[57]

Other cameras, like those commonly used in banks, make a videotape or film record of the scene—an important feature in the case of a robbery. Typically, to obtain maximum surveillance time for the amount of footage used, such cameras do not produce constant filming but instead make an exposure only every few moments. When photos of robbers taken by surveillance cameras are of poor quality, the images can usually be improved by computer enhancement.[58]

Sometimes a surveillance camera is placed behind a "two-way mirror" (a glass that appears as a mirror from the surveillance subject's vantage point, but which is transparent to observers—or a camera—on the opposite side). Such a setup was used during World War II when the Nazis forced a naturalized American citizen to serve as their contact person for the Duquesne spy ring. They threatened harm to the man's German mother if he refused to cooperate, but, in fact, he courageously worked as a double agent. Cooperating with the FBI, he held many conferences with the spies in a specially prepared room, outfitted not only with a two-way mirror but also a wall calendar and desk clock, placed so as to show in the photos and thus establish the date and time of each visit.[59]

Aerial surveillance represents another major type of surreptitious photography. It dates from 1862 when the Union Army made use of balloon photography (and telegraphy) to spy on enemy forces at the attack on Richmond. (Earlier, in May 1861, the Frenchman, Aime Laussedat, produced the first map based on measurements compiled from aerial photographs.)[60] Subsequently governments have routinely used aerial photographic surveillance as a security measure.

One of the most noteworthy incidents in this regard was the shooting down of a United States U-2 spy plane over the Soviet Union in 1960. Piloted by Francis Gary Powers, the plane was outfitted with expensive, automatic infrared cameras that were seeking photographic evidence of missile bases behind the Iron Curtain. Upon Powers's capture, the U.S. State Department employed the tactic of "plausible deniability" by maintaining that the incursion into Soviet air space was unintentional and claiming the plane was engaged in performing meteorological tests. "Unfortunately," according to one source, "when Powers was arrested the Russians had found that, apart from emergency food supplies, he had with him a flashlight, compasses, money in Russian, Italian and German currencies, a dagger, a pistol, gold coins and a silver dollar fitted with a needle containing a lethal dose of the poison curare." (Powers was exchanged for convicted Soviet spy Rudolf Abel in February 1962.)[61]

When spy planes proved too embarrassing in the wake of the U-2 inci-

dent, the United States began to rely on satellites with cameras that were capable of making detailed pictures of earthbound activities. In October 1962 the photographic evidence from the spy satellites sparked what has become known as "the Cuban missile crisis." President Kennedy announced that the Soviets were installing offensive missiles in Cuba and illustrated his message with photo blow-ups of missile launch stands and other facilities. Kennedy imposed a naval blockade of the island, whereupon, following a tense week in which the two super powers teetered on the brink of nuclear war, Soviet Premier Khrushchev yielded and agreed to remove the missiles.[62]

Of course tactics and techniques have been developed as counter-measures to surreptitious photography, including setting up X-ray beams at the gate of a plant engaged in producing classified items in order to fog any film concealed on employees.[63] And camouflage has been used since the advent of aerial reconnaissance to fool the eye—and the camera—of the enemy. For example, during World War II:

Large aircraft manufacturing plants and their environs were in some instances completely camouflaged by building decoys over these installations which included minute details down to decoy automobiles on the decoy streets, smoke coming out of chimneys and wash drying on the clothes line. Networks of streets were painted over the airstrips blending the otherwise conspicuous airstrips into the surrounding suburban housing pattern. An excellent example of this type of camouflage was executed at the Douglas Aircraft plant, Santa Monica, Calif. Coast defenses had their guns concealed effectively by quickly removable nets in some instances and in others by decoy houses which fell away instantly, exposing the gun ready for fire.[64]

As the foregoing discussion indicates, the use of surreptitious photography and the attempt to circumvent it have increased in innovative ways during the past; they seem certain to continue into the foreseeable future.

Legal Concerns

Photographs have been admitted as evidence in court cases since as early as 1859, but the question of the admissibility of color photos (although common from 1935) was not decided until 1943. At that time a court held that color photographs were admissible as evidence under the same legal rules that govern black-and-white pictures. Color slides projected on a screen have likewise been deemed admissible.[65]

Similarly, since they are generally considered to consist of a sequence of still photos, motion pictures have been admitted under the same rules of evidence, and, by extension, videotapes as well. (Videotape differs from motion pictures in that the image and sound, if any, are recorded on magnetic tape rather than on photographic film.)[66] With regard to sound movies,

those in which a magnetic tape or wire recorder is used *separately* to record sound, which is then *transferred* to the film strip, have been deemed inadmissible by a number of courts. That is because "tapes or wires that are prepared in this manner can be altered or cut almost without detection and certainly without affecting the visual portion of the film."[67] However, those sound movies in which the audio is recorded by what is termed *optical recording* (wherein a camera device transforms the audio into optical patterns which are directly recorded on the film) have been freely admitted by the court.[68]

Nevertheless, because all of these recording mechanisms are, after all, only representations of something and because they may be inadvertently distorted or even deliberately falsified in some way (as discussed in the following chapter), and for still other reasons, courts have understandably placed restrictions on their admissibility as evidence. Depending on the jurisdiction and other factors, courts may require photographs, slides, movies, and videotapes to meet certain criteria.

Overall, such evidence must fulfill the basic requirements of proper foundation, relevancy, and materiality. That is, the evidence should be introduced by the proper testimony as to its identity and accuracy; it must have a bearing on the issues in the case being tried; and, beyond being merely relevant, it should be of sufficient importance as to have a bearing on the outcome of the case.[69]

More specifically, each photograph should be provided with a complete notebook record supplying the following information (as listed in O'Hara) in the event it is requested in court:

1. Data to identify the photographs with the offense.
2. Data to identify the photographer.
3. Data to orient the camera position with the scene.
4. The date and hour when each photograph was taken.
5. Data reflecting light and weather conditions when each photograph was made, *f*/number and exposure.
6. Data reflecting the type and make of camera, film, and details regarding any special photographic equipment which was used.
7. Focal length of the lens.
8. Data regarding developing, printing, and any special laboratory techniques. This is usually furnished by the laboratory technician, but the investigator should be in a position to present the data and arrange for the appearance of the laboratory technician in court.
9. Data to reflect a complete chain of custody of the photographic film used.[70]

A similar record should be kept for any motion pictures.[71]

In addition, the photograph or film should be free from distortion.

That is, it should not misrepresent the object or scene that it purports to depict by any of the following: (1) incorrect point of view (one that obscures essential objects and inappropriately emphasizes others), (2) distorted perspective (misleading relationship of distances, caused, for instance, by improper relationship of the lens's focal length to the print-viewing distance), or (3) misrepresentation of tones (as by overexposure that may completely obscure some feature).[72]

Finally, the photograph or film should not unduly incite prejudice or sympathy on the part of jurors. For example, photographs—particularly color photographs—that show excessive blood and carnage or otherwise gruesome features may be deemed highly inflammatory and likely to unduly influence the passions of jurors. If the inflammatory potential is judged to outweigh the picture's evidential value, a court may rule the picture inadmissible.[73]

Perhaps it is worth noting that one famous piece of film footage—one scrutinized by legal experts and representing evidence in one of history's most famous crimes—may have failed this basic admissibility test. However, it was a case that never went to trial. It was the Kennedy assassination, and the film—graphically depicting the side of the youthful president's head being blown away—was made by an amateur, Dallas dress manufacturer Abraham Zapruder. If a brief digression may be made, it will illustrate how even such an amateur product, unintended as a forensic record, has served as a valuable—and yet controversial—piece of evidence.

Because the Zapruder film depicts the backward thrust of Kennedy's body in apparent response to the fatal shot (which is recorded striking his head at Zapruder film frame 312), some conspiracy theorists postulated that a second gunman fired from the front—from a position known as "the grassy knoll." In fact, as the film actually shows, the head first moved forward slightly, caused by the rearwardly striking bullet, then snapped backward, the result, the House Select Committee concluded, of "neurologic response" or "a propulsive effect" caused by the exploding skull, or both (or the acceleration of the presidential limousine, according to some[74]). Indeed a thorough and unbiased forensic review of the photographs and X-rays of the body established that the president's two wounds were both produced from the rear.[75]

Oswald fired three shots at Kennedy, one missing, another inflicting the neck wound (and also striking Governor Connally), and a third causing the fatal head wound. The Commission—using the known speed of Zapruder's Bell and Howell movie camera, 18.3 frames per second, to time the events—leaned to the theory that the shot that missed was the second of the three: "The possibility that the second shot missed is consistent with the

elapsed time between the two shots that hit their mark. From the timing evidenced by the Zapruder films, [sic] there was an interval of from 4.8 to 5.6 seconds between the shot which struck President Kennedy's neck (between frames 210 and 225) and the shot which struck his head at frame 313. Since a minimum of 2.3 seconds must elapse between shots, a bullet could have been fired from the rifle and missed during this interval." [76]

Warren Commission critics have refused to accept this scenario, but a reconstruction of the assassination by Jim Moore suggests a different possibility: that the missing shot was the *first* one fired, a theory that goes far to reconcile the forensic evidence, the time sequence, and other considerations, including Governor Connally's insistence that he was not struck by the first bullet but by the second. The issues are too complex to detail here, but the interested reader may study them in Moore's book, *A Conspiracy of One.*[77]

Would the Zapruder film have been admitted as evidence if Oswald had come to trial? Most likely it would have. Surely the import of the evidence far outweighs any inflammatory aspects, and indeed the issue recalls this excellent summary statement: "Because evidence can be anything having a bearing on the outcome of the case, the first rule of evidence provides that anything is admissible as evidence unless there is some rule which prohibits its admissibility." [78]

Even an admissible photograph or video, however, may still be challenged as to its veracity by opposing counsel in a court of law. One specialized technique for analyzing such images is called chronophotogrammetry. It is used for determining the time of day, and sometimes the date, a photograph or video was made. For example, a shadow cast on the ground from a telephone pole is—like a sundial—an indicator of the sun's azimuth, from which the time of day can be determined. In fact one study shows that the shading on a human face can be used—if the person's orientation is known—to determine time with an accuracy of one hour. According to Dr. James B. Hyzer, an engineering science consultant specializing in evidentiary video and photographic analysis, "Photographs or video sequences are commonly used to corroborate testimony that an individual was in a specific place at a critical time, or that certain objects were either present or absent before or after an accident occurred. In both of these examples, and many more, an essential element in validating the evidence is establishing 'beyond reasonable doubt' that the image was actually made at the time it is claimed to have been made." [79] The technique can also be used to determine whether or not a photograph or motion picture sequence has been falsified, and to determine the current sequence of recorded images so as "to better understand the chronology of an event." [80] Additional techniques for analyzing photographs will be given in the following chapters.

Recommended Works

Applied Infrared Photography. Rochester, New York: Eastman Kodak, 1972. Guide to the various applications and techniques of photography in the infrared region of the electromagnetic spectrum.

Fischer, John, and Joe Nickell. "Laser Light: Space-age Forensics," *Law Enforcement Technology*, September 1984, pp. 26-27. Introduction to laser technology applied to forensic analyses.

Hattersley, Ralph. *Beginner's Guide to Photography*, revised edition. New York: Doubleday/Dolphin, 1975. Introduction to the basics of still photography, from choosing a camera to conducting lighting experiments.

Hyzer, James B. "Chronophotogrammetry: Telling Time from Pictures," *PHOTO-Electronic Imaging*, February 1993, 40-43. An introduction to the specialized technique of analyzing photographic or video images to determine the time at which they were made.

Hyzer, William G. "Forensic Photography: An Overview," *PHOTO-Electronic Imaging*, February 1993, 16-17. Short article and table with brief descriptions of twenty-three photographic techniques used to provide evidence in legal cases, including (in addition to techniques covered in this chapter) holography (to portray objects in their true three-dimensional forms), high-speed cinematography (motion pictures recorded at extremely fast speeds, for example to show "deflection of a reciprocating saw blade"), in-water photography (to record evidence at bottom of rivers, lakes, harbors, etc.), photo-elastic recording (the photography of glass or other transparent models in polarized light to detect areas of stress), laser micrography (to reveal the presence and size of harmful particles, like asbestos fibers or poisonous aerosols, in the air), and others.

O'Hara, Charles E. *Fundamentals of Criminal Investigation*, third edition. Springfield, Illinois: Charles C. Thomas, 1973. Exhaustive textbook on all aspects of criminal investigation, including among its 46 chapters: "Photographing the Crime Scene" "Rules of Evidence," "Invisible Radiation," and "Documentary Evidence" (with a section on "Photography of Documents").

Robbins, Maurice, with Mary B. Irving. *The Amateur Archaeologists's Handbook*, third edition. Cambridge: Harper and Row, 1981. Thorough treatment of the subject—including planning excavations, conducting a "dig," and recording data—for the enthusiast.

Swanson, Charles R., Jr., Neil C. Chamelin, and Leonard Territo. *Criminal Investigation*, fourth edition. New York: McGraw-Hill, 1988. Comprehensive survey of criminal investigation and forensic techniques including crime scene photography, and rules of evidence; illustrated with many photomicrographs, photographic exhibits for court, etc.

6

TRICK
PHOTOGRAPHY

Whoever said "Pictures don't lie" was obviously not a photographer. All shutterbugs know that a photo may easily be faked: Just let them count the ways. One means—actually a group of varied techniques involving the camera, the darkroom, or other means—is by combining images. After examining these methods, we will look at other camera tricks, additional darkroom deceptions, retouching, and the use of computer technology, and then consider some ways of detecting trickery in photographs.

Combining Images

Among the oldest photographic tricks is combining two or more images to make a deceptive composite—a trick that can be accomplished in any of several ways. One of the simplest of these requires neither camera nor darkroom fakery, and produces what may be referred to as composite scenes. Additional methods include collages, "sandwich"-produced pictures, photomontages, multiple exposures, and other techniques.

Composite scenes. Studio photographs throughout the nineteenth century frequently involved posing the subject(s) before a scenic or other pictorial backdrop (as shown in Figure 6.1) and photographing the resulting arrangement so as to create the illusion that the persons depicted were actually part of the scene. Since the technology did not then exist to produce photographs large enough for backdrops, the scenes were necessarily painted. Although they appear to have seen some earlier use by daguerreotypists, the introduction of painted scenery is generally attributed to Antoine Claudet (a London banker turned daguerreotypist from France) in 1851. Henry Ulke is credited with introducing such backgrounds to the United States.[1]

Figure 6.1. Scenic and other pictorial backdrops were common to early studio photographs, such as this cabinet photograph of 1899. (Note also the base of the stand, showing behind the girl's feet, that extended behind the body and held the head in clamps to prevent movement during a lengthy exposure.)

While many photographers were artists who painted their own scenes or were able to hire a local artist to do the work, there were commercial suppliers in Europe (chief of which was A. Marion and Co. in London and Paris) and the United States (where L.W. Seavey, established in New York in 1865, became the largest supplier of painted scenery and papier-mâché accessories).[2] According to William C. Darrah: "Painted scenery was sold by the square foot, in panels on rolls. A twenty-four foot roll usually had six scenes, but as many as twenty scenes might be in a roll sixty feet in length. A roll might begin at one end with a wilderness scene blending gradually into a lake or rural country-side, moving into an estate or garden onto the steps of a mansion, into the drawing room and ending in the library walled with shelves of books. There were military camp scenes, seascapes, sunrises and much more."[3] Props were often used to help tie the foreground with the background. Thus a freestanding colonnade was used with a columned-porch manor scene, a rustic fence and straw with a forest background, an ornate gate with a trellised garden effect, a chair with an "interior" scene of window and bookshelves, and so on.[4]

In their modern form, composite scenes may be produced by what are termed front and rear projections. According to one authority:

You probably have seen more front and rear projections than you know. Think of Humphrey Bogart driving a car, talking to whomever was the current leading lady sitting by his side. He could take his attention from the road long enough to stare meaningfully into her eyes because the land racing by beyond the car window was a rear projection in the movie studio. Think of the magnificent living room in an advertisement for a furniture manufacturer. The exotic view from the living room window is supplied by front projection, and the room is a set in some photographer's studio.[5]

The difference in the two projection systems lies, most noticeably, in the placement of the projector in relation to the camera. Although both systems have the same camera-subject-screen orientation, the rear-projection system has the projector behind the screen which is translucent to permit the projected image to show through to the camera. In front projection, the image is bounced onto the screen from the front by any of several means.

There are advantages and disadvantages to both projection systems, but each is capable of producing unique special effects. For example, in a studio a "construction worker" (model) was seated astraddle an imitation steel I-beam (made of wood and plaster of paris) suspended in front of a screen. Onto this was projected a cityscape filmed from amid the steel beams of a skyscraper under construction. With the aid of a sparkler to simulate the sparks of the welding torch (which could not itself be used because of the wooden construction of the "beam"), the dramatic illusion was complete.[6]

Collages. Another type of combination picture is also done without camera or darkroom trickery. It is the collage (from the French *coller*, "to glue"), a composite picture produced by pasting together various pictures, cutouts, and such. The effect may be as crude as the foregoing description may imply, or a fully sophisticated technique in the hands of a skilled graphic artist and retoucher. The image to be cut out—say the figure of a man from one photo who is to be placed in the scene depicted in another—is removed with a utility knife, using a sheet of glass as the base so as to obtain the cleanest possible cut. Water-soluble retouching colors are then used to tone the cutout's white edges to match the colors of the chosen background. The resulting composite is then rephotographed to produce a negative from which the finished prints are made. (One should remember, of course, that copyright laws prohibit the use of photographs made by others for exhibition or publication purposes—unless the pictures are old enough for the copyright to have expired or have otherwise become part of the public domain.)[7]

"Sandwich"-produced pictures. In addition to the collage, composite pictures can also be made by placing two or more carefully selected negatives or

Figure 6.2 (*above*). An excellent example of an early photomontage, created from two or possibly three photographic negatives, betrayed by the image of the water superimposed on the rocks. Figure 6.3 (*below*). Detail showing overlapping of image. (Courtesy Dept. of Special Collections, University of Kentucky M.I. King Library; Thomas House, photoarchivist.)

transparencies (such as color slides) directly over each other, creating a composite picture that (depending on the type of transparencies) can be shown in a slide projector, or used to create a single image on film or photographic paper. For example, a transparency of a scene with a plain sky can be sandwiched with one having attractive white clouds and another of a bird in flight, resulting in a more interesting and visually pleasing picture. Problems of accumulated density (reduced transparency caused by multiple layers) and unwanted show-through are corrected by, respectively, increasing the exposure from the enlarger and retouching (discussed later in this chapter).[8]

Photomontages. The term *montage* (French for "mounting," from *monter*, "to mount") has been used loosely to describe any process for making a single picture from two or more pictures closely arranged or superimposed. This includes all the methods discussed thus far—background projection, collage (termed "cut montage"), and sandwiching—and other techniques.[9] (See Figures 6.2-6.5.)

However, at least one professional text uses "montage" to refer essentially to *darkroom* montage, a means of combining images from several photographs into a single image and commonly used in the nineteenth century. In modern advertising, photos are usually made specifically for the intended composite and so are photographed against a black background. The black serves as a "self-mask for the subject"; that is, when the composite is printed, only the subject exposes, the remainder of the picture area being masked or blocked from exposure by the black background.

To produce the montage, the objects may be placed against black velvet, lighted appropriately, and photographed. Then a "sized sketch" is made by placing the negative of the most important area in the enlarger, adjusting it to the desired size and position, and carefully tracing the general contour and most significant features; the process is repeated for each additional element. This serves as a guide for the final printing of each element onto a single piece of duplicating film or photographic paper. However, when elements of the picture cannot be "self-masked" as described above (when surrounded, for example, by a complicated background), special "element isolation masks" must be prepared. See Don and Marie Carroll's *Focus on Special Effects* for detailed instructions.[10]

As an example of what can be accomplished by montage, a photograph of three galloping white horses (with an uninteresting, winter-bare background) was used with two others—one of mist and one of a red-sunset sky—which combined to give an impression of a forest fire. The resulting montage was an exciting—albeit faked—scene of the horses fleeing an apparently encroaching conflagration.[11]

Figures 6.4-6.5. Amusing postcards— such as these examples dated 1941 (*top*) and 1908 (*bottom*)— were produced by photomontage techniques.

Multiple exposure. An additional means of making composite images— one that is widely known to laypeople, usually as a "double exposure"—is the recording of more than one exposure on a single frame of film. Such occurrences may be inadvertent: however, most modern cameras have features to prevent repeat exposures, and some have a double exposure lock which can be released after the first shot to permit additional exposures.[12]

Even cameras designed to prevent multiple exposures can usually be circumvented. With ordinary 35mm cameras, for example, the freshly loaded film can be marked with a sharpened "Stabilo" pencil (available from art stores). The mark should align with a point on the inside of the camera—say a dot of marking material such as nail polish placed just below and to the right of the shutter opening. After the first set of exposures is made, the film is rewound just until it releases from the take-up spool (one can feel the film become tight just before the film releases). This should leave the film leader hanging out of the film cassette (just as it was before it was loaded the first time), and the film can now again be loaded onto the take-up spool, the mark aligned manually, the film held in place with a finger, and the *rewind* crank turned until the film is snug. Now a second series of exposures can be

made so that the images will be arranged as desired. Otherwise, "noses that you wanted to touch tip to tip might merge nostrils, and the moon might fall into a lake or be impaled in the trees." [13]

Polaroid models can also be circumvented. Researcher Anson Kennedy has discovered that Polaroid One-Step Cameras can be used with the film door open, thus preventing the exposed picture from being fed out and developed; black tape is placed across the front of the film pack to prevent light leakage. (The camera does push about $1/8$" of the leading edge of the print out of the pack which must subsequently be repositioned by using a photographic changing bag.) Then a second exposure is made in the normal way. Another method is to make slides of the desired images, sandwich them together, and use a photographic enlarger to transfer the image to the Polaroid film, which is then placed in the camera and developed normally. [14]

One problem with multiple exposures is the tendency for the negative film to become overexposed, to get darker as a result of each exposure. However, this can be compensated for by deliberately underexposing the film—for example, by setting the shutter speed at a faster setting (one shutter-speed stop faster for each intended extra exposure) or by reducing the aperture to a smaller opening (one f-stop smaller per planned additional exposure). [15]

Many unusual effects are made possible by multiple exposures. These include some "ghost" and "flying saucer" pictures (as discussed in the next chapter). An example of the type of eye-catching illustration a double exposure can produce is one made by Don Carroll, showing a sleepless man on a mattress floating in a giant cup of coffee. Two lenses were used: The cup was shot first, using a 50mm lens. Then the studio floor was covered with black velvet and the man and mattress photographed with a 20mm lens from a ten-foot ladder. Since the studio wall would have partially shown in the picture, the shot was made through a hole cut in a piece of black paper, thus masking the unwanted background. [16]

A variation of the technique of multiple exposure is to record each of two or more objects to be photographed as a fraction of a long exposure. By this means "spirit" pictures such as those discussed later in chapter 7 can be produced. An exposure is made of the scene, but the person in the scene is there for only a portion of the time. The lens is covered and the person steps away; then the lens is uncovered and the exposure continued. This was also the method employed in so-called "composite photography," such as that of Sir Francis Galton mentioned in chapter 4. According to an 1898 description:

Composite photography consists in the fusion of a certain number of individual portraits into a single one. This is effected by making the objects which are to be photographed pass in succession before the photographic apparatus, giving each of them a fraction of the long exposure, equal to such exposure expressed in seconds and di-

vided by the number of the objects which are to be photographed. Composite photography is interesting when applied to photographs of persons. Theoretically this is what occurs: Features peculiar to each of the portraits, not having been sufficiently exposed, do not take; and the features common to all, having been given a proper exposure, alone leave a visible trace along the sensitized plate. Therefore, the result obtained may be considered as the type of the race or the family, but, of course, is only of limited value.[17]

Related to the double exposure is a method of producing a dual image sometimes called "duplex photography."[18] This involves masking half of the picture when making the first exposure and the other half when making the second. By this means a person can be shown twice in the same picture: for example, as an artist painting his own portrait. There are various means of accomplishing the masking, one being a special frame made to fit in the camera and having "two shutters that operate like the leaves of a door" (according to a late-nineteeth-century text).[19] A simpler means is to use a lens hood (an extension that shields the lens from unwanted light) with its open front end half-covered with black paper. After the first exposure, the cylindrical hood is turned 180 degrees (so that the black paper is then over the other half of the lens), and the second exposure is made. Still other methods and mechanisms can be employed.[20]

Other techniques. Among the other means of making a combination image is that of "multiphotography," as one nineteenth-century text termed it. This is a technique involving photographing mirrored images: "If an image is placed in front of two mirrors inclined to each other at an angle of ninety degrees, three images will be produced in the mirror; at sixty degrees, five images will be produced; at forty-five degrees, seven images; and if the mirrors are parallel, theoretically, an infinite number of images will result."[21]

This list is not exhaustive. Other techniques and/or variations of those discussed may also be used. However, the foregoing lists the methods used for the majority of combined-image photographs.

Other Camera Tricks

In addition to combined images (some of which are done by the camera), other types of trick photography are common. Among those that use the camera (rather than subsequent darkroom techniques) are tricks of perspective, use of special filters and other lens attachments, and motion effects.

Perspective tricks. Many interesting effects can be produced by taking advantage of perspective: the relationship of objects to each other—in terms of

distance and position—as recorded from a particular view. To cite an example that appeared in a fishing publication some years ago, the effect was of a small boy holding up a fish almost as big as himself. Actually the fish was a tiny one but was suspended on a line placed closer to the camera than the boy. He held out his fist as if holding the line and the illusion was complete.

This not only is an example of what one can do when the really "big one" gets away, but also illustrates a basic principle of perspective: the closer an object is to the viewer the larger the object will appear. Taking advantage of this principle, a magician created a simple photographic illusion in which two people, standing facing each other on a *level* plank, changed relative heights from one photograph to another by simply switching positions. The trick went unexplained, but obviously the board and line of view were at other than a right angle to each other, so that a given person was closer to the camera in one snapshot and farther away in the other. If necessary the board could be *tapered* and the wider end placed farther from the camera so that the normal diminishing effect of perspective is compensated for and the two ends appear the same width.[22]

Sometimes perspective causes distortion in a photograph, notably the tapering or "keystoning" effect (after the shape of a keystone in an arch) that one often sees in photographs of buildings. Such foreshortening is caused by failing to keep the lens—particularly a wide-angle lens—parallel to the subject's midpoint. If the desire is to minimize foreshortening, and if the situation prevents one from moving back or keeping the lens parallel, then one can use a PC (perspective control) or TS (tilt and shift) wide-angle lens. These are similar lenses (with different descriptions provided by their manufacturers) which can be shifted on their optical axis to correct distortion to some degree. However, such lenses are extremely expensive.[23] Of course, distortion is sometimes used as a deliberate effect in advertising photography, being manipulated "to emphasize line, direction, movement, distance, size, or any number of creative factors in the composition of an image."[24] A fish-eye (highly convex) lens provides an easy way to impart considerable overall image distortion to create an effect that many people find interesting.

Filters and other lens attachments. The use of filters for special enhancement or reduction of features, as in using a green filter to improve the contrast of dim writing on a green registration form, was discussed in the previous chapter. Color filters can also be utilized to alter the hues in color photographs: "Yellow filters eliminate the blue tones on rainy days, and give a warm feeling to sunset or early morning photographs when the light is low and the shadows long. Orange filters can be used to achieve something of a sepia tone look for a period photograph when using color film. In my opin-

ion, dark green filters are not of much use, although light green can gently tone a forest scene." [25]

In addition to filters, a number of lens attachments can be used to create special effects. These include the polarizing filter, used to produce deep blue skies with contrastingly white clouds in outdoor photography, for example; diffusion filters, to reduce sharpness and create softer images; diffraction grating, to reflect and diffract light so as to produce "startling" effects in black and white and "breathtaking" ones in color; and other attachments. [26]

Also, a variety of unusual effects can be produced by placing in front of the lens such materials as wire screening, to create star formations when focused on a bright light source; glass smeared with petroleum jelly for a blurry, image-softened effect; prisms, to produce multiple, overlapping images; textured glass, for certain "impressionistic" effects; and many other materials. [27]

Motion effects. Today's cameras with high shutter speeds make it possible to "freeze" the action of fast-moving objects. However, Don Carroll tells of the disappointment of one photographer who returned from Europe with photos of the Le Mans automobile race taken at $1/1000$ second. "Instead of capturing the thrill of the wildly racing automobiles," explains Carroll, "the shutter speed had effectively frozen the action, and the cars looked as though they were neatly parked on the roadway! He had neglected to previsualize the image in his mind." Carroll says, "A controlled amount of blur will show that the subject is in motion," adding:

There are times, of course, when you may want to absolutely freeze the action. Some of the most delightful and fascinating photographs I have ever seen were those showing insects and hummingbirds in frozen flight. The photographer had gone to a great deal of trouble to eliminate any blurring in the motion. However, in cases such as this, when a photographer wants to totally freeze action, the subject's movement is usually taken for granted. The bird needs only its position to suggest movement, much like a ballerina at the height of her leap or a diver suspended momentarily above the placid water. The car needs a certain degree of blur, the visual key that says *wizz* in our minds as we see the photograph. [28]

Blur can be provided in photos of moving objects simply by slowing the shutter speed, and it can be controlled by panning (moving the camera in a sweep), slowly to produce less blur or faster to produce more, even panning *opposite* to the subject's movement to increase the blur significantly. Freeze motion and blur can be effectively combined by using both available light and a high-speed flash. Sequential motion effects—such as the series of positions in a golfer's swing—can be recorded by using repetitive strobe lights capable of delivering six flashes per second. The shutter is held open for the

duration of the action, which can be performed in slow motion for enhanced effect.

Fake motion can be simulated also. A still object can be imparted with the blurring effect of motion by controlled use of panning and/or zooming. As well, a rotating lens attachment called a *repeater* can be used to simulate the effect of a repetitive strobe.[29] And there are many other techniques, including some that are employed in the darkroom.

Cinematic illusions. The subject of motion pictures, being somewhat beyond the intended focus of this book, can only be touched on briefly. However, even a brief discussion may prove profitable.

Many of the dramatic effects we see in the movies and on television are accomplished by illusions, either by or for the camera. For example, many times the effect of an airplane or helicopter crash has been effectively simulated by having the craft fly just out of sight over a rise, whereupon (as the aircraft veers sharply away) a large explosion is triggered at the ostensible crash point. The fireball completes the illusion that the plane or helicopter crashed, but the aircraft is safe for another day, as is a sizeable chunk of the film's budget.

As another example, consider a soldier being hit by, say, a mortar round. One sees the fire and explosion and the man's body—clearly not a dummy—blown into the air. Such an effect may be accomplished by using a mini-trampoline (set into the ground and covered with dirt) to propel the stuntman into the air. The "explosion" is simply the effect of a flashpot, which uses a spark to ignite a small amount of gasoline vapor together with the *sound* of an explosion, which is dubbed in later. The flash may actually be a little distance away from the stuntman but closer to the camera and on a line between the two; a telephoto lens is then used because of its tendency to compress distance.

The special effects crew can accomplish seeming wonders, ranging from massive debris falling on actors (simulated by balsa and Styrofoam) and arrows that unerringly hit their mark (owing to hollow shafts threaded on fishlines), to the use of miniaturized scenes and robots and other sophisticated gadgets. Even a seemingly straightforward high fall can require the services of special effects in cooperation with stuntmen and camera operators. For example:

George Roy Hill who directed *Butch Cassidy and the Sundance Kid* has given details of how the two principal actors—Robert Redford (the Sundance Kid) and Paul Newman (Butch Cassidy)—appeared to jump from a cliff top into a river to escape a posse. The water on this particular location was too shallow for the stuntmen to do the actual jump, so the stars did a jump off the cliff onto a platform erected just below the cliff face.

The jump itself, in which we apparently see Redford and Newman falling from the cliff top into the river, was done several months later by stuntmen at the Fox Ranch at Malibu, miles away from the original location. "We put our two stuntmen up on a seventy-foot crane. We stirred up the water with a dozen outboard motors to simulate the rapids." The Special Effects man had a sheet of glass painted to represent the cliffs of the original location and the stuntmen were filmed through the glass and panned down to where they hit the water. But this new location required the stuntmen to move from left to right of the screen when they jumped, whereas Redford and Newman for whom they were doubling had jumped from right to left. So the filmed version of the stuntmen's jump was finally reversed and cut into the end of the stars' jump. For such an effect the Special Effects man is essential. Without him the location, which had presumably been chosen with great care by the director, could not have been used. Alternatively, some other method of escape from the posse would have had to be introduced since the stars could not be shown leaping into that particular river from that particular cliff top.[30]

Camera tricks are widely employed in motion pictures. They range from simple undercranking (filming at a slower speed than that at which the film will later be projected, in order to create faster action), to very sophisticated techniques in which entire backgrounds are superimposed, "nighttime" scenes are shot in daylight (using special filters), and other effects are produced by technically impressive forms of animation—creating on film whatever a creative director can imagine.[31]

Additional Darkroom Deceptions

Earlier, we saw how certain techniques carried out in the darkroom (sandwiching of transparencies, for example) can produce deceptive composite images. Other special effects that can be produced in the darkroom include those accomplished by cropping, but using certain novelty effects, and by employing various other techniques.

Cropping. The term *cropping* refers to the framing of a picture by cutting off unwanted areas, either by removing strips from any or all edges with a paper cutter, by selecting only a particular area when making a copy print or a printing plate from the photo, or by similarly exposing only a selected area of the negative in the darkroom's enlarger in the process of making an original print.

By cropping, a picture may be enhanced in aesthetic ways—such as by improving the composition, selecting and emphasizing a particular area, or eliminating an unwanted feature, such as a telephone pole beside a historic house. Professional photographers typically make what are called *contact prints* (actual-size prints from the filmstrips, those from a given roll typically being placed together on a single sheet of photographic paper); then the

images that are selected for actual printing in an enlarger are marked direct-
ly on the contact print with a "grease pencil" (china-marking pencil) to
indicate any desired cropping.[32]

Cropping can be used in quite deceptive ways. For example, as we
shall see in the next chapter, excluding certain elements can help make a
"flying saucer" photograph look realistic, whereas inclusion of the elements
might point clearly to hoaxing, as by showing, for instance, the blurred fig-
ure of a person who has just launched, Frisbee-style, what can then be seen
as a small UFO model.

Even an ordinary photo may be cropped to produce a misleading or
"trick" effect. According to the book, *Photographic Tricks Simplified*: "When
you think of tricks in photography you need not only think of unusual meth-
ods to arrive at unusual pictures, but also of the use of creative vision to
transform a straight picture from the contact sheet into a trick photo. To
learn the art of cropping requires experimentation, daring, and the return to
old pictures many times as your eye improves with camera practice and work
in the darkroom."[33] By using two L-shaped pieces of heavy black paper to
frame different sections one can easily experiment on a photograph to see
the results that different cropping formats can have.[34]

Novelty effects. Just as certain novel treatments are possible with the cam-
era, similar or other effects can be accomplished in the darkroom. For exam-
ple, by various processes one can transform an ordinary photograph into a
high-contrast one—one with strong blacks and whites and lacking middle
tones, thus resembling a charcoal or ink drawing. Another treatment is "so-
larizing" a negative (producing what is known as a "Sabattier effect"). This
is accomplished by exposing partially developed film to light, resulting in a
partial reversal of the negative image and creating an unusual appearance in
the resulting print that can "lend a note of mystery, or the supernatural, to
your interpretation of a subject."[35]

Other novelty effects include "photograms" (cameraless silhouettes
made by placing objects directly on photographic paper, then exposing the
arrangement to light), reticulation (a textured effect caused by crinkling of
the film emulsion by alternating with hot and cold water), "bas-relief print-
ing" (a raised, sculptural effect achieved by sandwiching together, and
placing slightly out-of-register negative and positive images of the subject),
and other effects, including simply converting the finished print from a posi-
tive to a negative by making a positive print on thin photographic paper,
then using it to make a contact print on another sheet.[36]

Other techniques. Still additional effects that can be produced in the dark-
room include "flopping" (flipping the negative over so as to print the pic-

ture as a mirror-image of the subject), multiple printing (making a series of exposures on a single sheet of photographic paper, as for example, to simulate the effect of motion), and easel distortion (such as tilting the enlarging easel to create elongation of the image, or moving it to create motion effects).[37]

Of course, these techniques can be combined with other effects, including camera tricks, to create many unusual effects. For example, Don Carroll created an eye-catching photograph of "flying saucers," with multicolored lights, streaking above an automobile on a stretch of nighttime highway. The techniques involved making a prop (the "saucer," improvised from a hanging lamp, toy parts, and Christmas tree lights); using a black background and photographing through a hole in black paper (to mask out the background); employing strobe lighting, special filters, and a zoom technique (to create various light-and-motion effects); making multiple exposures (to create two additional UFOs); and duplicating slides (to add the highway scene with automobiles). The result was a dramatic effect that was used to illustrate an article in *Penthouse* magazine.[38]

Retouching

The term *photographic retouching* is a general one referring to various artistic techniques used to alter or improve a photographic image. Retouching of photographs has been common since the late 1850s[39] and in the 1860s was the subject of many arguments as to the legitimacy of the practice, especially with regard to portraits. For example, some prints by the French sculptor and photographer Adam Salomon, who used strong side lighting to give a "Rembrandt effect" to portraits and who was also a master of retouching, were examined by the Edinburgh Photographic Society in 1868 to determine "whether they were pure photographs or indebted to retouching for their beauty." They were found to have been retouched.[40]

Until 1870 retouching was done mostly on the positive print, but thereafter retouching of the negative was standard practice. The work was usually done manually by an artist, but various devices were manufactured to accomplish the work mechanically. The Getchell and Hyatt machine, for example, was operated by a sewing-machine treadle and could perform "all usual manual work, doing fine stippling and hatching."[41] Eventually, the airbrush (discussed later) was used for most professional retouching.

The following discussion treats the retouching (and "spotting" and hand coloring) of prints; the retouching of negatives; and so-called "subliminal" effects.

Figure 6.6 (*left*). Retouching with pen or pencil strokes directly on the finished print—as evident.in this ca. 1872 photograph—was common in the Victorian era. (As in this instance, fading of the photographic image often renders the retouchings obvious.) Figure 6.7 (*right*). Retouching of entire areas of a photograph—such as the painting out of the background in this photograph of Madame Curie (from an old publishing archive)—may be apparent from the resulting outlines.

Retouching of prints. The simplest, easiest type of retouching is performed with retouch pencils. These are used on matte-finish photographic paper or on glossy prints that have been given a coating of a special matte spray. (In an emergency, an ordinary pencil might be pressed into service, assuming the print is a black-and-white, matte-finish one. Stabilo pencils, available in black and white and capable of marking on smooth surfaces, can be used for glossy prints.) With the pencil, an indistinct edge of an object can be strengthened in a single stroke, and other minor touch-ups can be performed easily. (See Figure 6.6.) In earlier years such work was commonly performed on newspaper photos.

More professional manual retouching usually involves using a red sable watercolor brush to apply retouch paints or spotting dyes. The latter (produced in tones to match the basic ones present in most black-and-white printing papers) are used to "spot" prints—that is, to touch up the tiny blemishes that may appear in a finished print (resulting from a dirty or

damaged negative). With a finely pointed brush, suitable dye, and careful treatment, spotting may be quite unnoticeable. (Since the spotting colors are "penetrating dyes," they do not require preparatory treatment of glossy prints.) Much manual retouching is done with transparent colors. However, opaque retouch colors (or simply water-based gouache paints) can be applied to matte-finish paints (or, again, to matte-sprayed glossy ones) to paint out or otherwise alter entire areas of a photograph. (See Figure 6.7.)

Serious professional retouchers, however, employ the airbrush—particularly for retouching large areas of a print. This is a fine spraying device with an adjustable nozzle that permits very carefully controlled application of retouch colors. The print to be retouched first has its white borders protected by using photo tape, which is also used to fasten the picture to a suitable mounting surface. Then if a large area is to be covered—say the background is to be lightened so that a particular object stands out more emphatically—the object not to be covered is painted with a protective coat of masking compound, applied with a sable brush. Then the airbrush is used to apply a fine-mist coat of retouch paint until the desired effect is created. Finally, the masking compound is removed by rubbing the area gently with a pencil eraser.[42]

Other masking methods utilize stencils or frisket film—*thick* material being used when a softer edge is desired. By varying the techniques approprately, airbrush retouching can be used to tone overly white areas, provide "halo" and vignette effects, accomplish a variety of other effects for advertising purposes, and restore antique prints.[43]

There are two contrasting approaches to treating antique photographs. *Conservators* aim to conserve the original, typically by stabilizing the print to reduce further deterioration, repairing tears, and possibly painting in lost areas. However, as little as possible is done to alter the original artifact, and any process used must be reversible (that is, any materials that are used, such as glues or paints, can later be removed if desired). *Restorers*, on the other hand, may take drastic—often irreversible—steps to repair damage. These may include mounting the print and performing extensive retouching.[44] Actually, when the latter is required it should be done on a separate copy print or done on a clear acetate sheet placed over the original and then rephotographed.[45]

Retouching of color photographs is accomplished in essentially the same way as for black-and-white ones, except for the added complexity of mixing colors. Color retouching paints are typically water-based, *transparent* colors, which can be made opaque by mixing with white or with other colors. Premixed liquid colors, including opaque paints, are available, the transparent ones actually having greater tinting strength.[46]

Analogous to the retouching of color prints is the coloring of black-and-

white photos, although the process is fundamentally different. Either of two techniques is employed. The first involves the use of "heavy oils" (opaque colors applied as in an oil painting), a process requiring artistic skill since the opaque colors obliterate the features; therefore the shadow tones must be replaced by freehand painting. The second method uses transparent colors which are rubbed over the picture with cotton balls and swabs to produce an even tint, allowing the actual photographic image to show through. Because of the show-through, however, *sepia*-colored prints are preferable for portrait work over black-and-white ones, as the tones of the latter can give a gray pallor to the complexion. Complete Marshall's brand photo oil coloring kits are sold at many photo and art supply stores.

Retouching negatives. Because of the increasing use of small film format cameras, and the consequent diminishment of the negative size from 4 x 5 inches and even larger to negatives of postage-stamp size, retouching of negatives is falling into disuse. However, some larger negatives are still being used in commercial work, and the retouching is accomplished in either of two ways. The most common means utilizes retouching paint, which is opaque, applied to the *back* (non-emulsion side) of the negative. This limits the amount of light passing through the transparent negative, thus creating light areas in the processed print. A more drastic technique involves carefully scraping away the negative's emulsion with a razor-sharp blade, a technique that yields increasingly darkened areas.[47] Since the latter method is irreversible, one authority cautions: "It should be noted that this is a last resort method of negative alteration and if black highlights or silhouetting are required all efforts should be made to work on the positive print."[48]

Subliminal effects. In 1973, author Wilson Bryan Key created a stir with his book *Subliminal Seduction*, which claimed that hidden messages were being incorporated into advertising photographs by careful retouching. Key renewed claims stemming from a 1950s story: that moviegoers were being flashed, at one-third millisecond duration, the words "Eat Popcorn" and "Drink Coke," the subliminal messages resulting in a substantial increase in sales of popcorn and Coca-Cola. Key claimed that such subtle brainwashing techniques were still being used by major advertisers, not just in movies, but also television and even print advertisements. "Key found the word *sex*," reports one critic, "printed on everything from Ritz crackers to the ice cubes in a Gilbey Gin ad."[49]

Actually the "Eat Popcorn" story was a hoax, perpetrated by a man who hoped to boost his failing marketing business, and the evidence for the imagined subliminal practices and effects are just that: imagined.[50] Concludes one psychologist: "Subliminal advertising and psychotherapeutic ef-

Figure 6.8-6.9. Before and after photographs illustrate how damaged photographic treasures like this one can be restored by computer technology. (Photos courtesy of Lloyd Beard, Stone Photography Inc., Lexington, Ky.)

fects from subliminal tapes are ideas whose scientific status appears to be on a par with wearing copper bracelets to cure arthritis."[51]

Computer Technology

Not only retouching, but far more extensive altering of photographs can be accomplished with computers. A photograph, or even a frame from a videotape, is simply scanned into the electronic imaging system. There it is *digitized*—that is, translated into numbers representing its gridlike array of tiny picture units or *pixels*, perhaps 512 x 512 or more per image.[52] The photograph can then be altered as desired, even one pixel at a time. One expert explains the advantages of the process:

First of all, everything one can do to a digitized picture with a computer is reversible, which makes it much easier to play around with a picture, trying different transformations. Second, not only can the computer mimic everything a skilled professional can do with chemicals and enlargers in a darkroom, it can indeed also do things that are almost impossible to do any other way. How would you smoothly fade a picture from a negative to a positive version in a darkroom? In a darkroom you can correct perspective by tilting the enlarger lens or the printing paper, but how do you hold the paper to twist a picture into a spiral? Believe it or not, to a certain extent you can even restore the focus in a fuzzy picture or remove motion blur with a computer.[53]

The computer imaging systems are capable of accomplishing a full range of restorative or retouching possibilities. Without harm to the original, the computer can produce a copy image of an old photograph in which glare is removed from eyeglasses or the glasses themselves are removed, cracks and tears are invisibly mended, torn corners are replaced, missing portions are filled in, unwanted people are removed from a group picture, faded images are enhanced, facial blemishes are erased, and so on. (See Figures 6.8 and 6.9.)

As well, one can completely remove an undesirable background or even replace it with another, eliminate unwanted features (like ugly telephone lines from a picture of a house), and, indeed, perform countless other alterations. Since the computer technology works in color as well as black and white, one can change the color of a shirt or dress, or even "colorize" a black and white picture.[54] The Polaroid corporation of Cambridge, Massachusetts, has even offered through its custom Replica Service to make accurate reproductions of family portraits or museum masterpieces using a sophisticated computer process. It utilizes digital technology that permits color matching at more than 90,000 points per square inch, thus duplicating every "brushstroke, crack and chip in the original."[55]

For humorous, or commercial, or entirely dishonest purposes, photographs of people can be completely altered in a variety of ways. One manufacturer promises that its *Funny Faces* program can add tattoos, comically enlarge ears or stretch necks, and otherwise achieve novelty effects, including putting one person's head on another's body. Such transposition was used in the 1992 presidential campaign. A group calling itself the Presidential Victory Committee produced a thirty-second anti-Bill Clinton spot that featured a faked photo of Clinton posing with Senator Edward Kennedy., Indeed the picture showed Clinton holding Kennedy's hand in the air in the tradition of politicians on a convention platform, and the ad warned that Kennedy could end up in charge "of roads . . . and bridges." Later the producer of the ad, Floyd Brown, admitted that the photograph originally depicted Clinton with Senator Al Gore at the Democratic National Convention, and that the Massachusetts senator's head was substituted for that of the then Tennessee vice presidential candidate.[56]

In a more ominous case, independent candidate Ross Perot briefly dropped out of the presidential race because he alleged Republican dirty tricks included a plan to embarrass him by giving a doctored photo of his daughter to supermarket tabloids. "They were going to smear her with a fake photograph that they had done with a computer," claimed Perot, "where you put a head on another body." Perot was unable to prove his allegations, which were branded as "absolutely untrue" by Robert Teeter, head of President Bush's reelection campaign.[57]

Such possibilities do not bode well for photographic honesty. Noting

that the price of the necessary equipment had dropped drastically—from over $100,000 for the scanner alone to less than $3,000 for both computer and scanner—the editor of one magazine lamented that now anyone with a little cash "and some time to practice" could alter photographs. "The bottom line," he concluded, "is that even a photo expert may not be able to tell when a photo has been faked." [58]

Nor are only still pictures subject to alteration. Digital visual-effects technology is now being used by Hollywood filmmakers to accomplish such graphical feats as "wire removal"—the secret behind the flying scenes of Robin Williams (as Peter Pan) in Steven Spielberg's 1991 movie, *Hook*. Before about 1990, flying effects were often done by traveling matte techniques, in which an actor is photographed against a black background and the result inserted into separately filmed scenery. Finer-grain film and other advances made it increasingly difficult to hide the necessary wires, which became increasingly thin at the expense of safety. (During filming of one of the *Superman* movies, a wire rig failed, causing one of Christopher Reeve's stunt doubles to plummet several feet onto a studio floor—albeit, luckily, unhurt.) [59] Then came new digital techniques. As Tom Flynn, director of Inquiry Productions, explains:

It all started with *Back to the Future II*. That picture featured dozens of shots with Michael J. Fox on a flying skateboard. To execute these shots, technicians at Industrial Light and Magic (ILM), George Lucas's cuttingedge special-effects facility, rewrote the book on flying scenes. On the set, director Robert Zemeckis simply flew his cast around on big, bulky, clumsy, *safe* steel rods, wire harnesses, and the like. All the hardware was allowed to show. Then ILM technicians scanned each frame of film into a powerful graphics workstation. Using proprietary software, they extrapolated background imagery from either side of the objects to fill in the spaces where the hardware had been. And it all worked invisibly, frame after frame, 24 frames for every second of screen time. Finally, each manipulated frame was laser-scanned back onto 35mm or 70mm film negative. Cut into the finished picture, these highly manipulated shots matched perfectly with "virgin" first-generation footage. You never saw the wires, and you never saw where they'd been removed. [60]

Other new technologies are being developed, and Flynn warns that "the digital visual-effects technology behind today's special effects films is poised to thrust all our old ideas about 'photographic evidence' into the dust bin of history." [61]

Detecting Trickery

It may not always be possible to detect deception involving a photograph. After all, it may be an entirely straightforward, unretouched picture—albeit

one in which the scene is staged or faked in some way. As well, computer technology is becoming increasingly affordable and consequently widely available, prompting Tom Flynn to state: "The days when a skilled photo analyst could be sure of detecting a doctored image may soon be history."[62]

Nevertheless, there are procedures and techniques for detecting many types of photo deception, and it may well be that as the technology of fakery becomes more and more sophisticated, so will the techniques of analysis. In the meantime it will be useful to keep in mind some basic principles: investigating the provenance, checking circumstances of the picture, examining the negatives, analyzing anomalous features, and avoiding self-deception.

Investigating the provenance. With any questioned photo, always consider the source. With questioned historical photographs especially (recall our discussion in chapter 4), it is important to determine what is the picture's provenance (that is, the evidence that establishes its historical origin and hence, potentially, its provenance). Certainly provenance will be more significant in the case of a sensational work (one that seems "too good to be true"), and the refusal of an owner to explain how he or she obtained an item is, prima facie, suspicious, suggestive of possible fakery or, alternately, theft. According to one antiquarian dealer: "Where there is secrecy on matters which cannot be substantiated by records, suspicion is inevitable."[63]

Indeed, as with manuscript forgeries, fake repairs and other restorative efforts may be added to photographs to give the impression that the work is sufficiently old to require such conservation measures. Evidence of prior mounting or framing may also be faked to give the impression that the piece has previously been considered genuine by an earlier owner. As well, bills of sale, dealers' certificates of authenticity, and written statements puportedly from prior owners can all be fabricated.

Even published descriptions from old sales catalogs mean little (recall the "Emily Dickenson" [sic] photo discussed in chapter 4), as unscrupulous dealers exist and many of the antiquarian dealers of the past sold their wares "as is." Therefore, contradictory stories with regard to provenance or evidence that a provenance may have been faked should prompt the most thorough investigation and examination of the photograph in question.

With modern photographs, it is also appropriate to consider the source. Take, for example, a "lake monster" photo, that of the "Lough Leane aquatic monster," allegedly made near Killarney, Ireland, in 1981. The suspiciously out-of-focus picture (discussed further in the next chapter) was supposedly taken by one Patrick Kelly, a friend of entertainer Tony "Doc" Shiels but, according to an article in *Fate* magazine, actually a Shiels creation. Shiels, a magician, self-described "psychic entertainer," and professional Punch and Judy man, is also author of books that discuss successful

hoaxing techniques. He was not only fortunate enough to have made photos, as he claimed, of the Loch Ness monster (telling one magazine, "I am sure Nessie appeared as a result of my psychic powers") but also of a sea serpent named Morgawr, a Shiels hoax photo, according to the *Fate* article.[64] Given this information about the source, should anyone take the Lough Leane monster photograph seriously?

Checking the circumstances. Investigation of the circumstances attending the taking of a photograph—which may involve both internal and external features and any contradictions between the two—is important in analyzing questioned photographs. For example, as one UFO expert observes, "If a witness claims he took the picture on a sunny day, but in fact it was a rainy day (check the weather report), you naturally should be cautious."[65] Similarly UFO investigator Robert Sheaffer, in analyzing two UFO photos made in 1950 by a farm couple near McMinnville, Oregon, found serious discrepancies. He noted that although the camera had been aimed in a northerly direction when the snapshots were made, there were distinct shadows on the *east* wall of the couple's garage, demonstrating that the pictures were not taken shortly *after sunset* as claimed but rather in the early morning![66] Sheaffer's analysis also indicated that the picture allegedly shot first, by a matter of seconds, had actually been taken *several minutes following* the other.[67]

 In addition, the investigator should also examine the site where the photo was taken—the importance of which is also apparent from the McMinnville case (in determining the northward direction of the camera's aim). In another case, a thirteen-year-old boy hiking through a cemetery took three Polaroid photographs of a UFO. When an astute investigator observed that two of the pictures revealed what appeared to be the same forked branch of a tree (apparently above the object in each case), he asked the teenager to show him the site. The youth agreed. However, "that night the phone rang in my house," the investigator reports, "and on the phone was the boy in a very emotional state. It was all a fake, and he realized that when we got out in the field I would see that the same branch appeared in both pictures and therefore, that the object had not moved between the two pictures." The unidentified "flying" object had been made of papier-mâché and tied to a tree branch.[68]

Examining the negatives. Although not applicable to Polaroid pictures, like the McMinnville UFO photos just discussed, or the new filmless cameras (that store the image electronically in a form that can be manipulated by computers), one approach to detecting photo trickery is to examine the negatives. These may show actual retouching, or yield telltale evidence (as

from the edge of a photo within a negative's image area) that another picture was copied. With some techniques for producing composite pictures, like sandwiching of negatives, there will not be a single negative to correspond with the questioned photo; therefore a hoaxer may be forced to refuse to supply the negative or to claim it has been lost.

Actually, an investigator should insist on examining the negatives from the entire roll of film on which the questioned image was recorded.[69] These will probably be in the form of filmstrips cut from the roll, in which case it is important to make certain that every numbered frame is accounted for and that the cut ends of the strips match, since it would be possible to substitute a strip from one set of negatives for one in another. Studying the *sequence* of photos might provide direct evidence of fakery—for example, preliminary practice shots that reveal the actual mechanism by which a hoax was perpetrated. Or the sequence may be incompatible with the story provided by the person taking the picture. Filmmaker Tom Flynn, commenting on computer technology's capacity for fakery refers to the negative as "previously the Achilles' heel of photo manipulators."[70]

For these reasons, investigators have considered refusal to submit the original negatives for scrutiny to constitute grounds for suspicion. The National Investigations Committee on Aerial Phenomena (NICAP), once a major pro-UFO group in the United States, took this position. So did Philip Klass in his *UFOs Explained*, saying of NICAP's response to such refusals, "I fully share their suspicions."[71]

Analyzing anomalous features. In the case of early direct-positive photographs, or later prints that for whatever reason lack a negative, examination of the picture *may* still reveal anomalous features that give evidence of camera or other trickery. Among these features are the wavy bottom edges of otherwise realistic painted background scenes in old studio photographs; washout of the background in photographs made by using either front or rear projection; irregular edges and/or white or black-shadowed cut edges of objects in collage pictures; incompatible shadows or perspective views of people and things in pictures made from multiple photographs; show-through of images in the case of some combined-image pictures (like double exposures and those produced by "sandwiching" of negatives or transparencies); overexposure and "chameleon" effects (when an object in the foreground takes on the color and brightness level of the background) in the case of multiple exposures; and a central overexposed strip in a photo as a result of a dual-image photograph produced by masking first one, then the other half of a lens hood.

As well, there may be still other signs. Some photomontages may be detectable due to the different grain structures of, say, an object taken from

one picture and its surroundings taken from another.[72] And one "miracle" photograph, allegedly taken at the Medjugorje shrine in Yugoslavia and depicting the Virgin Mary, had a most curious anomaly: stereomicroscopic examination revealed the halftone pattern of photoengraving (explained in chapter 3)—proof that the color picture had been copied from a magazine or book.[73]

Retouching, restoration, and coloring of prints, and retouching of negatives can easily be detected whenever the originals can be obtained and their surfaces carefully examined. This is done with the aid of a suitable magnifier—such as a loupe or stereomicroscope—and oblique lighting (to enhance any surface irregularities). An ultraviolet light may more readily and dramatically reveal the effects of restorative work than is apparent in ordinary lighting.

One type of restorative technique may be difficult to detect: what is termed "intensification." This is the treatment of prints that have faded, including albumen prints and, especially, calotypes, by chemically redeveloping, fixing, and washing the print. Sometimes the process, which was condemned in 1985 by the Association of International Photography Art Dealers, may be suspected when the luster of the print is rich and immaculate but the print is on a worn and faded cardboard mount.[74]

As to computer-altered photographs, they may be exceedingly difficult to detect, especially since some printers even permit the transfer of the completed image onto either Polaroid film or 35mm negatives.[75] However, in important cases sophisticated analyses by a forensic laboratory may still prevail. Ironically, analysis by computer may represent the most successful means of detection of such pictures.

Avoiding self-deception. Another principle is a forewarning against bias. One scientific investigator urges "the intellectual discipline of subordinating ideas to facts." As he explains: "A danger constantly to be guarded against is that as soon as one formulates an hypothesis, parental affection tends to influence observations, interpretation and judgment; 'wishful thinking' is likely to start unconsciously."[76]

Good illustrations of the problem come from conspiracy buffs who "investigate" the Kennedy assassination. For years, some of them have claimed to discern, in certain segments of film footage, one or another man aiming a rifle at the presidential motorcade. However, in one instance the man was not only "apparently elevated into mid-air" (as one critic observed) but was at a point "where he could have been observed by the dozens of witnesses standing in front of the [Texas Book] Depository."[77]

Unfortunately, the blurred, spotty enlargements that supposedly show the "grassy knoll assassin" act as a Rorschach test for one's imagination. To

help the visualizing process along, some conspiracy mongers provide an accompanying drawing "clarifying" the features and in one case providing the man with a jacket. As it happens, the House Select Committee on Assassinations studied the film segments in question and determined that the assassin in one was actually a bystander on the steps that lead to the grassy knoll and that his "rifle" was actually a twig and a small break in the nearby foliage. Another "assassin" was nothing more than a pattern of chance shadows on a white concrete structure.[78]

Another illustration from the Kennedy case concerns the photos that Lee Harvey Oswald asked his wife to take some months before the assassination. Dressed in black, wearing a pistol in a holster, and holding the fatal rifle in one hand and some radical newspapers in the other, Oswald is shown in the small backyard of the house he rented at the time.

Conspiracy theorists have alleged that the photos are fakes—"forged" says Robert Groden, author of *High Treason*, "in advance of the assassination to make Oswald appear violent, and show him with weapons allegedly used in the murders of President Kennedy and Police Officer J.D. Tippit."[79] As Jim Moore explains in his sensible *Conspiracy of One*:

Groden notes that the line at Oswald's chin—suggesting that his head had been photographed atop someone else's body—becomes more pronounced in successive generations of photos. Being a photo analyst, Groden should know that this effect will always be the case when a photo is copied. Since detail is lost with each successive copy, disconnected lines in the original will eventually give the impression of a continuous line. The original photos, which Groden has had the opportunity to work with, do not show any kind of line extending all the way across Oswald's chin. The only thing shown in the region is the cleft beneath his lower lip. In *High Treason*, however, the line becomes quite apparent, and has obviously been added to the photography.[80]

To guard against self-deception, one should follow the advice of the scientific investigator quoted earlier, who adds that the best protection "is to cultivate an intellectual habit of subordinating one's opinions and wishes to objective evidence and a reverence for things as they really are, and to keep constantly in mind that the hypothesis is only a supposition."[81]

Recommended Works

Ades, Dawn. *Photomontage*. New York: Pantheon Books, 1976. Generously illustrated discussion of the use of photomontage techniques in the fine arts (especially in Dada and Surrealism), in commercial art, and in political propaganda.

Carroll, Don, and Marie Carroll. *Focus on Special Effects*. New York: Amphoto Books, 1982. Professional, color-illustrated guide to such photographic tricks as mak-

ing multiple exposures, sandwiching, combining images by darkroom montage and by collage, and the like.

Croy, O.R. *Croy's Camera Trickery*. New York: Hastings House, 1977. "How-to" guide to various types of photomontage, including "photomontage in the negative," "montage with the enlarger," "cut montage" (i.e., collage), etc., including various novelty effects such as tone separation, and screen, mirror, and distortion effects.

Flynn, Tom. "Photographic Proof? Not for Long." *Skeptical Inquirer* 17.2 (winter 1993): 118-20. Discussion of the use of computer technology in movie special effects with implications to the concept of photographs as evidence.

Holzmann, Gerard J. *Beyond Photography: The Digital Darkroom*. Englewood Cliffs, N.J.: Prentice Hall, 1988. Introduction and "hands-on" guide to the computer scanning and subsequent manipulation of photographs; includes a "cookbook" of computer transformations (all of which can be reproduced with a portable picture-editing system which can be run on a home computer).

Hopkins, Albert A., ed. *Magic: Stage Illusions, Special Effects and Trick Photography*, 1898. Reprinted New York: Dover, 1976. Treatise on creating illusions in the nineteenth century including three chapters on "Photographic Diversions": "Trick Photography," "Chronophotography," and "The Projection of Moving Pictures."

Martin, Judy, and Annie Colbeck, *Handtinting Photographs*. Cincinnati, Ohio: North Light, 1989. Comprehensive text on all aspects of the art of handcoloring photos, including the history and development of the art as well as the necessary materials and specific techniques.

Mitchell, William J. "When Is Seeing Believing?" *Scientific American*, February 1994, 68-73. Illustrated article on digital photomontage and other digital technology for manipulating photographic images which "has subverted the certainty of photographic evidence."

Photographic Tricks Simplified, by the Amphoto Editorial Board. Garden City, N.Y.: Amphoto, 1974. Guide to such techniques as multiple exposures, use of prisms and diffraction gratings, and other novelty effects; mostly black-and-white illustrations.

Podracky, John R. *Photographic Retouching and Air-Brush Techniques*. Englewood Cliffs, N.J.: Prentice Hall, 1980. Step-by-step guide to manual and airbrush retouching, including retouching negatives and color prints, as well as a chapter on "Photographic Restoration of Black and White Prints."

Van Hise, James. *The Special Effects of Trek*. Las Vegas, Nevada: Pioneer Books, 1993. Account of the special effects techniques employed in the *Star Trek* science-fiction TV series and motion pictures.

7

PHOTOGRAPHING THE PARANORMAL

It may be only natural that, given its popularity and special capabilities, photography in the mid-nineteenth century was applied to certain pseudo-scientific purposes. For example, in 1863 it was widely believed that—similar to the camera—the retina of the human eye at the moment of death retained whatever image was last registered on it. Therefore, as Aaron Scharf relates in his *Creative Photography:*

In the case of murder by assault its promise for crime detection was obvious if only the tiny picture on the iris could be extracted and enlarged. Thus, within thirty hours after the violent demise of such a subject in England, an experiment was made by a photographer, one Mr. Adams. *The Photographic Times* reported the event: "There was a great deal of dust flying and a great crowd collected, which materially interfered with the success of the experiment; but notwithstanding these unfavourable circumstances, Mr. Adams succeeded in taking a tolerably fair "negative" . . . He had taken an ambrotype picture of the eye of the deceased, and then rubbed out everything but a single object apparently in the centre of the eye; this was placed under an ordinary magnifying glass. At the first glance the object appeared blurred and indistinct, but on getting the proper focus the outlines of a human face were at once distinguishable.

Scharf explains the self-deception: "So exaggerated then was the efficacy of the all-seeing mechanical eye and so readily was its recorded image acceptable that those present had no difficulty in seeing the details of the face of the murderer. They saw what they wanted to see: long nose, prominent cheek bones, black moustache and other sinister distinguishing features."[1]

Many people believed that photosensitive plates were even able to record preternatural phenomena. Taking advantage of the advent of spiritualism, certain photographers began to make "spirit pictures"—photographs supposedly depicting the spirits of the dead.

And with the advent of the roll-film camera, which rendered snapshot

photography practical, amateurs also began to take pictures of "ghosts" and other paranormal phenomena. (*Paranormal* refers to the supposed existence of things beyond the range of normal experience and nature—including allegedly supernatural phenomena, such as levitation and weeping statues, together with potentially natural phenomena, like the abominable snowman.[2]) As such myths as "flying saucers" and the Loch Ness monster began to be widely disseminated by the modern mass media, snapshots of UFOs and monsters began to proliferate.

Photographs of all such phenomena have frequently been faked, as we shall see presently. Although there is not always a clear distinction between supposedly ordinary photographs that depict paranormal subjects on the one hand, and, on the other, photos that are themselves allegedly produced or altered in some paranormal manner, our discussion will be divided into two chapters that attempt to make the distinction. This chapter treats spirit photographs, UFO snapshots, pictures of legendary creatures, and photos of other paranormal subjects, followed by a discussion of photographs alleged to be produced in a paranormal manner in the next chapter.

Spirit Photography

Stories of "mediums" who could communicate with spirits of the dead are as ancient as the Old Testament. (Recall the account of the witch of Endor, who had a "familiar spirit" and who conjured up the ghost of Samuel at King Saul's behest [I Samuel 28:7-20].)

What has been called the Age of Spiritualism had its origin in 1848 at Hydesville, in northern New York state, at the home of a Methodist farmer named John Fox. Fox's young daughters, Maggie and Kate, claimed to be receiving communication—in the form of rapping noises—from the ghost of a murdered peddler. Assisted by the promotion skills of an older sister, Mrs. Leah Fish, the girls were soon demonstrating an apparent ability to contact other spirits—all of whom were conjured up at "séances" where they answered questions by means of the mysterious raps. Following successful demonstrations in New York City, the girls traveled throughout the United States promoting their "Spiritualist" society.[3]

In their wake, spiritualism flourished. Various strange phenomena began to be produced at séances: "spirits" tilted tables, rattled tambourines, spoke through trumpets, and wrote messages on slates. Many appeared as disembodied hands or even entire luminescent forms. Despite endorsements by such respected persons as scientist William Crookes, however, the growing cult of spiritualism was continually plagued by accusations of fraud. (For example, in 1876, after a medium had "materialized" her "spirit guide"—

Figure 7.1. Engraving (from the May 8, 1869, *Harper's Weekly*) depicts a "spirit photograph" by the notorious W.H. Mumler. The picture portrays Mrs. Mumler being attended by a "ghost."

an Indian named "Sunflower"—a reporter discovered the medium's accomplice hidden in a recess.) Eventually the Fox sisters confessed that their mysterious raps had been produced by trickery, but the spiritualist craze continued unabated.[4]

Trickery continued in the production of otherworldly photography. In 1861, a Boston engraver named William H. Mumler, who worked for the jewelers Bigelow Brothers and Kennard, discovered extra pictures on some amateur photographs he had taken of a fellow workman. This, together with the popularity of spiritualism at the time, gave Mumler the idea of going into business as a "spirit photographer."[5]

The extra pictures Mumler had discovered apparently resulted from the recycling of an old photographic plate. Since glass was not inexpensive, any spoiled or unwanted negatives were cleaned off and recoated with emulsion for further use. Sometimes a faint yellowish image would remain, scarcely visible in the negative but "being of a non-actinic color" (as an 1896 treatise explains) producing "quite a distinct image in the positive."[6] This discovery probably inspired the use of deliberate double exposure for spirit pictures.

In 1862 Mumler released what he claimed was "the first true photograph of a soul that has passed over." It showed the spirit photographer

himself with the somewhat hazy form of a woman. "This photograph," Mumler wrote in releasing the photograph, "was taken by myself, on a Sunday, when there was not a living soul in the room beside me, so to speak. The form on my right I recognize as my cousin who passed away about twelve years hence." [7]

Mumler was soon experiencing a thriving trade, regularly obtaining extra images on portrait photographs he took of living sitters at his Boston studio. These "extras" were recognized as deceased celebrities, or as dead relatives or friends of the sitter. (See Figure 7.1.) "In February of 1863, however," wrote magician John Mulholland in his *Beware Familiar Spirits*, "recognition went too far—Doctor Gardner, a leading Boston Spiritualist, recognized some of the 'extras' as living Bostonians." This seriously affected Mumler's business, but he does not appear to have abandoned it during the 1863-69 period as has been claimed,[8] as he took a spirit picture of the widowed Mary Todd Lincoln (with the spirit of her assassinated husband laying his hands consolingly on her shoulders) about 1865.[9]

In any event, Mumler resurfaced in New York in 1869, where he was prosecuted on a charge of swindling. Some accounts give the impression that Mumler confessed; actually, several of the spiritualist faithful testified that they recognized some of the "extras" as their deceased loved ones, and Mumler was eventually acquitted for lack of evidence.[10] He seems to have continued his work for a time (a photo with an "extra" of Beethoven was taken by Mumler ca. 1871), but he soon passed into obscurity and died in 1884.[11]

How sitters could "recognize" the extra or spirit pictures as their dead friends or relatives is no great mystery. In some cases (like that of Mrs. Lincoln) Mumler was able to obtain a likeness of the target "spirit." In other instances, however, Mumler's figures were heavily draped and in poor focus, so that it was difficult to discern the features clearly. People saw what they wanted as they did with the productions of spirit photographer G.H. Moss. The official report on his fraud observed: "A number of good recognitions were claimed from time to time by sitters, and these can only be accounted for in the light of subsequent events by the long arm of coincidence, and the will to believe that lies in all of us." [12] These same factors are demonstrated in another case, concerning a French spirit photographer.

The Frenchman's name was Jean Buguet and he operated in Paris and London during the 1870s. His technique was to prephotograph his assistants, suitably dressed in a gauzelike shroud or similar attire, and then make a second exposure of the sitter. Later, needing more variety, Buguet began using a dummy which he supplied with one of several interchangeable heads, all of which were seized by the police at the charlatan's Parisian studio. During the trial a picture-seller named Dessenon described the "spirit"

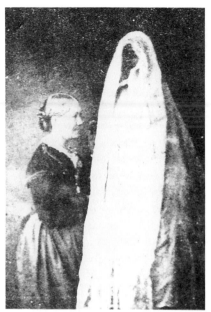

Figure 7.2-7.3. Bogus spirit photographs like these were common during the nineteenth century. (Courtesy of Dr. Gordon Stein, *Encyclopedia of Hoaxes*, 1993.)

portrait of his wife as being "so like her that when I showed it to one of my relatives he exclaimed, 'It's my cousin.'" At this Judge Millet asked, "Was that chance, Buguet?" to which he replied: "Yes, pure chance. I had no photograph of Madame Dessenon."[13]

Daniel Cohen, author of *The Encyclopedia of Ghosts*, points out that "most of the spirit photographs that were taken during this period look to the modern observer so obviously fake that one wonders how anyone but an idiot could have been taken in by them."[14] (Figures 7.2-7.3.) Yet credulity knows few bounds. Some defended Buguet despite his confession and conviction. One was spiritualist Stainton Moses who proffered a statistical argument. He maintained that the Frenchman had a high proportion of "recognitions"—40 out of 120, in contrast to those of spirit photographers named Hudson and Parkes (26/180 and 8/150 respectively) and comparable to the ratio of Mumler (15/40).[15]

Fred Gettings, author of *Ghosts in Photographs*, acknowledges that there were many fraudulent spirit photographers but rushes to defend Mumler and a host of others, including Buguet. Gettings is impressed with the "superior artistic quality" and recognizability of Buguet's prints, and with the fact that "inevitably, such pictures attracted a huge following, especially since many of his prints were published in the popular *Revue Spirite*, not as crude

lithographic copies, or as wood engravings, but as pasted in photographic reproductions, perhaps printed by the photoglyptic process." That was the French name for the Woodburytype, a mechanical printing process that reproduced the tonal qualities of a photograph, patented in 1866 and introduced into France the following year.[16]

Gettings blithely refers to "Buguet's style" and of "a spirit pose characteristic of Mumler's work"[17] apparently without realizing the implicit argument therein: such stylistic differences from photographer to photographer suggest their individualistic manipulation of the elements rather than the effect of some supernatural force (as they pretended) beyond their control. Thus Mumler's photographs are typified by white, ethereal figures standing behind a sitter and placing a cheek to theirs, or laying their hands consolingly upon their shoulders,[18] whereas those of Edward Wyllie show one or more disembodied heads peering out of circular or roughly keyhole shapes and having hard edges suggestive of collage-type cutouts.[19] Again, Gettings speaks of Robert Boursnell's "highly characteristic work"; his spirit extras are usually white-robed figures, the females having long white scarves over their heads, the men wearing beards and turbans.[20]

However, when Boursnell could obtain an actual picture of the deceased person from the sitter—using some pretext, such as needing it to help him identify the spirit, perhaps, or possibly himself having taken the person's picture once—Boursnell's style changed: the "extra" is wearing the exact clothing and striking the identical pose, indeed matching in every way the supplied photograph.

Similar fakery was obviously involved in a ca. 1917 spirit picture of a woman with the spirit of her sister who died ten years previously. Not only is the perspective wrong (its size places the spirit behind her sister, yet her transparent body is in front of her) but the face is *identical* to a portrait of the deceased made about 1905. In another case, one of two spirit faces appearing in an 1895 portrait of a man named J.R. Mercer was identified by Mercer as his first wife. Enlargement of the image reveals the characteristic pattern of a halftone screen, indicating the picture had been cut from a newspaper or other publication. But Gettings seems to believe the picture genuine, pointing to the fact of the woman's death sixty-nine years before, thus predating not only the halftone process but photography itself. It does not seem to occur to Gettings to question such an ancient man's recognition of someone whose image he has not seen in nearly seventy years![21]

Just as the styles of spirit photos varied, so did the techniques— twenty-two fraudulent methods by one 1921 count, "and more have been developed since," reports Mulholland.[22] Many spirit photographers were produced by double exposure, the "spirit" portion perhaps being made by some montage process. For example, Mrs. Ada Emma Deane liked to pro-

duce pictures of what she termed "Spirit Controls," often Egyptian princes or Indian Chiefs. One of the latter, a chief in war bonnet and full regalia, was shown to have been cut from the front cover of a popular magazine. Again, a picture taken by Mrs. Deane on Armistice Day 1924 showed spirits of dead war heroes hovering around London's memorial, the Cenotaph. Unfortunately for Mrs. Deane, the London *Daily Sketch* copied and enlarged the picture, discovering that the "heroes" were living ones: members of a professional soccer team.[23] As one spirit photographer candidly confessed to a friend, "It's 'ell to get the pitchers yer want to reproduce!"[24]

Apart from various camera and darkroom tricks, there were other ways of producing "spirits" on the photographic plate. While the sitter was intent on remaining motionless for the exposure, his head held in place by clamp or head-rest, it was only necessary "for the 'spirit,' suitably attired for the occasion," as an 1896 text explained, "to appear for a few seconds behind the sitter during the exposure and be taken slightly out of focus, so as not to appear too corporeal."[25]

Similarly, some pictures taken during séances are obviously ordinary photographs of dressed-up mediums, including those of the spirit "Katie King" who was allegedly summoned up by a winsome English girl named Florence Cook. Wearing a black dress, Florence would be tied into a spirit cabinet (in the style of the Davenport Brothers, who revealed their escape tricks to Houdini). Soon, "Katie" would emerge into the dimly lit room, dressed in white. One observer who attempted to grab the ethereal figure discovered it was quite material instead, and was under the impression that "Katie" was really "Florrie," decked in a rumpled dress and tea-towel.[26] The distinguished scientist William Crookes (discoverer of the element thallium) "gave the press a field day," reports one authority, "by falling for 'Katie' and embracing her rather too warmly and too often in the dimness of the seance-chamber"[27] (and later in the privacy of Crooke's own home[28]). Photographs of the "materialized" Katie King taken in séances in London in 1873 and 1874 show that her features match those of Florence Cook,[29] and one appears to show a dark dress beneath the spirit Katie's white one.[30]

Because one photo shows "Katie King" with an elderly gentleman whose eyes are apparently closed, one commentator remarked sarcastically that this "must have helped to sustain the illusion."[31] Actually, the sometimes closed and otherwise heavy-lidded eyes of both medium and sitters in most of the photos is owing to the necessity of using magnesium light to take them. The pictures also exhibit strong contrast of tone. Crookes said (in perhaps a revealing statement) that "photography is as inadequate to depict the perfect beauty of Katie's face, as words are powerless to describe her charms of manner."[32]

One ingenious method of producing spirit pictures utilized a fluores-

cent substance, such as bisulfate of quinine. As a late-nineteenth-century text explained: "This compound, although almost invisible to the eye, photographs nearly black. If a white piece of paper be painted with the substance, except on certain parts, the latter only will appear white in the picture."[33]

Of course, as indicated by the incident of the observer who grabbed "Katie King," skeptics took delight in exposing spiritualists in general and psychic photographers in particular. An unrelenting crusader against the spiritualists was magician and escape artist Harry Houdini (born in Budapest as Ehrich Weiss). At the urging of Sir Arthur Conan Doyle, who attempted to convert Houdini to a belief in spirits, or at least persuade him to cease his exposés of those Doyle had publicly endorsed, Houdini visited Alexander Martin. A Denver photographer, Martin was noted for providing his subjects with spirit extras, and Houdini received no fewer than five disembodied heads, arranged in an arc above his own head.

The magician was amused, especially that three of the "spirits" wore glasses: he had not known that opticians worked in the Land Beyond. Upon studying the photograph Houdini concluded that Martin had cut the heads from other photos, arranged them on a black background and made an exposure of the plate, masking the area in the center. With such a prepared plate, Martin could photograph any sitter and cause ghostly visitors to "materialize" over the person's head. Later Houdini made some strikingly effective double exposures of his own: one of himself clasping his own shrouded, levitated, ethereal form, and another in which he appears with Abraham Lincoln.[34]

Skeptics played a variety of tricks on the trick photographers. Some of the latter—in order to "prove" their work genuine—permitted sitters to bring their own plates. These would be surreptitiously exchanged for a prepared one, using some means to distract the person's attention. Then, if he desired, the sitter could even use his own camera. However, as Walter Gibson relates in his *Secrets of Magic:* "One keen investigator used that opportunity to turn a plate upside down while putting it in the camera. The plate had already been switched, so the spirit faces appeared when it was developed, but not quite as expected. Instead of floating above the living person's head and peering benignly downward, they were all upside down at the bottom of the picture, looking up in surprise."[35]

Similarly, investigator Harry Price brought his own plates for a session with psychic photographer William Hope, just as Hope had requested. Price, however, had secretly taken a precaution: he had the Imperial Dry Plate Company, Ltd., use X-rays to make a mark on the sealed plates. In due course Hope produced a picture with a spirit "extra," but since the plate lacked the X-rayed mark Price knew the plate had been switched.[36]

Yet another case of someone trying to outdo the spirit photographers is related by Mulholland in *Beware Familiar Spirits:*

Some of the most mysterious spirit photographs have been the work of persons hostile to the cause, who wanted to show what could be done by trickery. William Van de Weyde, a well know New York photographer, took some pictures for a group of investigators in New York in 1922, under the conditions laid down by Sir Arthur Conan Doyle as prerequisites for the acceptance of a spirit photograph. These conditions were, a. control of the photographic procedure by the investigators (they to buy plates, supervise exposure and development, etc.); b. appearance on the plate of a dead man's picture; c. resemblance of the picture to the dead man, but not to any known life portrait of him. All these conditions Van de Weyde complied with to the letter, and he got a spirit "extra" very definitely representing Professor James Hyslop, the well known psychic investigator, then dead. Van de Weyde admitted that the picture was a fraud, perpetrated to prove his personal disbelief in Spiritualism, but he made a hundred-dollar bet with Samri Frikell that Frikell could not discover the method.

Mulholland continues:

After a considerable amount of digging around, Frikell won the hundred dollars. The method was, as a matter of fact, much less subtle than some of those which spirit photographers have developed: he had in his files a photograph of Professor Hyslop which Hyslop had not cared to buy, and which therefore had never been seen by any one else; he bought a package of plates, carefully opened it, copied this unknown photograph on to one of the plates, repacked everything with the utmost exactness, and took the package to a photographic supply dealer. Here he asked one of the clerks to offer this particular package when he (Van de Weyde) and two other men came in to buy plates.[37]

In yet another case, an even more impressive demonstration was given by a spiritualist named C.P. MacCarthy of Sheffield, England. In this instance the committee purchased the plates which MacCarthy was never allowed to touch during the entire proceedings. Indeed, the camera was taken "straight from a supply dealer's stock," MacCarthy was searched, and then he was actually *handcuffed* while the plate was exposed and developed by a professional photographer. Even so, five of the plates bore "spirits," three of which the sitters recognized! Mulholland continues the story: "Afterward Mr. MacCarthy explained his method. First he hunted up some old photographs which looked like certain members of the committee. Mrs. William Ewart Gladstone was recognized by one of the sitters as his mother. Mr. MacCarthy managed by suggestion to get his own father to ask for a dead friend whose picture he had got hold of; this recognition, that is, was correct. He then made micro-photographs of the five pictures." (A microphotograph is a photograph reduced to microscopic size and known from at least as early as 1858 when it was described in a dictionary of photography.) As Mulholland continues:

Each microphotograph was about the size of a pinhead. These he mounted in a special tiny projector for throwing ultraviolet rays, invisible to the human eye, but active on photographic emulsions. The projector was about the size of his little finger. Where he hid it during the search he would not say; but he got hold of it in the dark-room, and was able by careful practice to point the proper picture at the proper plate from a distance of eighteen inches. The handcuffs, of course, did not prevent him from pointing his finger, under which he had the projector attached.

Mulholland gives no source for this story, but he does concede: "It seems to me that this honest trick is almost as remarkable in its details as would be a genuine spirit 'extra'! Certain magicians' tricks are more surprising when you know how they are done than when you do not, and I am inclined to put Mr. MacCarthy's performance in that class."[38]

Walter Gibson relates still one further ingenious method of making spirit photographs under "controlled" conditions. It utilizes a special table having a concealed electric light, and a developing tray having a shallow double bottom capable of holding a preexposed plate. After the sitter's portrait is taken on an unprepared plate, *which can even be marked for future identification*, the plate is put in the developing tray and covered so no light can enter. Gibson explains:

But light does get in from below, for the medium presses a hidden release and the center of the tabletop drops in two sections like miniature trap door. The light goes on automatically, but cannot be seen because of the covered tray.

The light causes the ghost portraits to be projected from the hidden plate in the double bottom of the tray to the sitter's original plate above. The medium presses the switch again, the light goes off, the trap closes, and the sitter's plate is removed from the tray. On the developed plate, the sitter's portrait appears with faces hovering above, dim but recognizable, like spirits.[39]

Ironically, photography played a role at one séance—not in producing fake spirit pictures but in providing pictures of the fake spirits. The séance took place at the infamous Camp Chesterfield, a spiritualist enterprise in Chesterfield, Indiana, long known as a source for such bogus phenomena as the production of "apports" (alleged gifts of the spirits, typically concealed on a medium's body or in a hidden compartment of his or her chair) and of "ectoplasm" (an imagined mediumistic substance (often faked with chiffon or gauze). Unwittingly, the administrators of the camp permitted investigators to film the "spirit materializations," but apparently they were unaware of the see-in-the-dark properties of infrared film. The photographs obtained revealed that "the ghosts were living people masquerading in luminous clothes," and using a secret door to effect their entrance and exit. However, the clever mediums at Camp Chesterfield soon thought of a way to explain the damning film to their followers. As a confessed former fraudulent medi-

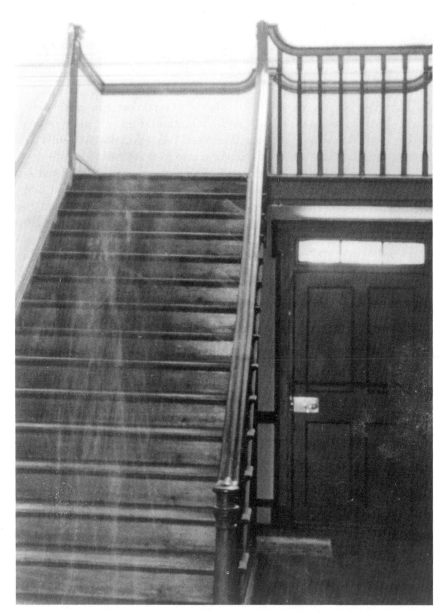

Figure 7.4. The "shadowly outline" of the ghostly "Gray Lady" of Liberty Hall in Frankfort, Kentucky. Is it truly a photograph of a ghost, or does it have a more mundane explanation? (Photographic copy courtesy of Bill Rodgers.)

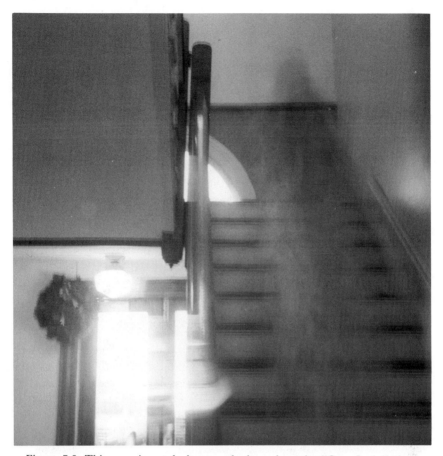

Figure 7.5. This experimental photograph shows how the "Gray Lady" ghost photo might have been produced: by having someone move quickly down the stairs while the shutter is kept open. (Photograph made for the author by Clint Robertson.)

um at the camp, M. Lamar Keene, stated in his book, *The Psychic Mafia*: "It was all 'trick photography,' we told our people, and of course the spirit communicators backed us up in our seances. That was good enough for our followers!"[40]

One of the most famous and widely published "ghost" photographs is one taken of the so-called "Brown Lady" on the stairway of historic Raynham Hall in Norfolk, England, in 1936. It was made by two magazine photographers who glimpsed the ghostly figure in time to take a quick exposure—or so they claimed. It is widely reported that photography experts examined the original photograph, with its vague image of a phantom figure, without detecting trickery. However, rarely seen is the sequel to the affair: More thor-

ough analysis demonstrated the picture was a fake, made by superimposing one image over another.[41]

A somewhat similar photograph of the Gray Lady's ghost at Liberty Hall in Frankfort, Kentucky (Figure 7.4), was examined by professional photographer Clint Robertson, although the original prints and negatives had conveniently vanished. Robertson reported: "My first theory on the Ghost of Liberty Hall photograph was that the camera simply malfunctioned. However, if a flash had been used and both camera and flash functioned properly, a normal flash photo would have resulted. A ghost or a person would have to be moving faster than the speed of light to be represented several times in one normal flash exposure." After considering other possibilities and performing "several empirical tests to determine whether or not the photograph is a result of a malfunction or darkroom manipulation," Robertson concluded: "It is my experienced and educated photographic opinion that the photograph is, at best, the result of an accident. I am certain for photographic and scientific reasons that the figure ascending the stairs definitely is a person and not an apparition."[42] One of Robertson's experimental photos (Figure 7.5) shows one way such an "accident" might have happened.

An accident may indeed be the explanation for certain other "ghost" photographs. For example, in the early 1900s a British photographer developed a photograph he had made inside a chapel, only to discern in one of the panels the faint image of a human face. Astonishingly, he recognized the features as those of a friend who had recently met a tragic end. Psychical researcher Frank Podmore showed the photograph to one of his own friends who immediately identified the face as that of someone else. Commented Podmore, "The outlines are in reality so indistinct as to leave ample room for the imagination to work in," a tendency we have already seen evidence of.

But what was the cause of the spirit image? There are several possibilities, apart from hoaxing, one of which lies in the long exposure needed for the relatively slow film used at the time, especially in dim light, such as that in the photo in question, which was taken indoors. As Daniel Cohen theorizes, since such an exposure would last an hour or more, the photographer would set up the camera using a tripod, open the lens, and then bide his time elsewhere. "If, during that period, someone walked into the scene that was being photographed and paused for a few seconds to look at the camera," Cohen speculates, "that person's face and form would register as a faint and ghostly image on the film." He concludes: "If the photographer did not know that someone had walked into the scene, he might indeed believe that he had photographed a ghost."[43]

Many of the modern snapshots that amateurs believe have recorded ghosts turn out to have been caused by an imperfection in the film or cam-

era, both of which should be examined whenever anomalous forms are encountered. Some anomalies, though, are transient. For example, at the "haunted" Mackenzie House in Toronto, Canada, Susy Smith, author of *Ghosts Around the House*, obtained a spooky picture. The published photograph shows one of her companions, a "warlock" named Raji, with his fingers extended over the keyboard of the antique piano. As Smith herself describes it, the photo "reveals a mysterious kind of mist between his hands and the keys. If this was caused by double exposure," she asks, "why is not the rest of the picture in duplicate?"[44]

Actually, the "mist" is simply the result of glare or "flashback," as it is sometimes called. The white pages of music resting on the piano simply bounced back her flash, the use of which is evident in glare on the polished wood and the extreme shadows present in the picture. Thus a portion of the image was "washed out." (A professional photographer examined the published photograph and concurred in my explanation of the "mist."[45])

As another example, consider photos in one of several silly books by Ed and Lorraine Warren—actually, "as told to," in this case, Robert David Chase. The book is titled *Graveyard: True Hauntings from an Old New England Cemetery*. Undaunted by having proclaimed various places tenanted by ghosts and even by sexually attacking demons(!), only to have the claims later exposed as hoaxes—"the Amityville Horror" being only one example of many[46]—the Warrens have turned their talents as "demonologists" to a quiet cemetery near their home at Monroe, Connecticut. The book includes nighttime photos taken in the cemetery showing what is alleged to be "a rare instance of spirit energy" captured on film. Actually there is only some mist, again attributable to the use of a flash, and some bright round dots, with the caption, "Spirit energy sometimes appears on film as a spherical shape."[47] Does it really? Then again, as one authority on photographic anomalies states (in the context of UFO photos), "If you take photographs by night using a flashlight, tiny particles of dust or raindrops in front of the camera may appear on the picture like brilliant balls of light."[48] That certainly describes the appearance of the "spirit energy" depicted in the *Graveyard* photographs.

As a result of such cases most knowledgeable investigators conclude that the photographic evidence for ghosts—like the evidence for spirit phenomena generally—is, at best, doubtful in the extreme.

UFO Snapshots

Mankind has always seen strange sights in the sky—phenomena we might now recognize as eclipses, comets, "shooting stars" (meteors), and other

celestial objects and events. Before the emergence of astronomy as a science, however, imagination interpreted them as gods, signs or portents, or evidence of another world peopled by strange beings. A ninth-century Latin manuscript, for example, tells of a belief, prevalent among the French peasantry, in a "certain region called Magonia from whence come ships in the clouds."[49]

Manned flight—beginning with the first ascent in a balloon at Paris in 1783[50]—fueled the modern imagination. In 1878 a farmer named John Martin, of Dallas, Texas, described to a reporter a large object he had seen in the sky which appeared "about the size and shape of a large saucer" when it was overhead. The Denison *Daily News* stated, "Mr. Martin is a gentleman of undoubted veracity and this strange occurrence, *if it was not a balloon*, deserves the attention of our scientists" (emphasis added).[51] From November 1896 to mid-1897 came a rush of reports from across the United States of sightings of "airships," accompanied by fanciful tales of conversations with the pilots as well as bizarre stories of airship crashes and even the retrieval of a Martian corpse. Apparently these stories were hoaxes by journalists and others.[52]

After World War I, "the world's first ufologist," Charles Fort, stirred interest in mysterious phenomena, including unidentified objects in the sky that Fort believe indicated visits from space aliens.[53] Fort (1874-1932) loved to taunt "orthodox" scientists (whose education and credentials he appears to have envied) with things they supposedly could not explain—fish falling from the sky, for instance. He did not actually investigate the occurrences but simply relied on reports in old newspapers and magazines and treated them as if, being in print, they were obviously true.[54]

In the 1920s, 1930s, and 1940s, science-fiction pulp magazines became popular, especially one created in 1929 called *Amazing Stories*. However, when its circulation began to lag and the magazine changed hands, a new editor named Ray Palmer boosted sales with wild stories of visitations by extraterrestrial creatures, and he decorated the covers with occasional illustrations of strange, circular spaceships. Material gleaned from Charles Fort's writings was used as "evidence" for alien activity. By 1946 sales had zoomed to 250,000 copies.[55]

The following year—when *Amazing Stories* was on the newsstand with an article on strange, craftlike objects—there came the sighting that would implant the term "flying saucers" in the popular imagination. On June 24, 1947, a businessman named Kenneth Arnold was flying his private plane over the Cascade Mountains in Washington state when he saw what he described as a chain of nine disc-like objects, each flying with a motion like "a saucer skipped across water" near Mount Rainier.[56] According to one writer: "Possibly no one was the more surprised by Kenneth Arnold's 1947 story, regarded as the UFO sighting that triggered off the 'modern era' and cer-

tainly gave the phenomenon its first popular name—flying saucers—than Ray Palmer. Palmer's fiction had become reality! Viewed with hindsight, Arnold's sighting came in the middle of a UFO-flap in the United States that lasted into July."[57]

Theories about just what Arnold saw abound, ranging from "a group of aircraft"[58] to "mirages due to temperature inversion."[59] In any case, additional sightings of "flying saucers" (later termed by Air Force investigators "unidentified flying objects" or "UFOs") soon proliferated across the United States. On July 4, 1947, in Seattle, one of the "saucers" was photographed. After considerable publicity, however, it was identified as a weather balloon.[60]

This was not the first photograph made of a UFO, however. That distinction is usually given to one José Bonilla at the Zacatecas Observatory in Mexico. On August 12, 1883, he was observing sunspot activity when he saw more than three hundred dark, unidentified objects crossing before the sun. Using wet photographic plates and an exposure time of $1/100$th of a second, he was able to take several photographs. It was subsequently determined that the objects were flocks of high-flying geese.[61]

Before long, suspicious, and even obviously hoaxed, photos began to appear—or rather to reappear. According to UFO historian Jerome Clark, during the great "airship" craze of 1896 and 1897 a Chicago newspaper carried a report (dated April 11, 1897) about one of the alleged sightings. However Clark states that the report was "based on what proved to be a faked photograph."[62]

Many of the modern photos depicted what are called "daylight discs": metallic, prototypically saucer-shaped objects,[63] like the one mentioned in the previous chapter as having been twice photographed by a farm couple at McMinnville, Oregon, in 1950. As we have seen, investigator Robert Sheaffer noted serious discrepancies in the story told by the couple (a Mr. and Mrs. Paul Trent). The two pictures had been taken in the morning rather than the evening and were separated in time by several minutes rather than a few moments.

These observations were not made by the original investigator. Dr. William K. Hartmann, a photo analyst from the University of Colorado, which had contracted with the U.S. Air Force to conduct a scientific study of UFOs, was initially impressed with the pictures. As related in *UFOs Explained* by Philip J. Klass:

Hartmann explained that the shadowed bottom of the object, visible in one of the photos, "has a particularly pale look, suggestive of [atmospheric] scattering between the observer [camera] and object. . . ." He noted that the apparent brightness ("luminance") of an object increases with its distance and that "if an object is suffi-

ciently far away, its brightness equals the sky brightness." Hartmann used a densitometer to measure the luminance, relative to that of the sky, of objects on the ground, such as a distant barn whose range was known. On this basis, Hartmann found that the technique appeared to be accurate for the Trent photos within an error of no more than 4 to 1. This would be accurate enough to determine if the UFO was only a few dozen yards away from the camera, and hence a small object, or many hundreds of feet away, in which case it must have been a giant craft. It was the latter conclusion that emerged from his photometric analysis.[64]

However, Klass decided to reinvestigate the case when he learned in 1969 that the McMinnville photos were the only ones showing a structured, craftlike object that Hartmann had concluded were probably authentic. He obtained copies of the negatives that had been made of the original Polaroid prints and sent them to Sheaffer. The discrepancies Sheaffer discovered led him to conclude that the pictures represented a hoax and that the object— which resembled an inverted pie tin flung into the air—was no doubt a small one after all. Sheaffer also developed a theory to explain Hartmann's erroneous findings. He showed experimentally that an oily film on the lens— as might accumulate from someone pushing on the lens to close the folding-type camera—diffused the light from a bright sky. This increased the luminance of a suspended metal object used for the experiment.[65] Indeed, apprised of Sheaffer's research, Hartmann conceded: "I think Sheaffer's work removes the McMinnville case from consideration as evidence for the existence of disklike artificial aircraft" (extraterrestrial spacecraft). He added that the case "proves once again how difficult it is for any one investigator . . . to solve all the cases. Perhaps no one has the experience for that, because there are too many phenomena and methods for hoaxing."[66]

Densitometer tests like those Hartmann used—together with image enlargement and analysis of the sun angles (as Sheaffer performed in the McMinnville case)—were successful in exposing as a hoax another set of UFO photographs. Those were Polaroid snapshots taken by a Zanesville, Ohio, barber who claimed the mysterious object hovered over his home for approximately one and a half minutes. However, the photographic analysis conducted by the Rand Corporation concluded: (1) the object was only about three to four inches in diameter, not the thirty feet claimed by the barber; (2) the object was merely three to four feet from the camera, instead of a considerable distance as alleged; (3) the photos were not taken within the space of a minute and a half, but instead about one hour and ten minutes had elapsed between photographs; and (4) the numbers on the photos' backs were out of sequence with regard to the barber's story.

When investigators presented the barber with a copy of the Rand report, he promptly confessed to the hoax, stating: "They were just about damn right about everything they said about these pictures."[67]

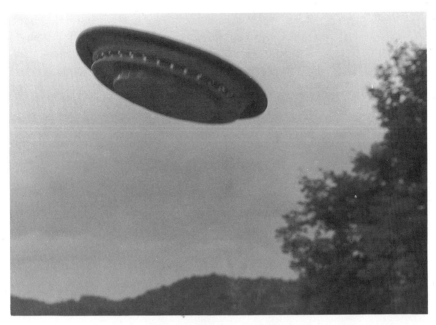

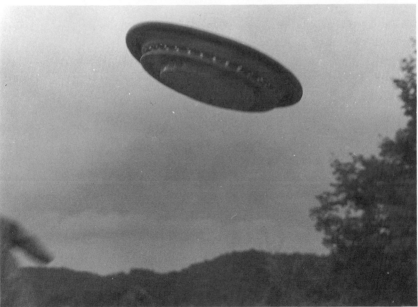

Figures 7.6-7.7. A photograph of an apparent "flying saucer" (*top*) is demonstrated a fake when it is shown to have been cropped from a full-size print, revealing the person who threw the small model discus-style into the air. (Experimental photo by John May.)

A different set of analyses was utilized by a UFO organization, Ground Saucer Watch (GSW), in an attempt to improve the accuracy of UFO photo analysis. They applied a computer-linked television monitoring system, originally designed to enhance X-ray photographs for purposes of quality control. The tests consisted of (1) *edge enhancement* (artificially enhancing the image's edges to reveal fine details—such as a thread holding up a model UFO—that cannot be seen in the picture with the unaided eye); (2) *color contouring* (mapping areas of different image densities with thirty-two artificial colors, thus providing information on the object's precise shape and its reflectivity in comparison to known objects); (3) *profiling* (using an electronic "cutting knife" to depict, in outline form, the object's profile or depth view); and (4) *digital image enhancement* (computer-manipulating the pixels—of which there are 250,000 minute squares in one photograph analyzed by the system—to enhance the image and study the distortion of its edges, the effect of distance).[68]

The pixels can be manipulated either to increase or decrease contrast; they can be used to lighten a picture's shadow areas while holding back the brighter areas and thus retain detail in both, something quite difficult to accomplish photographically. As well, the system can be used to calculate various measurements of angles and distances between objects in the photograph, thereby indicating whether the UFO is an object in the camera's view or an image subsequently superimposed on the scene.[69]

GSW analyzed a thousand UFO photographs in this manner and rejected all but forty-five (4.5 percent) as being misidentifications of the ordinary objects and hoaxes.[70] Among the latter were objects that appeared to have been suspended by threads and others that were probably small models (see Figures 7.6 and 7.7) flung discus-style into the air. Such unidentified Frisbee objects include one resembling a straw hat photographed by Rex Heflin near Santa Ana, California, in 1965.

But what about the 4.5 percent of photographs that "passed" GSW's tests? Are they proof that extraterrestrial spacecraft are a reality? Actually to draw such a conclusion would represent a logical fallacy known as *argumentum ad ignorantiam*, literally arguing from ignorance, as the unidentified objects simply remained unidentified.

More significant is the fact that the GSW technique is not infallible. For example, GSW examined a photograph taken over Calgary, Canada, and stated publicly that it was a "genuine" UFO, being large in size and distant from the camera. Subsequently, they were given another photograph to analyze. It happened to have been made by the same photographer of the identical daylight disc (as such UFOs are commonly called) on the very same roll of film. This time, however, GSW reported that the film "depicts the crudest attempt at a hoax that we have ever seen."[71] This incident illus-

trates once again the value of requiring that the complete roll of film be submitted for analysis.

Among the techniques that are known—or deduced—to have been used for producing hoax daylight disc pictures are the following: Suspending, sailing in the air, or placing on the ground a model spaceship; making photomontages (using portions of different pictures to produce a composite); taking a double exposure (especially by first photographing a model against a black background); superimposing cardboard cutouts, pictures, or models by attaching them to a pane of glass (or in the case of five UFOs photographed over Sheffield, England, in 1962, painting pictures on the glass), then photographing a scene through the pane; retouching negatives; placing a metal button on an aerial photograph and then rephotographing the view (a technique used by a Venezuelan airline pilot in support of an alleged sighting); and other methods, including projecting two "sandwiched" slides onto a screen and rephotographing the resulting image. (This has been suggested as a means possibly employed by a Swiss caretaker named Eduard "Billy" Meier who is known to have used models in producing hundreds of photos of "beamships" that have supposedly visited him personally.[72])

Of course, not all daylight discs are hoaxes. Some very striking ones, which appear to be aglow, are nothing more than "lens flares"—the result of interreflection between lens surfaces—caused by a bright light, like the sun, being photographed off-axis. Allan Hendry, in his *UFO Handbook*, provides photographs with unique lens flares that resemble "flying saucers."[73] Defects in film emulsion and lens defects can also cause UFOs to appear on prints.[74] As Jerome Clark states in his *UFO Encounters*, "Investigators tend to view with suspicion any 'UFO' photograph when no one observed anything unusual at the time" (a skeptical view that should also apply to other photographs of allegedly paranormal subjects or occurrences).[75]

Other potential sources for daytime UFO sightings and flying-saucer photographs are listed by Hendry in a chapter titled "The UFO Impostors: Daylight Disc IFOs" (that is, *identified* flying objects). These include weather, research, and other balloons; aircraft (for example, an airplane photographed from the front or rear can look like a shiny, domed saucer); meteors; lenticular (lens-shaped) clouds; kites, blimps, and hang gliders, windborne objects of various kinds; and many others.[76]

Nighttime UFOs—so-called "nocturnal lights"—represent the most frequently reported UFO events and also the "'least strange' events" according to the late Dr. J. Allen Hynek, astronomer and former consultant to the U.S. Air Force Project Blue Book (a former UFO research program). Although Project Blue Book (1952-1969) determined that there was no evidence that saucers were extraterrestrial vehicles, Hynek later promoted UFOs as a *cause celebre*. Nevertheless, he conceded: "It should be clearly

understood that *initial* light-in-the-night-sky reports have a very low survival rate. An experienced investigator readily recognizes most of these for what they are: bright meteors, aircraft landing lights, balloons, planets, violently twinkling stars, searchlights, advertising lights on planes, refueling missions, etc. When one realizes the unfamiliarity of the general public with lights in the night sky of this variety, it is obvious why so many such UFO reports arise." [77] Hynek was concerned only with cases that could not readily be dismissed. [78]

Of course hoaxers were cleverly faking this type of photograph as well. For example, as John Shaw relates in an essay, "Is a Picture Worth a Thousand Words?":

In March 1970, David Simpson initiated a photographic UFO hoax at Warminster in England which ran for two and a half years. At that time, Warminster was the UFO centre of England and anyone interested in the subject made the pilgrimage to the hills just outside the town in the hope of seeing one or more of the many UFOs reported. It was on one such "skywatch" one night that a group of people interested in the subject became the unwitting pawns in this event. David Simpson placed a purple light on top of a car some distance from the researchers while a colleague of his within the group appeared to take photographs of the "UFO". The group were not aware of this liaison; in fact the UFO had already been superimposed onto the film prior to the evening's events. The resulting film, taken away that night and processed by the group, showed two UFOs hovering above the hill.

Shaw continues:

Despite the fact that there were many inconsistencies in the witnesses' accounts of the night's events, such as two UFOs above the outline of hills in the photographs while the group observed one light below the level of hills at the time; and that a study of the previous frames showed some street lights to be on and other frames showed them to be off on the actual night in question, the photographs were extensively publicized by UFO buffs and purported to be genuine. An eminent French scientist went on record as saying that he was convinced of their authenticity. Sadly, many people interested in the subject will accept evidence on face value if it supports their case. [79]

What has been touted as "one of the most important UFO cases in the past 40 years," includes nighttime photos of glowing spacecraft taken in 1987 by a Gulf Breeze, Florida, architect named Ed Walters. However, the photographs contain revealing anomalies: for example, in one, the UFO overlaps a tree, yet the tree *shows through* the UFO image. Such anomalies are consistent with the confession of a neighborhood youth who had helped Walters fake some of the photos. This, said the youth, was accomplished by photographing a lighted model against a black background with a Polaroid camera capable of double exposure, then photographing a scene outside Walters's home. A local television used the technique to produce remarkably

similar photographs, but Walters continues to deny the charges of fakery, even though a small UFO model—resembling the UFO in the Gulf Breeze photos—was discovered hidden in the attic of his former home![80]

Not surprisingly, there are many ways to fake photos of nocturnal light UFOs, as Robert Sheaffer has demonstrated, for experimental purposes. One Sheaffer photograph shows two glowing, saucer-shaped craft in the night sky above some suburban houses. It was produced by making a triple exposure: one exposure for each of the UFOs (made by shining a light through a hole in the center of a 45 rpm phonograph record, tilting it to make the light an elliptical shape) and a third exposure to photograph the suburban scene. Another Sheaffer photo depicts a glowing spaceship in flight near the moon. The spaceship was fabricated from two aluminum plates, sailed through the air Frisbee style, and photographed. A strobe-type flash lamp was used to illuminate the model saucer while a time exposure was made of the moon.[81]

In the case of motion pictures, it may be thought that their analysis would be more difficult, but as one investigator observes: "On still photos, fakes are easy to do and hard to prove, but on film there is more to be analyzed." This is especially true in the case of UFO pictures, because, says the investigator, "with a moving image it's easier to pronounce about the size and—most of all—mass of the object."[82] Also, elapsed time may betray the hoaxer, as illustrated by another example. The film in question was 8mm movie footage of the London skyline. As investigator John Shaw explains:

The view showed a UFO hovering and then moving across the picture and out of the field of view. The witness had stated that the camera had been mounted on a tripod in his living room and while he was looking through the camera's viewfinder he had seen the UFO and commenced to film it. A detailed questionnaire had been completed by him and forwarded to me with the film. A frame by frame study of the film showed, on the left far horizon, a factory chimney was not smoking, but there was a long plume of smoke from it on the frame where the object started to move. As this was supposed to be one, continuous filming, obviously something was wrong. On interviewing the witness, with this in mind, I noticed that in his living room there was a table lamp which resembled the shape of the UFO. It was fairly easy to deduce that he had photographed the reflection of the lamp in the window glass, turned off the camera, presumably to rig a remote shutter release, and then filmed the skyline while he moved the lamp, reflecting its image in the glass. Unfortunately for him, in this period of time, the factory had gone into production and gave me the clue I needed to determine this case to be a hoax.[83]

An interesting example of the analysis of a UFO film is a case involving a professional cameraman who shot the footage while he was flying over Catalina Island, California, in 1966. It depicts a silver, disc-shaped object

estimated by the cameraman as being about sixty-five feet across and moving at a speed of 150 knots. The film remained unexplained for almost twenty years, until it was examined by NASA's image-processing facilities at the Jet Propulsion Laboratory:

A frame of the film was scanned, enlarged and displayed on a television monitor. This picture showed a fuzzy disc with all detail obscured in photographic grain. The following frame was also digitized and overlaid on the first; the two frames being averaged. This procedure was carried out with the third and fourth frame. On each pass, the grain in the picture diminished and the image of the UFO became sharper and exhibited more detail. Slowly the UFO became recognizable as a small, light aircraft, seen from about the same flight level (hence the absence of any wings seen in the film) and at three-quarter angle, which tended to obscure the tail fin of the aircraft. After enhancement even the cockpit and pilot could be discerned.[84]

Some of the most outrageous photographic hoaxes relating to UFOs do not depict the mythological flying saucers but take some other tack. Several hoaxes relate to "the Roswell incident," what the U.S. government says was the crash of a balloon-borne weather device called a "Rawin target" but what is believed by many UFO proponents to have been a flying saucer. They believe that photographs of the debris, showing the balsa frame and foiled paper of a Rawin target, were "switched" for that of the saucer, and that the craft's little humanoid occupants are hidden away at a government facility, such as the (nonexistent) "Hangar 18" at Wright Patterson Air Force Base.

In 1987, official papers purporting to reveal a government cover-up in the case were sent to a little-known UFO buff in the form of a roll of unprocessed 35mm film. These "MJ-12" papers (for "Operation Majestic Twelve") did not, however, withstand scrutiny. Glaring errors in format, content, and other elements showed that the "top secret" documents were amateurish fakes, obviously produced by a Roswell conspiracy buff.[85]

Other Roswell-related hoaxes continue. In his *UFO Encounters* Jerome Clark provides a few photographs of the alleged space creatures—with appropriate captions. One reads, for example: "Impressionable people believe this widely published photograph shows the body of an extraterrestrial humanoid recovered from the crash site of a flying saucer. In fact, the figure in the picture, taken in 1981, is a wax doll displayed in a museum in Montreal."[86]

Whatever the nature of the UFO photograph (or related picture) in question, one should keep in mind the criteria (discussed in the previous chapter) of investigating the provenance, checking the circumstances of the picture, examining the negatives, analyzing anomalous features, and avoiding self-deception. One researcher provides this cautionary note: "As long as there are people who fake UFO pictures and films for money, and as long as

there are no conclusive methods for analyzing these pictures, UFO research should not use photos as proof, only as further evidence in a well-researched case. But critics should consider also that the proof that you can make pictures or films of an aircraft model does not imply that no real aircraft exist!"[87] As yet, however, after decades of misidentifications, mythmaking, and outright hoaxes, there remains no convincing proof that extraterrestrials are visiting the planet Earth.

Pictures of Legendary Creatures

Like the elusive flying saucers, various creatures—monsters, fairies, and other legendary beings—manage to pose occasionally for a snapshot, as if to provide evidence of an existence that evades scientific verification. Unfortunately, once again, the images range from inconclusive to misidentified to fake.

One such creature is said to inhabit a great Scottish lake, Loch Ness, according to accounts dating from as far back as the sixth century. In *The Life of St. Columba*, the saint's biographer relates how Columba saved a man from being attacked by the monster by commanding it to depart, a tale about as credible as many other pious legends of saints (some of whom could fly and live their lives without eating[88]). The extent of the alleged encounters since then is disputed,[89] but the modern wave of sightings began in 1933.

On May 2 of that year the *Inverness Courier* carried an account by an anonymous correspondent (actually one Alexander Campbell), "STRANGE SPECTACLE IN LOCH NESS," telling how an unnamed couple had seen the waters of the loch disturbed by "no ordinary denizen of the depths" but perhaps by a great "monster," at least "judging by the state of the water in the affected area." The article ended by alluding to some earlier sightings and the "feelings of the utmost skepticism" that they evoked.[90]

As it happens, the couple were a Mr. and Mrs. John Mackay, nearby villagers. According to Ronald Binns in his *The Loch Ness Mystery Solved*:

There is strong evidence that Alex Campbell, even before he heard about the Mackays' experience, was himself deeply committed to the belief that Loch Ness was the home of monsters. . . . The most immediate evidence is contained in the news item itself. Looked at carefully it becomes clear that Campbell's report was by no means a neutral, detached account of two people having sighted something unusual in the loch. Campbell was writing as a passionate believer, interested in establishing a dramatic context for the Mackays' experience. Months later it turned out that Campbell's version of the "sighting" was wildly exaggerated. Mrs. Mackay revealed that her husband had seen nothing, since he had been concentrating on driving. She herself had first seen at a range of only one-hundred yards, a violent commotion in the water which seemed to be caused "by two ducks fighting." It also afterwards emerged that

Mrs. Mackay's brother Kenneth was a major source for stories of the monster being seen *before* 1933.[91]

The week after Campbell's report, the *Courier* carried a response by Captain John Macdonald, who responded: "In the first place, it is news to me to learn, as your correspondent states, that 'for generations the Loch has been credited with being the home of a fearsome monster.' I have sailed on Loch Ness for fifty years, and during that time I have made no fewer than 20,000 trips up and down Loch Ness. During that half century of almost daily intercourse with Loch Ness I have never seen such a 'monster' as described by your correspondent." Captain Macdonald *had* seen "what at first might be described as a 'tremendous upheaval in the Loch,'" but he ascribed this "very ordinary occurrence" to "sporting salmon."[92]

Nevertheless, with Campbell's story the genie was out of the bottle— or rather the monster was in the lake—and more "sightings" soon followed. Natural phenomena—a floating log, for example, or a group of fish—gave rise to some sightings. The monster became a master of disguise. Reports of its length ranged from 6 to 125 feet and its shape varied remarkably as well: at times it resembled a great eel, but at others it had a large hump, or several humps (nine, by one count). It also had flippers, fins, a mane, horns, tusks, and other features; then again it has lacked those features. With chameleonesque ability, it has appeared silver, gray, brown, blue-black, black, and so on. Appropriately, one early satirist dubbed it "Mr. Otterserpentdragonplesiosaurus."[93]

It will come as no surprise that the imagined monster has functioned as a lodestone for both tourists and hoaxers. In one instance monster tracks along the shore of the loch resembled those, zoologists said, of a hippopotamus. Perhaps, one might have speculated, the monster was akin to the mysterious "hippogriff" of Lake George, New York. (It terrorized vacationists early in the century, but in 1934 the American painter Harry W. Watrous admitted he had created it from a ten-foot log which he regulated from the shore with a rope and pulley.[94]) As it happened, the Loch Ness tracks were produced by a hoaxer using a cast made from a hippo's hoof![95]

Photographs of the alleged monster have appeared from time to time, the first arriving only six months after Campbell's story of the Mackays' sighting appeared in print. It was taken in November 1933 by Hugh Gray, a man Binns describes as a "leg-puller," and it depicts "a blurred and indistinct serpentine shape."[96] One pro-Nessie writer, Tim Dinsdale, conceded: "It does not show very much of anything. The print has either been touched up, or light has spoiled the picture. There are other features in it which are peculiar."[97] The second Loch Ness photo—the so-called "surgeon's photograph"—was taken in April 1934 by a London gynecologist named Robert

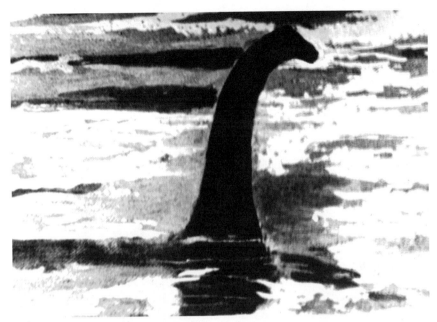

Figure 7.8. An obviously faked photo of the Loch Ness Monster, humorously sent out by a photo service as an "unretouched photo rushed here from London." (Courtesy of Dr. Gordon Stein, *Encyclopedia of Hoaxes*, 1993.)

Wilson. It is the classic Nessie photograph that so often accompanies accounts of the monster. Actually it is one of two snapshots made by Dr. Wilson, both of which show a dark shape—like the long neck and small head of a plesiosaur or other "sea monster"—silhouetted against the sunlit water. There is nothing to give an idea of scale, except the ripples on the water, which, if they are not waves, suggest a small creature. Some have suggested it was a large water bird found at Loch Ness, a cormorant.[98]

According to one journalist, "When I contacted Wilson himself, in quest of further details, he replied tersely that he made no claim to having photographed a monster and did not believe in it anyway." This sounds like a man tired of his prank, and indeed Wilson's youngest son "bluntly admitted that his father's pictures were fraudulent." Indeed, in 1994 two Loch Ness researchers reported they had learned the photo was part of a deliberate hoax, saying it depicted a model made from a toy submarine to which was affixed a neck and head made of plastic wood. Perhaps the exact day the photographs were taken in 1934 will help settle the matter: it was April 1, All Fool's Day![99] (See Figure 7.8.)

The many other apparently hoaxed photographs of Nessie include one taken in 1951 of "a three-humped monster"—or rather three humps only,

misaligned and unnatural looking and belonging to an unseen monster that leaves no wake.[100] Another, showing two differently sized humps was photographed in the water beside Urquhart Castle in 1955, but there are two versions of the photograph, prompting monster-hunting Professor Roy Mackal to ask: "If the object did, indeed, appear on the water in the original negative exposed of the scene, why was it necessary to rephotograph the 'original' print, with the resulting two different versions?"[101]

And then there are the photographs of the Loch Ness monster, the Lough Leane (Ireland) aquatic monster, and the sea serpent Morgawr, attributed to Tony "Doc" Shiels, the "psychic entertainer" mentioned in the previous chapter. The latter two photos depict monsters whose double-humped, long-necked shapes are "strikingly similar," possibly (according to one researcher) "shot using the same technique, that of a sculpted plasticine monster stuck onto a pane of glass in front of the camera."[102]

Not all photographs of the alleged creature are thought to be hoaxes, some images being attributed to swimming deer, salmon, even floating logs and other objects. Perhaps the most intriguing pictures are those on a film taken by monster hunter Dinsdale in 1960. An analysis of the film was conducted by the Royal Air Force's Joint Air Reconnaissance Intelligence Center (JARIC), which concluded that the moving object in the film was likely an "animate object." Carefully read, however, JARIC's report shows that the object—photographed a mile away—could be attributed to a motorboat. Indeed, Dinsdale reported the object had "a curious *reddish brown* hue about it," to which Binns responds: "An object with appears reddish brown at such a distance is clearly something which is relatively brightly coloured. Reddish brown is a reasonable colour for a motor boat, but an unusual one for the Loch Ness monster."[103]

An underwater photograph, taken in 1972 by Robert Rines and a crew from his Academy of Applied Science, supposedly depicted a "flipper" from an unknown creature. As it happens, the original computer-enhanced pictures were subsequently discovered to have been "significantly altered to give the impression of the flipperlike objects that appear in the published version."[104] The unretouched photos could depict virtually anything. In addition, expert review of the academy's sonar evidence—which Rines claimed as support for his interpretation of the "flipper" photograph—discredited the supposed proof of a lake monster's existence.[105]

Despite all the searches, no authentic trace of the monster—no carcass floating to the surface of the loch or skeleton bleaching on the shore—has ever been discovered. As *Time* magazine once reported, "There is hardly enough food in the loch to support such leviathans" and, "in any case, there would have to be at least twenty animals in a breeding herd" in order for the species to have continued to reproduce over the centuries.[106]

In contrast to the inviting region around Loch Ness, that of the Hima-
layan Mountains—the reputed habitat of legendary apelike creatures—is
more difficult to traverse. Moreover, the *yetis* as they are called, are said to
be shy and so are rarely seen and never captured. Yet for more than three
centuries the Sherpa people of the region have believed in the wild creature.
Through their contact with Sherpa guides, western explorers and moun-
taineers (including those who sought to climb Mt. Everest) brought back
rumors of the giant creature dubbed "Abominable Snowman" and said to be
up to eight feet tall, with conical skull and large feet.

Given the latter aspect of its reputed anatomy, together with its shy
nature, there should be no surprise that footprints of the creature, or photo-
graphs thereof, represent the most common form of evidence for the yeti's
existence. (A "yeti's scalp" turned out to be a fake made from the pelt of a
Nepalese serow, a chamois goat.) Unfortunately, the footprints photographed
by Frank Smythe in 1937 reveal that the trail "was indisputedly a bear's," and
the celebrated photos of mountaineer Eric Shipton, taken in 1951, depicted the
trail of a mountain goat. Confusion regarding the tracks can be caused by
several factors, such as snow melting, causing the tracks to enlarge and become
distorted before refreezing.[107]

One early sighting of a "wild man" was made by a Greek photogra-
pher named N.A. Tombazi, who saw the figure only momentarily and made
no pictures. He said that he did not believe in the "delicious fairy-tales"
about the yeti, and years later offered a theory that the "wild man" could
have been simply a hermit or ascetic. As Daniel Cohen comments in his *The
Encyclopedia of Monsters*:

There are Buddhist and Hindu ascetics who seek out the desolation of high places.
They can live at altitudes of fifteen thousand feet and can train themselves to endure
cold and other hardships that would kill the average person. They can and do walk
about naked or nearly so in the frigid mountain air. So Tombazi might really have
seen a wandering ascetic, as he first thought.

That is a disappointing beginning to the Abominable Snowman story, but it is
also quite typical, for the evidence that supports the existence of this creature has
frequently been less solid than it first appears.[108]

Such was the case with a 1986 photograph by British physicist Anthony
Wooldridge. Taken in the Himalayas near the India-Tibet border, the photo
depicted what Wooldridge and many others believed was the first yeti ever
photographed. Alas, recent evidence from photogrammetric surveys (photo-
grammetry being the science of making surveys and maps by photographic
means) demonstrated otherwise. The evidence proved—as Wooldridge him-
self admitted—"beyond a reasonable doubt that what I had believed to be a
stationary, living creature was, in reality, a rock." Corroborating evidence

came from a subsequent photo of the mountain slope that a local inhabitant took at Wooldridge's request. Absent the snow, there was indeed a rock feature on the slope that the physicist conceded was clearly the object he had photographed.[109]

An expedition to search for the yeti, conducted by Sir Edmund Hillary (conqueror of Mount Everest), proved fruitless, except for "yeti scalps" and similar fake relics, plus Sherpa tales. As an outcome of his search, Hillary denounced the whole concept of the Abominable Snowman as nonsense. Monster enthusiasts were angry, but Hillary's prestige and background gave him credibility. As a consequence, according to Cohen, "interest shifted to other monsters, particularly Bigfoot in the United States and Canada."[110]

Like the Abominable Snowman, Bigfoot is a large, hairy apelike creature. It is generally equated with the legendary American Indian Sasquatch (or "hairy man") which is said to live in caves in British Columbia and the Pacific Northwest. Questionable reports to the contrary, no credible capture of the alleged creature has been recorded, and skeptics are quick to point out that no carcasses or even partial skeletons have ever been recovered. "Surely the creatures die," insists Cohen.[111]

Bigfoot hoaxes have abounded. Those perpetrated with fake Bigfoot feet—like a pair carved from wood and used in 1930 by a forest service worker near Mount St. Helens to fool some visitors—have been especially common.[112] Hoaxes by persons dressing in realistic fur suits like one used in a hoax near Mission, British Columbia, on May 15, 1977, are occasionally uncovered.[113] In another case, a Sasquatch-type creature encased in a block of ice was exhibited at fairs and carnivals where it was billed as the Minnesota Iceman. Some "cryptozoologists" (as scientists who look for unknown animals term themselves) were impressed, but the figure turned out to be a rubber figure crafted by a Disneyland modelmaker.[114]

Photographs of Bigfoot turn up occasionally, but few gain much attention—deservedly so. One snapshot is "said to be of a white Bigfoot"—a creature reportedly seen frequently in the Lake Worth, Texas, area from July to November 1969. In one incident, it allegedly tossed an automobile wheel five hundred feet at a group of watchers. The black-and-white photo is remarkable only in its fuzziness: one book describes it as showing "the *back* of something white and hairy" (emphasis added),[115] whereas to the author it is only vaguely recognizable as a monster *facing left*.

The most publicized pictures of Bigfoot are on a motion picture film that records "one of the most momentous events in the annals of Bigfoot hunting"—or so gush Janet and Colin Bord in their credulous paperback, *The Bigfoot Casebook*. The brief, 16mm color film was taken in October 1967 by Roger Patterson, a longtime Bigfoot enthusiast who had frequently "discovered" the creature's tracks. Accompanied by a friend, he allegedly en-

countered a Sasquatch while the two Bigfoot buffs were riding horseback in the Bluff Creek area of northern California. As their frightened horses reared, the pair alleged, Patterson's horse fell, but he jumped clear and grabbed for the movie camera in his saddlebag. He briefly managed to film the creature that strode away, a few frames recording its hairy, pendulous breasts that identify it as a female of the legendary species.[116]

While one mystery-promoting book proclaims the film was never "proved to be a fake,"[117] it is important to note that, as proponents have the burden of proof in such cases, it was never proved authentic. It certainly has raised suspicions. For example, the stride of the creature seems exaggerated, as Cohen states, "almost as if a bad actor were trying to simulate a monster's walk." Dr. John Napier of the Smithsonian Institution, an expert in primate biology and anatomy, seemed to sum up the opinion of many scientists when he quipped: "I couldn't see the zipper."[118] In other words, all Patterson's film would have required was someone in a monster costume, like that used in the 1977 British Columbia hoax.

Lest it be thought that legendary monsters are always as elusive as those we have discussed thus far, we should not fail to mention the remarkable "hodag" that was captured alive at Rhinelander, Wisconsin. True, the creature was merely a dog over which three good ol' boys had stretched a decorated horse's hide ("hodag" was a combination of "horse" and "dog"), but according to Curtis D. MacDougall, author of *Hoaxes*, "this interested eastern scientists and circus owners, and the hodag created a sensation for weeks and months." Later a stuffed successor was exhibited at fairs and its image survived on picture postcards in northern Wisconsin for many years, the story becoming the subject of a 1928 book. One man recalled that during his childhood at Wausau, Wisconsin, "large photographs of the hodag on a fallen log, surrounded by a group of his captors armed with axes, pitchforks, etc. were fairly common. Many of them were used as decorations in the saloons."[119]

Any chronicling of the most ridiculous claims of the photographing of strange creatures must surely include the famous Cottingley fairy photographs. In 1917, two schoolgirls in Bradford, England, claimed they had encountered some fairies while playing in Cottingley Glen. Elsie Wright, age thirteen, and her cousin Frances Griffiths, ten, took a pair of photographs, one showing Frances with a group of dancing fairies and one portraying Elsie with a gnome. In 1920, the girls took three more photos of the wee creatures. Supposedly a photographic expert stated that the prints and negatives had not been tampered with, and Sir Arthur Conan Doyle was convinced of the genuineness of the girls' claims. In his book on the subject, *The Coming of the Fairies*,[120] the credulous author argued that innocent children were incapable of sophisticated photographic trickery and that they had no reason to lie or perpetrate a hoax.

For sixty years the photographs were the subject of controversy, but the outcome should never have been in question. First of all, the older girl, Elsie, was employed in a photography shop (albeit mostly as an errand girl). Moreover, she was evasive. When a reporter asked her where the fairies came from, she answered, laughing, "I can't say." Neither would she say where the tiny figures went after they had appeared for the camera. When the reporter pressed her for an answer, she became embarrassed.

Eventually, noting that the figures looked like cutouts that had been placed in the scene with the girls and then photographed, investigators employed computer analysis like that used for flying saucer photos. (Indeed, the tests were done by Ground Saucer Watch expert William Spaulding.) The computer compared the fairy figures with the human ones to see if the former were three-dimensional. They were not.

At length, an author collecting material for a book on illustration noted the similarity between the fairy photographs and a drawing in a popular children's book, published in 1915 and titled *Princess Mary's Gift Book*. The drawing illustrated a poem by Alfred Noyes, "A Spell for a Fairy." All Elsie did was copy the figures, making some minimal changes and adding wings. Then she placed the cutouts in the grass or affixed them to tree branches, and she and Frances took turns posing with them while the other took their picture. As paranormal investigator James Randi observes in his book *Flim-Flam!*, "There is not the slightest chance that Elsie just happened to photograph fairies that were in positions so similar to those in a book she could have had about the house." [121]

Finally, but somewhat anticlimactically, Elsie and Frances confessed to the hoax. What had begun as merely the prank of a couple of schoolgirls soon got out of hand when newspaper reporters and famous authors like Sir Arthur Conan Doyle became involved. [122]

Among the additional photos of beings from other realms, we must not neglect to mention pictures of angels. In the case of a pair of "angel" snapshots the author attempted to track down, not only were the negatives unavailable but the photographers remained anonymous. Apparently the pictures were to be accepted—like belief in angels themselves—on faith. More definitive results were obtained in the case of a snapshot circulated in North Carolina in 1990 which showed a Christlike robed figure, with arms outstretched, floating among sinister clouds. Naturally, it is possible to see, and photograph, "pictures" in clouds—a product of their random shapes that everyone is familiar with—but this picture was different: the clouds did not look natural, and when the photograph was subjected to a computerized analysis that measured its density, the image was shown to lack the three-dimensional properties of genuine photographic images. [123]

Photos of Other Paranormal Subjects

Paranormal claims are practically limitless, and many offer opportunities for photography—"weeping" statues, for example and "psychokinetic" (mind-over-matter) spoon bending. However, these phenomena are witnessed independently of the camera, and so—though there may well be trickery involved[124]—the trickery does not necessarily require the participation of photography. Some claims—of levitation, for instance—may be performed either as an illusion for an audience, as a magician's stage trick, or for the camera. Only those phenomena meeting the latter criterion will be included in the following discussion: they include levitation, psychokinesis, and auras.

The law of gravity notwithstanding, for centuries certain mystics have been alleged to possess the ability to levitate. Apart from the realm of legend and the results of trickery, the evidence for levitation appears nonexistent. Yet, the legendary tradition obviously lies behind the claim of transcendental meditation (TM) founder Maharishi Mahesh Yogi that he could teach his credulous disciples to levitate. His ministry of information even issued a photograph depicting a TM student sitting in the lotus position and apparently levitating several inches in the air.

Her scarf, however, was obviously blown upward, revealing that the photo did not portray her in tranquil levitation but rather caught her in the act of *bouncing*. Skeptics quickly duplicated the photographic feat. A young volunteer, without any training whatsoever (either TM or gymnastical), simply bounced on a mat in the lotus position. By means of a strobe flash, used to freeze the movement, a photograph was taken that replicated the TM "levitation" effect.[125]

Spiritualist mediums have likewise claimed the ability to levitate, usually creating the illusion in darkened rooms using a variety of tricks. According to Joyce Robins's *The World's Greatest Mysteries*—which would be more aptly titled *The World's Most Credulous Book*—"Many photographs exist which apparently give incontrovertible proof that the pull of gravity can be defied." A full-page photograph chosen to illustrate this astonishing comment is nothing short of hilarious. It is a flash-illuminated picture of a séance held at Wortley Hall in Finsburg Park, London, showing the attendees holding hands and medium Colin Evans "levitating." A cord leading from a device in Evans's hand indicates it was he who triggered the flash-photograph—a critical act since the evidence of the photo itself reveals the mechanism of "levitation" and thus indicates its momentary nature: Evans's feet are a blur above the seat of his chair, his body is in a partially crouched position, and his hair is in disarray. If springing into the air from a crouched position is levitating, then

Mr. Robins's book is a serious work of science and scholarship. (It carries a praiseworthy introduction from science fiction writer Colin Wilson.) [126]

Another case of alleged levitation involved a faked photograph. The photo depicted Brazilian medium Carlos Mirabelli in a standing position with his head near the room's ceiling. Examined by paranormal researcher Gordon Stein, however, the photo was found to have been chemically retouched so as to remove the stepladder that Mirabelli was standing on. [127]

The levitation or other movement of objects—supposedly accomplished by psychokinesis—has also been "documented" by photography. A lightweight aluminum tray-table is shown in Robins's book "levitating in Missouri, USA." Actually, since the table is resting against the upper portion of a door casing—obscured from the camera's view by the tray top—the photo provides not evidence but amusement. As was said of Patterson's filmed Bigfoot, that one could not see the zipper, here one cannot see the attaching mechanism. [128]

As another example of supposedly levitating objects, there are experiments reported by an American group calling itself the Society for Research into Rapport and Telekinesis. Their experiments utilized "minilabs"—a minilab consisting of a transparent box into which a few small objects were placed, and the floor of the box then being covered with coffee grounds. Persons attempted to use their telekinetic (psychokinetic) powers to move the objects. The coffee grounds were supposed to safeguard against the box being shaken or tilted, and the objects were monitored by movie camera. "However," concedes Robins, "the resulting film of levitating pens and objects moving across the floor of the box have been disputed by psychic researchers who have produced films of their own to show how the evidence could have been faked." [129] Instead of using only film as proof, the society should obtain the services of someone like magician James "The Amazing" Randi, who has had years of experience in setting up controlled tests for claimants of psychokinetic and other psychic powers—all of whom, lamentably, have failed to date. [130]

Just as some people claim the power of psychokinesis, others purport to have the ability to see auras, fields of light that supposedly surround people, and possibly other living things, as a manifestation of their psychic energy force. The colors of the auras are supposedly related to an individual's personality and changing moods, even health. However, when Dr. W.J. Kilner published *The Human Atmosphere* in 1911, the *British Medical Journal* stated (in its January 6, 1912, issue), "Dr. Kilner has failed to convince us that his aura is more real than Macbeth's visionary dagger." [131]

Claims that the aura has been photographed are typically based on a misunderstanding of the simple scientific principles involved. For example, infrared photography can indeed produce photographic images of people with

aura-like bands of radiance surrounding them—evidence, however, not of mystical energy forces but rather of the emanations of body temperature.[132]

In the 1970s interest in the aura was boosted by the popularity of a technique known as "Kirlian photography," supposedly invented in 1939 by a Russian electrical technician named Semyon Kirlian but actually known previously as corona discharge photography. Kirlian claimed to have shown through experimentation with the technique that the aura could be used to diagnose illness in both animals and plants, and he "is said to have" produced Kirlian photographs which "show a complete aura even though the subject has had a limb amputated."[133]

The process utilizes a high-voltage, high-frequency electrical discharge that is applied across a grounded object. This yields an air-glow or "aura" that can be recorded directly onto photographic film, plates, or paper.[134] New Age cultists, who are long on mysticism and short on science, are impressed by the striking photographs showing fingers or entire hands bordered with bright, corona-like bands of "energy" (a term they use liberally, if naively, in their pseudoscientific discussions of such alleged phenomena as psychokinesis, poltergeists, and faith healing[135]). They believe that the resulting "auras" of living things contain information about their "life-force," those of people indicating their psychic state.

As it happens, however, the same "energy" emanates from nonliving things as well—paper clips, coins, shears—and, in fact, the Kirlian aura is really only "a visual or photographic image of a corona discharge in a gas, in most cases the ambient air." Experiments indicate that it is not the subject's condition (whether health, mood, or attitude) that determines the image's size and shape but rather the *amount of moisture*. Dry fingers were found to produce corona images similar to those yielded by dry, inanimate objects. The color of the corona was also influenced by the amount of moisture present.[136]

One application of photography in the study of the paranormal is the use of surreptitious photography to detect chicanery. For example a "Mirrorscope Spy Lens" (mentioned in chapter 5) could be used to deceive someone into thinking that the camera was not trained on him or her (as in the case of "poltergeist" disturbances in which a child is suspected of throwing objects and performing other mischief), while actually capturing the behavior on film.

Hidden surveillance cameras have been successful in guarding against trickery by psychics who appear to demonstrate special powers. Some classic cases illustrate the value of videotaping in permitting the investigator to study an otherwise fleeting series of actions. Take the Suzie Cottrell case for instance. The winsome young lady performed alleged psychic feats using a deck of playing cards. Among other demonstrations, she could apparently predict,

in writing, what card someone would select from a deck that was spread out, face down, on the table. She had performed this feat on *The Tonight Show*, and her father had subsequently contacted the Committee for the Scientific Investigation of Claims of the Paranormal (CSICOP) to request that she be tested. (CSICOP was founded by scientists like Carl Sagan and Isaac Asimov to examine critically the evidence for paranormal phenomena.)

James Randi and Martin Gardner (the well-known science writer who is also a skilled magician) had charge of the testing protocol. Explains Randi:

We prepared a testing area by installing a videotape camera and outlining with white tape the exact area to be covered by the camera. This was to be the limited test area in which all action had to take place. Should Suzie's hands or any of the cards wander out of the test area, the experiment was to stop immediately and return to "ground zero," all materials being confiscated and held for examination. We had a good number of decks of cards, all labeled and fresh. And, most important of all, we were going into the fray with a definitive statement that had been read and understood and agreed to by Suzie Cottrell and her group.[137]

Cottrell was permitted to perform her feat once without controls and without the video recorder running; *however*, another one was secretly recording every action! In this way the magicians learned her trick: In handling the deck, she glimpsed the top card, then employed a standard magician's "force" to ensure that is was the one selected. Then, when the serious testing began, Randi insisted on cutting the cards just before they were spread, and as a result Cottrell failed to score.

In his book *Flim-Flam!*, Randi provides a series of photographs prepared from the videotape which show in step-by-step fashion how Cottrell performed her card trick. Even in some of these still photos her hand is a blur, demonstrating that the motions would have been difficult for most observers to follow.[138]

Another case involved an English girl who claimed to be able to bend spoons merely with her brainwaves. Randi's protocol for the experiment required her to hold in one hand the spoon, the upper bowl of which was blackened in a candle flame so as to prevent her touching it without thereby leaving evidence (on both her hand and the spoon). The hand and spoon were to be kept in view between a camera and a mirror (to provide additional viewing advantage). Actually, the mirror was a "two-way mirror" with observers on the other side. As a consequence of these safeguards a successful demonstration could be substantiated or, alternately, any trickery could be detected and recorded. In this instance, the girl gave up after two hours of straining to effect a bend in the unyielding spoon.[139]

People perpetrate hoaxes for a variety of motives. One person who took

questionable photographs of the Loch Ness monster reportedly expected to receive some 200,000 British pounds in syndication fees during the first six months.[140] As one writer notes, in addition to "financial gain," there is also the lure of "personal ambition," or "that curious form of arrested maturity which leads adults to perpetrate hoaxes."[141]

Paranormal claims offer many opportunities for hoaxing, in large part because of the powerful will to believe in such phenomena on the part of many people. Photographs represent an easy means of "proving" the existence of strange beings and mystical powers for which there may otherwise be a lack of evidence. Many people believe—wrongly, as this book continues to demonstrate—that photos do not lie. According to photographer Dave Corbett (whose comments, although they are in the context of UFO photos, could apply to any "paranormal" subject):

While the old saying "A picture is worth a thousand words" may be true, there is another saying among photographers, "Every photo is a work of fiction." Assign a hundred photographers to photograph the same thing, and you'll get a hundred very different photos. Which is the most accurate? Which photo captures the subject most objectively? Without having seen the actual scene at the time of the photograph, there would be no way to tell. Each photographer has hundreds of choices of lighting, exposure, composition, and techniques. How each photographer chooses to manipulate these variables will affect the overall look of the final photo. So while the picture is worth a thousand words, the story told will be different every time.

Corbett continues: "This is the problem with photographs as evidence in UFO sightings. Everyone has seen airplanes, and most can recognize a model plane shot in a movie. Hollywood's best special effects technicians have a hard time recreating something as mundane as an airplane successfully. Unless you've seen a flying saucer with your own eyes, how do you know what a photograph of one looks like?" Corbett has made several "UFO" photographs that have been declared genuine by pro-UFO researchers, one of whom was a former NASA mission specialist. He points out that most admitted hoaxers have had no special photographic training, and he adds: "Most people with a basic high-school photo class under their belt, and a little mechanical ability could easily produce some very convincing photos."[142] It is well to keep this possibility in mind in the case of *any* photograph that purports to provide evidence of paranormal phenomena.

Recommended Works

Baker, Robert, and Joe Nickell. *Missing Pieces: How to Investigate Ghosts, UFOs, Psychics and Other Mysteries.* Buffalo: Prometheus Books, 1992. Complete handbook for investigating and evaluating paranormal claims.

Clark, Jerome. *UFO Encounters: Sightings, Visitations, and Investigations.* Lincolnwood, Ill.: Publications International, 1992. Nicely illustrated overview of UFOs from the perspective of a longtime ufologist/UFO historian.

Cohen, Daniel. *Encyclopedia of Ghosts.* New York: Dorset, 1984. Comprehensive, generally skeptical look at ghosts and ghostly phenomena, including spirit photography.

Cohen, Daniel. *Encyclopedia of Monsters.* New York: Dodd, Mead and Co., 1982. Authoritative reference work on monsters of all types, including Bigfoot, Loch Ness Monster, yeti, and others.

Gettings, Fred. *Ghosts in Photographs.* New York: Harmony Books, 1978. Attempts to portray spirit photography as a legitimate paranormal phenomenon while acknowledging fakes abound; an unintentional study in excessive credulity.

Greenway, John L. "The Photograph as Esthetic Norm in Fin-de-Siecle Scandinavia," in Faith Ingwerson and Mary Kay Norseng, eds., *Fin(s) de Siecle in Scandinavian Perspective*: Studies in Honor of Harald S. Naess. Columbia, S.C.: Camden House, 1993, pp. 138-49. Includes interesting discussion of how faith in the camera's ability to record invisible reality—an ability actually demonstrated by X-rays, infrared photos, and spectroscopy—led to acceptance of the possibility of photographing psychic auras, spirits, even fairies.

Hendry, Allan. *The UFO Handbook.* Garden City, N.Y.: Doubleday, 1979. Generally skeptical treatment of UFOs by an experienced investigator who provides many photographs of UFO "impostors" and fake UFOs.

Klass, Philip J. *UFOs Explained.* New York: Vintage, 1976. Authoritatively skeptical analysis of claims that extraterrestrial spacecraft are visiting the planet Earth.

Mulholland, John. *Beware Familiar Spirits.* 1938; reprinted New York: Scribner, 1979. Exposé of the trickery employed by fraudulent spirit mediums, including "Spirit" photographs.

Randi, James. *Flim-Flam! Psychics, ESP, Unicorns and Other Delusions.* Buffalo: Prometheus Books, 1987. Thorough debunking of a panoply of paranormal claims by a world-famous magician-investigator.

Spencer, John, and Hilary Evans, eds. *Phenomenon: Forty Years of Flying Saucers.* New York: Avon, 1988. Overview of the phenomenon by a number of ufologists offering different perspectives; includes two chapters on photographic evidence and analysis.

8

PARANORMAL PHOTOGRAPHS

In contrast to those pictures that are said to have involved ordinary photographic processes in recording paranormal subjects—ghosts, UFOs, and monsters—some pictures are alleged to have actually been *produced* in a paranormal manner. As we shall see in the following discussion—concerning miracle pictures, photos by spirits, and psychokinetic photographs—some of these images are produced on film while others appear on ordinary cloth or other materials.

Miracle Pictures

Some interesting images that have been widely publicized by the popular press are said to have been produced in a miraculous way. These include an alleged "photograph" of Christ and certain related images, as well as photographs that are supposedly produced by "Sun Miracles" and by the "Holy Spirit."

"Photos" of Jesus and Mary. The Holy Shroud of Turin—a fourteen-foot length of linen cloth that many believe wrapped Jesus's body in the tomb—bears a mysterious "twofold" image: Representing the front and back imprints of an apparently crucified man, it has been called a "photograph of Christ,"[1] even "the first Polaroid in Palestine."[2] The claim that the image has photographic qualities stems from a discovery made when it was first photographed in 1898.

Initially, the shroud's owner—Umberto I of the House of Savoy, King of Italy, and hereditary owner of the heirloom—refused to permit photographing of the shroud because he felt that such reproduction of the sacred "relic" would diminish the reverence accorded it. Eventually, however, Um-

berto acquiesced, and during an exposition of the shroud in May 1898 an amateur photographer named Secondo Pia was permitted to make two exposures—one of fourteen minutes' duration and another of twenty.

Later, when Pia held his developed glass-plate negatives to the light, he was so startled by what he saw that he almost dropped them. The *negative* plates showed an essentially positive image: one in which the highlights and shadows appeared as they normally do for a figure in a picture, not reversed as would be expected on a negative. Therefore, if the latter (reversed) image was a positive, then the actual picture on the cloth was obviously a *negative*. Proponents of the controversial cloth's authenticity used the discovery to counter claims that it was the handiwork of a medieval artist. How, they asked, could an artist produce "perfect photographic negatives" before even the concept of photography had originated?

At first it was thought that the image negativity might have been owing to "optical illusion." One person theorized: "the shroud, having been photographed by electric light, transparently through its substance, the paint, even though white, being opaque, would come out dark in the photograph, and produce a negative effect." In fact, though, the shroud was not lighted from behind, nor would that have been possible because of an attached backing cloth. A more credible possibility was that Pia had overexposed the plates, but, in fact, subsequent photographs and examinations show that this was not the case and that the observations were correct.[3]

Proponents, calling themselves "sindonologists" (*sindos* is Greek for a shroudlike cloth), began to theorize how such a negative image might have been produced. One possibility was that the body had been covered with oils and spices and that the prominences, which would normally appear in highlight, therefore produced dark imprints on the cloth, and the recesses, which would ordinarily be dark, did not print at all, leaving white spaces instead. Unfortunately, this "contact" theory was obviously untenable because—as experiments readily showed—such an image would contain severe wraparound distortions, a simple consequence of transferring a three-dimensional form (a body) to a two-dimensional surface (a cloth). The shroud image also contained areas that would not have been imprinted by simple contact and so, some theorists held, must in some way have been *projected* onto the cloth.

Thus was born the so-called "vaporograph" theory proposed by French zoologist Yves Delage in 1902. "Vaporography" was described as a physico-chemical process in which weak ammonia vapors from the body (produced by the fermenting of urea in sweat) reacted with spices on the cloth (likened to a sensitized photographic plate) to produce a vapor "photograph" or "vaporograph." However, vapors do not travel in perfectly straight, vertical lines but rather diffuse and convect. Experiments (including some of my own) readily demonstrate that vaporographic images would lack the high

resolution (clarity of detail) of those on the shroud and, in fact, would consist simply of a large round blur.[4]

The discrediting of "vaporography" left shroud proponents still in need of a theory to explain the shroud image, consistent with its distinctive properties. Following modern examination of the shroud by an initially secret commission in 1973, other image properties were noted, especially the superficiality of the stain which extends only two or three fibers deep into a given thread. Since a fluid medium (such as dye or paint) would be expected to soak into the cloth, proponents argued that the image was obviously not the work of an artist.[5]

In 1978 more extensive tests were conducted by the Shroud of Turin Research Project (STURP), an organization of scientists whose leaders served on the Executive Council of the pro-authenticity Holy Shroud Guild. But long before the group had conducted a single test of the cloth some of its members were postulating a miracle as the explanation for the image. Of course, they knew better than actually to use the non-scientific word *miracle*, so they used terms like "flash photolysis," supposedly a burst of "radiant energy" emanating from the body of Christ at the moment of resurrection.[6]

Alas, the 1978 tests did not support the radiation-scorch concept. For example, actual scorches on linen (like those on the shroud caused by a chapel fire in 1532) exhibit a strong reddish fluorescence, while the shroud images do not fluoresce at all. More importantly, no known radiation could act across varying distances and then fail to penetrate the cloth, or could produce such a resolved image without lenses or other focusing means. To term radiation—even "miraculous" radiation —that which does not have the properties of radiation is patently unscientific.[7]

In fact, the evidence against the shroud's authenticity is overwhelming. The method of wrapping the "body" (so as to produce the front and back images) is inconsistent with the gospel description and Jewish practices. There is no provenance for the cloth before the middle of the fourteenth century, at which time it appeared in Lirey, France, in the possession of a soldier of fortune who could not explain how he, a man of modest means, had acquired the "relic." Moreover, a bishop's investigation uncovered an artist who confessed he had "cunningly painted" the image.[8]

The image gives evidence of artistic creation. For example, the figure resembles the traditional paintings on Christ, specifically those in the French gothic style. There are also serious anatomical flaws. For instance, a footprint on the cloth is incompatible with the position of the leg accompanying it, and the hair falls on either side of the face as for a standing, rather than recumbent, figure. Also the "blood" failed to mat the hair; flowed in unnatural, "picturelike" fashion; transferred to the cloth even from places (such as the arms) where it would have been *dried*; and remained *red*, unlike genuine blood which blackens with age.[9]

Figure 8.1. A negative photograph of a rubbing image produced by the author. (Wet cloth was molded to a bas-relief sculpture and, when dry, powdered pigment was applied to prominences.)

Scientific tests were conducted by famed microanalyst Walter C. Mc-Crone, who illustrated his findings with color photomicrographs. McCrone proved that the image contained an artist's pigment, red ocher, whereas off-image areas did not, and that the "blood" was red ocher tempera paint (with a small amount of another pigment, vermilion). For his efforts, Mc-Crone was, he says, "drummed out" of STURP. STURP recalled the samples and turned them over to two other member scientists who soon claimed they had "identified the presence of blood." However, forensic analyst John F. Fischer reviewed their claims and explained how results similar to theirs could be obtained with tempera paint. As it happens, neither of the two STURP scientists is either a forensic serologist or a pigment expert, thus raising the question of why they were chosen for the analyses.[10]

Finally, in 1988, radiocarbon dating of the cloth revealed that the flax from which the linen was made was harvested circa A.D. 1260-1390 or about the time of the forger's confession. Tests conducted by laboratories at Oxford, Zurich, and the University of Arizona, using accelerator mass spectrometry were given added credibility by correct dates obtained from a variety of control swatches. These were from the first century B.C. and the eleventh and fourteenth centuries A.D., respectively.[11]

But what about the shroud's photonegative properties? These were

clearly exaggerated. The shroud image, in fact, differs from a photographic negative in several important respects, most obviously in that the beard and hair are opposite in tone to what we should expect (dark on the original "negative" imprint), giving the effect, when a positive is made, that Jesus was an albino or a white-bearded old man. Therefore, the image is at best a quasi-negative. In fact, there are artistic processes that can produce strikingly similar quasi-negative images with minimal depth of penetration. I demonstrated one simple method in 1978. The method is similar to making a rubbing from a gravestone, except that a bas-relief sculpture is used. Wet cloth is molded to the relief and, when dry, rubbed with a dauber using a powdered pigment. (See Figure 8.1.)

The shroud controversy did illustrate the different approaches to evidence taken by the opposing groups. Sindonologists began with the desired answer and worked backward to the evidence. Lacking any viable hypothesis for the image formation, they offered one explanation for the lack of provenance (the cloth might have been hidden away), another for the forger's confession (the reporting bishop might have been mistaken), still another for the pigments (an artist copying the shroud could have splashed some on), and so forth. In contrast, skeptics allowed the preponderance of *prima-facie* evidence to lead them to a conclusion: The shroud is the handiwork of a medieval artisan. The various pieces of the puzzle interlock and corroborate one another (for example, the confession is supported by the lack of prior record, and the red "blood" and presence of pigments are consistent with artistry).[12]

An example of the sindonologists' faulty reasoning is the attempt to equate the shroud with the ancient "Image of Edessa," thereby attempting to provide it with a provenance it clearly did not have. The legend of the Edessan image is related in a mid-fourth-century Syriac manuscript that tells how King Abgar of Edessa wrote a letter to Jesus entreating him to come and cure his leprosy. Abgar's messenger was instructed that if Jesus would not accompany him to Edessa he was at least to bring back a portrait. Subsequently, "The Savior . . . washed his face in water, wiped off the moisture that was given to him, and in some divine and inexpressible manner had his own likeness impressed on it."[13]

There are other strains of the legend about a miraculous "self-portrait" of Jesus, notably one concerning Veronica, a pious woman of Jerusalem. She so pitied Jesus struggling to carry his cross to Golgotha that she used her veil (or kerchief) to wipe his face, thereby obtaining an image imprinted with his bloody sweat. There were numerous such portrait veils—known as "Veronicas"—their proliferating nature being explained by the image's ability to miraculously duplicate itself.[14]

Of course because such images (according to Thomas Humber) are

"supposedly miraculous, but, in fact, painted," they bear little association with photography, let alone the Shroud of Turin. Nevertheless, although the Edessan Image bore only a facial picture, shroud writer Ian Wilson supposes that it was really the shroud in disguise, folded in such a way that only the face showed! To explain how *both* an Edessan Image and a purported holy shroud are mentioned *separately* on certain twelfth- and thirteenth-century lists of relics, Wilson opines that the "other" Edessan cloth was a *copy*, made from the genuine, hypothetically folded, shroud![15]

Miraculous portraits of the Virgin Mary are also said to exist, the best known of which is a sixteenth-century depiction in Mexico City. "Yearly," according to Jody Brant Smith's *The Image of Guadalupe*, "an estimated ten million bow down before the mysterious Virgin, making the Mexico City church the most popular shrine in the Roman Catholic world next to the Vatican."[16] Although the image is said to be neither a painting nor a photograph, it is indeed the one and has interesting connections to the other, as we shall see.

The cloth is accompanied by a supposedly contemporary account of its "miraculous" appearance. It is related in the *Nican Mopohua* ("an account"), written in the native Aztec language and sometimes called the "gospel of Guadalupe." According to this source, in early December of 1531 (some ten years after Cortez's defeat of the Aztec Empire), a recent Christian convert named Juan Diego saw a bright light atop a hill. Climbing the hill he encountered the Virgin, radiant in a golden mist. She wished the peasant to tell the Bishop of Mexico to build a temple to her at the site.

The skeptical bishop requested a "sign" and so the Virgin asked Juan Diego to gather in his cloak some flowers which were blooming miraculously and take them to the bishop. "He then unfolded his white cloth, where he had the flowers, and when they had scattered on the floor, all the different varieties of *roses de Castilla*, suddenly there appeared the drawing of the precious Image of the ever-virgin Holy Mary, Mother of God, in the manner as she is today kept in the temple at Tepeyac, which is named Guadalupe. When the bishop saw the image, he and all who were present fell to their knees."[17]

Actually this legend seems to have been borrowed from a Spanish legend in which the Virgin appeared to a shepherd and led him to discover a statue of her; the Spanish site was even on a river known as Guadalupe. Moreover, as Smith states: "The Shrine which held the Image of Guadalupe had been erected on a hill directly in front of the spot where there had been an important temple dedicated to the Aztec Virgin goddess Tonantzin, 'Little Mother' of the Earth and Corn."[18] Thus the Christian tradition took advantage of an Indian one and was grafted onto it (a process folklorists call *syncretism*).

Although the image is said to have been produced miraculously, there are obvious artistic elements throughout, such as the traditional features and pose of the Virgin, as well as such standard motifs as the forty-six stars on her mantle (signifying the number of years required for building the temple of Jerusalem), and an angel at her feet. Indeed, a painting in Barcelona is said to be "of the exact form as the Virgin of Guadalupe." Paint is everywhere obvious on the latter image, despite the claims of miraculists that only certain areas have been altered and that "original" portions (including the robe, mantle, hands, and face) are "inexplicable," even "miraculous."[19]

Actually, close-up photography shows that pigment has been applied to the highlight areas of the face sufficiently heavy as to obscure the texture of the cloth. Portrait artist Glenn Taylor points out that the eyes, including the irises, have outlines as they often do in paintings but not in nature, and that the outlines appear to have been done with a brush. In addition, infrared photographs show that the hands have been modified (outlined, and some fingers shortened) and there are also anomalous lines that infrared photos reveal in the robe's fold shadows that appear to be sketch lines from a preliminary drawing.[20]

In fact testimony at a formal investigation of the cloth in 1556 held that the image "was painted yesteryear by an Indian" and that it "was a painting that the Indian painter Marcos had done." Indeed, there was an Aztec painter known as Marcos Cipac active in Mexico at the time of the Image of Guadalupe's appearance there.[21]

One of the silliest examples of "scientific research" conducted on the Guadalupan Image recalls the nineteenth-century belief (discussed at the beginning of the previous chapter) that the eye could retain an image at death which could be "extracted and enlarged." In the case of the Image of Guadalupe "several ophthalmologists" and "a computer expert" have discovered "what seems to be the reflected image of a man's head in the right eye of the Virgin" followed by still more tiny figures. However, at one point in his own discussion of the endeavor, Smith does wonder whether the proliferating wee people represent anything more "substantial than the human shapes we see in the clouds, the result of what Father Harold J. Rahn once termed a 'pious imagination.'"[22]

Since 1991 a mere *photograph* of the Image of Guadalupe that has been touring the United States (often linked to anti-abortion activities) has been alleged to actually possess magical powers. According to newspaper accounts, "some people have reported visions of rose petals seeming to fall from the photo, or the feel of a heartbeat on the image." There are also "reports of healings and other signs" including what one person thought was a flash of light, but the Associated Press was careful to note that these were "unsubstantiated."[23] They are further evidence of the pious imagination,

which—to the astonishment of rational thinkers—can transform a photo of a painted fake into a miraculous icon.

Incredibly, claims of an *animated* stutue of the Virgin—able to weep, move her eyes, tilt her head, change the position of her hands, even walk about a Thornton, California, Catholic church at nighttime—were supposedly documented in photographs in 1981. Indeed, some photograph backgrounds contained mysteriously intruded images of Jesus. Miracles, many of the faithful said, were at work in the church.

Unfortunately, one person who touched the Statue's tears found them "oily and sticky," indicating they were not genuine. Eventually a clerical commission that investigated the case branded the statue's "weeping" and nighttime perambulations a probable hoax. The movements of the Madonna's eyes, chin, and hands, as supposedly shown in photographs, were apparently nothing more than the result of variations in photographic angles. Two photos which showed the image of Christ in the background were examined by a forensic scientist and revealed as the handiwork of a hoaxer. For their efforts, the investigating clerics were denounced as "a bunch of devils" by some who refused to accept their negative findings.[24]

"Sun miracle" photographs. When the Virgin Mary allegedly appeared at Fatima, Portugal, in 1917, many onlookers experienced what is termed a "sun miracle." Sun miracles are now commonly reported at other Marian apparition sites, which seem to be springing up frequently, and are variously described. The sun may seem to "dance," pulsate, spin with colored streamers, or produce other effects. Skeptics attribute the phenomena to optical effects resulting from such factors as temporary retinal distortion caused by staring at the intense light, or the effect of darting the eyes to and fro so as to avoid fixed gazing, or other illusory effects, combined with religious hysteria.[25]

In recent years, pilgrims to the sites are attempting to document sun miracles in photographs. Polaroid cameras are preferred so the results can be seen immediately. At Cold Spring, Kentucky, on August 31, 1992, the author saw many of these photos which—not unexpectedly—showed only simple lens flares, although earnest miraculists were turning their prints this way and that, attempting to discern a face or figure in the anomalous glare shapes.[26]

A specific type of sun-miracle photo shows "the outline of what could be an entrance superimposed on the sun." Miraculists have dubbed the phenomenon "the doorway to heaven." Others have called it the "Golden Door," mentioned in Revelations 4:1, which states: "After this I looked and, behold, a door was opened in heaven: the first voice which I heard was as it were of a trumpet talking with me; which said, Come up hither, and I will shew thee things which must be hereafter." As it happens, the striking Gold-

en Door effect is commonly produced by the Polaroid One Step camera—a fact observed by Dale Heatherington of the Georgia Skeptics (a group that investigates paranormal claims). Heatherington realized that the phenomenon was an effect produced by the camera and soon discovered that the polaroid's iris had the exact same shape (straight vertical sides, curved top and bottom) as the Golden Door in the photographs. He then calculated the height-to-width ratio of both the Golden Door in the photos and the camera's aperture and discovered they were the same. Heatherington states: "It seems that through some quirk in the Polaroid One Step camera optics, an image of the iris is projected onto the film when a bright point source of light is centered in the field of view." He duplicated the effect himself by photographing the sun and even a 50-watt halogen spotlight in a dark room. As he concluded, the Golden Door is "actually the doorway into the camera, not heaven." [27]

"Holy Spirit" picture. If exiled Cuban singer Roberto Torres is to be believed, a miracle involving a photograph took place during his heart surgery in Miami in 1992. Torres, fifty-one, had asked a friend to take still pictures and video footage of the procedure because, as he explained, "you don't get a triple bypass every day." At "the most critical point" of the surgery, however, the camera flash failed; when the photos were processed after the successful operation, the photo taken at that point showed what Torres and his wife believe is the "Holy Spirit" in the form of a dove's head. Discharged from the hospital on May 20, Torres held a press conference during which he handed out copies of the "dove" photograph.

Paranormal investigator Wesley M. Johnson, however, together with another investigator and an independent professional photographer, examined Torres's 5 x 7 inch color print and original negative, in conjunction with the videotape. The latter "reveals the 'dove' to be simply a combination of shadows formed due to the doctor's gown sleeve being bunched up inside his surgical glove," reports Johnson. The video "clearly shows folds of cloth under the glove in a typical cloth-folding co-linear pattern, corresponding to the dove's 'head' and 'neck.' The 'eye' in the still photo appears to be a small spot of blood, although this is not absolutely certain, and could be a poorly lit, lightly recessed end-fold." Johnson also notes that the shape of the "dove's" head more closely resembles a nighthawk or whippoorwill. As to the flash failing at the "critical" stage, it actually failed to function on *six other shots*, rendering the claim meaningless.[28]

Johnson notes that seeing a "dove" in the random shapes in the picture is like seeing images in the clouds. Since Mrs. Torres describes herself as a "very religious" person, and since her husband had a life-threatening operation that prompted dramatic changes in his outlook (he began to read the

Bible, for example), the stage was set for a "miracle" to be perceived. More objective people will agree with Johnson, "There may be the illusion of a bird-of-prey in one of the photographs, but no 'Holy Spirit.'"[29]

Photos by Spirits

In contrast to "spirit photographs"—ostensibly ordinary photos that, however, depict otherworldly figures—there are also certain pictures that are supposedly produced by the spirits themselves. One method used to be called *dorchagraphy* (a term coined by Andrew Glendinning from the Gaelic *dorcha*, the opposite of *sorcha*, "light"). Later it supposedly enlisted spirit entities in producing pictures, but without the use of ordinary illumination. As Fred Gettings explains in *Ghosts in Photographs*: "Glendinning experimented with several mediums, including the Scotsman Duguid, who worked in his own home, and adopted the most simple of methods. He would take a few plates from a newly opened box of quarter plates, and then place one of these, still in its paper wrapper, into Duguid's hands, and then fold the medium's hands firmly in his own. Duguid described the sensation as being rather like that of holding the handle of a magnetic battery while a slight current was being passed through it. When this 'electrical' experience had stopped, the plate was developed."[30] The first successful dorchagraph was obtained by Glendinning and Duguid in April 1896. Gettings does not reproduce it, but he does display one from the same sitting. Portraying a nude woman, the picture was obviously rendered by an artist and probably copied from a chromolithograph of the period. An area around the head has the hard-edged, irregular appearance of a crude cutout—further evidence that the picture is as phony as any other spirit photograph.[31] Obviously the prepared plate was switched for the new one.

A suspiciously similar phenomenon was reported in 1978 when a Minnesota psychic group released an out-of-focus photograph. It showed the face of a bearded man that the group claimed was the guardian angle Jeremiah. He was allegedly conjured up at a séance, in which an instant camera was used to snap pictures in the darkness—without any flash. After a skeptical report in a science magazine, however, the group's unsubstantiated claims soon faded away.[32]

Another form of alleged psychography was being used as a swindle in Connecticut in 1964. A Mr. and Mrs. William Donnelly were operating a spiritualist "church" in the town of North Oxford where they collected mandatory "donations" of several dollars per person per meeting. At the séances, "skotography" was demonstrated. This is described as "a process by which

purported spirit photos are produced on paper, cloth, or film by supposedly supernatural means."

As the lights in the séance room were turned out, "medium" Donnelly turned on a safelight (the type used in photographer's darkroom for handling photographic paper without exposing it). On a table in front of the sitters were three trays of photographic chemicals: developer, fixer, and wash water. Each participant was given a small square of photographic enlarging paper (an "Indiatone" pebble-surfaced variety) that appeared to be blank, and was told to hold it between his or her palms as they prayed and concentrated on the square. At length they were instructed to immerse their papers in the three chemicals whereupon—to their astonishment—each square was seen to bear a "spirit" face.

The intrepid James Randi was called into the case by the concerned brother of one of the credulous victims, and Randi immediately devised a simple and straightforward investigative strategy. Randi knew that a piece of photographic paper, preexposed with a fake spirit image, would still appear blank and be unaffected by the safelight. With the victim agreeing to participate in a test of Donnellys, Randi prepared a piece of identical photographic paper in a small, light-tight envelope. This was secretly marked (by exposing one-quarter of an inch of the paper along one edge to light) and the man was instructed to switch his paper for Donnelly's. Explains Randi:

The theory was that, since the now-sealed-up square was not the subject of the concentration, the substitute square should develop a face, along with a black edge where it had been previously exposed, if the phenomenon were a genuine one. Also, the original paper would, upon subsequent development in a darkroom, exhibit only a blank space. However, if the phenomenon were a trick, the substitute paper should develop blank with a black edge, despite the fervent prayers directed at it, while the original would be expected to develop a face—previously imprinted there as a latent image by the operator of the game before it was handed out.[33]

The man followed the instructions, with the result that the "skotography" scam was what proved to be exposed—along with the purloined paper, which was found to have a typical "spirit" face preexposed upon it. Unfortunately the man rationalized that, while there was an attempt to deceive him on *this* occasion, he had seen too much amazing phenomena at the séances to doubt the overall genuineness of the spiritualists. Randi says, "He continued to attend the circle faithfully even after any exposure of the scam that he had fallen for, until it was eventually disbanded."[34]

As indicated, the so-called skotography can be produced on cloth as well as paper and film. It can be coated like the other materials with light-sensitive emulsion, or it can be used in a different way, as I learned in mid-1985 when asked to investigate a spirit-pictures case. In dark-room séances, swatches of

cloth were imprinted with portraits of the sitters' own "spirit guides." This was accompanied by a "materialization," in which ghostly entities took turns speaking through a luminous, apparently floating "spirit trumpet." The "medium" collected about $800 for the evening show.[35]

The approach was comparable to that in the previously described skotography case, except that a red safelight was used and the images did not require chemical development. The process, called "spirit precipitation on silk," supposedly involved having the spirits produce their self-portraits by using an open bottle of black ink. The squares of "silk" (actually synthetic fabric) were apparently blank before the lights were turned off, at which time they were handed out by the glow of the safelight. "The dimness of the red light," one informant stated, "caused a cloudy, relaxed effect on the eye, making it hard to distinguish detail." He added: "This, of course, gives way to creative visualizations, such as seeing ectoplasm" (the alleged mediumistic substance mentioned in the previous chapter).[36] At length, the medium took the red light from person to person, directing the cloths be turned over, whereupon a few thumbprint-sized pictures of faces were seen on each.

Professional photographer Robert H. van Outer, forensic analyst John F. Fischer, and I examined one of the cloths from the séance. Preliminary visual examination indicated they were probably actual photographic images, as indicated by the clarity, tonal gradations, and arangements of highlights and shadows—all similar to those in photos of real, three-dimensional objects photographed with illumination from a directional light source. Indeed, there was even a partial shadow area behind one figure, an element that seemed incompatible with the reputed method of image production. Microscopic and other tests indicated that the ink was not a fluid variety as alleged but was instead consistent with ink *transferred* from newspaper or magazine photos. (Although no halftone dots were detected, their presence was precluded by the coarseness of the cloth.) Under ultraviolet light, faint circular areas were observed around each image on the cloth, and argon laser light revealed prominent solvent stains. Invisible to the unaided eye, these were caused by a liquid dissolving fluorescing substances in the cloth and carrying them to the margin of the "stain." Experimentation showed that alcohol, but not certain other liquids, would produce the identical effect.[37]

Not only did the analyses point to a transfer process, but so did the conditions under which the squares of cloth were passed out and the images revealed, which permitted the cloths to have had images placed on them before the séance. Interestingly, in *The Psychic Mafia* confessed medium M. Lamar Keene tells how "spirit precipitation" was accomplished: "The trick here was to prepare the silks in advance. I used to cut pictures out of old magazines or use snapshots of spirits known to the sitters if I had them, soak

the picture in ammonia for thirty seconds, place it on bridal silk, put a handkerchief over it, and use a hot iron. The image impregnated the silk." On occasion, anticipating skeptics, Keene would have sitters sign their pieces of "silk" (which was often satin), have the silks secretly removed and prepared by confederates in an adjacent room, and then have them returned before the séance ended. Keene continues: "Once at Camp Chesterfield, while doing precipitations, I got lazy or careless or both and caused a minor crisis. Sick of cutting out and ironing the damn things, I used any picture that was handy, one of a little girl on a recent cover of *Life* magazine. The woman who got the silk recognized the picture and went to Mamie Schultz Brown, the president of the camp that year. Mamie was very excitable; she almost fainted when the woman confronted her with the silk and the incriminating picture from *Life*. . . . However," Keene added, "we smoothed it over by telling the woman that sometimes the spirits did mischievous things like that just to remind us they were still human and liked a joke."[38]

Using information from Keene and the results of the analyses, the author was able to replicate the "spirit precipitations" effect as well as to cause police warrants to be issued charging the medium (who happened to be from Camp Chesterfield) with "theft by deception."[39]

Still another type of alleged spirit-produced picture—consisting of written messages from a "ghost" emblazoned across Polaroid photos—was featured on the Fox Network television program *Sightings*. For a few years now, two young California men have been obtaining the mysterious messages from their household ghost. The men simply ask the ghost a question, then make a snapshot with their Polaroid Spectra System camera; the answer appears in white printing across the picture as it develops. The *Sightings* program provided a "continuous-shot video" of one such question-and-answer sequence, intended to demonstrate that the film was not tampered with *after* being placed in the camera. It did not, of course, preclude a gimmicked film pack having been substituted for a "pristine" one.

The author appeared with the two young men on the Toronto television program *The Shirley Show*. They maintained that Polaroid film cannot be faked (since the print feeds out immediately upon exposure), a claim the author pointed out was demonstrably untrue—as the two men surely knew: One of them works in a film processing lab, and the other is an amateur filmmaker! Moreover, a photographic expert demonstrated for *Sightings* one (overly complicated) method of producing the writing effect, while a stage magician demonstrated another (but kept secret the means).

The expert's method was based on his "computer-enhanced photographic analysis" which showed artifacts resembling cotton fibers in the area around the lettering. Therefore, he concocted the following laborious procedure: He pulled cotton balls into strips and laid them on black paper to

Figure 8.2. A Polaroid snapshot of magician James "The Amazing" Randi demonstrates how easily "spirit" writing and other anomalies can be added to such photographs. (Experimental photo by Anson Kennedy.)

form letters, then used an ordinary 35mm camera to photograph the message. From the resulting negative he made a positive transparency the same size as a Polaroid print. The transparency thus had *clear* lettering on an *opaque* background. In the darkroom this transparency was placed atop a print, exposed, and returned to the film pack. An entire pack of ten prints could be produced in this manner, so that when the pictures are taken each has a ghostly white message written across it.[40]

Investigator Anson Kennedy has come up with a simpler method: coating a piece of clear acetate with an opaque coating and then scratching out the message with a knife.[41] Or given the availability of a darkroom, one could simply photograph black writing on a sheet of paper, the *negative* of which could be projected onto the Polaroid film in an enlarger.[42] One of Kennedy's productions is shown in Figure 8.2.

Kennedy concludes by noting that simply duplicating an effect does not prove the original was not produced supernaturally. "However," he adds, "when one is presented with the options of preternaturally scrawling out messages or of a clever, but entirely human, manipulation of the film ahead of time, one cannot but suspect that the latter is the more likely possibility."[43] Indeed, on *The Shirley Show* when the author challenged the two men to sign an agreement by which they would attempt the writing under controlled conditions, they refused. Their "no" should serve as a proverbial word to the wise regarding "spirit" photographs of whatever variety.

Psychokinetic Photographs

In 1967 the world learned of a Chicago man with apparently remarkable powers: he could merely *think* of pictures and cause them to appear on photographic film—a supposedly psychokinetic (PK) process called "thoughtography." The man, an often unemployed bellhop named Ted Serios, was the subject of a sensational article in *Life* magazine and even an entire book written by Denver psychiatrist Jule Eisenbud, *The World of Ted Serios*.[44]

To accomplish his marvelous feat, Serios looked through a paper tube that he pressed against the camera's lens. A Polaroid model was used, which Serios did not handle, together with film that was not tampered with and that others inserted into the camera. Under these conditions Serios produced images of buildings, people, even aircraft. Many were distorted in one way or another, but many were also remarkably clear and distinctly photographic in appearance. Serios even allowed his paper tube, which he called his "gismo," to be examined by those in attendance.

Nevertheless, magicians and photo experts were skeptical, and upon studying videotapes of Serios's work saw evidence that he was slipping something in and out of the paper tube. In other words, they believed the "gismo" held a *gimmick* (in magician's parlance, a small device used secretly in producing a trick). Soon they had improvised a tiny projecting device: a hollow cylinder with a lens at one end and a photographic transparency at the other. James Randi tells how to make one:

You will need a small, positive (magnifying) lens, preferably about half an inch in diameter and with a focal length of about one and a half inches. The latter can be ascertained by measuring the distance between the lens and the image of a distant object cast upon a piece of paper. You'll need a small tube—as long as the focal length—to hold the lens. From any color transparency (a thirty-five-millimeter slide or a sixteen-millimeter motion picture frame, for example) cut a circle that will fit onto one end of the tube and attach it with glue. The lens is fitted to the other end.

Randi continues:

You use the Serios gimmick by holding it in the hand with the lens end toward the palm. The victim—holding the Polaroid camera, which has been focused to infinity (distant)—is to snap the shutter when your hand is held before the lens. Keep the tube pointing straight into the camera. If it is off-center it will produce smeary pictures, as Serios did on many occasions. The photo that results is usually of poor but interesting quality. The pictures are often in the middle of a Polaroid frame, with a circular shape surrounded by black, as would be expected. If you like, you can be sure your device is not detected by placing a loose tube of paper around it. The device will slide out easily, and you can offer the paper tube for examination, though any parapsychologist will hesitate to look too carefully.[45]

By this means skeptical investigators were soon duplicating the alleged PK-photographic effects. Serios was unwilling to appear before a committee of photo experts and sleight-of-hand practitioners, but finally acquiesced to the face of a public challenge issued by *Popular Photography* magazine. At one point during the session, after an exposure was made, a magician asked to examine the paper tube, to see if there was anything inside. Serios backed away, putting his hand in his pocket. However, no "thoughtograph" appeared, and the session ended with accusations on both sides: The committee members suggested Serios was a fake, afraid to try his tricks before those who could detect them. On the other hand, Serios and Eisenbud blamed the poor results on a hostile atmosphere.[46]

Nevertheless, the session was effectively Serios's Waterloo. According to Gordon Stein in his *Encyclopedia of Hoaxes*: "Serios lost interest in making thoughtographs and Eisenbud lost interest in defending Serios. In the absence of carefully controlled tests, the use of the lens/film system [i.e., the projection device] was the best explanation of how the images got on the film."[47]

A successor to Ted Serios arrived in 1978 in the form of a sixteen-year-old Japanese boy named Masuaki Kiyota. He demonstrated his supposed ability to project mental pictures onto unexposed Polaroid film "under very tight conditions." Actually when skeptical investigators were asked to participate in tests conducted in London by Granada Television, they discovered that when conditions were "fairly tight" Kiyota "was unable to fulfill his claim to project mental images onto film." In fact, "the only time he achieved any success was after the film had been in his possession—and not under any control—for at least two hours." They added that "unfortunately, no steps were taken to ensure that the film pack could not be tampered with."

One investigator succeeded in producing photographs—including an image of Bath Cathedral—in a manner consistent with those the Japanese youth produced. Improvising a darkroom from a dim hallway (which yielded just enough light to see by when his eyes adapted to the dark), he took apart a film pack and folded back the film then used a "pinhole projector" at a distance of six to eight inches to expose the film for two or three seconds. (The projector was made from a slide viewer by covering the front lens with a piece of cardboard pierced with a small darning needle.) He reported: "The size of the subject on the print can be varied by altering the distance of the projected image. This means that sometimes only part of the original slide will be reproduced. The positioning of the main subject can also be altered by different angles of projection. For example, two of Masuaki's previous successes were aerial photographs of the Statue of Liberty. While the view and the shadows were identical, the Statue in one picture was in a different position of the frame."[48]

Another alleged psychokinetic marvel is Israeli-born Uri Geller, who

claims to be guided by super-beings from a distant planet and to be able to read minds, bend keys and spoons with PK, see while blindfolded, and perform other feats. Skeptics point out that Geller is a former magician, that magicians can duplicate his effects by clever tricks, and that he refuses to perform when magicians are observing—apparently afraid that they might discover his trickery. In fact Geller has actually been caught cheating. In one instance, although he pretended to cover his eyes while a secretary made a simple drawing, Geller actually peeked, thus enabling him to appear to read her mind and reproduce the drawing. Again, instead of bending a key "by concentration" as he pretended, Geller bent the key against a table when he thought no one was looking.

He was also caught cheating in a photographic experiment in which he was to peer through a camera's lens cap, which had been taped in place, to project onto film a thoughtograph. As it happens, "the Man with the Magic Eyes" (as he was once styled) had been left alone with the camera briefly, and the resulting picture showed what *Popular Photography* magazine's photo experts concluded was Geller surreptitiously holding the lens cap a short distance from the lens! With an ordinary camera lens the effect might have been some mysterious play of light and shadow, but in this case the camera was equipped with a "fisheye" lens.[49] Comparable to a convex security mirror in a department store, which gives a wide-angle (if somewhat distorted) view of the area, the fisheye lens extends the angle of viewing from the 45 degrees obtained with a normal lens to a 100-degree angle of view.[50] Geller had apparently loosened the tape by gently twisting the lens cap back and forth, then replaced the cap after making an exposure.

According to the premier issue of a bizarre Russian magazine called *Aura-Z*—a self-described "illustrated quarterly journal of ufological and paranormal phenomena"—thoughtographs can even be produced unintentionally. Or perhaps they should be termed hallucinographs: the claim is that "visual hallucinations" of mental patients were filmed with a variety of cameras and even without cameras, using "flat negative film and infrachromatic photo plates in lightproof packets." Some of the resulting images are published, including a wormlike "Numeral 1," a roundish "Moon," and others; among those not illustrated are "a brass band," "a church," and "a bottle of vodka." The article claimed that "some of the photographs were shown to the patients after their recovery, and they acknowleged their hallucinations."[51]

Asked to comment on the report, one "Professor A. Chernetsky, Ph.D." thought the recording of mental images by camera plausible. As he opined:

If the potentials of tension on the retina are high enough to excite the atoms in the receptors of the retina and transfer their electrons to a higher energy level, then in the

reverse process when the electrons fill a lower level they will emit quanta of light and thus make the eye a source of light of this or that intensity distributed throughout the retina according to the potential relief and visual notions of the patient.

It is evident that provided the speed of the film, the time of exposure and the stability, a phenomenon of this type might be able to be registered on the film.

However, he added: "It is more difficult to explain the inadvertent exposure of a flat film placed inside an opaque light-proof packet. Here we are obliged to suggest that radiation from the eye is carried out not only in the visible scale of wave-lengths but in some other one too, in which the black paper of the packet becomes transparent. This problem requires a special and more profound investigation conducted by physicists, specialists in radiation, biologists and neurophysiologists."[52]

The professor (whose field of expertise goes unreported) might have added magicians. Although the article speaks blithely of "control experiments" that were allegedly conducted, there is no mention of the incredible results being monitored by outside investigators and magicians to rule out trickery. Neither is there mention of the alleged experiments being replicated by others or even of publication in peer-reviewed scientific journals. Until these conditions are fulfilled, perhaps we should avoid getting our "science" from fringe literature.

It is important to distinguish between a healthy and appropriate skepticism—one that places the burden of proof where it belongs, on the proponent of an idea—and a simple refusal to believe something in the face of overwhelming evidence. Among the latter would be those who persist in doubting that the United States landed men on the moon, and those who call themselves "holocaust revisionists" (who deny the Nazis carried out mass murder against Jews). Therefore, since skepticism is "simply a doubting state of mind," what is needed is not so much skepticism as *discernment*, or critical thinking.[53] Such thinking does not inhibit the truth; instead the demand for rigorous proof helps insure that it emerges from the cacophony of controversy.

To close on a lighter note, a parody of the "holocaust revisionists" was circulated recently, pretending to prove that "the 'state' of Idaho is a baseless myth." For example, referring to various geographic sources, the parody questions, "Isn't it strange that a state with such vast land resources has so few people?" Or more pointedly, "Do you know *anybody who knows anybody* from Idaho?" Moreover, there is the satellite information which "shows absolutely *no evidence* that there is any state where 'Idaho' is supposedly located." And finally, there is the "photographic 'evidence'":

Many people, skeptical of the clear evidence that Idaho does not and never did exist, point to photographs that they've seen in encyclopedias and postcards seeming to show parts of the state of Idaho.

It is important to note that a photograph without a caption is often meaningless. A picture of people in boats surrounded by mountains could have been taken in Colorado or Nevada, but when the holy caption says that this is a picture of the 'Salmon River' in 'Idaho,' gullible readers tend to swallow this information whole *without any further examination.*

We have examined literally hundreds of these 'photographs,' and the ones that are not outright fakes are all clearly taken in other parts of the nation.[54]

As this parody demonstrates, whatever photographic question is under investigation—whether it involves some paranormal claim, civil or criminal matter, or historical issue—it must be approached with the proper attitude. Investigators of whatever variety share a belief that mysteries invite solution, that adequate proof can be an attainable goal, and that a discerning mind and appropriate rules of evidence are the means to that goal. It is hoped that this book will facilitate those means.

Recommended Works

Eisenbud, Jule. *The World of Ted Serios.* New York: William Morrow, 1967. Credulous account of one person's claims to produce "thoughtographs" (psychokinetically created photos), recommended only as an example of claims that ultimately fail to withstand scrutiny (see Reynolds and Eisendrath).

Nickell, Joe. *Looking for a Miracle.* Buffalo, N.Y.: Prometheus Books, 1993. Investigative study of miracles, many involving photographs of allegedly miraculous occurrences, others pictures that are supposedly made by miraculous means (including the Shroud of Turin).

Nickell, Joe, with John F. Fischer. "Phantom Pictures: Self-portraits of the Dead," chapter 4 of *Secrets of the Supernatural.* Buffalo, N.Y.: Prometheus Books, 1988. Case study of a fraudulent spiritualist medium's production of "spirit precipitations" on silk—supposedly portraits of sitters' spirit guides.

Randi, James. "A Skotography Scam Exposed," *Skeptical Inquirer* 7.1 (Fall 1982): 59-61. Exposé of the fraudulent production of spirit photos (supposedly by non-camera means).

Reynolds, Charles, and David B. Eisendrath. "An Amazing Weekend with the Amazing Ted Serios," *Popular Photography,* October 1967: 81-87, 131-41, 158. Report on an encounter with a "thoughtographer," effectively debunking his alleged production of thought-pictures, by mental power alone (see Eisenbud).

Stein, Gordon. *Encyclopedia of Hoaxes.* Detroit: Gale Research, 1993. Compendium of illuminating studies of hoaxes of every variety, including a section on "Photographic Hoaxes" (with entries on the Cottingley Fairies, Kirlian Photography, Spirit Photography, Ted Serios and Thoughtography, and Other Photographic Hoaxes).

LANDMARKS IN PHOTOGRAPHY

The following chronology—though not exhaustive—does attempt to indicate some of the major developments in photography, together with tips on identifying such distinctive forms as daguerreotypes, ambrotypes, and tintypes. It should assist in those problems in which dating of a photographic image is important.

ca. 1700	Portable camera obscura (capable of projecting images onto a surface for tracing) is commonly available and used for making sketches from nature.
1727	Recognition comes that darkening of silver salts is owing to light, not heat.
1816	J. Nicephore Niepce produces positive photographic image on paper, but is unable to "fix" (prevent from fading).
1820s	Permanent photographs are produced experimentally by Niepce.
1829	French painter L.J.M. Daguerre becomes partner with Niepce.
1833	Niepce dies.
1834-39	Experiments are made by Fox Talbot, an Englishman, using a camera obscura to produce and fix prints on paper. Called a "calotype," its reversed image is termed (by Herschel in 1841) a "negative." By contact with another piece of sensitized paper, a positive could be made.
1837	Daguerreotype is perfected; represents first practical photographic process.

1838	Experimental stereoscope viewer is developed. (Through it, special double-photo cards yielded a single three-dimensional picture.)
1839	Daguerre's invention is announced to French Academy of Sciences.
1840	Hand coloring of daguerreotypes is probably practiced by this time.
early 1840s- ca. 1860	Daguerreotype photos (easily recognizable by their mirrorlike silver surfaces) are popular.
1850s	Viewing of stereographs (stereoscopic pictures) becomes popular.
1850	Photographic slides for magic lanterns (known since the seventeenth century) are patented. (Earlier slides were painted.)
1851	English architect Scott Archer publishes—but does not patent—the wet collodion process. The glass plate is exposed wet in the camera, then developed and fixed.
1855-1865	Ambrotypes (positive-appearing photographic images on glass) are in use, being most popular during the late 1850s. (They were cheaper than daguerreotypes.)
1856	The tintype—a photographic image on thin sheet iron—is invented by an Ohioan, Hamilton L. Smith. (Such images are easily identified, even behind glass, by their attraction to a magnet.)
late 1850s - early 1900s	Tintypes (also called ferrotypes) are popular.
1859	Cartes de visite become extremely popular. (They were approximately $2^{1}/_{4}$ x $3^{1}/_{2}$-inch paper prints mounted on $2^{1}/_{2}$ x 4-inch cards.)
1860s	Nearly all cartes de visite are imprinted with two thin gilt lines as a border on the mounting card.
1862	"Cabinet" photograph (4 x $5^{1}/_{2}$-inch paper print mounted on $4^{1}/_{4}$ x 6-inch card) is introduced for scenic views. In the mid-1860s it became popular for portraits.
1864	Collodion emulsion (emulsion of silver bromide in collodion) represents advance over wet collodion.

1864-66	Between September 1, 1864, and August 1, 1866, cartes de visite may carry a tax stamp on the reverse.
1871	Replacement of collodion by gelatin yields dry photographic plates (introduced commercially later in the decade).
1880	First reproduction of a photographic halftone appears in a daily newspaper (New York's *Daily Graphic*). Under magnification, halftoning is revealed as a mechanical pattern of dots—like a checkerboard in the middle tones and only tiny, unprinted circles in the dark areas.
1884	Roll film is developed; George Eastman and W.H. Walker patent a machine for continuously coating photographic paper with emulsion.
1888	First portable roll-film camera—the No. 1 Kodak—is marketed.
1890s	Cyanotypes (photographs in uniform blue tones with a matte print surface) are popular for pictorial scenes, reproduction of architectural drawings, and the occasional portrait photo. (Process dates from 1840s but was used infrequently until this time.)
1891	First fixed color photos from nature are made by G. Lippmann.
1896	First radiographs (X-ray photos) are made; same year in which Röntgen discovered X rays.
1906	"Panchromatic" plates (which would photograph full color spectrum) are marketed.
1914	First panchromatic film is made by Eastman Kodak company.
Since 1930	Great advances in color photography are made: improved dyes and high-speed films with low graininess.
1948	"Instant" photography arrives with marketing of first Polaroid camera and film.

Recommended Works

Beaumont, Newhall. *The Daguerreotype in America*. New York: Dover, 1976. Illustrated treatment of this type of photography.

Blodgett, Richard E. *Photographs: A Collector's Guide*. New York: Ballantine, 1979. Collector-oriented treatment of the various aspects of old photos, 248 pp., illustrated.

Darrah, William Culp. *Stereo Views*. Gettysburg, Pa.: Privately printed by the author (R.D. 1, Gettysburg 17325), n.d. Useful guide to this specialized subject.

————. *Cartes de Visite in Nineteenth Century Photography*. Gettysburg, Pa.: W.C. Darrah, 1981. Another useful guide.

Hughes, Therle. *Prints for the Collector*. New York: Praeger, 1971. Guide to identifying such nonphotographic prints as woodcuts, etchings, engravings, acquatints, lithographs, etc.

Reilly, James M. *Care and Identification of 19th-Century Photography Prints*. Rochester, N.Y.: Photographic Products Group, Eastman Kodak Co., 1986. Excellent guide to identifying types of photos and preserving them; has detailed, color identification chart.

Ritzenthaler, Mary Lynn, Gerald J. Munoff, and Margery S. Long. *Archives and Manuscripts: Administration of Photographic Collections*. Chicago: Society of American Archivists, 1984. One of the Society's Basic Manual Series, covering all aspects of administering photographic archives; includes chapters on "History of Photographic Processes," (with chronology chart), "Preservation of Photographic Materials," etc.

Witkin, Lee D., and Barbara London. *The Photograph Collector's Guide*. Boston: New York Graphic Society, 1979. Excellent reference on all aspects of old photographs, for the serious collector; 438 pp., illustrated.

NOTES

Chapter 1. Introduction

1. Brian Coe, *The Birth of Photography: The Story of the Formative Years, 1800-1900* (London: Spring Books, 1989), 6.

2. For a fuller discussion see Robert A. Baker and Joe Nickell, *Missing Pieces* (Buffalo: Prometheus Books, 1992), 101-5. See also Joe Nickell, "Literary Investigation: Texts, Sources, and 'Factual' Substructs of Literature and Interpretation," Ph.D. diss., University of Kentucky, 1987, 1-11.

3. Baker and Nickell, *Missing Pieces*, 103.

4. Ibid., 103-4. See also Elie Shneour, "Occam's Razor," *Skeptical Inquirer* 10 (1986): 310-13.

5. Joe Nickell, *Pen, Ink, and Evidence: A Study of Writing and Writing Materials for the Penman, Collector, and Document Detective* (Lexington: Univ. Press of Kentucky, 1990).

Chapter 2. The History of Photography

1. *Encyclopaedia Britannica*, 1960, 21:113, s.v. "Spain."

2. Ibid., 13:669, s.v. "Landscape Painting."

3. Ibid., 18:266, s.v. "Portrait Painting."

4. Ibid., 20:654, s.v. "Silhouette." See also Coe, *Birth of Photography*, 8.

5. Coe, *Birth of Photography*, 8-9.

6. Nickell, *Pen, Ink and Evidence*, 166-68.

7. Coe, *Birth of Photography*, 8-9.

8. Leonardo da Vinci, quoted in translation in ibid., 9.

9. Ibid.; *Encyclopaedia Britannica*, 1960, 4:658-59, s.v. "Camera Lucida and Camera Obscura."

10. Humphry Davy, "An Account of a Method of Copying Paintings Upon Glass etc., Invented by T. Wedgwood Esq., with Observations by H. Davy," *Journals of the Royal Institution* 9 (June 22, 1802), quoted by Peter Turner, *History of Photography* (Greenwich, Conn.: Brompton Books, 1987), 14; and Coe, *Birth of Photography*, 10, 13.

11. Coe, *Birth of Photography*, 13-15. (This early photograph is preserved in the Gernsheim Collection at the University of Texas.)

12. Ibid., 22, 24.

13. James M. Reilly, *Care and Identification of 19th-Century Photographic Prints* (Rochester, N.Y.: Eastman Kodak Co., 1986), 1.

14. John Ward, "The Beginnings of Photography," in Colin Ford, ed., *The Story of Popular Photography* (North Pomfret, Vt.: Trafalgar Square Publishing, 1989), 13.

15. Bernard Marbot, "The New Image Takes Its First Steps," in Jean-Claude Lemagny and André Rouille, eds., *A History of Photography* (Cambridge: Cambridge Univ. Press, 1987), 20; Turner, *History of Photography*, 16.

16. Marbot, "New Image," 20-21.

17. *Ency. Brit.*, 1960, 15:824, s.v. "Morse, Samuel Finley Breese."

18. Coe, *Birth of Photography*, 18-19.

19. Marbot, "New Image," 23.

20. Quoted in Ward, "Beginnings," 20.

21. Ibid., 19-22; Marbot, "New Image," 23-24.

22. Quoted in Coe, *Birth of Photography*, 17.

23. *Conservation of Photographs* (Rochester, N.Y.: Eastman Kodak, 1985), 26; Reilly, *Care and Identification*, 50.

24. Turner, *History of Photography*, 16.

25. Quoted in ibid., 19.

26. Quoted in ibid., 19-20.

27. Marbot, "New Image," 25.

28. Ward, "Beginnings," 21-22. See also Turner, *History of Photography*, 23.

29. Reilly, *Care and Identification*, 50; see also Ross J. Kelbaugh, *Introduction to Civil War Photography* (Gettysburg, Pa.: Thomas Publications, 1991), 7.

30. Coe, *Birth of Photography*, 30.

31. *American Heritage Desk Dictionary* (Boston: Houghton Mifflin, 1981), s.v. "collodion."

32. Kelbaugh, *Introduction to Civil War Photography*, 7; Ford, *Story of Popular Photography*, 179.

33. Coe, *Birth of Photography*, 31.

34. Ibid.

35. Ibid., 32.

36. From an ad reproduced in ibid., 31.

37. Kelbaugh, *Introduction to Civil War Photography*, 15.

38. Ibid.

39. As noted in ibid., 15, 48.

40. David Allison, "Photography and the Mass Market," in Ford, *Story of Popular Photography*, 48.

41. Kelbaugh, *Introduction to Civil War Photography*, 15.

42. Ibid., 27.

43. Coe, *Birth of Photography*, 32. See also Richard Blodgett, *Photographs: A Collector's Guide* (New York: Ballantine Books, 1979), 34; Kelbaugh, *Introduction to Civil War Photography*, 27.

44. Kelbaugh, *Introduction to Civil War Photography*, 27.

45. Coe, *Birth of Photography*, 32; Allison, "Mass Market," 48.

46. Reilly, *Care and Identification*, 51.

47. Blodgett, *Photographs*, 34, 35; *Conservation of Photographs*, 31. See also Josette Sivignon, "Chronology," in Lemagny and Rouille, *History of Photography*, 269.

48. Allison, "Mass Market," 48.

49. Coe, *Birth of Photography*, 32-34.

50. *Conservation of Photographs*, 32.

51. Kelbaugh, *Introduction to Civil War Photography*, 27; Coe, *Birth of Photography*, 36.

52. Blodgett, *Photographs*, 35.

53. *Conservation of Photographs*, 32.

54. Kelbaugh, *Introduction to Civil War Photography*, 27.

55. Ibid.; Blodgett, *Photographs*, 34-35.

56. Quoted in Allison, "Mass Market," 48.

57. Coe, *Birth of Photography*, 35, 36.

58. Quoted in Coe, *Birth of Photography*.

59. Blodgett, *Photographs*, 43; Coe, *Birth of Photography*, 26-28.

60. Coe, *Birth of Photography*, 28.

61. Ibid.

62. Ibid., 29; Reilly, *Care and Identification*, 2-4.

63. Blodgett, *Photographs*, 46.

64. Coe, *Birth of Photography*, 35. See also Reilly, *Care and Identification*, 4.

65. Reilly, *Care and Identification*, 7-9.

66. Blodgett, *Photographs*, 47.

67. *American Journal of Photography*, N.S. 4 (1862): 360, quoted in William C. Darrah, *Cartes de Visite in Nineteenth Century Photography* (Gettysburg, Pa.: W.C. Darrah, 1981), 4.

68. Darrah, *Cartes de Visite*, 4.

69. Ibid.

70. Ibid.; Coe, *Birth of Photography*, 36.

71. Blodgett, *Photographs*, 67.

72. Ibid.

73. Kelbaugh, *Introduction to Civil War Photography*, 19.

74. Coe, *Birth of Photography*, 36, 136.

75. Allison, "Mass Market," 55. According to Allison, Window "also introduced a sturdy and practical studio camera in the early 1860s."

76. Blodgett, *Photographs*, 70.

77. Ibid., 59; Allison, "Mass Market," 56.

78. Blodgett, *Photographs*, 59.

79. Coe, *Birth of Photography*, 56.

80. Blodgett, *Photographs*, 59.

81. Kelbaugh, *Introduction to Civil War Photography*, 36.

82. Coe, *Birth of Photography*, 38.

83. Ibid., 38-39.

84. Quoted in ibid., 39.

85. Blodgett, *Photographs*, 55, 238; Coe, *Birth of Photography*, 39-40.

86. Coe, *Birth of Photography*, 40-43.

87. Ibid., 43.

88. These devices are illustrated in Ward, "Beginnings," 21, 24.

89. Coe, *Birth of Photography*, 44.

90. *The Compact Edition of the Oxford English Dictionary* (Glasgow: Oxford Univ. Press, 1971), s.v. "snap-shot."

91. Coe, *Birth of Photography*, 44-45.

92. Ibid., 48; Coe, "The Rollfilm Revolution," in Ford, *Story of Popular Photography*, 60.

93. Coe, "Rollfilm," 60-61; Coe, *Birth of Photography*, 50-51.

94. Coe, "Rollfilm," 60-62.

95. Ibid., 62.

96. Ibid., 63; Coe, *Birth of Photography*, 56-57.

97. Coe, "Rollfilm," 64-65.

98. Quoted in ibid., 63.

99. Coe, *Birth of Photography*, 61.

100. Ibid., 46-48, 60-61; John Chittock, "From Home Movie to Home Video," in Ford, *Story of Popular Photography*, 154. See also Eadweard Muybridge, *The Human Figure in Motion*, facsimile edn. (New York: Bonanza, 1989).

101. Coe, "Rollfilm," 84-85.

102. Blodgett, *Photographs*, 115.

103. Geoffrey Crawley, "Colour Comes to All," in Ford, *Story of Popular Photography*, 133.

104. Ibid., 88-89.

105. "Eastman Kodak Unveils Filmless Camera System," *Lexington* (Kentucky) *Herald-Leader*, May 29, 1991.

106. Anne McCauley, "An Image of Society" in Lemagny and Rouille, *History of Photography*, 62.

107. Turner, *History of Photography*, 7.

Chapter 3. Historical Photo Mysteries

1. Reilly, *Care and Identification*, 50; *Conservation of Photographs*, 25-27; Blodgett, *Photographs*, 33-34; Coe, *Birth of Photography*, 21.

2. Michael J. Deas, *The Portraits and Daguerreotypes of Edgar Allan Poe* (Charlottesville: Univ. Press of Virginia, 1988), citing Floyd and Marion Rinhart, *The American Daguerreotype* (Athens: Univ. of Georgia Press, 1981), 425.

3. Deas, *Portraits and Daguerreotypes of Edgar Allan Poe*, 156-57, cf. 47-49.

4. Reilly, *Care and Identification*, 51-52.

5. Kelbaugh, *Introduction to Civil War Photography*, 15.

6. Reilly, *Care and Identification*, 52.

7. Kelbaugh, *Introduction to Civil War Photography*, 27.

8. Ibid., 19, 27.

9. Darrah, *Cartes de Visite*, 194-96.

10. Ibid., 29, 33, 57, 175, 178, 189, 194-96.

11. Ibid., 10; Blodgett, *Photographs*, 70.

12. Blodgett, *Photographs*, 59.

13. See Nickell, *Pen, Ink and Evidence*.

14. Alison Gernsheim, *Victorian and Edwardian Fashion: A Photographic Survey* (New York: Dover, 1981), 32-33.

15. *Conservation of Photographs*, 35.

16. Lemagny and Rouille, *History of Photography*, 271; *Ency. Brit.*, 1960, 17:806, s.v. "Photography."

17. Photographer Robert H. van Outer, Lexington, Ky., personal communication, August 25, 1991.

18. *Journey Into Imagination: The Kodak Story* (Rochester, N.Y.: Eastman Kodak Co., 1988), 28.

19. Coe, "Rollfilm," 84.

20. Martin Willoughby, *A History of Postcards* (Secaucus, N.J.: Wellfleet Press, 1992), 68-77.

21. Kelbaugh, *Introduction to Civil War Photography*, 48.

22. Ordway Hilton, *Scientific Examination of Questioned Documents*, revised edition (New York: Elsevier Science Publishing, 1982), xiv.

23. Blodgett, *Photographs*, 16, 18, 238.

24. Photohistorian Bill Rodgers, Frankfort, Ky., personal communication, cited in Joe Nickell, "A Study of Five Unidentified Family Photos," unpublished transcript for client, December 17, 1992.

25. Ibid.

26. Coe, *Birth of Photography*, 21. Coe states: "If a right-way-round picture was required a mirror or prism was interposed between the sitter and the lens." However Kelbaugh in *Introduction to Civil War Photography* (p. 15) writes of the similarly direct-positive ambrotype: "In addition, the plate could usually be finished so the image was not reversed (like your reflection in a mirror) without a special device *inside* the camera" (emphasis added).

27. Deas, *Portraits and Daguerreotypes of Edgar Allan Poe*, 47-51, 158-59.

28. Blodgett, *Photographs*, 28.

29. Richard Busch, "Collectors Beware!" *Popular Photography*, May 1977, 123.

30. Ibid., 132.

31. Ibid.

32. Harold Denstman and Morton J. Schultz, *Photographic Reproduction* (New York: McGraw-Hill, 1963), 33-54.

33. David G. MacLean, "Fake Civil War Tintypes Discovered at Antique Mall," *Antique Week*, November 16, 1992: 29.

34. Ibid.

35. Busch, "Collectors Beware!" 111, 122.

36. Ibid., 133; MacLean, "Fake Civil War Tintypes," 29.

37. Busch, "Collectors Beware!" 134-35.

38. Stuart Bennett, *How to Buy Photographs* (Oxford: Phaidon-Christie's, 1987), 56.

39. Busch, "Collectors Beware!" 137.

40. Ibid., 134.

41. Bennett, *How to Buy Photographs*, 56.

42. Jane Langton, *Emily Dickinson Is Dead* (New York: St. Martin's, 1984).

43. Charles Hamilton, *Great Forgers and Famous Fakes* (New York: Crown, 1980), 32-34, 107.

44. Nickell, *Pen, Ink and Evidence*, 188-89.

45. Ibid., 117-21; Kenneth Poli, "Critical Focus," *Popular Photography*, March 1979: 6, 222: Mark Jones, ed., *Fake? The Art of Deception* (Berkeley: Univ. of California Press, 1990), 244-45.

46. Bennett, *How to Buy Photographs*, 120-21.

47. George Oliver, *Photographs and Local History* (London: B.T. Batsford, 1989), 8.

48. Ibid., 11-12.

49. W. Lynn Nickell, *The Changing Faces of West Liberty: A Pictorial History* (Berea, Ky.: Kentucke Imprints, 1988).

50. Adapted from Joe Nickell, "Vintage Photos of West Liberty Collected," *The Licking Valley Courier*, January 23, 1986.

51. *Ency. Brit.*, 1960, 2:306, s.v. "Arctic Regions"; Curtis D. MacDougall, *Hoaxes* (New York: Dover, 1958), 119-21, 222.

52. Gilbert M. Grosvenor, editorial, *National Geographic* 177.1 (January 1990): 44.

53. Thomas D. Davies, "New Evidence Places Peary at the Pole," *National Geographic* 177.1 (January 1990): 46, 54-55.

54. Ibid., 58.

55. Ibid., 45, 52-53.

56. Joseph L. Galloway, "One Picture That Cannot Tell a Story," *U.S. News and World Report*, July 29, 1991: 5.

57. "U.S. Raises Doubts About MIA Photos," *The Orlando Sentinel* (Orlando, Florida), August 6, 1991; "4th MIA Photo Found in Magazine," *Lexington* (Kentucky) *Herald-Leader*, August 9, 1991.

58. "Photo Source Discredited," *Lexington* (Kentucky) *Herald-Leader*, July 26, 1991.

59. "Pentagon Gets Copy of Photo," *Lexington* (Kentucky) *Herald-Leader*, July 20, 1992.

60. ABC News, *20/20*, June 5, 1992, transcript no. 1224, p. 1.

61. Ibid., pp. 1-4.

62. Walter F. Rowe, "The Case of the Lying Photographs: The Civil War Photography of George N. Barnard," *Journal of Forensic Sciences*, JFSCA, 28.3 (July 1983): 735-55.

63. Ibid., 743.

64. Ibid., 747.

65. Ibid., 742.

66. F.T. Miller, *The Photographic History of the Civil War* (New York: Review of Reviews Co., 1911), cited in Rowe, "Lying Photographs," 742.

67. William Frassanito, *Gettysburg: A Journey in Time* (New York: Charles E. Scribners, 1975), cited in Rowe, "Lying Photographs," 736.

68. Rowe, "Lying Photographs," 736.

69. Ibid., 736-37.

70. Joe Nickell, *Ambrose Bierce Is Missing and Other Historical Mysteries* (Lexington: Univ. Press of Kentucky, 1992), 76.

71. David A. Crown, "The Greatest Air Combat Photographs of All Time," paper presented to the American Society of Questioned Document Examiners' 49th annual conference, Lake Buena Vista, Florida, August 3-8, 1991: 1.

72. Ibid., 1-2.

73. Ibid., 2.

74. Ibid., 4.

75. Ibid.

76. See Murray Morgan, *One Man's Gold Rush: A Klondike Album*, with photo-

graphs by E.A. Hegg (Seattle: Univ. of Washington Press, 1967). However, many of the photographs are unpublished and are in archival repositories such as Yukon Archives, Whitehorse, Yukon.

77. This study is adapted from Joe Nickell, "Gold Rush: The Signs of the Times," *Canada West* 11.1 (Spring 1981).

78. See, for example, Hegg's photos in Morgan, *One Man's Gold Rush*, 145-46.

79. Morgan, *One Man's Gold Rush*, 209-10. Hegg had left the plates with a colleague who stored them, packed in sawdust, between the inner and outer walls of his cabin. Years later a woman who rented the cabin discovered them while repairing an interior wall and contemplated using them as panes for a greenhouse. When she asked her boss how to get the gray stuff off the plates, he recognized their true nature and value, bought a supply of glass panes and traded her one for one.

Chapter 4. Photography and Identification

1. John Wilkes, *The London Police in the Nineteenth Century* (Minneapolis: Lerner Publications Company, 1984), 35.

2. For a concise history of identification see Henry Soderman and John J. O'Connell, *Modern Criminal Investigation* (New York: Funk and Wagnalls, 1952), 68-98.

3. Fred E. Inbau, Andre A. Moenssens, and Louis R. Vitullo, *Scientific Police Investigation* (New York: Chilton, 1972), 25-26. See also C.A. Mitchell, *The Expert Witness* (New York: D. Appleton, 1923), 37-41.

4. Darrah, *Cartes de Visite*, 40; Inbau, Moenssens, and Vitullo, *Scientific Police Investigation*, 2.

5. *The Compact Edition of the Oxford English Dictionary* (New York: Oxford Univ. Press, 1971), I: 1871, s.v. "mug."

6. Darrah, *Cartes de Visite*, 40-41.

7. Wilkes, *London Police*, 35.

8. "Mug Photography" in *Police Photography*, lesson 8 of the course in "Civil and Criminal Identification and Investigation" (Chicago: Institute of Applied Science, 1962), 2.

9. Mitchell, *Expert Witness*, 25.

10. "Mug Photography," 3.

11. Ibid., 4-10. This source listed seven requirements, but I have subsumed that additional one—"good reproduction of marks and scars"—under the first.

12. Ibid., 14.

13. Ibid., 24.

14. Ibid., 17-18.

15. For photographs of Beck and Thomas, see Jurgen Thorwald, *The Century of the Detective* (New York: Harcourt, Brace and World, 1964), illustration facing p. 84.

16. "Double Trouble: Synchronicity and the Two Will Wests," chapter 6 of Joe Nickell with John F. Fischer, *Secrets of the Supernatural* (Buffalo: Prometheus Books, 1988), 75-88. This is a revised version of the author's article, "The Two 'Will Wests': A New Verdict," *Journal of Police Science and Administration* 8.4 (December 1980), 406-13.

17. Douglas P. Hinkle, *Faces of Crime: True Crime Stories from the Files of a Police Artist* (Atlanta, Ga.: Peachtree Publishers, 1989), 30.

18. Ibid., 12-13, 16, 163. For additional information—including procedures for utilizing multiple, possibly conflicting, witnesses—see Charles E. O'Hara, *Fundamentals of Criminal Investigation*, third edition (Springfield, Ill.: Charles C. Thomas, 1973), 641-46.

19. Alex MarKovich, "Jigsaw Puzzle Helps Catch Crooks," *Popular Science*, November 1960; 126-28; Charles R. Swanson, Jr., Neil C. Chamelin, and Leonard Territo, *Criminal Investigation*, 4th edition (New York: McGraw-Hill, 1988), 356-57 (illus. p. 357).

20. Jacques Penry, *Looking at Faces and Remembering Them: A Guide to Facial Identification* (London: Elek Books, 1971).

21. Hinkle, *Faces of Crime*, 14.

22. Nancy Burson, Richard Carling, and David Kramlich, *Composites: Computer Generated Portraits* (New York: Beech Tree Books [William Morrow], 1986), 53.

23. Ibid., 10. Galton's "Composite of the Members of a Family," which displays portraits of the individual family members, as well a "Composite of Men," "Composite of Women," and the "Co-composite," is reproduced in ibid., 11.

24. Ibid., 14-15. (illus. pp. 58-64); Hunt Helm, "Updated Computer-Drawn Portrait Added to Search for Missing Girl," Louisville *Courier-Journal*, August 7, 1986; Robert S. Boyd, "It Looks Like a Case for Technology," *Lexington* (Kentucky) *Herald-Leader*, undated clipping following List's conviction.

25. Gregory Byrne, "Random Samples" column, *Science* 243: 610.

26. Joe Nickell, "Report on an Examination of Photographs in an Old Family Album," prepared for Mrs. Oscar Dillon, Nicholasville, Ky., February 3, 1993.

27. The ambrotype is owned by the Woodford County Historical Society, Versailles, Ky.

28. Joan M. Beamis and William E. Pullen, *Background of a Bandit: The Ancestry of Jesse James* (second edition; n.p.: privately printed, n.d. [ca. 1870]), 19; Frank Triplett (with Mrs. Jesse James and Mrs. Zerelda Samuel), *The Life, Times and Treacherous Death of Jesse James* (St. Louis, 1882), 65.

29. Deas, *Portraits and Daguerreotypes*, 7.

30. Ibid., 132.

31. Ibid., 134.

32. Ibid., 137.

33. Ibid., 8.

34. Dan DeNicola, "Is It Really You, Emily Dickinson?" *Yankee Magazine*, Nov. 1983: 124-25, 216, 219; Jane Langton, "Emily Dickinson's Appearance and Likeness . . . Book 1," unpublished set of four notebooks on loan to author.

35. Sylvia De Santis (Head Librarian, Monson Free Library and Reading Room Association, Monson, Mass.) letter to Joe Nickell, March 3, 1993; Polly Longsworth, *The World of Emily Dickinson* (New York: W.W. Norton, 1990), 40-41, 129.

36. *Harper's Weekly*, May 6, 1865.

37. Charles Hamilton and Lloyd Ostendorf, *Lincoln in Photographs: An Album of Every Known Pose* (Norman: Univ. of Oklahoma Press, 1963), 237.

38. Military files of Milo Welton and John A. Welton, Co. K. 4th Pennsylvania Cavalry, Military Records Division, National Archives, Washington, D.C.

39. Jane Dillon, personal communication; Nickell, "Report on an Examination of Photographs in an Old Family Album," 6-7.

40. Norman D. Gleason, Sovereign Grand Secretary of The Sovereign Grand Lodge of the Independent Order of Odd Fellows, letter to Joe Nickell, April 27, 1993.

41. Joseph Gardner, personal communication; see "Hidden Identity," chapter 4 of Nickell, *Ambrose Bierce Is Missing*, 36.

42. The comparison of a questioned item with a known one is the basis for forensic comparisons of all types: fingerprints, bullets, handwriting, etc.

43. Michael Eddowes, *The Oswald File* (New York: Clarkson N. Potter, 1977), 1-2. The discussion of Oswald's "double" in this chapter is adapted from Joe Nickell with John F. Fischer, *Mysterious Realms* (Buffalo, N.Y.: Prometheus Books, 1992), 35-52.

44. Eddowes, *Oswald File*, 139.

45. House Select Committee on Assassinations, *Appendix to Hearings*, 95th Congress, 2nd Session, vol. 8 (March 1979), 247.

46. Ibid., vol. 6, 273-81.

47. Gerald L. Posner and John Ware, *Mengele: The Complete Story* (New York: McGraw-Hill, 1986), 320.

48. Hugh Berryman, forensic anthropologist at the University of Tennessee Medical School, quoted in Robert A. Erlandson, "Exhumation Requested to Determine if Body Is Really John Wilkes Booth," *Lexington* (Kentucky) *Herald-Leader*, March 17, 1992.

49. Emily A. Craig, letter to Joe Nickell, May 4, 1993; report to Joe Nickell, July 26, 1993.

50. "Computer Upholds Billy the Kid Legend," *Lexington* (Kentucky) *Herald-Leader*, March 4, 1990; Gregory Byrne, "Random Samples: Did Billy Really Die a Kid?," *Science* 243 (Feb. 3, 1989): 610; Jake Page, "Was Billy the Kid a Superhero—or a Superscoundrel?," *Smithsonian*, February 1991: 137-48.

51. "Computer Upholds Billy the Kid Legend."

52. Ibid.

53. Nickell, "Tracking Jesse James in Kentucky," 235.

54. Richard M. Dorson, *American Folklore* (Chicago: Univ. of Chicago Press, 1959), 243.

55. Nickell, *Ambrose Bierce Is Missing*, 36.

56. Reg Little, "Count Slams Treblinka 'Show Trial,'" *Oxford Times* (England), April 22, 1988.

57. Tom Teicholz, *The Trial of Ivan the Terrible* (New York: St. Martin's Press, 1990), 176-77.

58. Ibid., 174-75.

59. See Nickell, *Ambrose Bierce Is Missing*, 46.

60. Ibid., 46-47.

61. Teicholz, *Trial of Ivan the Terrible*, 302-6. On July 29, 1993, the Israeli Supreme Court threw out Demjanjuk's conviction, saying that his identification as "Ivan the Terrible" could not be proved beyond a reasonable doubt; however, they added that they were convinced he had belonged to a Nazi unit that exterminated Jews. See "U.S. Doesn't Want 'Ivan' Suspect," and "UK Teacher Says Demjanjuk Is Guilty," *Lexington* (Kentucky) *Herald-Leader*, July 30, 1993. Earlier, in upholding Demjanjuk's deportation, a federal judge stated: "Mr. Demjanjuk's alibi was so incredible as to legitimately raise the suspicions of his prosecutors that he lied about everything—including his denial that he was Ivan the Terrible." See "Deportation

Upheld for Man Convicted of Nazi War Crimes," *Lexington* (Kentucky) *Herald-Leader*, July 1, 1993.

62. House Select Committee on Assassinations, Appendix to Hearings, 95th Congress, 2nd Session, vol. 6 (March 1979), 273-81.

63. Soderman and O'Connell, *Modern Criminal Investigation*, 97.

64. Alfred V. Iannarelli, *Ear Identification* (Fremont, Cal.: Paramont, 1989), a revised edition of *The Iannarelli System of Ear Identification*.

65. Penry, *Looking at Faces and Remembering Them*, 82-92.

66. J.W. Osterburg, *The Crime Laboratory* (Bloomington: Indiana Univ. Press, 1968), 34-35.

67. Alfred V. Iannarelli, *Ear Identification*.

68. Alfred V. Iannarelli, letter to Hon. Louis Stokes, Chairman, House Select Committee on Assassinations, Dec. 5, 1980.

69. Alfred V. Iannarelli, letter-report to Joe Nickell, November 14, 1987.

70. Alfred V. Iannarelli, letter to Joe Nickell, April 17, 1979.

Chapter 5. Investigative Photography

1. Inbau, Moenssens, and Vitullo, *Scientific Police Investigation*, 5-6.

2. "Crime-Scene Photographs," in *Police Photography*, lesson 8 of the course in "Civil and Criminal Identification and Investigation" (Chicago: Institute of Applied Science, 1962), 11.

3. Swanson, Chamelin, and Territo, *Criminal Investigation*, 51.

4. Inbau, Moenssens, and Vitullo, *Scientific Police Investigation*, 6-7

5. Confidential case in the author's files. A "psychological autopsy" attempts to determine the victim's state of mind at the time of a possible suicide.

6. Swanson, Chamelin, and Territo, *Criminal Investigation*, 52.

7. Ibid., 52-53.

8. Ibid., 54; Inbau, Moenssens, and Vitullo, *Scientific Police Investigations*, 7-8.

9. Inbau, et al., ibid.

10. Swanson, Chamelin, and Territo, *Criminal Investigation*, 53-54.

11. R.M. Boyd, "Buried Body Cases," *FBI Law Enforcement Bulletin*, 48.2 (February 1979): 1-7, cited in Swanson, Chamelin, and Territo, *Criminal Investigation*, 256-61. For handling evidence, see "An Outline of the Rules for Handling Physical Evidence," appendix of Inbau, Moenssens, and Vitullo, 173-99.

12. Maurice Robbins with Mary B. Irving. *The Amateur Archaeologist's Handbook*, 3rd edition (Cambridge: Harper and Row, 1981).

13. H. Zim, R. Burnett, and W. Brummitt, *Photography: The Amateur's Guide to Photography* (New York: Golden Press, 1964), 146.

14. Swanson, Chamelin, and Territo, *Criminal Investigation*, 56-57 (illus. p. 57).

15. O'Hara, *Fundamentals of Criminal Investigation*, 663, 666.

16. "The Finger Print Camera," in *Police Photography* (see n. 2), 28-32.

17. William Bradford Huie, "Why James Earl Ray Murdered Dr. King," *Look*, April 15, 1969: 112.

18. O'Hara, *Fundamentals of Criminal Investigation*, 815.

19. "Photomacrography," in *Police Photography*, lesson 9, (see n. 2), 2, 5; Swanson, Chamelin, and Territo, *Criminal Investigation*, 109 (illus).

20. "Photomicrography" in *Police Photography*, lesson 9 (see n. 2), 8-9; "Microphotography" in ibid., 9: *Edmund Scientific 1993 Annual Reference Catalog* (Barrington, N.J.: Edmund Scientific Co., 1993), 120. For information on microdots, see C.B. Colby, *F.B.I.: The G-Men's Weapons and Tactics for Combatting Crime* (New York: Coward-McCann, 1954), 32, and Donald McCormick, *The Master Book of Spies* (London: Hodder Causton, 1973), 134-35.

21. Inbau, Moenssens, and Vitullo, *Scientific Police Investigation*, 75-79, 87-96.

22. Ibid., 70-86 (firearms), 87-96 (tool marks); *Firearms Identification*, lessons 5 and 6 of the course in "Civil and Criminal Identification and Investigation" (Chicago: Institute of Applied Science, 1954), 29-42.

23. *Police Photography* (see n. 2), 7.

24. Inbau, Moenssens, and Vitullo, *Scientific Police Investigation*, 57-58. Ordway Hilton, *Scientific Examination of Questioned Documents*, revised edition (New York: Elsevier Science Publishing Co., 1982), 17.

25. O'Hara, *Fundamentals of Criminal Investigation*, 819-20.

26. *Police Photography*, lesson 9 (see n. 2), 6; *Firearms Identification*, lesson 6 (see n. 22), 8, 21.

27. Hilton, *Scientific Examination of Questioned Documents*, 139; O'Hara, *Fundamentals of Criminal Investigation*, 819; Osborn, *Questioned Documents*, 59.

28. Nickell, *Pen, Ink and Evidence*, 74-87.

29. Hamilton, *Great Forgers and Famous Fakes*, 134-36, 261.

30. Nickell, *Pen, Ink and Evidence*, 64, 66; Albert S. Osborn, *Questioned Documents*, second edition (Montclair, N.J.: Patterson Smith, 1978), 339-62.

31. *Applied Infrared Photography* (Rochester, N.Y.: Eastman Kodak, 1972), 36.

32. O'Hara, *Fundamentals of Criminal Investigation*, 815; Hilton, *Scientific Examination of Questioned Documents*, 365.

33. O'Hara, *Fundamentals of Criminal Investigation*, 762.

34. Jones, *Fake?*, 277, 279 (photograph).

35. O'Hara, *Fundamentals of Criminal Investigation*, 764.

36. Ibid., 764-65.

37. Ibid., 765.

38. *Applied Infrared Photography*, 54.

39. *Applied Infrared Photography*, 36-38, 52; Ann Waldron, *True or False! Amazing Art Forgeries* (New York: Hastings House, 1983), 22.

40. *Applied Infrared Photography*, 16-17.

41. Ibid., 53, 56-57; Samuel T. Williamson and Herman Z. Cummins, *Light and Color in Nature and Art* (New York: John Wiley and Sons, 1983), 298-99.

42. O'Hara, *Fundamentals of Criminal Investigation*, 766.

43. Ibid., 766-67. See also Ada Nisbet, *Dickens and Ellen Ternan* (Berkeley: Univ. of California Press, 1952).

44. *Applied Infrared Photography*, 18-35, 51.

45. John F. Fischer and Joe Nickell, "Laser Light: Space-age Forensics," *Law Enforcement Technology*, September 1984: 26.

46. Allen A. Boraiko, "LASERS: A Splendid Light," *National Geographic* 165.3 (March 1984), 335-62.

47. Fischer and Nickell, "Laser Light," 26-27.

48. Brian E. Dalrymple, "Visible and Infrared Luminescence in Documents:

Excitation by Laser," *Journal of Forensic Sciences*, JFSCA, 28.3 (July 1983): 694 (photograph).

49. Ibid. See also other articles in the *Journal of Forensic Sciences* such as B.E. Dalrymple, "Use of Narrow-Band-Pass Filters to Enhance Detail in Latent Fingerprint Photography by Laser," *Journal of Forensic Sciences*, JFSCA, 27.4 (October 1982): 801-5.

50. Coe, *Birth of Photography*, 48 (photograph).

51. Ibid.

52. H. Keith Melton, *OSS Special Weapons and Equipment* (New York: Sterling, 1991), 103-6; "Miniature Book Camera," *Things You Never Knew Existed*, novelty catalog (Bradenton, Fla.: Johnson Smith Company, 1993), 61.

53. O'Hara, *Fundamentals of Criminal Investigation*, 189.

54. Ibid.; Edmund Scientific catalog (n. 20), 88.

55. Edmund Scientific catalog (n. 20), 193.

56. O'Hara, *Fundamentals of Criminal Investigation*, 208; documentary segment, *NBC Nightly News*, July 25, 1993.

57. Ibid., 192-93. This two-camera system was used by university police at Case Western Reserve University.

58. Byrne, "Random Samples," 610.

59. Colby, *F.B.I.*, 31.

60. Lemagny and Rouille, *A History of Photography*, 48.

61. McCormick, *Master Book of Spies*, 30-31; *Britannica Book of the Year: 1963* (Chicago: Encyclopaedia Britannica, 1963), 470, s.v. "International Propaganda."

62. Ibid., 79, 84; *Britannica Book of the Year: 1964*, 627, s.v. "Kennedy, John Fitzgerald."

63. O'Hara, *Fundamentals of Criminal Investigation*, 775.

64. *Ency. Brit.* 1960, s.v. "Camouflage."

65. Inbau, Moenssens, and Vitullo, *Scientific Police Investigation*, 16.

66. Ibid., 19-20.

67. Ibid., 19.

68. Ibid.

69. For more on rules of evidence, see ibid., 15-20; Swanson, Chamelin, and Territo, *Criminal Investigation*, 573-87.

70. O'Hara, *Fundamentals of Criminal Investigation*, 61.

71. Inbau, Moenssens, and Vitullo, *Scientific Police Investigation*, 19-20.

72. O'Hara, *Fundamentals of Criminal Investigation*, 58, 59.

73. Inbau, Moenssens, and Vitullo, *Scientific Police Investigation*, 17.

74. Michael M. Baden, *Unnatural Death: Confessions of a Medical Examiner* (New York: Random House, 1989), 7.

75. Jim Moore, *Conspiracy of One: The Definitive Book on the Kennedy Assassination* (Fort Worth, Texas: Summit Group, 1990), 153, 165-203.

76. *Report of the President's Commission on the Assassination of President Kennedy* (New York: Bantam Books, 1964), 115.

77. Moore, *Conspiracy of One*, 187-203.

78. Swanson, Chamelin, and Territo, *Criminal Investigation*, 573.

79. James B. Hyzer, "Chronophotogrammetry: Telling Time from Pictures," *PHOTO-Electronic Imaging*, February 1993, 40-43.

80. Ibid., 40.

Chapter 6. Trick Photography

1. Darrah, *Cartes de Visite in Nineteenth Century Photography*, 331. (For more on Claudet, see Turner, *History of Photography*, 22-23, 27.)

2. Ibid., 31.

3. Ibid.

4. See illustrations in ibid., 30-34.

5. Don Carroll and Marie Carroll, *Focus on Special Effects* (New York: Amphoto, 1982), 68.

6. Ibid., 68-87 (color photographs, pp. 75, 76).

7. Ibid., 170-75.

8. Ibid., 116-27.

9. O.R. Croy, *Croy's Camera Trickery* (New York: Hastings House, 1977), 18-19, 31-37, 66-69, 70-73.

10. Carroll and Carroll, *Focus on Special Effects*, 152-69.

11. Ibid., 161-63.

12. Croy, *Croy's Camera Trickery*, 18.

13. Carroll and Carroll, *Focus on Special Effects*, 102-3. See also *Photographic Tricks Simplified* (Garden City, N.Y.: Amphoto, 1974), 24.

14. Anson Kennedy, Doraville, Georgia, personal communication, July 21, 1993.

15. Carroll and Carroll, *Focus on Special Effects*, 99.

16. Ibid., 104 (color photograph).

17. Albert A. Hopkins, ed., *Magic: Stage Illusions and Scientific Diversions, Including Trick Photography*, 1898; reprinted as *Magic: Stage Illusions, Special Effects and Trick Photography* (New York: Dover, 1976), 459.

18. Ibid., 438.

19. Ibid.

20. Croy, *Croy's Camera Trickery*, 20-21.

21. Hopkins, *Magic*, 451-52.

22. Porter Henry, "Skeptics Analyze Tools for Analysis and Persuasion," *Skeptical Inquirer* 17.2 (winter 1993), 126-28 (photos p. 128).

23. Carroll and Carroll, *Focus on Special Effects*, 29.

24. Ibid.

25. Ibid., 39.

26. Ibid., 35-47. See also *Photographic Tricks Simplified*, 32-33.

27. *Photographic Tricks Simplified*, 27-35.

28. Carroll and Carroll, *Focus on Special Effects*, 49.

29. Ibid., 53, 56-59, 60-67.

30. Arthur Wise and Derek Ware, *Stunting in the Cinema* (London: Constable, 1973), 176-77.

31. Ibid., *passim*.

32. Hattersley, *Beginner's Guide to Photography*, 67-69.

33. *Photographic Tricks Simplified*, 50.

34. Ibid.

35. Ibid., 70-72.

36. Ibid., 56, 62, 76, 77.

37. Ibid., 52, 66, 80.

38. Carroll and Carroll, *Focus on Special Effects*, 96-97 (color photograph).

39. Darrah, *Cartes de Visite in Nineteenth Century Photography*, 28.

40. *Encyclopaedia Britannica*, 1960 ed., s.v. "Photographic Art."

41. Darrah, *Cartes de Visite in Nineteenth Century Photography*, 28-29.

42. John R. Podracky, *Photographic Retouching and Air-Brush Techniques* (Englewood Cliffs, N.J.: Prentice-Hall, 1980), 13, 22-24.

43. Ibid., 107-48.

44. Terry Trucco, "Where to Find It: Refreshing the Images of the Past," *New York Times* "Consumer's World," November 12, 1992.

45. Podracky, *Photographic Retouching and Air-Brush Techniques*, 143-48.

46. Ibid., 185-202.

47. Ibid., 151-62.

48. Ibid., 158-60.

49. Anthony R. Pratkanis, "The Cargo-Cult Science of Subliminal Persuasion," *Skeptical Inquirer* 16.3 (spring 1992): 265.

50. Ibid., 260-72; Timothy E. Moore, "Subliminal Perception: Facts and Fallacies," *Skeptical Inquirer* 16.3 (spring 1992): 273-81.

51. Moore, "Subliminal Perception," 279.

52. Gerard J. Holzmann, *Beyond Photography: The Digital Darkroom* (Englewood Cliffs, N.J.: Prentice Hall, 1988), 1-13.

53. Ibid., 4.

54. Advertising literature of Pixel Magic, Inc.

55. "Polaroid Can Copy Your Masterpieces," *Lexington* (Kentucky) *Herald-Leader*, February 10, 1991.

56. Campaign Notebook: Anti-Clinton Ad Doctored," *Lexington* (Kentucky) *Herald-Leader* October 24, 1992.

57. "Texan Says GOP Tricks Made Him Quit the Race," clipping citing Star-Ledger Wire Services (Newark, N.J., *Star-Ledger*), October 26, 1992.

58. Donald Michael Kraig, "I See by the Papers," *Fate*, September 1991: 5.

59. Tom Flynn, "Photographic Proof? Not for Long," *Skeptical Inquirer* 17.2 (winter 1993): 118-20.

60. Ibid., 119.

61. Ibid., 118.

62. Ibid., 120.

63. Mary A. Benjamin, *Autographs: A Key to Collecting* (New York: Dover, 1986), 127.

64. Mark Chorvinsky, "Our Strange World: The Lough Leane Monster Photograph Investigation," in two parts, *Fate*, March 1993: 31-35, and April 1993: 31-34. See also Ronald Binns, *The Loch Ness Mystery Solved* (Buffalo: Prometheus Books, 1984), 106.

65. Gerald Mosbleck, "The Elusive Photographic Evidence," in John Spencer and Hilary Evans, eds., *Phenomenon: Forty Years of Flying Saucers* (New York: Avon, 1988), 210.

66. Philip J. Klass, *UFOs Explained* (New York: Vintage Books, 1974), 170-79.

67. Ibid., 175.

68. Frank D. Drake, "On the Abilities and Limitations of Witnessess of UFO's and Similar Phenomena," in Carl Sagan and Thornton Page, eds., *UFO's: A Scientific Debate* (New York: W.W. Norton, 1974), 248, 253-54.

69. John Shaw, "Is a Picture Worth a Thousand Words?" in Spencer and Evans, *Phenomenon*, 218.

70. Flynn, "Photographic Proof?" 120.

71. Klass, *UFOs Explained*, 167.

72. Carroll and Carroll, *Focus on Special Effects*, 77, 79, 86, 99; Croy, *Croy's Camera Trickery*, 21, 70-71; Gerald Mosbleck, "The Elusive Photographic Evidence," in Spencer and Evans, *Phenomenon*, 209.

73. Joe Nickell, *Looking for a Miracle* (Buffalo: Prometheus Books, 1993), 214. See also Nickell, *Pen, Ink and Evidence*, 181, 184, 203.

74. Bennett, *How to Buy Photographs*, 122-24.

75. Holzmann, *Beyond Photography*, 12.

76. W.I.B. Beveridge, *The Art of Scientific Investigation* (New York: Vintage, n.d.), 67-68.

77. Moore, *Conspiracy of One*, 105.

78. Ibid., 105-6.

79. Ibid., 128-29.

80. Ibid., 128-29.

81. Beveridge, *Art of Scientific Investigation*, 68.

Chapter 7. Photographing the Paranormal

1. Aaron Scharf, *Creative Photography* (London: Studio Vista, 1965), 32-33.

2. For a discussion, see Nickell, *Looking for a Miracle*, 9-10.

3. John Mulholland, *Beware Familiar Spirits* (1938; reprinted New York: Scribner, 1979), 27-45; Milbourne Christopher, *ESP, Seers and Psychics: What the Occult Really Is* (New York: Crowell, 1970), 175.

4. Mulholland, *Beware Familiar Spirits*, passim: Christopher, *ESP, Seers and Psychics*, 174-76.

5. Mulholland, *Beware Familiar Spirits*, 147.

6. Walter E. Woodbury, *Photographic Amusements* (New York: Scovill and Adams, 1896), reprinted in Hopkins, *Magic*, 432. See also Walter B. Gibson, *Secrets of Magic: Ancient and Modern* (New York: Grosset and Dunlap, 1967), 146.

7. Mumler, quoted in Peter Haining, *Ghosts: The Illustrated History* (Secaucus, N.J.: Chartwell, 1987), 76. A photograph which Haining captions "The first known 'Spirit photographs' [sic] taken by William Mumler of Boston, showing himself and the ghost of his cousin," is identified as actually a "photograph of Moses A. Dow with female spirit" in Fred Gettings, *Ghosts in Photographs* (New York: Harmony Books, 1978), 27. Gettings advises, "Though often deemed the very first spirit photograph, it was not." Haining's illustration appears to be a heavily recopied and retouched version of the one provided by Gettings.

8. Mulholland, *Beware Familiar Spirits*, 148.

9. Gettings, *Ghosts in Photographs*, 24 (photograph).

10. Mulholland, *Beware Familiar Spirits*, 148; Gettings, *Ghosts in Photographs*, 23-25. *Cf.* Haining, *Ghosts*, 77.

11. Gettings, *Ghosts in Photographs*, 25.

12. Ibid., 91.

13. Ibid., 37-40; Daniel Cohen, *The Encyclopedia of Ghosts* (New York: Dorset

Press, 1984), 244-47. (Cohen gives the name as Buget.) See also Mulholland, *Beware Familiar Spirits*, 149-50; Haining, *Ghosts*, 77-78.

14. Cohen, *The Encyclopedia of Ghosts*, 244.

15. Gettings, *Ghosts in Photographs*, 40; Mulholland, *Beware Familiar Spirits*, 149-50.

16. Gettings, *Ghosts in Photographs*, 35-37, 149 (n. 26). For more on the Woodburytype, see Coe, *Birth of Photography*, 99. The process was named for Walter Woodbury whose *Photographic Amusements* is cited in n. 6.

17. Ibid., 37, 43.

18. Ibid., 24-27, 41-44 (photos).

19. Ibid., 28, 76-78 (photos).

20. Ibid., 29-34 (photos 30-34). Haining (*Ghosts*, 79) gives Boursnell's first name as Richard.

21. Gettings, *Ghosts in Photographs*, 5-6, 75-77.

22. C. Vincent Patrick, 1921, cited by Mulholland, *Beware Familiar Spirits*, 149.

23. Haining, *Ghosts*, 78-79 (photos 78); Mulholland, *Beware Familiar Spirits*, 152.

24. Mulholland, *Beware Familiar Spirits*, 152.

25. Woodbury (1896), in Hopkins, *Magic*, 433.

26. Cohen, *The Encyclopedia of Ghosts*, 22-29; R.C. Finucane, *Appearances of the Dead: A Cultural History of Ghosts* (Buffalo, N.Y.: Prometheus Books, 1984), 187-88.

27. For the story of Florence Cook and William Crooke's apparent tryst, see Trevor H. Hall, *The Spiritualists* (New York: Helix Press, 1963).

28. Cohen, *The Encyclopedia of Ghosts*, 26.

29. Compare the photos of "Katie King" in Gettings, *Ghosts in Photographs*, 46-48, with a portrait (and another spirit picture of "Katie King") in Cohen, *Encyclopedia of Ghosts*, 24.

30. See the photograph in Gettings, *Ghosts in Photographs*, 7.

31. Finucane, *Appearances of the Dead*, caption to figure 9 (illustrations following p. 120).

32. Gettings, *Ghosts in Photographs*, 49.

33. Woodbury (1896) in Hopkins, *Magic*, 435.

34. Milbourne Christopher, *Houdini: The Untold Story* (New York: Thomas Y. Crowell, 1969), 177-78, photo following p. 160.

35. Gibson, *Secrets of Magic*, 147.

36. Mulholland, *Beware Familiar Spirits*, 152.

37. Ibid., 153-54.

38. Mulholland, *Beware Familiar Spirits*, 154-55. See also Thomas Sutton, *A Dictionary of Photography*, 1858, cited in *The Compact Edition of the Oxford English Dictionary*, 1971, s.v. "microphotograph."

39. Gibson, *Secrets of Magic*, 146.

40. Christopher, *ESP, Seers and Psychics*, 174-75; M. Lamar Keene (as told to Allen Spraggett), *The Psychic Mafia* (New York: St. Martin, 1976), 41.

41. Cohen, *Encyclopedia of Ghosts*, 87-90; John Fairley and Simon Welfare, *Arthur C. Clarke's Chronicles of the Strange and Mysterious* (London: Collins, 1987), 140-41 (photo).

42. Nickell, *Mysterious Realms*, 19-33.

43. Cohen, *Encyclopedia of Ghosts*, 250, 251.

44. Susy Smith, "Turbulence in Toronto," chap. 2 of *Ghosts Around the House* (New York: World Publishing, 1970), 38-50.

45. Nickell, with Fischer, *Secrets of the Supernatural*, 17-27.

46. See Jay Anson, *The Amityville Horror: A True Story* (New York: Bantam Books, 1978): cf. Peter Lester, "Beyond the Amityville Hogwash . . . ," *People*, September 17, 1979: 90-94; and Rick Moran and Peter Jordan, "The Amityville Horror Hoax," *Fate*, May 1978: 43-47.

47. Ed and Lorraine Warren with Robert David Chase, *Graveyard: True Hauntings from an Old New England Cemetery* (New York: St. Martin's, 1992), photo following p. 102.

48. Mosbleck, "The Elusive Photographic Evidence," 208.

49. Archbishop of Lyons, *Liber contra insulam vulgi opinionem*, ninth-century manuscript, quoted in Jerome Clark, *UFO Encounters* (Lincolnwood, Ill.: Publications International, 1992), 9.

50. *Encyclopaedia Britannica*, 1960 ed., s.v. "balloon."

51. Denison, Texas, *Daily News*, January 25, 1878, quoted in Clark, *UFO Encounters*, 7, and in Baker and Nickell, *Missing Pieces*, 185.

52. Baker and Nickell, *Missing Pieces*, 185-86; cf. Clark, *UFO Encounters*, 16-18.

53. Clark, *UFO Encounters*, 21-23.

54. Baker and Nickell, *Missing Pieces*, 261, 266.

55. Ibid., 186-87; Clark, *UFO Encounters*, 78.

56. Quoted in Edward J. Ruppelt, *The Report on Unidentified Flying Objects* (New York: Ace Books, 1956), 23.

57. Lionel Beer, "The Coming of the Saucers," in Spencer and Evans, *Phenomenon*, 23.

58. William K. Hartmann, "Historical Perspectives: Photos of UFO's," in Sagan and Page, *UFO's: A Scientific Debate*, 15.

59. Baker and Nickell, *Missing Pieces*, 187.

60. Ruppelt, *The Report on Unidentified Flying Objects*, 32.

61. Baker and Nickell, *Missing Pieces*, 185.

62. Clark, *UFO Encounters*, 21.

63. J. Allen Hynek, *The UFO Experience* (New York: Ballantine Books, 1972), 59.

64. Klass, *UFOs Explained*, 171.

65. Ibid., 176-77.

66. Ibid., 178.

67. Allen Hendry, *The UFO Handbook* (Garden City, N.Y.: Doubleday, 1979), 206.

68. Ibid., 206-7.

69. John Shaw, "Is a Picture Worth a Thousand Words?" 213-14.

70. Ibid., 213.

71. Hendry, *UFO Handbook*, 210.

72. Ibid., 205; Shaw, "Is a Picture Worth a Thousand Words?," 218; Mosbleck, "Elusive Photographic Evidence," 209-10; Clark, *UFO Encounters*, 88, 102; Ruppelt, *Report on Unidentified Flying Objects*, 279; Donald H. Menzel and Ernest H. Taves, *The UFO Enigma* (Garden City, N.Y.: Doubleday, 1977), 193-95. See also Gary Kinder, *Light Years: An Investigation into the Extraterrestrial Experiences of Edward Meier* (New York: Atlantic Monthly Press, 1987), 201, 224-25.

73. Hendry, *UFO Handbook*, 203 (photos); for another deceptive lens-flare-caused UFO photograph, see Clark, *UFO Encounters*, 101. See also James Randi, "Lens Flares as UFOs," *Skeptical Inquirer* 6.4 (Summer 1982): 5-6.

74. Hendry, *UFO Handbook*, 203 (photos); Donald H. Menzel and Lyle G. Boyd, *The World of Flying Saucers* (Garden City, N.Y.: Doubleday, 1963), plate VIII (facing p. 209).

75. Clark, *UFO Encounters*, 101.

76. Hendry, *UFO Handbook*, 57-69.

77. Hynek, *UFO Experience*, 41-42.

78. Ibid.

79. Shaw, "Is a Picture Worth a Thousand Words?," 215.

80. Robert Sheaffer, "Psychic Vibrations: Gulf Breeze Flap Fades, But Still Entertains," *Skeptical Inquirer* 15.4 (summer 1991): 359-360; Philip J. Klass, "MU-FONS's Director Opts to Ignore Results of Salisbury Investigation and Will Soon 'Reindorse' the Ed Walters Gulf Breeze Photo-case," *Skeptics UFO Newsletter* 19 (January 1993): 2-3.

81. Klass, *UFOs Explained*, 166 (photos fol. p. 116).

82. Mosbleck, "Elusive Photographic Evidence," 210.

83. Shaw, "Is a Picture Worth a Thousand Words?," 219.

84. Ibid., 214-15.

85. See Joe Nickell and John F. Fischer, "The Crashed-saucer Forgeries," *International UFO Reporter*, March/April 1990.

86. Clark, *UFO Encounters*, 120 (photos 120-21).

87. Mosbleck, "Elusive Photographic Evidence," 211.

88. Nickell, *Looking for a Miracle*, 231-63.

89. Stories of the monster being sighted in 1520, 1771, and 1885 are unverified. See Ronald Binns, *The Loch Ness Mystery Solved* (Buffalo, N.Y.: Prometheus Books, 1984), 48-51.

90. "Strange Spectacle on Loch Ness," *Inverness Courier* (Inverness, Scotland), May 2, 1933, cited in Binns, *Loch Ness Mystery Solved*, 9-11.

91. Binns, ibid., 12.

92. Quoted in Binns, ibid., 16.

93. Nickell, *The Magic Detectives* (Buffalo, N.Y.: Prometheus Books, 1989), 90-92; Binns, *Loch Ness Mystery Solved*, 22-23.

94. Curtis D. MacDougall, *Hoaxes* (New York: Dover, 1958), 14.

95. Nickell, *Magic Detectives*, 91-92.

96. Binns, *Loch Ness Mystery Solved*, 98, 209.

97. Tim Dinsdale, *The Story of the Loch Ness Monster* (London: Universal-Tandem, 1973), cited in Binns, 99.

98. Binns, *Loch Ness Mystery Solved*, 96-97, 198 (photos fol. 36).

99. Ibid., 96-98; "Loch Ness Researchers Call Famous Photo Fake," *Lexington* (Kentucky) *Herald-Leader*, March 16, 1994.

100. Ibid., 99-100.

101. Roy P. Mackal, *The Monsters of Loch Ness* (London: Macdonald and Janes, 1976; Futura, 1976), cited in Binns, ibid., 102.

102. Mark Chorvinsky, "Our Strange World: The Lough Leane Monster Photograph Investigation," in two parts, *Fate*, March 1993: 31-35, and April 1993: 31-34.

103. Binns, *Loch Ness Mystery Solved*, 107-125.

104. R. Razdan and A. Kielar, "Sonar and Photographic Searches for the Loch Ness Monster: A Reassessment," *Skeptical Inquirer* 9.2 (1984-85): 147-58.

105. Ibid.

106. "Myth or Monster" *Time* 20 (1972): 66.

107. Baker and Nickell, *Missing Pieces*, 254-55.

108. Daniel Cohen, *Encyclopedia of Monsters* (New York: Dodd, Mead and Co., 1982), 6-7.

109. Michael Dennett, "Abominable Snowman Photo Comes to Rocky End." *Skeptical Inquirer* 13.2 (1989): 8-9.

110. Cohen, *Encyclopedia of Monsters*, 9.

111. Ibid., 18. See also Richard Cavendish, *Encyclopedia of the Unexplained* (London: Routledge and Kegan Paul, 1974) 219, and Janet Bord and Colin Bord, *The Bigfoot Casebook* (Harrisburg, Pa.: Stackpole, 1982), 20.

112. Michael Dennett, "Bigfoot Jokester Reveals Punchline—Finally," *Skeptical Inquirer* 7.1 (1992): 8-9.

113. Bord and Bord, *Bigfoot Casebook*, 128 (photo).

114. Cohen, *Encyclopedia of Monsters*, 25; Eugene Emery, "Sasquatchsickle: The Monster, the Model, and the Myth," *Skeptical Inquirer* 6.2 (1981-82): 2-4.

115. Bord and Bord, *Bigfoot Casebook* 97-99, 182, (photo 99).

116. Ibid., 80.

117. Joyce Robbins, *The World's Greatest Mysteries* (New York: Gallery Books, 1989), 109.

118. Cohen, *Encyclopedia of Monsters*, 17.

119. MacDougall, *Hoaxes* 17-18 (photo fol. 24).

120. Arthur Conan Doyle, *The Coming of the Fairies* (New York: Samuel Weiser, 1921).

121. James Randi, "Fairies at the Foot of the Garden," chapter 2 of his *Flim-Flam! Psychics, ESP, Unicorns and Other Delusions* (Buffalo, N.Y.: Prometheus Books, 1982). This is an extremely detailed discussion of the case, including analyses of the original glass-plate negatives.

122. Terence Hines, *Pseudoscience and the Paranormal* (Buffalo, N.Y.: Prometheus Books, 1988), 4-5; Nickell, *The Magic Detectives*, 67-69.

123. "Experts call 'Hugo Christ' Photo Fake," *Evening Post* (Charleston, S.C.) April 12, 1990.

124. For a discussion of "weeping" statues, see Nickell, *Looking for a Miracle*, 53-64; for psychokinetic spoon bending see Nickell, *Magic Detectives*.

125. Randi, *Flim-Flam!*, 102-8 (photos 103).

126. Robins, *World's Greatest Mysteries*, 56-59 (photos).

127. Gordon Stein, "Famous Levitation Photo Is a Fake," *Skeptical Inquirer* 15 (winter 1991): 119-20.

128. Robins, *World's Greatest Mysteries*, 57 (photo).

129. Ibid., 38.

130. James Randi, *James Randi: Psychic Investigator* (London: Boxtree, 1991).

131. W.J. Kilner, *The Human Atmosphere*, 1911; reprinted as *The Aura* (York Beach, Maine: Samuel Weiser, 1984), iii.

132. *Encyclopaedia Britannica*, 1960 ed., s.v. "Photography."

133. Cavendish, *Encyclopedia of the Unexplained*, 49.

134. Baker and Nickell, *Missing Pieces*, 174-75.

135. Robins, *World's Greatest Mysteries*, 34, 37, 189.

136. Arleen J. Watkins and William S. Bickel, "The Kirlian Technique: Controlling the Wild Cards," *Skeptical Inquirer* 13.2 (winter 1989), 172-84; John O. Pehek,

Harry T. Kyler, and David L. Faust, "Image Modulation in Corona Discharge Photography," *Science* 194 (October 15, 1976): 263-70.

137. Randi, *Flim-Flam!*, 254-65.

138. Ibid., 274 (sequence of photographs).

139. Ibid., 218-20 (photo 218).

140. Shaw, "Is a Picture Worth a Thousand Words?" 216.

141. Benjamin, *Autographs*, 88.

142. Dave Corbett, "Can UFO Photos Be Trusted?," *Minnesota Skeptics Newsletter*, June, 1992: n.p.

Chapter 8. Paranormal Photographs

1. Peter M. Rinaldi, *It Is the Lord* (New York: Warner Books, 1973), 25-26.

2. Michael Thomas, "The First Polaroid in Palestine," *Rolling Stone*, December 1978.

3. Joe Nickell, *Inquest on the Shroud of Turin*, second updated edition (Buffalo, N.Y.: Prometheus Books, 1988), 27-28, 107-8.

4. Ibid., 77-84.

5. Ibid., 100.

6. Ibid., 87-88.

7. Ibid., 85-94.

8. Ibid., 11-21, 31-39.

9. Ibid., 41-48, 57-75, 127-32, 157-60.

10. Ibid., 119-32.

11. Joe Nickell, "Unshrouding a Mystery: Science, Pseudoscience, and the Cloth of Turin," *Skeptical Inquirer* 13.3 (spring 1989): 296-99.

12. Ibid., 298.

13. This and the basic outlines of the story are given in Ian Wilson, *The Shroud of Turin*, rev. ed. (Garden City, N.Y.: Image Books, 1979), 272-90.

14. Thomas Humber, *The Sacred Shroud* (New York: Pocket Books, 1978), 92.

15. Wilson, *Shroud of Turin*, 272-90.

16. Jody Brant Smith, *The Image of Guadalupe* (Garden City, N.Y.: Doubleday, 1983), 4.

17. Cleofas Callero, trans., *Nican Mopohua*, in Smith, *Image of Guadalupe*, 121-25.

18. Smith, *Image of Guadalupe*, 20.

19. Philip Serna Callahan, *The Tilma under Infrared Radiation* (Washington, D.C.: Center for Applied Research in the Apostolate, 1981), 10, 18, 20.

20. See Joe Nickell and John F. Fischer, "The Image of Guadalupe: A Folkloristic and Iconographic Investigation," *Skeptical Inquirer* 8.4 (spring 1985): 243-55. See also Callahan, *Tilma Under Infrared Radiation*, 30-44.

21. Smith, *Image of Guadalupe*, 20-21.

22. Ibid., 79-83, 111 ff.

23. "Photo Draws Believers In Power of Cloak," *Lexington* (Kentucky) *Herald-Leader*, December 26, 1992.

24. Nickell, *Looking for a Miracle*, 74-75.

25. Ibid., 195-97, 215-21.

26. Ibid., 266.

27. Dale Heatherington, "The Mystery of the Golden Door," *Georgia Skeptic* 5.3 (May/June 1992): 1, 3 (photos).

28. Wesley M. Johnson, "'Holy Spirit' Dove on the Surgical Glove?" *Tampa Bay Skeptics Report* 5.2 (Fall 1992): 1, 5, (photo, drawings).

29. Ibid., 5.

30. Gettings, *Ghosts in Photographs*, 9.

31. Ibid., 10 (photograph).

32. "Psychic Vibrations," *Skeptical Inquirer* 3.2 (winter 1978): 11-12.

33. James Randi, "A Skotography Scam Exposed," *Skeptical Inquirer* 7.1 (Fall 1982): 59-61.

34. Ibid., 61.

35. This case is described at chapter length in Nickell, *Secrets of the Supernatural*, 47-60 (photos).

36. Ibid., 51.

37. Ibid., 52-55.

38. Keene, *Psychic Mafia*, 110-11.

39. Nickell, *Secrets of the Supernatural*, 58. The medium could not be extradited on what were multiple misdemeanor charges, and he reportedly died some time ago. The replicated spirit images were done by a variation on the Keene recipe: placing a square of polyester cloth over a newspaper photo, moistening the cloth with alcohol, and rubbing it firmly with a burnishing tool.

40. Anson Kennedy, "'Spirit Writing' Pictures—Exposed,"*Georgia Skeptic*, Fall 1993, 2-4.

41. Ibid.

42. Other methods may present themselves to the creative imagination.

43. *The Shirley Show*, Toronto, April 15, 1993.

44. Paul Welch, "A Man Who Thinks Pictures," *Life*, September 22, 1967: 112-14; Jule Eisenbud, *The World of Ted Serios* (New York: William Morrow, 1967).

45. Randi, *Flim-Flam!*, 223.

46. Charles Reynolds and David B. Eisendrath, "An Amazing Weekend with the Amazing Ted Serios," *Popular Photography*, October 1967: 81-87, 131-41, 158.

47. Gordon Stein, *Encyclopedia of Hoaxes* (Detroit: Gale Research, 1993), 185.

48. Christopher Scott, "Television Tests of Masuaki Kiyota," *Skeptical Inquirer* 3.3 (spring 1979): 42-48.

49. Yale Joel, "Uri Through the Lens Cap," *Popular Photography*, June 1974.

50. *Trick Photography: A Modern Photo Guide* (Garden City, N.Y.: Minolta/ Doubleday, 1982), 26-27.

51. "Visual Hallucinations Captured on Film," *Aura-Z* (published in Russia), March 1993, 81-89.

52. Ibid., 89.

53. Dan Korem, *Powers: Testing the Psychic and Supernatural* (Downers Grove, Ill.: InterVarsity Press, 1988), 29.

54. Unattributed article, reprinted in Dennis Pearce, "News from the Net," *Kases File*, (newsletter of the Kentucky Association of Science Educators and Skeptics), July 1993.

INDEX

Italicized page numbers indicate pages with illustrations.